Jewish Identity in Modern Art History

THE S. MARK TAPER FOUNDATION

IMPRINT IN JEWISH STUDIES

BY THIS ENDOWMENT

THE S. MARK TAPER FOUNDATION SUPPORTS

THE APPRECIATION AND UNDERSTANDING

OF THE RICHNESS AND DIVERSITY OF

JEWISH LIFE AND CULTURE

Jewish Identity in Modern Art History

Edited by

CATHERINE M. SOUSSLOFF

University of California Press
Berkeley Los Angeles London

*The publisher gratefully acknowledges the generous
contribution toward the publication of this book provided
by the S. Mark Taper Foundation.*

Paul Celan's poems "Deathfugue" and "Tübingen,
January," in Lisa Saltzman's essay, "To Figure, or Not to
Figure: The Iconoclastic Proscription and Its Theoretical
Legacy," are reprinted, with the publisher's permission,
from John Felstiner, *Paul Celan: Poet, Survivor, Jew*
(New Haven, Conn.: Yale University Press, 1995).

Donald Kuspit's essay, "Meyer Schapiro's Jewish
Unconscious," first appeared in *Prospects* 21 (1996):
491–508. It is reprinted with the permission of
Cambridge University Press.

Library of Congress Cataloging-in-Publication Data

Jewish identity in modern art history/edited by
 Catherine M. Soussloff.
 p. cm.
 Includes bibliographical references and index.
 ISBN 0–520–21303–3 (alk. paper).
 ISBN 0–520–21304–1 (pbk: alk. paper)
 1. Arts, Jewish. 2. Arts, Modern—20th century.
 3. Jews—Identity. 4. Jews in art. I. Soussloff,
 Catherine M.
 NX684.A5J49 1999
 704.03'924—dc21 98–31211

University of California Press
Berkeley and Los Angeles, California

University of California Press, Ltd.
London, England

To my sisters, Margie and Betsy,
and to my brothers, Andy and Greg,
with love

Contents

PART III: ART HISTORIANS AND CRITICS

Acknowledgments

The subject of this book has preoccupied me for three years. The field of Jewish studies has a venerable history in the American university, mainly as a subdiscipline of the larger field called religious studies and, less frequently, except in Jewish institutions of higher education, as a separate department. In recent years, at least in California, which I know best, history and literature departments have offered courses on topics related to Jewish history and identity. I hope that this book will contribute to the established interdisciplinary field known as Jewish Studies. I hope that it will also reveal, as the essays in this book demonstrate consistently, the value of that field for the teaching and study of the visual arts in America in the second half of the twentieth century.

One of my pleasures in assembling the essays for this book has been the realization that a thriving and exciting group of scholars today are writing about Jewish topics in art and art history. I have come to know and rely on many of them. The contributors to this volume are foremost among these. Five of the papers in this volume began as presentations at a session I organized at the College Art Association annual meeting in 1996. I am grateful to Margaret Olin, Lisa Saltzman, Donald Kuspit, Charlotte Schoell-Glass, and Louis Kaplan for their hard work at that time and since then. I am also grateful to Steven Z. Levine, Eunice Lipton, Ruth Mellinkoff, Keith Moxey, and Larry Silver, who were particularly generous toward this project. Two essays, Steven Z. Levine's "Mutual Facing: A Memoir of Friedom," in *The Writings of Michael Fried,* edited by Jill Beaulieu (forthcoming), and Eunice Lipton's "The Pastry Shop and the Angel of Death: What's Jewish in Art History," in *People of the Book: Thirty Scholars Reflect on Their Jewish Identity,* edited by Jeffrey Rubin-Dorsky and Shelley Fisher Fishkin (Madison: University of Wisconsin Press, 1996, 280–297), influenced my thinking as I put together the session. I am grateful to both authors for sharing their work in manuscript and for their generous and loyal support

throughout this project. Both before the CAA meeting and afterward a number of graduate students and scholars have spoken with me about their work on Jewish topics and allowed me to read their unpublished writing, for which I am also grateful. Here I should especially like to mention Olga Hazan, Michael Krausz, Kevin Parker, Peter Selz, Ellen Handler Spitz, James Marrow, and Janet Wolff.

This book presents a number of approaches to Jewish identity in visual culture, about which I learned a great deal initially thanks to the conference "Prophets and Losses: Jewish Experience and Visual Culture," organized by Janis Bergman-Carton at Southern Methodist University in October 1996. I cannot express strongly enough my admiration for, and gratitude to, the conference participants, who shared their ideas with a generosity and openness that we all found remarkable. Without the enthusiasm of Janis Bergman-Carton herself and Carol Ockman, Rachel Perry, Steven Platzman, Gabriel Weisberg, Albert Boime, Nicholas Mirzoeff, Margaret Olin, Deborah Lefkowitz, Carol Zemel, Norman Kleeblatt, Ken Aptekar, and Eunice Lipton, I doubt that this book could have been conceived.

At the University of California at Santa Cruz I have been lucky to have colleagues who have encouraged me in my work on Jewish identity. My thanks to Murray Baumgarten, Jim Clifford, Alla Efimova, Greta Slobin, Beth Haas, Hayden White, Margaret Brose, Lidia Curti, Iain Chambers, Mark Franko, and Karen Bassi. I am grateful to Aaron Kerner, Gabriella della Rosa, and Sarah Whittier, my research assistants, who have been patient, kind, and resourceful and often willing to work under difficult time constraints. And I appreciate the support of my work by the University of California at Santa Cruz Faculty Research Fund.

I completed the final preparation of this book during a term as a fellow at the University of California Humanities Research Institute at the University of California at Irvine, and I am grateful to the Trustees for their support of my sabbatical leave. The UCHRI staff, under the directorship of Patricia O'Brien, have been gracious and helpful. I appreciate the recognition of this project's significance on the part of my colleagues in the seminar Jewish Identity in Diaspora. Thanks to Bluma Goldstein, Richard Hecht, Kerri Steinberg, and Irwin Wall for reading with a generous spirit my essay in this volume and to Erich Gruen and Daniel Boyarin for their encouragement.

At the University of California Press I am privileged to have found a thoughtful and sympathetic editor in Deborah Kirshman. She and her staff, Kim Darwin and Jennifer Toleikis Abrams, have been most supportive. In addition, I wish to thank Stephanie Fay for her expert copyediting and advice.

Finally, I am aware that none of my work would be complete or meaningful without the love and strengths of my husband, Bill Nichols, and my daughter, Genya. Thank you both.

Introducing Jewish Identity to Art History

CATHERINE M. SOUSSLOFF

In February 1996 I chaired a session called "Jewish Identity in Art History" at the annual meeting of the College Art Association of America in Boston, Massachusetts. The membership of this organization consists of approximately thirteen thousand museum professionals, university and college art and art history teachers and graduate students, and practicing artists. To my knowledge, this was the first time in the eighty-five-year history of the organization that Jewish identity had been the subject of a session. It also marked the first exploration of several related topics: the meaning of anti-Semitism for art history, the significance of Jewish émigré art historians to the discipline, and the effects of Jewish ethnicity on the interpretation of art. The contributions of Jewish exiles from German-speaking countries prior to and during World War II, while part of the "lore" of art history, have been noted only sporadically by scholars over the last fifty years. The ambivalent structural situation of Jews in art history continues today. Both reluctance and fascination are suggested by the circumstances surrounding the College Art Association session on which the present volume is based: initially rejected, the session was included in the program only after board members prevailed upon the program organizers to reconsider their decision.

In the appendix to an exceptional article, "*Kunstgeschichte* American Style," published in 1969, Colin Eisler listed approximately eighty names of émigré art historians who had fled the Nazis and settled in America.[1] Although not all were Jews, among the art historian émigrés most were German Jews, and Eisler points out that *they* were in large part responsible for the growth of the discipline of art history in America in the latter part of the twentieth century. Very recently, the important work of Karen Michels, a German scholar and contributor to this volume, has documented carefully that most of the best-known art historians of the second half of this century in America and in other English-speaking countries have been Jewish

émigré scholars. In America in the 1930s and 1940s they joined an art world made up of artists, art dealers, and critics, some of them Jews of earlier diasporas. Particularly significant among them for the writing about art were Bernard Berenson, Meyer Schapiro, and Clement Greenberg. Jewish émigrés and their students have trained four generations of students in art, art history, and museum studies, resulting in a definitive formative influence on art and art history. Based on these facts of emigration and influence alone, the importance of Jewish art historians, critics, and artists in the interpretation and exhibition of art in America and the English-speaking world must be considered meaningful for art history.[2]

Numerous studies focus on émigré intellectuals in other disciplines and their impact on American culture and society, but until very recently these art historians and their criticism of art have not been interpreted in light of their Jewishness.[3] Because National Socialist policy toward the Jews in Germany and Austria hit German art history particularly hard relative to other disciplines or, to put it another way, because most of the fortunate art historians who made their way to America as a result of that policy were Jews, this book seeks to understand a historiography peculiar to art history. Despite the experiences of the émigrés and their influence in America, we find in the discipline a critical situation in which significant topics in the history of art related to Jewishness have been elided or are absent.

This situation begins with the accounts of the past given by the art historians themselves. For the most part, these critics wanted to avoid the notion that their religion or ethnicity had anything to do with their art criticism. Thus any topic or method that ostensibly approached issues related to Jewishness or Jewish identity could not be consciously or overtly dealt with. These avoidances over many years and several generations have produced an *aporia* at the very heart of the project of art history, a space of doubt brought about by the suppression of the history of the discipline and its effects on discourse. The subjectivity of the interpreter of art and its presence in the interpretation have been evacuated into this space. It bears emphasizing here that this is not simply a biographical issue related directly and only to the experiences of particular individuals, although these experiences should be remembered and respected. The subjectivity of the interpreter bears upon the written record itself, that is, what the art historian has written, and upon the subsequent history of that writing in citation and in the practices of scholarship and art criticism, where identity and historiography converge and become manifest as discourse.

In this endeavor to understand Jewish identity in art history we must also probe the topic of anti-Semitism, both conscious and unconscious, for its effects on this particular discipline and its discourse.[4] For some years now, historians have suggested that one effect of anti-Semitism on the configuration of the educated and professional classes in Germany was the concentration of a large number of Jews in art-related disciplines and endeavors.[5] The Jewish presence in the discipline of art

history was proportionally greater than the number of Jews in other disciplines, and virtually every study of exiles from Nazi Germany in the United States considers American anti-Semitism a major factor in the reception of all Jewish intellectuals in America. In Europe, too, Jews were discriminated against, both in the academy and in society in general.[6]

Considering anti-Semitism as an "ideology of desire," that is, a prejudice brought about by the needs and desires of the dominant group in order to maintain power, the psychologist Elizabeth Young-Bruehl claims that such prejudices "reinstate inequalities and distinctions when the force of movements for equality has been registered and (often unconsciously) rejected."[7] The perhaps understandable reluctance of art historians to claim and examine critically their own subject positions, particularly in regard to Jewish ethnicity, follows, then, from two factors related to both anti-Semitism and assimilation. In the German context, Jews had some small hopes of finding in art history the professional affiliation not available to them in other fields. Then, particularly after exile from Europe, a significant number of Jews, having attained positions of influence, powerfully affected art and art history, a situation that suggests how they registered and seized the opportunities available—in the form of institutional affiliations in the academy, museums, and galleries. Immigrant Jews in America and elsewhere found new freedom, but they had also become aware of a difference they feared to express, lest it result in anti-Semitism.

This volume unabashedly seeks to explore the Jewish subject position in art history and its manifestations in art-historical discourse. The very possibility of a historiography of Jewish identity in art history reveals that art history has entered a new era, one in which some of its practitioners desire "a description of the facts of the discourse."[8] Given the significance, as well as the large number, of contributions to the discourse by Jews, the project of the historiography of art history will be incomplete, indeed inchoate, until we can situate the function of Jewish identity in the epistemology of the discipline—and by implication the cultural identity of any writer, critic, or historian, as described below. I understand "discourse" here, in the widest possible sense of the term, to include texts, that is, art-historical writing and museum publications, as well as the visual artifacts that are the subject of those texts.[9] Because the history writing discussed here concerns the interpretation of texts, images, and material culture, issues of representation and ethics, images and ideology, cannot be divided conveniently into separate visual and textual realms. The essay in this volume by Larry Silver on the Jewish "history painter" Maurycy Gottlieb demonstrates the interconnectedness of history, painting, and Jewish identity particularly well. Likewise, the essay by Robin Reisenfeld broadens the discourse by considering the implications for art history of collecting by Jewish patrons. When we consider these areas of discourse, visual representation, and subjectivity together, long-held assumptions about art and interpretation come under question.

My presumption here is that the historical subjectivities of art historians, indeed of any writer, are evident and meaningful at more than a purely biographical level.[10] In saying this, I do not mean to deny the importance of the lived experience of the individuals concerned. Many of the essays in this volume gesture to the biographical, and Charlotte Schoell-Glass has found it particularly important for assessing the influence of anti-Semitism on Aby Warburg's cultural history. The case of Aby Warburg demonstrates that at the deep level, below the biographical surface of an individual's existence, lie the resonances with the "facts" of a life that constitute an identity. The essays in this volume take soundings of what lies behind and within discourse to probe the meaning of Jewish identity for that discourse.

The certainty of the interconnectedness of interpreter, interpretation, and audience rests on an epistemological foundation delineated by linguistic theorists, particularly Émile Benveniste. He argues that when language is enunciated as discourse, the speaker establishes simultaneously both herself and the other "to whom the utterance is addressed."[11] Benveniste distinguishes this kind of enunciation from "histoire," in which the speaker effaces herself from an active position, letting history intransitively reveal itself. According to Roland Barthes, history writing embodies a defaulting, which, however, should not be understood as entailing a complete erasure of the speaker. We might think of it instead as an absence that can be recuperated or interpreted—an assimilation, if you will, of the speaker to the text.[12] Benveniste insists that no enunciation can escape manifesting "the attitudes of the enunciator towards that which he or she enounces."[13] Barthes goes further. He believes that "the language of the image is not merely the totality of utterances emitted . . . it is also the totality of utterances received: the language must include the 'surprises' of meaning."[14] These "surprises of meaning" can be understood here as the often unexpressed dimensions of subjectivity, such as how ethnicity and experience manifest themselves. This relationship to the world that is constructed through the self's act of enunciation we might call the cultural identity of the speaker.

In the past twenty-five years or so, this system, in which the speaker and language function together and through which a useful description can be made of the power relationships between individuals and political systems, systems of thought, and ideologies, has been known as discourse. Thus, the domination of art history by Jewish writers raises the question of how or to what degree these art historians create discourse.[15] Conversely, how does discourse "create" them? In what particular ways does Jewish subjectivity resist the situation against which it struggles, and can we see this in the writing on art by Jews? And most immediate to our lives today, does the discourse on art in America in the latter half of this century represent evidence of the struggle of a Jewish identity and, if so, in what ways? These essays suggest some of the reasons for the fascination and attendant repulsion that much of the discipline has exhibited in its reluctance to confront the difficult issues that Jewish iden-

tity raises for art history writing—issues having to do with the mystification of the visual image; the nationalistic and anti-Semitic programs that underpin much of the story of art; the complex problems of identification and interpretation that arise in the diasporic and historically specific contexts of Jewish artist, Jewish art patron, and Jewish art critic.

These are not easy topics to confront, especially, perhaps, for members of a discipline often considered among the most "interpretative" in the academy yet simultaneously resistant to reflectiveness. The most prominent resisters include the Jewish art historians themselves.[16] To what extent is the problem a function of the assimilationist positions of Jewish art historians, both in Europe and, later, in America and England? Many of the essays, such as those by Margaret Olin, Kalman Bland, Larry Silver, Robin Reisenfeld, Karen Michels, and Donald Kuspit, present evidence that anti-Semitism in art history should be understood as a part of the inheritance of the Enlightenment. It is the often undeclared component in the general history of art to which Jews and non-Jews alike have subscribed for two hundred years. The argument, referred to in both Karen Michels's and Louis Kaplan's essays, is that the humanizing potential of art, proposed by Kant in his Third Critique and supported by Hegel's philosophy of aesthetics, resulted in a "policing out" of difficult issues of ethnicity and politics in favor of a narrative based on an ideal humanistic view for the historiography of art.[17]

Even leaving aside the philosophical foundations of this view, an ideal humanistic historiography of art characterizes the contributions from the Germanic milieu since the time of Johann Joachim Winckelmann (1717–1768).[18] Margaret Olin argues in her essay that the interpretation of art according to national styles followed the formation of the nation-state, which erased Jewish art, making it impossible except as a "primitive" precursor.[19] Lacking a nation, Jewish art lacked an identity. The existence of the state of Israel and the history of Zionism since its foundation call for a reconsideration of the ways in which the historic absence of a Jewish state functions historiographically in the discipline, but this volume will not pursue such a line of thought. Ironically, the democratic principle of equality, encountered by the Jewish émigrés to America and predicated on the erasure of difference—the melting pot—supports the idealist humanist historiography of the discipline as constructed in Europe.[20] Whether or not this view of art history as a humanistic discipline—to invoke a famous essay by Erwin Panofsky—has proved true in the actual experience of individual art historians, its strength as myth is found in the resistance to the exploration of issues of subjectivity in the discipline as a whole.

The resistance is addressed explicitly in many of the essays that follow. Indeed, as they reveal, the exploration of resistance in the historiographical realm leads directly to profound questions regarding dogma, atavism, taboo, and aniconism in the critical practices of art history. These cultural concepts, which border on the

psychological, become most apparent in the context of the visual image and arti-fact, particularly in the domain of religion. Kalman Bland argues that for two centuries Jewish aniconism, defined as the denial of Jewish art, served two, often competing, ideological agendas. If Jewish aniconism was theorized as bad because it differed so strongly from the reverencing of images by Christians, it supported an anti-Semitism whose ultimate purpose became one of eradicating all Jews and their culture from Europe. When Jewish aniconism was viewed positively, it perpetuated the narrative that modern assimilated Jews "learned" the value of images from the dominant Christian ideologies. Lisa Saltzman sheds another light on the dilemma of artistic representation for Jewish identity when she rereads Theodor Adorno's statement on the impossibility of representation after Auschwitz in conjunction with the biblical taboo on imagery in order to redeem both the politics and theory of an antimimetic position. Charlotte Schoell-Glass explores anti-Semitism in relation to theories of atavism, an aspect of genetic theory often used to explain racist ideology. She demonstrates how Aby Warburg attempted to resist such dangers in his creative cultural history.

The exceptional rigor and complexity of art-historical scholarly apparatuses, such as the typical museum catalogue, give the impression of an exhaustive comprehension of the past and its culture. Yet a point of departure for many of the papers in this volume is the serious lack of historical knowledge regarding the very figures who serve many of us as our most central references. The historiographical explorations represented in this volume lead to new insights into issues of content and style in the work of art, as well as to new perspectives on many of the prevailing and historical philosophical positions regarding visual art and the field of aesthetics.

Lisa Bloom's article on the Jewish identities of the artists Eleanor Antin and Judy Chicago presents a particularly strong case for the powerful hermeneutic that ensues when gender, ethnicity, and discourse are considered together. The evidence collected in this volume suggests that the patterns of resistance in history writing may be fruitfully explored, perhaps even delineated, by the cultural markers of ethnicity and gender. In the past such efforts have been made, although rarely in art history, from the perspective of "class," enabling an alternative critique or the revelation of hidden and covert historiographic agendas. An unusual example of this approach from within the discipline can be found in Arnold Hauser's argument concerning the hidden meaning of the power of the film medium.[21] The historical reasons for art history's resistance to class-centered interpretations are too complex to address adequately here, although many of the essays in this volume raise the question, as they must when the topic is the complex socio-economic-cultural construction called art.

Class-based alternatives to the study of art are found most notably in the approaches to culture of the Frankfurt School, particularly in the work of Walter Ben-

jamin. In certain fields, especially in the study of modern art, such studies have offered useful alternatives to the traditional accounts that are focused on the co-dependent terms of national period styles and individual artists. The more productive models of cultural interpretation proposed by the Frankfurt School, such as those that consider the social situation of the observer, say, or questions of media, deal with the issue of subjectivity. The allure of this alternative cultural criticism for art history is particularly strong because of the Germanic flavor of the discipline, the attraction of one Germanic discipline to the many familiar sounds and modes of argumentation of another Germanic discourse. The mainly German Jewish ethnicity of the members of the Frankfurt School means that their contributions to the study of identity and subjectivity in the realm of art may be fraught with complexities that deserve due consideration when their methods are appropriated. It is true, for example, that many of the members of the Frankfurt School essentially sought to negate, for what may seem legitimate political reasons, the power of art, particularly after their emigration.[22] When Lisa Salzman interprets Adorno's famous statement about the prohibition of images, she warns us about the problematic issues involved in relating Adorno's Jewishness to his criticism of mimetic representation.

Today, in the study of cultural objects and the societies that produce them, ethnicity and gender have offered more flexible and fruitful prospects than class from which to probe the meaning of representations, particularly in the visual media. Both ethnicity and gender allow the interpreter to explore issues of subjectivity in makers, audiences, and critics in ways not possible if the interpretational lens remains fixed on economic factors alone. The field of cultural studies is a nascent discipline in which approaches to culture previously pursued through history, anthropology, art history, and media studies (film, television, and video) are brought to bear upon material culture of every variety and type, including everyday objects, high art, and texts.

In the context of cultural studies Jewish identity has a peculiarly problematic profile. Thus *historiographic resistance adheres to the topic of Jewish identity* more than to other aspects of visual studies.[23] In a recent book with the subtitle *The New Jewish Cultural Studies,* Jonathan and Daniel Boyarin make the important observation that the difficulties in establishing a "Jewish place" in cultural studies relate both to the precedence of the Jewish Diaspora relative to other diasporas currently studied by scholars, such as the black Atlantic diaspora, and to the "retrospective devaluation of Jewish difference in exile since World War II."[24] By revealing the powerful ways that an assimilationist ideology has influenced art history and the interpretation of art, this volume provides substantive insight into the reasons for the current views of Jewish identity in cultural studies.

The problem of Diaspora and diasporas, one writ large throughout the Bible and history, the other plural and lowercase, affects every area of life in America today,

not just the academic field of cultural studies. The competition among and for diasporas in the academy is more than a current ivory-tower sporting event. It indicates profoundly that cultural studies mirror the persistently embattled positions of minority groups in contemporary society. Our academic "culture wars" are just one public articulation of our most serious diasporic social problems. Inasmuch as many, but not all, of the essays in this volume employ strategies often associated with cultural studies to explore the issue of Jewish identity in art history, the tensions inherent in appropriating methods from diaspora studies for interpreting identity issues related to "the Diaspora" deserve some specific comment.

Clearly, no theorist of contemporary postmodern culture would want to claim that a Jewish identity is essential to an understanding of that culture, any more than others would make such a claim for a black, gay, or female identity.[25] David Theo Goldberg and Michael Krausz, the editors of a volume called *Jewish Identity,* understand that identity formation is "never complete, always in process (and after death is often carried out by others, in one's name)."[26] This view locates the understanding of identity in history and, therefore, in flux, open to change and to changes of meaning or signification, retrospectively as well as contemporaneously. For example, the Jewish historian Yosef Yerushalmi brilliantly rereads Sigmund Freud's Jewish identity to reveal a sense of historical situation and vicissitude in the theory of psychoanalysis.[27]

The competition and confrontation between Jews and other minority groups in America, especially African Americans, necessarily play a role in the interpretation of these groups' identity. Such conflicts have occurred during much of the historical period covered by this book. Recently, for example, K. Anthony Appiah has argued that the successful assimilation of Jews into mainstream American culture intensifies, rather than lessens, the differences between "blackness" and "whiteness": "If African-Americans did become white, as the Italians and the Jews did, there wouldn't be any point to whiteness anymore."[28] The reception given to the exploration of Jewish identity, both inside and outside the academy, is bound to be affected when ethnic and cultural concerns elide with "race," as they often do in these debates, for both historical and polemical reasons.

No doubt, at least in the field of cultural studies, some will question the use of approaches that reject the dominant Eurocentric views of history and society, with which Jews are so often associated, to study Jewish identity. In addition, the art historians and critics examined here have written about the high art forms not ordinarily considered in the field of cultural studies. Scholars of cultural studies have concentrated more on indigenous and popular forms of art, such as Afro-Pop or street art, as yielding a greater understanding of diasporic identities. In significant methodological ways this book challenges the field of cultural studies by raising a variety of historiographic and interpretational issues around the subject of Jewish identity.

This volume seeks something more than an understanding of the Jews in art history according to traditional or even the usual postmodern notions of diaspora. The prevailing trends toward subjectivity found in other disciplines, particularly those in which "the visual" is central, have pointed the way for the approaches taken here. In anthropology, for example, a responsible ethnographic method today insists upon an ethical self-awareness on the part of the ethnographer toward the subjects and the ethnographer's own subject position. Charlotte Schoell-Glass's essay on Aby Warburg's research reveals, in his interest in anti-Semitism, just such a perception of responsibility on his part as a cultural historian.

In literary and film studies the issue of the interpreter's relationship to the text has been examined since the late 1960s, beginning with the debates on authorship instigated by Roland Barthes and Michel Foucault. Feminism and queer studies have required that the multiple subjectivities of the interpreter be considered in historical critique. If scholars in the traditional humanities and social sciences were already concerned with issues of subjectivity and authorship, those in the newer field of cultural studies, particularly those actively examining the African diasporas, have extended the issue of identity itself and its many manifestations in overtly political directions.[29]

My own interest in the topic of Jewish identity in art history has been provoked by the thinkers in all these disciplines who have investigated the many ways in which an understanding of subjectivity, both expressed and unexpressed, expands our grasp of the political investments and ethical choices reflected in history writing. But I must admit that my energy for this topic, like that of many of the contributors to this volume, lies in a realm more subjective than what is usually understood by "the scholarly." As historians, we can begin only from where we sit today. I can acknowledge my motivation briefly by confessing my desire to understand my own Jewish identity and its role in my choice of profession and field. I found in art history, both past and present, many others who, like myself—or like my father, whose model I followed—had repressed or suppressed their Jewishness in their professional lives and writing. Somehow they had converted, assimilated, or at least "passed," many of them if only by studying the most Christian of periods in the history of art, the Renaissance, also my own specialization. My fellow authors in this volume have their own reasons for exploring the topic at hand. To examine these fully would require another volume at least, but also the courage to take what we have learned from this volume into our own lives and discourses. If we understand our discursive past in the various complex ways described by these essays, how will that understanding guide us as we write the future of the discipline?

I have suggested here many reasons for the rarity of explicit references to ethnicity in art history. The essays in this volume explore many of these reasons. For the curious, or for those dissatisfied, for whatever reason, with the historiography as it has been explained to date, one way to begin uncovering the missing parts of the

story of art history is to acknowledge the lineage of those who wrote it. This volume begins to do that by pointing to the ways in which Jewish art historians have told the story of a largely Christian art in a Christian world to a mainly Christian audience. Many of these Jews have been called, and have called themselves, "secular Jews." This is a term heavy with meaning in a discipline that deals constantly with religious images and representations. Elements of iconoclasm, as Louis Kaplan's essay on Clement Greenberg suggests, adhere to the secularization, by art criticism or the art historians themselves, of not only their own discourse, but also the work of others.

The most prominent example in the literature of the ambivalence associated with this secularization is the famous article of 1961 by the left-leaning art historian Meyer Schapiro on the politically conservative art historian and connoisseur Bernard Berenson.[30] There is no better place to start investigating the complexities of Jewish subjectivity in art history than this article in which Schapiro comes down hard on Berenson's "zeal for the problem of authorship" and his love of attribution, concerns associated with the art market. As Donald Kuspit notes in his contribution to this volume, Schapiro speculates on some possible influences in Berenson's life and work resulting from his conflicted relationship to Judaism and his disavowal of a Jewish identity, but Schapiro's essay reveals as much about his own Jewish identity as about Berenson's conversion away from Judaism.

Schapiro focuses on Jewishness as a means of understanding Berenson's ethics. He uses Berenson's memoir and his own interviews with the aged scholar as sources for the assessment of "values." He questions the very truthfulness of the autobiographical account, finding discrepancies and omissions throughout. Schapiro slyly employs the stereotype of the "merchant Jew" to criticize Berenson's commerce in art which, according to Schapiro, badly colored his aesthetic positions. Robin Reisenfeld's important essay on the Jewish patronage of German expressionist artists, published here, demonstrates how this stereotype of the venal Jew prevailed in Germany when Berenson was active. Such a Jew was identified with commerce in general and with the art market in particular. As with Schapiro, the stereotype was applied not only by Christians to Jews, but by Jews to Jews. Schapiro contrasts his characterization of Berenson's commercial behavior with the Jewish love of "the Book" and a "more seriously philosophic" system of values operative in Jewish ideology since the Haskalah, or Jewish Enlightenment.

Schapiro is absolutely sure that Berenson "wished his Jewish ties to be forgotten," yet the evidence of the latter's *Sketch for a Self-Portrait* suggests a more complex relationship to Jewish subjectivity than Schapiro allows. In his *Sketch* Berenson compares himself to three historically prominent Jews: Saint Paul, perhaps the most famous Jewish convert to Christianity; Spinoza, perhaps the most famous Jewish secular philosopher and someone who was excommunicated from Judaism; and the Gaon of Vilna.[31] Schapiro believes that for Berenson the first two figures were sig-

nificant because "they broke with the religion of their ancestors."[32] He denies, however, that Berenson's act was, like theirs, one "of courageous conviction," believing instead that it "helped to accommodate him to a higher social milieu."[33] But Berenson's identification with the Gaon of Vilna (Elijah ben Solomon Valman, 1720–1797) calls Schapiro's interpretation into question. As Schapiro points out, Berenson's parents changed the family name to Berenson and identified his birthplace as Vilna when they emigrated to Boston, changes on which Berenson himself was silent. But he claimed descent from a Jewish hero, the famous Gaon of Vilna. *Gaon* is a Talmudic term for the leader of the Exile (or *Galut*), and the Gaon of Vilna, like other *Gaonim,* was a person who stood as a political, religious, and cultural representative of his people to non-Jews.[34] While remaining devoted to Judaism, the Gaon of Vilna welcomed new learning and ideas. Thus one aspect of Berenson's self-definition can be read very differently from those that inspired Schapiro's condemnation of him for self-serving conversion and commercialization. Berenson was more aware of the historical significance of his place in the world and of the place of the assimilated Jew in art history than Schapiro gives him credit for. Berenson's own views and knowledge of Jewish history provide important clues to the negotiation of Jewish identity for both the interpreter and the interpreted.

In *Being and Nothingness* Jean-Paul Sartre characterized the process of knowledge as a social assimilation. He wrote: "There is a movement of dissolution which passes from the object to the knowing subject. The known is transformed into *me;* it becomes my thought and thereby consents to receive its existence from me alone."[35] Sartre later recognized the flaw in this alimentary metaphor for social absorption in the case of the Jews.[36] Jewish hopes for assimilation could never achieve such fulfillment. The Jew could never be totally digested. As Sartre said: "In a word, the Jew is perfectly assimilable by modern nations, but he is defined as one whom these nations do not wish to assimilate."[37] The assimilating culture will absorb those aspects of Jewishness that suit its purpose and violently evacuate those that do not. No longer merely an external substance, for Sartre the undigested becomes the antithesis of the assimilating self, a fetish, if you will, for the dominant group. The rejection of things "too Jewish" transforms them into the refused, the indigestible, the deformed, even the kitsch, to use a Yiddish term. The materiality of things "too Jewish" has recently been the subject of an exhibition curated by Norman Kleeblatt of the Jewish Museum, New York City.[38] Contributors to it attempted to "create" a discourse of power from the dominant culture's views by using the unabsorbed aspects of Jewish-American identity. The responses to this exhibition evidence the ambivalence that adheres to the topic of Jewish identity, especially to those features of Jewishness that defy assimilation.

Michel Foucault has shown that a concept of identity is required by the dominant, assimilating culture as much as it is denied to and negotiated by what he calls

the unassimilated Other.[39] This essentialized self is inevitably achieved at the expense of the Other. The arguments that Sartre and Hannah Arendt made concerning the necessity of anti-Semitism for the success of German nationalism and National Socialism support Foucault's conception of the subject's freedom.[40] The German Jewish émigrés achieved their most successful assimilation after flight, in part by establishing an art-historical discourse from which they had removed any trace of the earlier assimilationist dilemma. But this move prevented them from speaking as fully situated cultural subjects. Silent about their identity, these historians could locate neither themselves nor the discipline they helped to found in the historical moment, or predicament, they actually experienced. Nevertheless, these art historians can be situated today, not to reconstruct an irretrievable past, but to transform the present discourse and to reassess the course of art history. I sense that this project will profoundly affect our understanding of the past and our own significance as interpreters in the world today.

Given that this topic remains relatively unexplored, it seemed appropriate that the essays in this volume relate the problem of Jewish identity in art history to a wide variety of important topics. For all of this variety the writers here are focused on the visual, on representation, on images and imagery in the context of discourse. Chronologically, the topics begin in the nineteenth century and span the twentieth. They address issues in the European, mainly German-speaking, and American contexts. They deal with aesthetics and criticism, collecting and the art market, feminism, psychoanalysis, and cultural history, as well as with individual art historians. In part, the essays were chosen with such a scope in mind, to ensure that all the important areas of the problem of Jewish identity in the discipline were represented, even if they could not be fully explored in a collection of essays. The contributors take a variety of political positions, not all of them held by the editor, nor obviously by the other contributors. Rather than being an entirely collaborative effort—something we have to some degree strived for—such an endeavor is necessarily pluralistic. Although this pluralism is not always desirable in edited collections, or in politics, it can be an advantage where the goal is to understand the complexities of Jewish identity and the introduction of the subject to art history.

Notes

1. Colin Eisler, "*Kunstgeschichte* American Style: A Study in Migration," in *The Intellectual Migration: Europe and America, 1930–1960,* ed. Donald Fleming and Bernard Bailyn (Cambridge, Mass.: Harvard University Press, 1969), 544–629.

2. As an example of the pervasive influence of Jewish art historians, I use my own professional genealogy, which is by no means exceptional in its patterns of scholarly kinship.

As an undergraduate at Bryn Mawr College in the early 1970s I studied with Charles Mitchell, who had been trained in England at the Warburg Institute (originally founded in Hamburg by the Jewish art historian Aby Warburg) by Otto Kurz (A Viennese Jew); James Snyder and Charles Dempsey, both of whom had worked at Princeton with Erwin Panofsky (a Jew formerly with the Warburg Institute in Hamburg); Arthur Marks, a Jew trained at the Courtauld Institute in London; and Dale Kinney, who had worked with Richard Krautheimer and Walter Friedlander, both German Jews, at the Institute for Fine Arts, New York University. A record of my graduate training would make this genealogy even longer. Karen Michels has published as much statistical information as we have about the importance of the German-Jewish genealogy for English-speaking art history; see especially her contribution to this volume and her earlier essay "Transfer and Transformation: The German Period in American Art History," in *Exiles and Emigrés: The Flight of European Artists from Hitler*, ed. Stephanie Barron, with Sabine Eckmann (Los Angeles: Los Angeles County Museum of Art, 1997), 304–15.

3. Recently, two important books on the general topic of Jewish identity and representation have appeared: Tamar Garb and Linda Nochlin, eds., *The Jew in the Text: Modernity and the Construction of Identity* (London: Thames and Hudson, 1995); see especially the essays by the editors; and the exhibition catalogue *Exiles and Emigrés*. In the latter volume, Martin Jay summarizes the literature and bibliography on the German intellectual exile in "The German Migration: Is There a Figure in the Carpet?" 326–37. Books on *Exilforschung* (exile, or perhaps diaspora, studies) in Germany and America treat few art historians. See, however, the entries for individual art historians in Herbert A. Strauss and Werner Röder, eds., *International Biographical Dictionary of Central European Emigrés 1933–1945* (Munich, New York, London, Paris: K. G. Saur, 1983), vol. 2.

4. On anti-Semitism in America, see Leonard Dinnerstein, *Antisemitism in America* (New York: Oxford University Press, 1994). On an argument that turns on anti-Semitism in art history, see Kevin Parker, "Art History and Exile: Richard Krautheimer and Erwin Panofsky," in *Exiles and Emigrés*, 317–25.

5. On this concentration, see particularly Peter Paret, "Bemerkungen zu dem Thema: Jüdische Kunstsammler, Stifter und Kunsthändler," in *Sammler, Stifter und Museen: Kunstförderung in Deutschland im 19. und 20. Jahrhundert*, ed. Ekkehard Mai and Peter Paret (Cologne: Böhlau, 1993), 178–83.

6. I speak here only of Jews in Europe in the modern postemancipation period, when issues of Jewish identity were changed and complicated by assimilation and a moving away from traditional, uniquely Jewish communities. This period coincides exactly with the rise of the study of art's history and its philosophy—that is, aesthetics in the university. For the strongest argument that anti-Semitism was produced by the confrontation with modernity and that together they produced a distinctive "Jewish identity," see Michael A. Meyer, *Jewish Identity in the Modern World* (Seattle and London: University of Washington Press, 1990).

7. Elizabeth Young-Bruehl, *The Anatomy of Prejudices* (Cambridge, Mass.: Harvard University Press, 1996), 30. Significantly, in light of the topic of this book, Young-Bruehl is relying here on the definition of anti-Semitism by the Viennese art historian and Jewish émigré-turned-psychoanalyst Ernst Kris. I will examine Kris's relationship to Jewish identity in a forthcoming essay on Viennese Jewish identity, psychoanalysis, and art history.

8. Michel Foucault, *The Archaeology of Knowledge,* trans. A. M. Sheridan Smith (London: Tavistock, 1972), 9–10.

9. There are many discussions of the term *discourse.* For the best, see Paul Bové, "Discourse," in *Critical Terms for Literary Study,* ed. Frank Lentricchia and Thomas McLaughlin, 2d ed. (Chicago: University of Chicago Press, 1995), 54–55.

10. On biography, the history of the term, and its characteristics as a genre, see Catherine M. Soussloff, *The Absolute Artist: The Historiography of a Concept* (Minneapolis and London: University of Minnesota Press, 1997), especially Chapter 1, "On the Threshold of Historiography: Biography, Artists, Genre," 19–42.

11. Émile Benveniste, quoted in Toril Moi, *Feminist Theory and Simone de Beauvoir* (Cambridge, Mass.: Blackwell, 1990), 83.

12. Roland Barthes, *Mythologies* (Paris: Éditions du Seuil, 1957), 193–247.

13. Émile Benveniste, quoted in Moi, *Feminist Theory,* 83.

14. Roland Barthes, "The Rhetoric of the Image," in *Image, Music, Text,* ed. and trans. Stephen Heath (New York: Farrar, Straus and Giroux, 1977), 47.

15. The work of Michel Foucault has been essential to the understanding of how subjectivity and discourse interarticulate. In this essay I have been helped particularly by Paul Rabinow's interview with Foucault published as Michel Foucault, "Sex, Power, and the Politics of Identity," in *Ethics: Subjectivity and Truth,* ed. Paul Rabinow, trans. Robert Hurley et al. (New York: New Press, 1997), 162–73.

16. For an example of how this argument plays out, see Parker, "Art History and Exile," in *Exiles and Emigrés,* 317–25. The most thorough disciplinary critique along these lines of resistance and Jewish identity is the important book by Bryan Cheyette, *Constructions of "the Jew" in English Literature and Society: Racial Representations, 1875–1945* (Cambridge: Cambridge University Press, 1993).

17. Of particular importance for my understanding of Kant and neo-Kantianism in the context of Jewish identity is the essay by Jacques Derrida, "Interpretations at War: Kant, the Jew, the German," *New Literary History* 22 (Winter 1991): 39–95.

18. For the tensions in Winckelmann's own subjectivity with regard to his view of the history of art, see the excellent book by Alex Potts, *Flesh and the Ideal: Winckelmann and the Origins of Art History* (New Haven: Yale University Press, 1994). For a brief discussion situating Winckelmann's significance in the idealist narrative of the history of art, see my article, "Historicism in Art History," in *The Encyclopedia of Aesthetics,* ed. Michael Kelly (Oxford and New York: Oxford University Press, 1998).

19. See also Margaret Olin, "Nationalism, the Jews, and Art History," *Judaism* 45 (Fall 1996): 461–82.

20. In my thinking here I have used the work of Slavoj Zizek in Slavoj Zizek, ed., *Mapping Ideology* (London and New York: Verso, 1994). He has argued that the democratic society's mythology of equality with its attendant erasure of difference is an impossibility in an actual, lived sense. Therefore, according to this view, this imaginary erasure cannot achieve an actual democracy, because a sense of community can only come with the recognition of difference. In actuality the émigrés were not given entirely open and equal treatment when they came to America, as Anthony Heilbut has documented. See Anthony Heilbut, *Exiled in*

Paradise: German Refugee Artists and Intellectuals in America, from the 1930's to the Present (New York: Viking, 1983). Heilbut does not treat art historians to any degree. See the essay by Sabine Eckmann in *Exiles and Emigrés,* 30–39, for further discussion of inequalities of emigration and quotas.

21. Arnold Hauser, *Naturalism, Impressionism, the Film Age,* vol. 4 of *The Social History of Art* (New York: Random House, 1951), 252: "The film, whose public is on the average level of the petty bourgeois, borrows these formulae from the light fiction of the upper middle class and entertains the cinema-goers of today with the dramatic effects of yesterday. Film production owes its greatest successes to the realization that the mind of the petty bourgeois is the psychological meeting place of the masses. The psychological category of this human type has, however, a wider range than the sociological category of the actual middle class; it embraces fragments of both the upper and the lower classes, that is to say, the very considerable elements who, where they are not engaged in a direct struggle for their existence, join forces unreservedly with the middle classes, above all in the matter of entertainment."

22. See the treatment of the Frankfurt School figures by Heilbut, *Exiled in Paradise.*

23. This is the argument of Yosef Hayim Yerushalmi, *Zakhor: Jewish History and Jewish Memory* (Seattle and London: University of Washington Press, 1982), who bases it on the historiographical tradition within Judaism.

24. Jonathan and Daniel Boyarin, eds., *Jews and Other Differences: The New Jewish Cultural Studies* (Minneapolis and London: University of Minnesota Press, 1997), viii. For a good survey of the issues involved in diaspora studies, see James Clifford, "Diasporas," in *Routes: Travel and Translation in the Late Twentieth Century* (Cambridge, Mass., and London: Harvard University Press, 1997), 244–77. The interpretation of the Diaspora (writ large) has everything to do with the changing fortunes of and changed conditions in Zionism: see Yitzhak F. Baer, *Galut* (New York: Schocken Books, 1947), and Arnold M. Eisen, *Galut: Modern Jewish Reflection on Homelessness and Homecoming* (Bloomington and Indianapolis: Indiana University Press, 1986). For the black Atlantic diaspora, begin with Paul Gilroy, *The Black Atlantic: Double Consciousness and Modernity* (Cambridge, Mass., and London: Harvard University Press, 1993). The conflict over Diaspora and diasporas in cultural studies can be related to the social relations of African Americans and Jews in America in the 1990s.

25. See, for example, Stuart Hall quoted in Kobena Mercer, *Welcome to the Jungle: New Positions in Black Cultural Studies* (New York and London: Routledge, 1994), 25.

26. David Theo Goldberg and Michael Krausz, eds., *Jewish Identity* (Philadelphia: Temple University Press, 1993), 1. I am grateful to Michael Krausz for discussing the topic of Jewish identity with me early in my research.

27. Yosef Yerushalmi, *Freud's Moses: Judaism Terminable and Interminable* (New Haven and London: Yale University Press, 1991).

28. K. Anthony Appiah, "The Multiculturalist Misunderstanding," *New York Review of Books* 44 (9 October 1997): 30. The issues of assimilation raised by the example of art historians and their discourse relate to many of Appiah's points, but do not always support them.

29. See, for example, Gilroy, *The Black Atlantic;* Stuart Hall and Paul du Gay, eds., *Questions of Cultural Identity* (London: Sage, 1996); Mercer, *Welcome to the Jungle.*

30. Meyer Schapiro, "Mr. Berenson's Values," in *Theory and Philosophy of Art: Style, Artist, and Society* (New York: George Braziller, 1994), 209–26. This essay is a sort of book review of a biography of Berenson. Presumably, part of Schapiro's point is to "correct the record." When Schapiro uses the term *values,* he clearly means the political and ethical values that he associates with Berenson's writing, his role in the art market, and his personal life. Schapiro's politics were widely discussed in the obituaries that appeared after his death; see, for example, "Meyer Schapiro, Ninety-one, Is Dead; His Work Wove Art and Life," *New York Times,* 4 March 1996. See also Margaret Olin, "Violating the Second Commandment's Taboo: Why Art Historian Meyer Schapiro Took on Bernard Berenson," *Forward* 98 (4 November 1994).

31. Schapiro, "Mr. Berenson's Values," 211 and 225, note 5.

32. Although Spinoza was excommunicated, the evidence is that he never gave up his belief in Judaism. He was known as a Jew all his life but maintained close ties with Catholic clergy and laypeople.

33. Schapiro, "Mr. Berenson's Values," 211.

34. I wish to thank Richard Hecht for his generous assistance in this aspect of my research. There is much more to be said about Berenson and Schapiro and Jewish identity than I can provide here.

35. Jean-Paul Sartre, *L'Être et le néant* (Paris: Gallimard, 1957), 275–76 (my translation).

36. Jean-Paul Sartre, *Anti-Semite and Jew,* trans. George J. Becker (New York: Schocken Books, 1948), 97: "He absorbs all knowledge with an avidity which is not to be confused with disinterested curiosity. He hopes to become 'a man,' nothing but a man, a man like all other men, by taking in all the thoughts of man and acquiring a human point of view of the universe. He cultivates himself in order to destroy the Jew in himself, as if he wished to have applied to him—but in modified form—the phrase of Terence: *Nil humani alienum puto ergo homo sum.* [Nothing human is alien to me therefore I am a man]."

37. Ibid., 67.

38. Norman Kleeblatt, ed., *Too Jewish? Challenging Traditional Identities* (New York: Jewish Museum, and New Brunswick, N.J.: Rutgers University Press, 1996).

39. See especially Michel Foucault, "The Ethics of the Concern of the Self as a Practice of Freedom," in *Ethics: Subjectivity and Truth,* 281–301.

40. See Sartre, *Anti-Semite and Jew;* and Hannah Arendt, *The Origins of Totalitarianism* (1951; New York: Harcourt, Brace, 1973). The important study of Jewish artists and art by Richard Cohen, *Jewish Icons* (Berkeley and Los Angeles: University of California Press, 1998), appeared too late for me to consider it in this essay.

PART I

Theories, Laws, and Disciplines

From Bezal'el to Max Liebermann
Jewish Art in Nineteenth-Century Art-Historical Texts

MARGARET OLIN

> The conception of Jewish Art may appear to some a contradiction in terms.
> —Cecil Roth, Introduction to *Jewish Art*

> Jüdische Kunst—gibt es das überhaupt? [Jewish art: is there any such thing?]
> —Franz Landesberger, *Einführung in die Jüdische Kunst*

> Treatments of Jewish art invariably feel constrained to begin by discussing
> whether there even is such a thing as "Jewish art."
> —Steven Schwarzschild, "The Legal Foundation of Jewish Aesthetics"

 "Jewish art" is the name of a concept, but few scholars profess to believe it corresponds to anything that actually exists. As a category it is not very precise. A multitude of disparate objects could fall under the heading, such as the secular work of Jewish artists, sacred manuscripts, and the murals and mosaics that adorn early synagogues. A few of these objects— the murals of the synagogue at Dura-Europos, the Sarajevo Haggadah—have attracted the attention of art historians.[1] Yet for the general public, including the Jewish public and much of the art-historical world, the term "Jewish art" remains something of an oxymoron. Jews may have made images, but that does not make the images themselves Jewish. Almost by definition, or rather by commandment, Jewish art does not exist. It is prohibited by the Second Commandment, which restricts Jews from making a likeness of "anything that is in heaven above, or is in the earth beneath, or that is in the waters beneath the earth."[2]

Whether or not the Torah really proscribes the practice of the visual arts (the commandment is accompanied by an injunction against bowing before and serving such idols) can be disputed.[3] But the widespread assumption that it does colors all treatments of Jewish art, from the recommendations and interpretations of rabbis and

scholars of Judaica to the scholarship of the professional art historian. In the latter pursuit, which is my subject here, the proscription might seem to make self-evident the neglect of the study of Jewish art. But that would be comprehensible only if Jewish art were a matter that concerns Jews alone. For professional art historians, the concept of Jewish art functions within art-historical discourse and thereby affects the interpretation of art beyond the immediate problem of whether Jews may make images and remain Jews. These wider consequences of the concept of Jewish art suggest how art history structures an understanding of its material, emphasizing certain categories of material and marginalizing others. Therefore, keeping in mind that a concept of a nonexistent art has made its way into the discipline, I would like to delineate the place of the discourse about Jewish art, or rather about the lack thereof, in the structure of the art-historical discipline as it took shape during the nineteenth century. My argument does not address the ontological status of Jewish art; it is not a plea for art history departments to add a specialization in Jewish art, whether by this is meant art associated with Jewish ritual or art made by Jewish artists. As an explanation for the role of the art-historical concept of Jewish art (or of its absence) in art-historical scholarship, the Second Commandment loses its centrality as a causal explanation. It becomes merely one justification among others for a position with a very different function.

In the nineteenth century, nationalism imbued art history with a pattern of aims and categories it shared with modern anti-Semitism. Anti-Semitism was part of a structure of racism that helped give nationhood a basis in biology, while cultural phenomena such as art history were among the diverse conflicting criteria by which nineteenth-century scholars classified people into races or nations.[4] Narratives of art history tended further to chronicle a people's emerging awareness of nationhood, showing its reflection in cultural forms.[5] Like orientalism, of which anti-Semitism can be considered a subcategory, anti-Semitism took a unique shape whenever it entered into academic pursuits. It acquired a vocabulary and a scientific basis. These were most obvious in the budding science of race, which became an important pursuit during the nineteenth century, inflecting (and infecting) the humanistic disciplines as well.[6]

In German-speaking countries, where art-historical scholarship initially took shape, the discipline was intertwined with nationalism throughout the century, absorbed intimately into activities related to the pursuit and, in 1871, the achievement of German unity. When Herder used language to identify the shared cultural heritage that makes a people a nation, Winckelmann had already inaugurated modern art-historical scholarship by tying Greek art to the Greek climate, culture, and form of government.[7] The visual was thoroughly bound up in the national by the time German Romanticism promoted Gothic as a German national style, and certain media, such as wood, were cultivated as part of a German heritage.[8] Institutional art

history grew up in the midst of such phenomena. The first chair in the field was established in Berlin in 1844.[9] By 1871 art history was established in many German and Austrian universities, and scholars of art history, like other German professors, were civil servants, appointed directly by their governments to posts in museums and universities.[10] Art-historical surveys were often written or underwritten by government officials, or dedicated to royalty.[11]

The resulting scholarship often concerned itself with issues relating to nationalism. While some of it responded critically to nationalistic programs, or sought to guide nationalistic ideas in one or another direction, much of it uncritically supported national claims.[12] A nation can be viewed as a contingent phenomenon, but the project of nationalism was to reveal it as the unchanging element that made history cohere. This function made the investigation of origins central to nationalistic narratives. Scholars argued that a national art must be grounded in primal traits identifiable in their pure form in early handicraft and ornament.[13] They sought to define German nationhood through the works of tribes that later became German. Hubert Janitschek searched "back to the darkness of the tribal past" for "the soft and gradually perceptible stirrings of the artistic spirit of the Germanic tribes."[14] He traced official German nationhood to the Treaty of Verdun in 843 and German national feeling to a much earlier date, as evidenced in art (Fig. 1).[15] A Swedish scholar attributed the growth of his own discipline, prehistoric archaeology, to beneficent powers (presumably governmental) that supported "the urge of the people for self-recognition."[16]

Like any other language, however, the language of nationalism could not consist in the name of just one nation.[17] Nationalists had to compare or contrast their own nationality with a network of alternative ones. To define Gothic as German was to deny that it was French. To define the German spirit as like the Hellenic required a definition of both peoples. Industrious, practical Romans and beauty-loving Greeks were crucial to the construction of Germanic spiritual depth. The immutable character of Indian imagination, of Chinese materialism, and of the so-called primitive peoples, conceived as stagnating at a low level for centuries, provided a thorough bass beneath the melody of rapidly developing and highly evolved Western art.[18] The project of detecting the essence of each people corresponded to attempts to identify pure languages and explore their unsullied roots.[19] The importance of ethnic Others to the shaping of German identity meant that a German scholar could form a consciousness of German identity through studies of the art of ancient Rome, baroque Italy, the Levant, or India. Jews were one element in this vast complex.

Academic art history departments as we know them now are not ideal places to examine the treatment of a marginalized art-historical concept, because they tend to ignore such concepts altogether. A few professors in a limited number of fields generally have to represent the entire discipline. Surveys and handbooks, however,

FIGURE I

Chapter heading from H. Janitschek's *History of German Art,* 1890.

attempt to cover a wide range of artistic phenomena comprehensively. While drawing distinctions between the worthwhile and the less worthwhile, such surveys seek to include both. Thus an academic art history department, in which nationalists set the terms of the discourse, where works are placed in unified evolutionary scheme, and where the contributions of countries, peoples, and races head the scholarly agenda might have little room for scholars specializing in obscure, undervalued works by artists not identified with a particular country. Since handbooks or surveys might well cover such phenomena, they make a useful starting point for an investigation into the treatment of marginalized art-historical concepts.

In fact, nineteenth-century art-historical surveys uniformly carried a section explicitly devoted to ancient Jewish art. Coverage of Jewish art attests not only to the continued authority of the Bible, but also to an intimate relation between early

art history and religious studies, analogous to that between secular and religious hermeneutics. The important art historian Karl Schnaase actively sought to relate art to Christianity.[20] He also edited the *Christliches Kunstblatt,* one of several art-historical journals identified explicitly as Christian.[21] Schnaase, inspired by Hegel, was convinced of the significance of religion as the barometer of a people and of the position of Christianity in a developmental process.[22] Given the religious associations of art-historical scholarship, a concept at least of ancient Jewish art appears to have been indispensable. Since the biblical monuments do not survive, and some scholars admitted ignorance of their appearance, the discussions of Jewish art were brief and confined to what could be culled, selectively, from the Hebrew Bible. Yet scholars expended great efforts to describe the monuments meticulously by conjecture and to draw from them wide-ranging conclusions about the Jewish artistic character. These conjectural portrayals of Jewish art created patterns that later scholars found ready-made for them. These patterns formed a bridge between anti-Semitic or orientalist tropes and modern art-historical scholarship.

The notion of Jews as fantastic orientals appears in the earliest significant art history handbook, *Handbuch der Kunstgeschichte,* published in 1842 by Franz Kugler. Whether or not it could be said to have had predecessors, Kugler's book self-consciously proclaimed its own innovation, and its pioneering status was accepted by later writers.[23] Certainly Karl Schnaase acknowledged Kugler's priority in his own survey, published the following year. He dedicated his study to Kugler, whom he had never met, and included a preface defending his right to publish on the same subject.[24] Albeit with modifications, the structure of Kugler's handbook prevails even today.[25] Its continued importance may be due in part to Kugler's influential student, the art historian Jacob Burckhardt, whose help Kugler enlisted in completing the second edition.[26] Between them, Kugler and Burckhardt helped shape the discipline of art history in its earliest stages.

The inclusion of references to Jewish art in the first major survey of art history illuminates the significance of the concept of Jewish art in early conceptions of art history. Kugler was genuinely interested in appreciating the great wealth of artistic material available to him. Yet he reached, in true nineteenth-century fashion, for a nonchronological, developmental structure, to give form to his chaotic mass of facts. The Prussian Kugler managed to give art history a Germanic cast by beginning and ending the volume with German art, in effect crediting it as both the source and the goal of art history.[27] His rhetoric entailed art history in nationalism, even imperialism, beginning with the preface: "Our whole science is still quite young," he wrote. "It is an empire, with whose conquest we have just begun to concern ourselves, whose valleys and forests we still have to clear, whose barren steppes we have yet to make arable."[28]

In Kugler's landscape, the Jews, even before their entrance into the promised land, assumed an exotic role. Although lack of evidence inhibits his descriptive zeal, Kugler can say with assurance that the Jews were Syrian or Semitic. That attribution alone enables him to impute to ancient Jews the love of external luxury associated with orientalism:

> And so we know that in their artworks, in greater or lesser degree, their main consideration was splendor and luxury, that they specifically loved bright metallic decorations, and covered their architectural interiors and also sculpture with expensive metallic materials, [and] that ornament of splendidly colored, cleverly woven fabrics was found necessary to fit out these works.[29]

Another trait orientalists attributed to the people of the Near East was "fantasy." Thus the cherubim on the ark of the tabernacle become "fantastic figures, as is characteristic of Asiatic visuality; . . . they combined [the human figure] with wings and other animal parts."[30] Kugler did not use such terms to describe the boy angels at the feet of Raphael's Sistine Madonna, the painting he later calls the "freest outpouring of Raphael's spirit."[31]

Some art historians, with the Hebrew Bible in mind, were puzzled by the gulf between the greatness of Jewish poetry and the frailty of Jewish art. Elie Faure, in 1909, would condemn the Temple of Solomon artistically as the "house of a terrible and solitary god," the Jews' sole artistic effort unworthy of "that Jewish genius, so grandly synthetical, but closed and jealous . . . whose voice of iron has traversed the ages."[32] Karl Schnaase, however, offered a thoughtful and, for the postmodern reader, potentially subversive reading of the relation between poetry and painting in Judaism. He differentiated his survey of art history from that of Kugler on the basis of Kugler's metaphor of geographical conquest. While Kugler creates a map of art, Schnaase uses art to penetrate the soul of the peoples who create it. Although his methods may be different, his judgment of Jewish art is similar to that of Kugler. Like Kugler, he is aghast at the cherubs for their combination of human and animal forms, criticizing them for the "unnatural affixing of wings."[33] Like Kugler, he attributes to the Jews a love of luxury and condemns them on that basis. In accordance with the strictures of the Arts and Crafts Movement that was taking shape at that time, Schnaase contrasts a true architectural sense, which likes to see construction itself, to the Jewish sensibility that, like the costumes of barbarians, hides the body with heavy clothes.[34] In accordance with his Hegelian ideas, Schnaase ties his judgment to "internal national character," relating it primarily to religion.[35]

The passage draws heavily on Lessing's distinction in *Laocoön* between painting as an art of space and poetry as an art of motion. Schnaase finds the ancient Jews in-

capable of artistic sensibility in the visual arts while they excelled in poetry because of their concern for constant motion.

> We can recognize [the concern for motion] in all expressions [of the Jews], even in the poetry. Their fantasy is too much in motion, the movement is too vigorous, too strong, too bold, to permit it to be carried out quietly in the visual arts. Every pictorial image that is introduced in the soul immediately evokes a new one, which drives out the first. Either this does not suffice for the metaphoric aim, and the second is called forth to supplement it, or it evokes, through the many-faceted nature of its appearance, a memory of something else that relates to the object, and therefore emerges and obscures the first image.[36]

Tracing links between religion and art, however, Schnaase argues that the Jews' religion kept them in constant motion because it was based on fear, and for this reason he finds the Jewish religion ill-suited to the visual arts.[37] He backs up his assertion by analyzing metaphors in Hebrew poetry. The sensibility he accords it might today be called cinematic:[38]

> How the eyes wander, illuminating with a lightning stroke now this object, now that, heaven and earth and land and sea, the mountains with game in their forests, the plains with their fruit trees, the people, and the flowers. Each single thing emerges suddenly sharply and individually out of the dark, but ducks back into it just as quickly because another is suddenly illuminated.[39]

The ornate prescription for the tabernacle in the Book of Exodus lent itself to visions, like Kugler's and Schnaase's, of Jews as purveyors of fantasy.[40] But in art-historical writings, the tabernacle was generally overshadowed by the Temple of Solomon, which evoked different, although related, tropes. These concerned the Jews' lack of artistic character and the imitative propensities considered characteristic of Jews in most fields of endeavor.[41] The nineteenth century's lively interest in biblical history and archaeology saw to it that the temple site was excavated, and studies and speculations about it abounded.[42] These resulted in a variety of reconstructions of the temple and its progeny.[43] The archaeologists Perrot and Chipiez created meticulous reconstruction-drawings, not of the Temple of Solomon, which they regarded as "an edifice of mediocre grandeur," but of the Temple of Ezekiel, "a unique and curious mixture of reality and fiction, . . . the last word of sacerdotal ambition; . . . also the most powerful effort that the Hebraic genius imposed to translate its ideas into sensible forms, . . . its most beautiful work of art, one could even say that it is the only one that it produced."[44] On paper the authors reconstructed Ezekiel's prophetic vision of the temple in fanciful detail, down to the ornaments flanking the doorway and crowning the

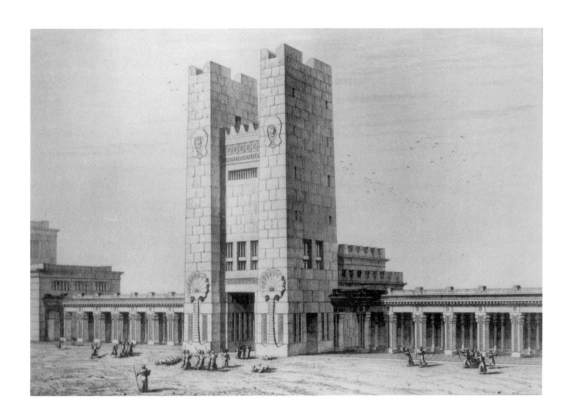

Reconstruction of the Temple of Israel's outer sanctuary as found in
G. Perrot and C. Chipiez, *History of Art in Antiquity,* 1887.

columns (Fig. 2). They regarded the edifice that they spent so much effort recon-
structing, however, as diminutive compared with the monuments of Karnak and
Luxor and, more important, as unoriginal. Everything in it was borrowed from
the valleys of the Nile and the Euphrates.[45] They marveled that of the entire an-
cient world, the greatest description of architecture passed down to us was that
of the temple of this people, whom they regarded as the "least artistic of the
great peoples of antiquity."[46]

They could as well have marveled that the temple had continued to attract a great
deal of literary attention in the nineteenth century, including their own tome; for
they felt the need to justify the attention they lavished on it: "The disproportionate

role that the little Jewish people has played in the history of humanity" justified the interest in everything they touched.[47] It was a role about which they expressed ambivalence. Their interest was ostensibly based in religion, on the heritage of Christianity, "born in the shadow of their temple," but the authors introduced the Jews initially in relation, not to religion, but to capital and finance: "Today it is not without a kind of fear that modern society seeks to account for the enormous mass of capital they have accumulated in their hands."[48] By contrast with Schnaase, Perrot and Chipiez discounted the difference between Jewish poetry and the visual arts, finding the same deficiencies in both.[49]

Other art historians also disseminated the view of Jews as shameless imitators. Wilhelm Lübke wrote in his survey in 1888 that "Jews, having no art-ideas of their own, borrowed the architectural forms which they employed on an eclectic principle from the nations dwelling around them."[50] Various authors had different conjectures about the models for Jewish art. The cherubim, for example, were said by the author of a French survey to be "identical with the winged bulls of Assyria," while Lübke perceived in them "undoubtedly Persian ideas," reminiscent of the relief of Cyrus, and his English editor corrected him as to the form, without suggesting an alternative source.[51] While from a postmodern standpoint, there is a certain appeal to the proposition that Jews appropriated their art, a nineteenth-century writer who asserted that Jews borrowed from others the art they could not create on their own only lent historical support to the anti-Semitic stereotype of Jews as parasites and chameleons. All such conjectures about sources are accompanied by dismissive judgments of Jewish art.

The two views we have discerned so far, the view of the Jews as a people without art and the view of the Jews as exotic purveyors of fantasy, were not always incompatible. Schnaase, for example, although he advanced the notion of exces-sive Jewish fantasy, cited the participation in the construction of the Temple of Solomon by the Phoenician Hiram as proof that Jews did not have an indigenous architecture.[52] Excessive fantasy, apparently, did not exercise itself in the creation of art.

Neither of these two views, however, is as insidious as a third, which invoked the commandment forbidding graven images to portray Jews as a people against art. Hegel, in his early essay "The Spirit of Christianity and Its Fate," portrayed Jews as representations of pure isolating negativity. The spiritual emptiness of the Jews was reflected in the emptiness of all their creations: their sanctuary was an "empty room," their day dedicated to God an "empty time," their God invisible.[53] "They despise the image because it does not manage them, and they have no inkling of its deification in the enjoyment of beauty or in a lover's intuition."[54] Similar assumptions about the intolerant and domineering Hebrew God, jealous of the reverence for images, made their way from anti-Semitic tracts to mainstream art-historical

explanations. The absence of Jewish art in one interpretation turned into the rejection of art by Jews in another, and active Jewish hostility toward art became an art-historical trope.[55] In the anti-artistic mode, Jews grew into a threatening anti-nationality and could reenter art history as the villain. Just as Richard Wagner feared Jews as a threat to Western music, so writers such as the notoriously anti-Semitic Josef Strzygowski could portray Semitic anti-art as a diabolical force, giving anti-Semitism a voice in art history.[56] He did so by turning other writers' religious and rhetorical analyses into an agonistic racial theory. The question in his *Orient oder Rom* (1901) was not artistic cultures but race: "It is the contrast of two races, that to which the Greeks and Romans belong and the Semitic."[57] Understandably, the Orient, crippled by anti-artistic Semites, ultimately succumbed to "the great Germanic artistic flowering in the North."[58]

The remarks of art-historical scholars about the art of the ancient Jews, like their discussions of primitive Germanic tribes, employ a myth of origins to assess the distinctive artistic character of Jewish artists, both ritual and secular, from Bezal'el, the maker of the tabernacle in the desert, to the Berlin-born impressionist Max Liebermann. Jewish artists could be described as possessing a strange and oriental sensibility, as devoid of artistic sensibility, or as antagonistic toward art altogether. Jews were written out of art history either as marginal to it, or as a people defined by their deficiencies: a lack of history, a lack of land, and a lack of art.[59]

The German impressionist painter Max Liebermann, for example, was often written out of history in this fashion. Strzygowski's handbook of contemporary art turned him into a fantastic oriental personage, even though his assimilated family had lived in Berlin for generations, and Berlin's most fashionable society frequented his studio (Fig. 3).[60] Sometimes, however, Liebermann was considered a maker of French art.[61] This characterization was not more benign. Liebermann could well have made Jewish art *because* he was a German making French art. A true German, after all, can only have made German art. When in the course of a tirade against French impressionism, the German nationalist Henry Thode identified Liebermann's main influence as the Dutch painter Josef Israels, another Jewish artist, the effect was to locate the origin of Liebermann's internationalism in his cosmopolitan Jewishness. Thode proceeded to deny the Berliner any German character: "Liebermann could just as well work in Holland or in France and be just as much at home; nothing explicitly German is present in him."[62] He contrasts Liebermann in this respect with another, non-Jewish, German painter influenced by French impressionism, Fritz von Uhde: "In him, the German essence strongly manifests its effectiveness in the treatment of related problems."[63] Even recourse to his German pedigree could not save Liebermann from charges of Jewish cosmopolitanism. As late as 1950, a critic looking back recalled that "Germany . . . came to recognize

FIGURE 3
Max Liebermann, *The Studio of the Artist at the Brandenburg Gate in Berlin,*
1902, oil on canvas. Saint Gall, Kunstmuseum.

Liebermann . . . as her most characteristic contemporary painter." The key word
was *most*. That proved, said the critic, that "the achievements of assimilated Jews
involved excesses." Liebermann's excess was an "excess of German rectitude."[64]

A similar inclination to strip Jews of their citizenship characterizes some of the
more xenophobic contributions in the *Protest deutscher Künstler,* a collaborative
lament about the intrusion of French paintings into German galleries and French
styles into German art. The protesters associated critics and gallery owners known
to be Jewish with the hated French only indirectly.[65] But one of the most explicit

counterarguments to the protest identified the anti-Semitism behind this maneuver. The critic Wilhelm Hausenstein classified the protesters succinctly among those who "improve the world with the logic of anti-Semitism."[66]

Hausenstein was right. Strzygowski, for example, went so far as to arouse fears of racial miscegenation, in his image of Hellenic art as a beautiful maiden who sells herself to an "old Semite."[67] The Semite keeps her as the jewel of his harem, surrounded by the "Semitic pack" teeming with silk, gold, and jewels. This hedonistic art culminated in proliferations of flat patterns that "celebrated their orgies in the Arabesque."[68] Although the arabesque was an Islamic form, Strzygowski denoted the tenacious race responsible for this debauchery as "der ewige Jude" ("Eternal Jew").[69]

Explicit anti-Semites were as frequent in art history as anywhere else. But the worry about miscegenation that Strzygowski made explicit was implicit everywhere in art history written on national lines. Characterizations of Jewish art in effect distinguished it from the art of cultures in which Jewish artists participated, leaving these cultures unproblematically German, French, or Spanish. Thus the voice of anti-Semitism was built into the language along with nationalism and became part of the structure of art history, even where anti-Semitism was not the object. Indeed, once the structure of the discipline was set, it was difficult either to fit into it a work that engages Judaism directly or to account for such a work without falling into anti-Semitic language.

The first scholarly study of a work acknowledged as Jewish, the 1898 Vienna publication of the Haggadah of Sarajevo, could not avoid these problems. It was a major scholarly collaborative effort of the art historian Julius von Schlosser and the paleographer Heinrich Müller, with an appendix by the rabbi and scholar of Jewish art David Kaufmann. Such collaborative projects were by then frequent in manuscript studies, having been inaugurated in 1889 by the publication of *Die Trierer Ada-Hanscrift,* edited by Karl Lamprecht, and continued by such joint projects as Franz Wickhoff's study of the Vienna Genesis manuscript with the paleographer W. Hartel.

Lamprecht studied the Ada manuscript as a signifier of the development of the German nation.[70] Wickhoff's work centered on a definition of Roman art.[71] With national character in the foreground in such models, Schlosser's interpretive essay inevitably dealt with its subject in national terms. Schlosser grappled repeatedly with the tropes of Jewish art. His essay begins with racial characterizations, speculations about the racial mixture of Jews with surrounding peoples, primarily Ashkenazim and Sephardim, and allusions to phylogenetic theory. Schlosser was antagonistic to racism in its uglier aspects and regarded himself as an Italian-German crossbreed.[72] He may have meant his discussion of Jewish racial identity to confound the simplistic assumptions of his contemporaries, for his essay suggests that the Jews took on the characteristics of the peoples around them and thus were not an alien race.

Sephardim, for example, are stereotypically Latin in their "bolder, prouder physiognomy," while Ashkenazim have physical characteristics of Germans.[73] Yet his remarks, and the literature he cites in his discussion, reveal that he found racial determinations—the racial character of the artist—indispensable for art-historical analysis: "There appear also to be racial differences [between Sephardim and Ashkenazim]. This is particularly important just now, when the development of modern natural sciences forces us to inquire into the question of phylogeny, into the role of ethnicity in the work of art."[74]

In his discussion of the Haggadah, Schlosser draws on literary sources and on histories of Jews by both Jews and Christians, with the result that he avails himself of different stereotypes at different stages of the argument. Thus Jews are oriental makers of "exaggerated and monstrous art."[75] But when working in the styles of the surrounding society, they become drab borrowers as described by the likes of Lübke: they never "progressed beyond clever imitation."[76] Furthermore, when they deviate from borrowed styles instead of imitating them exactly, Schlosser characterizes the deviations as distortions, rather than calling them, as he could have, creative embellishments.[77] For evidence of the Jews' general artistic disability, he draws on his own time, citing Josef Israels as the sole living Jewish artist of any note, thus omitting from the canon a number of well-known Jewish artists whose work he would have known, such as Camille Pissarro or Max Liebermann.[78]

Significantly, Schlosser posits a Jewish role in art history in two brief passages. One role is social-historical. Jews' imitative capacities, he suggests, disseminated Western artistic ideas throughout the world, a "mission of cosmopolitans" that their "exceptional historical fate" vested in them in other cultural areas as well.[79] The other role is pedagogical. Schlosser describes as telling and interesting for the study of medieval art the Jewish treatment of forms developed by Christians, an assertion supported by a quotation from a Jewish scholar who makes modest claims for Jewish studies: "We do not mean to point to a Jewish mine full of unsuspected treasures. The Jewish lights are reflections, but often very accurate [ones]. Their sketches often have minute features to offer that are lacking elsewhere and complete our historical picture."[80] These remarks, which Schlosser cites in closing, marginalize Jews by suggesting that if Jewish art is telling for the study of medieval art, it is because it was not a part, but rather a reflection, of that art. By assigning to Jewish art a kind of emissary role, Schlosser makes the Jewish contribution essential rather than peripheral but in so doing perpetuates the myth of Jewish internationalism and outsider status, in effect attributing any art that Jews produce to the cultures surrounding them. Jewish artists become messengers.

Schlosser's lightly disparaging remarks about Jewish art are perhaps less revealing than the laconic reaction to them from the first Jewish professor of art history. Reviewing Schlosser's edition of the Haggadah, Adolf Goldschmidt found no

indication that the work represented an "artistic development of its own."[81] Gold-schmidt's reactions confirm that Schlosser's analysis of Jews as imitators or distorters of mainstream styles prevented Jewish art from accommodation within mainstream art history. Schlosser's characterizations were not mere anti-Semitic tropes, how-ever, but outcomes of the structure of art history. By defining acceptable subjects for art-historical study in purely national and racial terms, this structure marginal-ized the Haggadah.

Schlosser's approach, and Goldschmidt's reaction, would become typical for twentieth-century art-historical scholarship, in which Jewish art, no longer treated separately in published surveys, merits barely a mention. Surveys take Schlosser's lead in accounting for their subject according to canonical developments, all of them non-Jewish. Schlosser's student E. H. Gombrich in his *Story of Art,* for example, cites Christian developments to justify our interest in "the humble wall-painting from the Jewish synagogue" of Dura-Europos, pointing out that "similar consider-ations began to influence art when the Christian religion spread from the East and also took art into its service."[82] In Frederick Hart's popular survey, and in that by Hugh Honour and John Fleming, the Jewish frescoes already appear under the rubric Early Christian art, while H. W. Janson places them under the heading Ro-man art. All the authors seem to accept the notion of a ban on images in Judaism, for all of them find it necessary to comment on the contradiction between a reli-gion that forbids art and the figured decorations on a synagogue.[83] Gombrich is the only one to propose an explanation. He invokes two tropes about Jewish art at once, relating the Jewish ban on images to the Jewish lack of artistic know-how. "The artist was doubtless not very skillful. . . . But perhaps he was not really much concerned with drawing lifelike figures. The more lifelike they were, the more they sinned against the Commandment forbidding images."[84] These writers of surveys, of course, merely echo more specialized writings on the murals of Dura-Europos. Even specialists find it necessary to baptize the monument to bring it into mainstream art history, granting Dura that place because of its relation to Early Christian art.[85]

My examination of the typology of Jewish art brings up an issue that I can only begin to broach here. The modernist conception of history rests on several as-sumptions, among them the assumption of a steady progress of linear, chronologi-cal time and the assumption of the continuity of unchanging identity. These no-tions are incompatible; the tension between them began two centuries ago with modernism itself. The very designation of a national identity introduces a timeless, ahistorical element into Western culture, even though the unchanging character peculiar to the West is thought, paradoxically, to cause the West to develop rapidly, unlike the static Chinese or the "eternal Jews." Thus the linear history that deter-mines the course of the art-historical survey, and the single-minded concentration

on the unchanging character of any given thread of this history, are tied to, and in tension with, the map of art first created by Franz Kugler.[86]

This tension both necessitates and nullifies the category "Jewish art." The categories into which art history has divided its subject presuppose a unitary self, both for the work of art and for the artist. To frame the issue differently, modernist criticism sought to elucidate the unity forged by a work of art from elements that may be disparate or ambiguous, and to reveal the unifying thread of identity that runs through the seemingly heterogeneous oeuvre of an author. While the notion of the unitary subject supporting this idea has recently fallen into disfavor, it could be said that a modernist trope held that a work of art could speak in one voice only, the authentic voice of the monolingual individual.[87] Since modernism conceived groups of people, such as nations, "organically" along the lines of a "body politic," a unitary individual presupposed a nation conceived in the same mold: the counterpart to the unitary individual is a unitary group.

A national group, by excluding dissonant voices on the basis of their dissonance, just as connoisseurs exclude uncharacteristic works from the oeuvre of a great master, makes itself more homogeneous, thus validating the concept of a national art. One way to exclude a group is to redefine it. The concept of Jewish art serves this function. If the essence of Indian art, "imagination," helped give "rational" Europeans the right to political power over India, the imitative character of Jewish art gave non-Jewish Europeans the title to Jewish artistic contributions, making Europe homogeneous and turning the synagogue at Dura-Europos into a monument of Early Christian art.

But if one thinks of actions rather than of being, of narrative positions rather than ontology, then a work of art can speak in several narrative voices. The question whether it is "Jewish art" becomes meaningless, since to say something is Jewish is not the same as to say it may speak "Jewish" at a given moment or for a given listener, just as the author of the present essay may speak or write as a Jew, as a woman, as a member of a scholarly community, or in several other voices. By separating art objects into national categories, we turn them into national objects, rather than objects that might, among their other qualities, speak French, or address French issues. This essentialism makes the concept of French or German art credible. It helps make Jewish art incredible.

The art of the people of ancient Israel was Jewish art because it could be used to create the typology known as Jewish art. My sketch of this typology explores the role played by nationalism in traditional art historians' ideas about art, such as the idea of Jewish art. The question whether "Jewish art" exists presupposes the national structure I seek to disclose. Therefore this question is part of the material that I am interrogating. The question "Is there a Jewish art?" is one that the structure of art history forces us to ask.

1. Sources for the epigraphs are as follows: Cecil Roth, "Introduction," in *Jewish Art,* ed. Cecil Roth (New York: McGraw-Hill, 1961), 20; Franz Landsberger, *Einführung in die Jüdische Kunst* (Berlin: Philo Verlag, 1935), 9; Steven Schwarzschild, *The Pursuit of the Ideal: Jewish Writings of Steven Schwarzschild,* ed. Menachem Kellner (Albany: State University of New York Press, 1990), 109. All translations, where not otherwise indicated, are my own. Probably the monument that has elicited the most extensive interest is the mural decoration of the synagogue at Dura-Europos. For literature, see the bibliography in Kurt Weitzman and Herbert L. Kessler, *The Frescoes of the Dura Synagogue and Christian Art* (Washington, D.C.: Dumbarton Oaks, 1990).

2. Exodus 20:4–5; Deuteronomy 5:8.

3. The rabbinical literature concerning the proscription of images is wide-ranging. Schwarzschild cites the complex and nuanced ruling of the sixteenth-century legal compendium *Shulchan 'Aruch* as the basic text for the modern accepted attitude toward images (Schwarzschild, 110). For a discussion of attitudes toward Judaism and art focused on responses in Jewish circles, see the contribution of Kalman Bland in this volume.

4. On the relation between culture and concepts of race, see, for example, George W. Stocking, Jr., "The Turn of the Century Concept of Race," *Modernism/Modernity* 1 (1994): 4–16; also George L. Mosse, *Toward the Final Solution: A History of European Racism* (Madison: University of Wisconsin Press, 1985).

5. On narratives of nationalism, see Homi K. Bhabha, *The Location of Culture* (London and New York: Routledge, 1994), 139–70. On the relation between racism and nationalism, see Etienne Balibar, "Racism and Nationalism," in Etienne Balibar and Immanuel Wallerstein, *Race, Nation, Class: Ambiguous Identities,* trans. Chris Turner (London, New York: Verso, 1991), 37–67. On the historical distinction between racist and religious anti-Semitism, see Robert S. Wistrich, *Antisemitism: The Longest Hatred* (London: Thames Methuen, 1991), 3–53.

6. See Edward Said, *Orientalism* (New York: Pantheon, 1978), esp. 113–23. Said would not accept the characterization of anti-Semitism as a subcategory of orientalism, although he acknowledges the resemblance (27–28). On racial science, see, for example, John M. Efron, *Defenders of the Race: Jewish Doctors and Race Science in Fin-de-Siècle Europe* (New Haven, Conn., and London: Yale University Press, 1994), esp. 13–57. J. J. Winckelmann's "beau ideal," according to Efron, unwittingly gave racist anatomists a standard by which to quantify beauty in racial terms (Efron, 15).

7. Johann Gottfried Herder, *Auch eine Philosophie der Geschichte zur Bildung der Menschheit* (1774), in *Johann Gottfried Herder Werke,* vol. 4, *Johann Gottfried Herder Schriften zu Philosophie, Literatur, Kunst und Altertum 1774–1787,* ed. Jürgen Brummack and Martin Bollacher (Frankfurt: Deutscher Klassiker Verlag, 1994), 9–107; Winckelmann, Johann Joachim, *Gedanken über die Nachahmung der griechischen Werke in der Malerei und Bildhauerkunst* (1755) (Stuttgart: Reclam, 1969). On the racist potential of the equation of nations and language, see Mosse, *Toward the Final Solution,* 35–50.

8. For relevant quotations and some analysis, see Paul Frankl, *The Gothic: Literary Sources and Interpretation through Eight Centuries* (Princeton, N.J.: Princeton University Press, 1960), 417, passim.

9. On early art historians in Germany and elsewhere, see Udo Kulterman, *Geschichte der Kunstgeschichte: Der Weg einer Wissenschaft* (Munich: Prestel, 1990).

10. On the relation between the civil service and the academic community, see Fritz Ringer, *The Decline of the German Mandarins: The German Academic Community, 1890–1933* (Cambridge, Mass.: Harvard University Press, 1969), 15–25.

11. The first art-historical survey of note, Franz Kugler's *Handbuch der Kunstgeschichte* (Stuttgart: Ebener & Seubert, 1842), is dedicated to "Seine Majestaet den Koenig Friedrich Wilhelm den Vierten von Preussen." Kugler was professor at the Academy of Fine Arts in Berlin. The next year he entered the Prussian Ministry of Ecclesiastical Affairs, Education, and Medicine. On Kugler, see especially Peter Paret, "Art as History; History as Politics: *The History of Frederick the Great* by Kugler and Menzel," in *Art as History: Episodes in the Culture and Politics of Nineteenth-Century Germany* (Princeton, N.J.: Princeton University Press, 1988), 11–60. On the role of institutions in forming "official nationalisms," see Benedict Anderson, *Imagined Communities: Reflections on the Origin and Spread of Nationalism* (London and New York: Verso, 1983), esp. 80–103.

12. On the polemical use of scholarship to argue for specific national or international goals, see Margaret Olin, "Alois Riegl: The Late Roman Empire in the Late Habsburg Empire," in *The Habsburg Legacy: National Identity in Historical Perspective,* ed. Ritchie Robertson and Edward Timms, *Austrian Studies* 5 (Edinburgh: Edinburgh University Press, 1994), 107–20.

13. Balibar, "The Nation Form: History and Ideology," in *Race, Nation, Class,* 86–106.

14. Hubert Janitschek, *Gerschichte der deutschen Malerei* (Berlin: G. Grote'sche Verlagsbuchhandlung, 1890), 4.

15. Ibid., 3.

16. Sophus Müller, *Nordische Altertumskunde nach Funden und Denkmälern aus Dänemark und Schleswig,* trans. Otto Luitpold Jiriczek (Strassburg: Karl J. Trübner, 1898), 2:308.

17. I refer to the linguistic theory of Ferdinand de Saussure, *Course in General Linguistics,* ed. Charles Bally and Albert Sechehaye, trans. Wade Baskin (New York: McGraw-Hill, 1959).

18. For example: "As therefore, in its political condition, the East ever remained on the low plane of a strongly hierarchical despotism, as any higher independent progress beyond that was out of the question, so its art, also was imprisoned in a narrow circle of lifeless symbols. . . . Thus it could neither reach a high degree of development nor any positive progress. . . . In this respect, this art, though the growth of ages, ever remained a child, obliged to have recourse to outward symbols, instead of employing intellectual means of expression." This is from Wilhelm Lübke, *Outlines of the History of Art* (1860), ed. Clarence Cook, trans. Edward L. Burlingame (New York: Dodd, Mead, 1888), 1:117–18. Such statements conform to the pattern Johannes Fabian describes in *Time and the Other* (New York: Columbia University Press, 1983), in which he demonstrates that Western anthropologists distinguished Western culture from ethnic Others by designating the Others as outside of time and Western culture within it. For searching discussions of the wider significance of historiographical treatments of China and India, see Ronald Inden, *Imagining India* (Oxford: Basil Blackwell, 1990); Prasenjit Duara, *Rescuing History from the Nation State: Questioning Narratives of Modern China* (Chicago: University of Chicago Press, 1995), 17–50. For the view from another outsider discipline, that of Byzantine art, see Robert S. Nelson, "Living on the Byzantine Borders of Western Art," *Gesta* 35 (1996): 3–11.

19. See Mosse, 38. For the anti-Semitic potential of the notion of pure languages, see Sander L. Gilman, *Jewish Self-Hatred* (Baltimore: Johns Hopkins University Press, 1986).

20. See, for example, Karl Schnaase, *Über das Verhältnis der Kunst zum Christenthums und besonders zum evangelischen Kirchen. Ein Vortrag auf Veranstaltung des Evangelischen Verein für kirchliche Zwecke am I. März 1852* (Berlin: W. Schultz, 1852).

21. *Christliches Kunstblatt für Kirche, Schule und Heim,* founded and edited by Schnaase and C. Grüneisen, with J. Schnorr von Carolsfeld from 1858 to 1877 (continued thereafter under other editors). Other such journals were the *Zeitschrift für christliche Archäologie und Kunst,* founded in 1856, and the *Zeitschrift für christliche Kunst,* founded in 1888.

22. On Schnaase's relation to Hegel, see Gregor Stemmrich, "C. Schnaase: Rezeption und Transformation Berlinischen Geistes in der Kunsthistorischen Forschung," in *Kunsterfahrung und Kulturpolitik im Berlin Hegels,* ed. Friedhelm Nicolin and Otto Pöggeler, Hegel-Studien 22 (Bonn: Bouvier Verlag Herbert Grundmann, 1983): 263–82; and Michael Podro, *The Critical Historians of Art* (New Haven, Conn.: Yale University Press, 1982), 31–43.

23. Kugler (ix) calls his book "the first comprehensive attempt of its kind," adding "at least I believe it is unnecessary to take into account anything that has been written so far about the whole of art history. . . ."

24. The dedication reads: "Most sincerely dedicated to Dr. Franz Kugler, Professor at the Royal Academy of Art in Berlin, in recognition of his successful effort in the field of art history." On the first page of his preface, Schnaase mentions that he has never met Kugler. Karl Schnaase, *Geschichte der bildenden Künste bei den Alten* (Düsseldorf: Julius Buddeus, 1843), 1:vii. On Kugler's reaction to Schnaase, see Stemmrich, 278–79.

25. For discussions relevant to the shaping of the art history text, see Robert S. Nelson, "The Map of Art History," *Art Bulletin* 79 (1997): 28–40. See also Mitchell Schwarzer, "Origins of the Art History Text," *Art Journal* 54 (1995): 24–29.

26. Kugler, *Handbuch der Kunstgeschichte,* 2d ed. "mit Zusätzen von Jac. Burckhardt" (Stuttgart: Ebner and Seubert, 1848).

27. This is the effect of Kugler's treatment, although he asserted that his starting point was arbitrary (Kugler, 1st ed., 4–5).

28. Kugler, x.

29. Ibid., 70.

30. Ibid., 78.

31. Ibid., 727. On the boy angels, see also Kugler's earlier work on painting, *A Hand-Book of the History of Painting from the Age of Constantine the Great to the Present Time,* trans. "a lady," ed. C. L. Eastlake (London: John Murray, 1842), 298.

32. Elie Faure, *History of Art: Ancient Art* (1909), trans. Walter Pach (New York and London: Harper and Brothers, 1921), 104–5.

33. Karl Schnaase, *Geschichte der bildenden Künste,* 2d ed., vol. 1, *Die Völker des Orients* (Düsseldorf: Julius Buddeus, 1866), 234.

34. Ibid., 227. The conviction that construction should be shown was a stricture of the Arts and Crafts Movement, associated, for example, with Augustus Welby Northmore Pugin. See his *The True Principles of Pointed or Christian Architecture* (London: John Weale, 1841). As its name implies, Pugin regarded the honesty implied in his architectural theory as in-

separable from its Christianity, contrasting it, however, not with Jewish, but with pagan architecture and values.

35. Schnaase, *Geschichte der bildenden Künste,* 2d ed., 1:236.

36. Ibid.

37. Ibid., 238–40.

38. Ibid., 238.

39. Ibid.

40. Exodus 25:10–27:9.

41. The image of the Jew as chameleon seems to date from the assimilation that followed emancipation in the early nineteenth century. Jews became more threatening because more difficult to detect. See Leon Poliakov, *The History of Anti-Semitism,* trans. Miriam Kochan, vol. 3, *From Voltaire to Wagner* (London: Routledge and Kegan Paul, 1975), esp. 255–305.

42. Schnaase, in the second edition of his history of the fine arts, cites significant literature about the temple, commenting on the growth in knowledge of the subject since his first edition. He attributes the growth to an increase in knowledge about oriental architectural styles. Schnaase, *Geschichte der bildenden Künste,* 2d ed., 1:217–18 n. 1.

43. The significance and long history of reconstructions of the temple are traced in Paul von Naredi-Rainer, *Salomos Tempel und das Abendland: Monumentale Folgen historischer Irrtümer* (Cologne: Dumont, 1994), 155–99.

44. Georges Perrot and Charles Chipiez, *Histoire de l'art dans l'antiquité,* vol. 5, *Judée, Sardaigne, Syrie, Cappadoce* (Paris: Librairie Hachette, 1887), 241–42. The temple in question is described in Ezekiel 40–43.

45. Ibid., 124.

46. Ibid., 475.

47. Ibid., 110.

48. Ibid., 122.

49. Ibid., 476.

50. Lübke, 1:86. The book was first published in German in 1860. For a discussion of the ideological implications of the entailment of Phoenicians and Jews in nineteenth-century scholarship, see Martin Bernal, *Black Athena: The Afroasiatic Roots of Classical Civilization,* vol. 1, *The Fabrication of Ancient Greece, 1785–1985* (New Brunswick, N.J.: Rutgers University Press, 1987), 337–99.

51. S[alomon] Reinach, *Apollo: An Illustrated Manual of the History of Art throughout the Ages,* trans. Florence Simmons (New York: Charles Scribner's Sons, 1904), 28; Lübke, 83 and note 2.

52. Schnaase, *Geschichte der bildenden Künste,* 2d ed., 1:228.

53. G. W. F. Hegel, *Early Theological Writings,* trans. T. M. Knox (Philadelphia: University of Pennsylvania Press, 1948), 182–205.

54. Ibid., 192.

55. Herbert Read explains the lack of Jewish art in this way, for example, in *Art and Society* (New York: Macmillan, 1937), 99. Wistrich traces this attitude to Voltaire in *Antisemitism,* 48–49. David Freedberg, in a penetrating discussion of "The Myth of Aniconism," which goes far beyond the Jewish example, identifies a historiographical tradition which, convinced

of the moral and spiritual superiority of aniconism, "suppressed the possibility of iconicity at the beginnings of Greco-Roman culture." See *The Power of Images: Studies in the History and Theory of Response* (Chicago: University of Chicago Press, 1989), 65.

56. Richard Wagner, "Das Judentum in der Musik" (1850), *Gesammelte Schriften und Dichtungen* (Leipzig: E. W. Fritsch, 1887–88), 5:66–85.

57. Josef Strzygowski, *Orient oder Rom: Beiträge zur Geschichte der spätantiken und frühchristlichen Kunst* (Leipzig: J. C. Hinrichs'sche Buchhandlung, 1901), 39. For more on Strzygowski, see Margaret Olin, "Nationalism, the Jews, and Art History," *Judaism* 45 (1996): 461–82.

58. Strzygowski, *Orient oder Rom,* 150.

59. According to Joseph Ernest Renan, the "Semitic" race had "no mythology, no epic, no science, no philosophy, no fiction, no plastic arts, no civic life: there is no complexity, nor nuance; an exclusive sense of uniformity." Quoted in Wistrich, *Antisemitism,* 47.

60. Strzygowski wrote about Liebermann: "In order to salvage the title of art for painting that lacks ideas of its own, he called the search after new variations in artistic qualities 'fantasy.' Naturally fantasy takes place completely in the artist: it emerges from purely sensory presuppositions. At the basis of this concept is race." *Die bildende Kunst der Gegenwart: Ein Büchlein für Jedermann* (Leipzig: Quelle und Meyer, 1907), 270.

61. Alois Riegl referred to Liebermann's art as a typical example of *Stimmungskunst* in "Die Stimmung als Inhalt der modernen Kunst," in *Gesammelte Aufsätze,* ed. Karl M. Swoboda (Augsburg and Vienna: Benno Filser, 1929), 36. He illustrated the original publication, in the *Graphische Künste* 22 (1899): 47, with a drawing by Liebermann. But in a review of *Die deutsche Kunst des neunzehnten Jahrhunderts: Ihre Ziele und Thaten,* by Cornelius Gurlitt, he denied Liebermann a "Germanic" nature, writing that he "ebensogut Franzose sein könnte" (could as well be French). *Die Mitteilungen der Gesellschaft für vervielfältigende Kunst,* supp. to *Graphischen Künsten* 23 (1900): 3.

62. Henry Thode, *Böcklin und Thoma: Acht Vorträge über neudeutsche Malerei* (Heidelberg: Carl Winter's Universitätsbuchhandlung, 1905), 101.

63. Ibid.

64. Herbert Howarth, "Jewish Art and the Fear of the Image," *Commentary* 9 (February 1950): 147.

65. Carl Vinnen, ed., *Ein Protest deutscher Künstler* (Jena: Eugen Diederichs, 1911). The *Protest* contains numerous allusions to specific Jews, such as Julius Meier-Graefe, and some criticism of Max Liebermann (esp. A. Goetz, 54–55) and Paul Cassirer (esp. Hans Rosenhagen, 65–69). Liebermann could well have been the mercenary "leading Berlin artist" who, according to a contributor who signs himself Professor Keller of the Düsseldorf Academy (probably Ludwig Paul Wilhelm Keller), said that dealers make a city into an artistic capital, not good painters (38).

66. Wilhelm Hausenstein, "Mittelstandspolitik," in *Im Kampf um die Kunst: Die Antwort auf den 'Protest deutscher Künstler,'* ed. Alfred Walter Heymel (Munich: R. Piper, 1911), 108.

67. "Hellas in des Orients Umarmung," *Beilage zur Münchener Allgemeinen Zeitung* 40–41 (1902): 314.

68. Ibid., 326.

69. Ibid., 315.

70. See Katherine Brush, *The Shaping of Art History: Wilhelm Vöge, Adolph Goldschmidt, and the Study of Medieval Art* (Cambridge: Cambridge University Press, 1996), 42.

71. Franz Wickhoff, "Der Stil der Genesisbilder und die Geschichte seiner Entwicklung," in *Die Wiener Genesis,* ed. Wilhelm Ritter von Hartel and Franz Wickhoff (Vienna: F. Tempsky, 1895), 1–98. On the national aim in that work, see Olin, "Alois Riegl," in *The Habsburg Legacy,* ed. Robertson and Timms, 107–20.

72. On the Italian identity of Schlosser and other Austrian scholars, see Olin, "Alois Riegl," 113.

73. Julius v. Schlosser, "Die Bilderschmuck der Haggadah," in *Die Haggadah von Sarajevo,* ed. Heinrich Müller and Julius v. Schlosser (Vienna: A. Holder, 1898), 217, and note 2.

74. Ibid., 216–17.

75. Ibid., 248.

76. Ibid., 241.

77. Ibid., 248.

78. Ibid., 241.

79. Ibid., 248.

80. Ibid., 251–52. The source of Schlosser's quotation is Moritz Steinschneider, "Robert von Anjou und die jüdische Literatur," *Vierteljahrsschrift für Kultur und Literatur der Renaissance* 1 (1886): 137. Steinschneider was referring here to literature, rather than art. The fact that literature was generally regarded as a field in which Jews excelled and made original contributions makes his remark telling, especially considering its appearance in a journal edited by the son of Abraham Geiger, the important exponent of Wissenschaft des Judenthums (science of Judaism, a movement to bring the study of Judaica into mainstream academia) and champion of the Jewish Reform movement.

81. Adolf Goldschmidt, review of *Die Haggadah von Sarajevo,* by Heinrich Müller and Julius v. Schlosser, *Repertorium für Kunstwissenschaft* 23 (1900): 337.

82. E. H. Gombrich, *The Story of Art,* 12th ed. (New York: Phaidon Press, 1972), 89–90.

83. H. W. Janson, *History of Art,* 4th ed., rev. Anthony F. Janson (New York: Abrams, 1991), 252–53; Frederick Hart, *Art: A History of Painting, Sculpture, Architecture,* 3d ed. (Englewood Cliffs, N.J.: Prentice-Hall; New York: Abrams, 1989), 292; Hugh Honour and John Fleming, *The Visual Arts: A History,* 3d ed. (New York: Abrams, 1991), 261–62.

84. Gombrich, *The Story of Art,* 89.

85. On this subject, see Annabelle Jane Wharton, "Good and Bad Images from the Synagogue of Dura Europos: Contexts, Subtexts, Intertexts," *Art History* 17 (March 1994): 1–25.

86. On the connection between linear time and the geographical space of the nation-state, see, for example, Smadar Lavie and Ted Swedenburg, *Displacement, Diaspora and Geographies of Identity* (Durham, N.C., and London: Duke University Press, 1996), 2. See also Nelson, "The Map of Art History."

87. Two well-known critiques of the notion of the unitary oeuvre are Roland Barthes, "From Work to Text," in *Textual Strategies: Perspectives in Post-Structuralist Criticism,* ed. Josué V. Harari (Ithaca, N.Y.: Cornell University Press, 1979), 73–81, and Michel Foucault, "What Is an Author?" in ibid., 141–60. For recent explorations of the unitary state and its effect on

the subject, see Steve Pile and Nigel Thrift, eds., *Mapping the Subject: Geographies of Cultural Transformation* (London and New York: Routledge, 1995). I have discussed the trope of the unitary artist in my essay "Validation by Touch in Kandinsky's Early Abstract Art," *Critical Inquiry* 16 (Autumn 1989): 144–72. See now Catherine M. Soussloff, *The Absolute Artist: The Historiography of a Concept* (Minneapolis: University of Minnesota Press, 1997).

Anti-Semitism and Aniconism
The Germanophone Requiem for Jewish Visual Art

KALMAN P. BLAND

 In 1922 Marc Chagall was in Moscow and Erwin R. Good-enough was at Oxford University. Chagall, the famous Jewish artist, was preparing to leave for the West; Goodenough, the as-piring scholar, was contemplating the Greco-Roman provenance of Jewish artifacts and symbols. Chagall was musing in Yiddish. Goodenough was conversing with his mentors in English. Without defining his terms, Chagall remarked ambiguously, "Were I not a Jew (with the content that I put in the word), I would not be an artist at all, or I would be someone else altogether. . . . I know quite well what this small people can accomplish. . . . When it wished, it brought forth Christ and Christian-ity. When it wanted, it produced Marx and socialism. Can it be then that it would not show the world some sort of art? Kill me, if not."[1] Goodenough was "gently told" by "all" of his dons that "Jewish Scripture and tradition alike forbade the mak-ing of images, and so long as a group was loyal to Judaism at all it would have noth-ing to do with art." Six years later, Goodenough was a junior faculty member at Yale University. His senior colleague Professor Paul Baur reassured him "that there was no such thing as Jewish art."[2]

It is customary to explain and resolve the dispute between "some sort of art" and "no such thing as Jewish art" by referring to ancient Israelite laws.[3] This appeal to biblical authority is inadequate. Rather than clarify historical and historiographical complexities, the theological explanation mystifies them. It overlooks the herme-neutical dexterity with which commentators superimpose diverse ideas on ancient texts. It cannot explain why Jewish aniconism, denying the existence of Jewish art, became the established, conventional wisdom in modern secular scholarship. It can-not explain why the idea of Jewish aniconism has persisted throughout the twentieth century despite the apparent evidence to the contrary amassed by a host of archae-ologists, ethnographers, archivists, and art historians. Ignoring cultural politics, the

theological explanation also fails to explain why so many critics and museum cura-
tors deny aesthetic status to Jewish ceremonial objects or folk art.[4] To fathom the
modern denials and affirmations of Jewish art, factors less theological and more re-
cent than ancient biblical laws must be located.

Consider the ideologically motivated difference between the authoritative *Jewish
Encyclopedia* published in 1902 and the equally authoritative *Catholic Encyclopedia*
published in 1910. The *Jewish Encyclopedia* includes an entry titled "Art, Attitude of
Judaism Toward." It was written by Kaufmann Kohler, a prominent scholar, a lead-
ing Reform rabbi, and one of the *Encyclopedia's* chief editors. Consulting Kohler, we
learn that "it is . . . somewhat incorrect to speak of Jewish art. Whether in biblical
or in post-biblical times, Jewish workmanship was influenced, if not altogether
guided by Jewish art." As if anticipating Goodenough's mentors at Oxford and Yale,
Kohler explained the absence of an indigenous Jewish art by referring to the pro-
hibition contained in Exodus 20:4, declaring that "plastic art in general was dis-
couraged by the Law; the prohibition of idols in the Decalogue being in olden times
applied to all images, whether they were made objects of worship or not."[5]

The *Catholic Encyclopedia* was convinced otherwise. Staunchly defending its own
ritual practice against Protestant iconoclasm, the *Catholic Encyclopedia* argued that the
biblical prohibition against idolatry "was never understood as an absolute and univer-
sal prohibition of any kind of image. Throughout the Old Testament there are instances
of representations of living things, not in any way worshiped, but used lawfully." As
if correcting Kohler and Goodenough's mentors, it concluded its richly detailed sur-
vey of the copious archaeological evidence attesting to Jewish ritual art by announc-
ing that "when Christians began to decorate their catacombs with holy pictures, they
did not thereby sever themselves from the custom of their Jewish forefathers."[6]

The inference is inescapable: When inflected by early-twentieth-century Roman
Catholic accents, the history of Jewish art was construed one way; when inflected
by the contemporary accents of Reform Judaism or Protestant Christianity at Yale
and Oxford, it was construed quite differently. A more general inference is also in-
escapable: Along with everything else in modernity relating to religion, aesthetics,
race, and nationalism, the very idea of Jewish art is steeped in factious ideological
debate.

In the sections to follow, I argue that anti-Semitism and Jewish assimilation pro-
foundly shaped the modern discourse on Jewish art.[7] I investigate the nineteenth-
and early-twentieth-century Germanophone intellectuals who first authorized the
doctrine of Jewish aniconism. Their disciples perpetuated and modified it. Coping
with Jewish emancipation and anti-Semitism, these intellectuals, including Kauf-
mann Kohler, were intent on dissociating Judaism from the visual arts. Their mo-
tives were mixed: Aniconism was either a vice to be condemned or a virtue wor-
thy of praise. Condemnation served the ideological needs of those who hoped to

rid Europe of Judaism. Praise served the ideological needs of those who struggled to perpetuate assimilated Jewish life in Diaspora. Regardless of ideological motive, they agreed that Judaism was fundamentally aniconic. Partisans of "some sort of art" were the minority. Coping with emancipation and anti-Semitism, they were intent on affiliating Judaism closely with the visual arts. Their motives, too, were mixed. Some, like Marc Chagall, took secular pride in Jewish national creativity. Most were dismayed or disappointed with assimilated life in Europe. They were inspired by the ideals of secular or religious Zionism. Some were merely nostalgic for a lost past.

In 1790, not long after the American and French Revolutions, Immanuel Kant, preferring the abstract and the disembodied over the sensate and the sensible, pietistically conceded that "perhaps the most sublime passage in the Jewish Law is the commandment: Thou shalt not make unto thee any graven image, or any likeness of any thing that is in heaven or on earth, or under the earth, etc. This commandment alone can explain the enthusiasm that the Jewish people in its civilized era felt for its religion when it compared itself with other peoples, or can explain the pride that Islam inspires. The same holds also for our presentation of the moral law, and for the predisposition within us for morality."[8]

Hegel closed the pincers of a double bind. Rather than praise Judaism and Islam for their imageless God, as did Kant, Hegel berated them for failing to represent their God visually. In the introduction to the published version of the lectures on fine art he had delivered in Berlin during the 1820s, Hegel spoke for Christian practice. He argued that "everything genuine in spirit and nature alike is inherently concrete and, despite its universality, has nevertheless subjectivity and particularity in itself. Therefore the Jews and the Turks have not been able by art to represent their God, who does not even amount to such an abstraction of the Understanding, in the positive way that the Christians have. For in Christianity God is set forth in his truth, and therefore as thoroughly concrete in himself, as person, as subject, and, more closely defined as spirit."[9]

Acculturated German Jews who remained Jews would seek to escape the double bind by agreeing with both Kant and Hegel where it was possible and correcting them where it was necessary. Kant approved of aniconic Mosaic law; Hegel disapproved. Unable to dispute Hegel's empirical observations, the German Jewish intellectuals eagerly adopted Kant's admiration for aniconism. Finding Hegel's awe of progressive "Spirit" congenial to their own temperament, tradition, and reformist cause, they used Hegelian categories and principles to prove Kant wrong when he declared Judaism lacking in true religion, ethical significance, and universal concern.[10] When they finished their work, Judaism became fundamentally aniconic, preeminently spiritual, coterminous with ethics, and quintessentially universal.[11]

These major motifs in German Jewry's complex antiphonal response to Kant and Hegel were sounded by Dr. Solomon Formstecher (1808–1889), a Reform rabbi serving in Offenbach. In 1841, Formstecher published *Die Religion des Geistes: Eine wissenschaftliche Darstellung des Judenthums nach seinem Charakter, Entwicklungsgange und Berufe in der Menscheit* The Religion of the Spirit: A Scientific Exploration of Judaism according to Its Character, Historical Development, and Vocation to Humanity). He proposed that Judaism, as long as it "battled" the paganism that surrounded it, would have to consider the plastic arts (*Plastik*) its "severe foe" and "to find its own symbols only in the sphere of the spiritual." Judaism could permit itself the "charms [*Zauber*] of poetry, accompanied by melody and rhythm," which lead people to religious ecstasy, "but no plastic art form should awaken thoughts of God, no sculptured statues represent Him."[12] Formstecher bluntly asserted that "Judaism is hostile [*Feind*] to the plastic arts."[13] He firmly believed that there can be only "ethical, but not aesthetic manifestations of the absolute."[14] The "mysterious [*räthselhafte*] cherubs," the "only plastic art forms" allowed to stand in the Temple, were no exception to this rule. Formstecher explained that the cherubs were permitted only because they symbolized God's angelic servants but not God Himself.[15]

Ten years later, the same interrelated motifs of Jewish aniconism and Jewish ethical spirituality were orchestrated poignantly by Heinrich Heine (1796–1856), the renowned poet and cultural critic who was born a Jew and who underwent a lukewarm conversion to Lutheranism in 1824. In 1854, two years before his agonizing death, Heine recollected the course of his impassioned life. Contemplating his rediscovery of Judaism, he acknowledged that Judaism was aniconic, but not without a compensatory art of its own. Heine wrote that formerly he

> could not forgive the lawgiver of the Jews for his hatred of all visual imagery [*Bildlichkeit*] and the plastic arts [*Plastik*]. I failed to see that Moses, despite all his hostility to art [*Befeindung der Kunst*], was himself a great artist [*Küntsler*] and possessed the true artistic spirit. In his case, as in that of his Egyptian countrymen, this artistic spirit was directed solely toward the colossal and the indestructible. But unlike the Egyptians he did not fashion his works from baked bricks and granite. He built human pyramids [*Menschenpyramiden*]; he carved human obelisks; he took a poor shepherd tribe and from it he created a people that was also to defy the centuries—a great, immortal, holy people, a people of God, which could serve as a prototype of humanity. . . . I have learned to appreciate the [Jews] better; and if pride of birth were not a ridiculous contradiction in a champion of the Revolution and its democratic principles, the writer of these pages would take pride in the knowledge that his ancestors belonged to the noble house of Israel; that he is descended from martyrs who have given the world a God and a morality and who have fought and suffered on all the battlefields of thought.[16]

Heine's requiem for Jewish visual art remained popular with German Jewish intellectuals. Sixty years after he composed it, the requiem was transcribed and fine-tuned by Hermann Cohen (1842–1918) in his monumental synthesis of neo-Kantian and existentialist religious thought, the posthumously published *Religion der Vernunft aus den Quellen des Judentums* (Religion of Reason out of the Sources of Judaism).[17] In the chapter devoted to Law (*Das Gesetz*), Cohen advanced the argument that Jewish observances are not restricted to worship. They pervade the entirety of life, constituting a "yoke of the Kingdom of God," which at the same time serves as a "ladder to heaven [*Himmelsleiter*]." The Law is therefore not dispensable; it should not be abrogated, at least not in its entirety. Cohen raised the "great question" then being debated between the reformers and the traditionalists regarding the extent to which the burden of the Law can be "reduced" without destroying its "effectiveness."[18] Searching for guidelines on what can safely be eliminated from Jewish observance, he invoked the precedent of Judaism's traditional abandonment of visual arts: "The plastic arts [*Plastik*] and painting [*Malerei*] were kept at a safe distance from the pure worship of God."

Formstecher's cherubs had disappeared, but like Formstecher, Cohen did not conclude that Judaism is bereft of all arts. Citing Heine by name, Cohen invoked the "poetically articulated" notion that Moses "carved human pyramids." Cohen explained that this implicitly superior and compensatory "art work of people [*Kunstwerk der Menschen*]" was achieved "by means of the laws." He concluded that "the laws themselves can therefore not be without all artistic value," especially not without the artistic value associated with the verbal art of "poetry." "As poetry," Cohen continues, "the artistic value of the laws permeates all forms, the tragic and the idyllic." Cohen then replayed the complex polyphony of anti-Kantian and neo-Kantian strains in Heine's requiem: "Out of the bounds of the laws, at all times, came forth those Israelites who achieved great things for culture in all of its branches . . . uppermost of all the great moral impulses. The intrinsic connection between the laws and public morality could never be misunderstood."[19]

Cohen repeated these arguments in a later chapter, "The Virtues." Claiming to shed new light on the biblical prohibition against the worship of images, Cohen drew a distinction between the Jewish and Christian use of symbols. The aniconism that Hegel had found to be a deficiency, Cohen pronounced a virtue. He declared that "the veracity of the Jewish consciousness of God is precisely the reason for the aversion to the plastic arts [*Abwehr der Plastik*]." As if echoing Formstecher, Cohen explained that the prophets and psalmists scorned the paganistic visual images of God but found their natural ally in the verbal arts of poetry. Cohen assured his readers that "what the religious consciousness loses in the visual arts [*bildenden Kunst*], it makes up for amply through lyrical poetry. . . . Monotheism makes no concession to the visual arts, for thereby the unique God would come to danger."[20]

Cohen had laid the foundation for these points at the beginning of the book. In chapter 1 Cohen noted the striking fact that "Judaism presents its chief sources in literary documents." In contrast, "polytheism . . . possesses its monuments primarily in the form of plastic arts. Plastic art makes of itself an analogy to nature. Poetry, on the other hand, the original language of literature, is able to make spiritual thoughts more inward than can the visual arts."[21] And again in chapter 2, "Image-Worship [*Der Bilderdienst*]," which interprets the Second Commandment, the visual arts are excluded from representing the unique God, for God is "absolutely the archetype for the mind [*Urbild für den Geist*], for the love of reason, but not an object for mimetic reproduction [*Nachbildung*]."[22] Cohen then asserted, "There necessarily arises in prophetic monotheism the opposition to, the contradiction of, [visual] art, which is the original mode of operation of the human spirit."[23] Judaism was therefore an "anomaly" in the history of culture, and Cohen considered himself obliged to explain why the Jews alone were able to dispense with the visual arts. Not altogether confident in his solution, he surmised that it was the victory of the more powerful verbal art of poetry over the less potent visual art of images. Striking a variation on the theme sounded by Heine, Cohen concluded that "the prophets would not have been able to carry on the fight against art in the visual images of God if they themselves had not been able to lead it as artists [*Künstler*], as poet-thinkers [*Dichterdenker*] in the full power of a poetic imagination."[24]

Perhaps expressing his approval of the efflorescence of synagogue construction in nineteenth-century Germany,[25] Cohen conceded that religious architecture was a noteworthy exception to the rule of a systematic aversion to the visual arts, "for architecture did not fall into the worship of visual images. Rather it can create works for men who serve the unique God, but not for God who might dwell in such a house."[26] Cohen returned to this topic in a later chapter devoted to "Prayer [*Das Gebet*]," which puzzles over the apparent contradiction between prophetic monotheism's aversion to visual images of God and its endorsement of housing this imageless God in an actual building. After all, Cohen argued, "the dwelling of the unique God is a mystery [*Geheimnis*], and building a house for Him seems a violation [*Verletzung*]." He resolved the problem by insisting that the house was built, not for God, "not even for His image which does not exist, but only for men who want to pray, not to offer sacrifices."[27]

Unable to improve on the beauty of Heine's formula, Hermann Cohen cited it literally, modulating its poetic excesses. The Mosaic aversion to visual art translates into a repudiation of the polytheistic practice of representing spiritual entities in visual form, regardless of whether those entities are human or divine.[28] Cohen, however, found Heine imprecise for ignoring Judaism's sponsorship of religious architecture. According to Cohen, religious architecture was compatible with Judaism because it facilitated strictly spiritual acts of verbal and conceptual worship. Heine

was right, however, in stressing the idea that Moses was an artist of another kind: Moses shaped a moral society informed by the supreme principles of ethical monotheism.

Moses also left room for a second, less metaphorical type of art: poetry. Formstecher agreed. So did Heine, for Heine also boasted that Judaism's literature, especially its Bible, a "portable homeland," was Judaism's supreme contribution to general culture.[29] Franz Rosenzweig (1886–1929), Hermann Cohen's innovative and admiring disciple, also assigned to poetry a preeminent place in religious existence. In *Star of Redemption* (*Stern der Erlösung*), Rosenzweig declared that

> poetry . . . comes to be the truly vital art, and a certain human maturity is even more indispensable for the great poet than for the painter or musician. . . . Art and music are still somewhat abstract; the former appears to some extent mute, the latter blind. As a result, oral revelation, beginning with Moses, has never confronted visual art . . . without some misgivings. No such misgivings apply to poetry . . . for poetry supplies structure as well as discourse. . . . Therefore poetry is, because most alive, the most vital art. It is not necessary for every person to have a taste for music or painting, to be an amateur producer or reproducer in the one or the other. But every complete human being must have a taste for poetry; indeed he must be an amateur poet himself. At the very least he must have once written poetry. Even if, at a pinch, one can be human without composing poetry, one cannot become human without having done so for a time.[30]

Formstecher, Heine, Cohen, and Rosenzweig championed the notion that the spirit of Jewish ethical monotheism was inimical to the visual arts but altogether compatible with the verbal arts of poetry, especially the religious poetry of the Bible. In Cohen's hypothetical formulation, biblical poetry might never have been created "if a stop had not been put to the plastic arts. This characteristic consists in the lyric poetry of the Psalms, which praises neither God alone nor man alone. Plastic art, by contrast, can only depict those two forms in isolation, thus hampering lyric poetry."[31]

Such assumptions and conclusions are not self-evident. It is not obvious that ethical monotheism necessarily excludes the visual arts, that poetry is the supreme art form, that visual art is more sensually provocative than verbal art, that visual art is incapable of depicting God and man together, or that the verbal and visual arts cannot thrive in the same society. It is therefore apparent that these German Jewish intellectuals were convinced by something powerful and authorizing in their culture. When they advanced the cause of Jewish aniconism, they rebuffed Hegel by following the respected lead of Kant, who had extolled the biblical prohibition against visual images. When they crowned poetry the supreme art, they were building on the foundations laid by Herder in the *Spirit of Hebrew Poetry* (1782). They were also

following the prestigious lead of both Kant and Hegel. In *The Critique of Judgement*, Kant had declared that "among all the arts poetry holds the highest rank. . . . It expands the mind. . . . Poetry fortifies the mind: for it lets the mind feel its ability. . . . it does not sneak up on the understanding and ensnare it by a sensible exhibition."[32] Hegel had asserted that poetry is the "most spiritual presentation of romantic art. . . . Poetry is the universal art of the spirit which has become free in itself and which is not tied down for its realization to external sensuous material; instead, it launches out exclusively in the inner space and the inner time of ideas and feelings. . . . Poetry [unlike the other arts] is adequate to all forms of the beautiful, and extends over all of them."[33] For intellectuals steeped in the German Romantic tradition, then, poetry, philosophy, and religion, in their highest forms, were almost synonymous. As Friedrich Schlegel (1772–1829) put it, "He who has religion will speak poetry."[34]

Salomon Ludwig Steinheim (1789–1866), a physician by profession and a Jewish theologian by vocation, also appreciated poetry, but he preferred "hymns and melody." Steinheim was impressed by Aristotle's discussion of the role of music in educating youth, citing at length the discussion in *Politics* 8.5.[35] Steinheim also considered it a scientifically valid fact that hearing was the highest of the five senses, for hearing does not relate to "spatial entities [*Räumliches*]." It is attuned to "temporality [*Zeitliche*], motion, activity, [and] the work of various powers in the visible world."[36] Steinheim considered hearing the last of the senses to emerge in nature and therefore anatomically the least widely distributed in organic nature.[37] He deduced that hearing has an affinity with "spatial-becoming [*Räumlich-Geschehendes*]" but not with "spatial-being [*Räumlich-Seiendes*]" and that "through hearing, by means of sound, spirit [*Geist*] recognizes spirit."[38] Praising Kant for being among the very few who "ponder carefully what they assert," Steinheim agreed with Kant's dictum that the ban against visual images of God was the "supreme prohibition in the Old Testament." For Steinheim, as for Formstecher, Heine, and Cohen, "visual and corporeal manifestations belittle and corrupt the notion of God." Unlike them, however, Steinheim held that the "highest and most pure thought regarding God can and should only" take the form of "word and musical note [*Ton*]."[39]

Comparing himself to Plato, who banned poetry, Steinheim declared that he would not be misunderstood if people deduced that he was advocating the total elimination of visual art from all worship within the confines of a religious building.[40] Steinheim did not, however, favor the elimination of visual art from all corners of Jewish life. He was not a philistine and did not want to be identified with "rigid Quakerism [*Stockquäkerthum*]." He appreciated the visual arts for their service to beauty, for their decorative and didactic powers, and especially for their ability to depict historical narratives. He invoked the precedent of the most "devout pietists [*Frommen*]," holding the most "uncompromising beliefs [*unbeugsamen Glaubens*],"

who allowed art its rightful place in Jewish life. For proof, he mentioned having seen illuminated texts and prayerbooks originating in the fifteenth or sixteenth century adorned with the "painted initials" and "decorated representations." Such paintings, Steinheim assured his readers, were used only as an aid to "devotion [*Andacht*]"; they excluded any "sacrilegious depictions of God." For actual worship, however, sculpture and painting lack music's ability to transcend materiality and lead the soul to the spiritual domain of "holiness and everlasting bliss [*Seligkeit*]."[41]

Heinrich Graetz (1817–1891) admired Steinheim. They both associated Judaism intimately with the verbal and the musical. Destined for fame as the author of the multivolume *Geschichte der Juden,* Graetz published a programmatic essay in 1846 outlining his thoughts on "the structure of Jewish history." Against the backdrop of a radical distinction correlating paganism with "nature" and Judaism with "spirit," he drew a sharp contrast between pagans, who experience the divine as something visible, and Jews, who experience God "through a demonstration of His will, through the medium of the ear." Carrying this theological distinction into the realms of aesthetics and morality, Graetz absorbed and revised Hegel:

> Paganism sees its god, Judaism hears Him; that is, it hears the commandments of His Will. . . . Furthermore, artistic expression also develops differently according to the different concepts of God. The artistic act created in Greek paganism, in accord with its sensuous God-concept, is the art of sculpture, that lovely fragrant blossom of the pagan form of perception. In Judaism, on the other hand, which perceives its God in the alternatingly loud and soft sounds of the movement of the waves, in the rhythm of word sounds, the artistic drive, in harmony with this particular view of God, gave birth to music combined with religious poetry. . . . It is unnecessary to dwell on this viewpoint any longer, for the entire structure of Judaism attests to it. The sharp opposition of Judaism to a paganism sunk in idolatry and immorality, traits which are conspicuously evident at a single glance, is nothing but the broad antithesis between the religion of the spirit and the religion of nature, divine transcendence and immanence.[42]

In 1874, writing the introduction to the first volume of his *History,* Graetz elaborated on this distinction between licentious Greek visuality and chaste Hebraic aniconism. "Hellenism," he wrote, "dispersed the flowers of art and the fruits of knowledge. It unveiled the realm of beauty and illuminated it with an Olympian clarity of thought." By contrast, Hebraism showed "a certain deficiency in failing to leave behind any gigantic structures of architectural wonders," because it "probably lacked any architectural skill. . . . Likewise, it did not build temples for its God—the Solomonic Temple was built by Phoenicians—because the goal was to transform the heart of man into God's temple. Israel neither sculpted nor painted gods, for it

considered the deity as an object of solemn and devout reverence and not as a subject of frivolous play." In the realm of literature, Hebraism did not "excel in artistic epics and still less in tragedy and comedy" because of its "aversion against mythologies . . . as well as against the levity and theatrics of the stage." But it did produce "two other genres which reflected the full richness of its idealistic life: the psalms and the poetically wrought eloquence of the prophets." According to the world-historical division of artistic labor imagined by Graetz, "Greek literature illuminated the realm of art and knowledge, Hebraic literature idealized the realm of the sacred and the moral." Devoted to holiness and sexual restraint, the Jews survived history. Devoted to art, philosophy, and debauchery, "sunk in lewdness and sexual aberrations," the ancient Greeks, along with all the other nations of antiquity, disappeared. Hebraism entailed the "overcoming and controlling [of] . . . selfishness and animal desires"; it disallowed "animal-like behavior and sexual perversion." "History provided the test. Nations which defiled themselves through immorality, growing callous through the use of force, succumbed to death."[43]

In 1889, chafing under the ever-escalating friction of political and racial anti-Semitism, Graetz applied his stereotypes of ancient civilizations to modern Europe, writing that "whereas the Latin race is more permeated with the spirit of Hellenism, the Anglo-Saxon race is penetrated with the Biblico-Judaic spirit because its mind is more directed to truth than to beauty."[44] Six years earlier, Graetz had been less generous with the Anglo-Saxons and far less cautious in spelling out the differences between Hellenic "beauty" and Hebraic "truth." Thinking of widespread prostitution, the number of illegitimate births, and the ravages of syphilis in nineteenth-century Europe, Graetz waxed eloquent on the horrid implications of the preference for beauty over truth and virtue. The ancient pagan goddesses of love, Aphrodite and Venus, according to Graetz, transformed themselves in modern European culture into the twin ideals of "love" and "beauty."

> The goddess of infamy still continues to ravage the spinal cord of the civilized world. Antiquity was little more than a public house of infamy, and modern civilization has merely transformed it into private houses. The showing of nudes in all art exhibitions whether in the form of Venus or that of the repentant Magdalena, the rush to Makart's sensual colors of flesh, and the intense interest in so-called academies that destroy any sense of shame and against which the police have moved in vain, prove sufficiently that the cult of Aphrodite still has enthusiastic adherents in our civilized world. And now, in addition, the filthy novels à la Zola. . . . [45]

Convinced that "the survival or demise of nations is determined by the observance or violations of the laws of sexual morality," and eager to pronounce that "the palm branch for sexual restraint belongs from antiquity to the present solely to the people of Israel,"[46] Graetz asserted the moral superiority of Judaism over European

culture, thereby offering his answer to the pressing questions of his day: How did Judaism manage to survive endless persecution, and how might Judaism guarantee its survival despite the adversities assailing it from the direction of modern racial and political anti-Semitism? To both questions, the answer was the same: Judaism survives because it defies the natural and cultivates the spiritual. Being spiritual, it espouses ethical monotheism and therefore, unlike the pagans, constitutionally refuses to indulge in the visual arts.

Heine anticipated Graetz in 1854 when he confessed his former disappointment with Moses for having spurned the visual arts. Heine admitted his mistaken enthusiasm for Greek culture. Just as he had come to realize that Moses was a greater "artist" than any mere sculptor or painter, so too had he come to understand that the "Greeks were only beautiful youths, while the Jews were always men, powerful, unyielding men. This applies, not only to ancient times, but also to the present day, despite eighteen centuries of persecution and misery."[47]

Heine and Graetz had developed the related themes of anti-Hellenism, Jewish aniconism, manly Jewish restraint, Jewish spirituality, and the historic survival of Judaism despite adversity. In *Moses and Monotheism,* so did Freud.[48] Because Freud so neatly capsulized the nineteenth-century Jewish funicular arguments that elevated Jewish ethical culture while dropping the visual arts, it is worth citing him at length:

> Among the precepts of Mosaic religion is one that has more significance than is at first obvious. It is the prohibition against making an image of God, which means the compulsion to worship an invisible God. . . . The prohibition . . . was bound to exercise a profound influence, for it signified subordinating sense perception to an abstract idea; it was a triumph of spirituality [*Geistigkeit*] over the senses [*Sinnlichkeit*]; more precisely, an instinctual renunciation accompanied by its psychologically necessary consequences. . . . Through the Mosaic prohibition, God was raised to a higher level of spirituality. . . . All such progress in spirituality results in increasing self-confidence, in making people proud so that they feel superior to those who have remained in the bondage of the senses. . . .
>
> The preference which through two thousand years the Jews have given to spiritual endeavor has, of course, had its effect; it has helped to build a dike against brutality [*Roheit*] and the inclination to violence [*Gewalttat*] which are usually found where athletic development [*Muskelkraft*] becomes the ideal of the people. The harmonious development of spiritual and bodily activity, as achieved by the Greeks, was denied to the Jews. In this conflict their decision was at least made in favor of what is culturally the more important. . . . Progress in spirituality consists in deciding against the direct sense perception in favor of the so-called higher intellectual processes—that is to say, in favor of memories, recollection, and logical deduction.
>
> . . . The religion that began with the prohibition against making an image of God has developed in the course of the centuries more and more into a religion

of instinctual renunciation. Not that it demands sexual renunciation; it is content with a considerable restriction of sexual freedom. God, however, becomes completely withdrawn from sexuality and raised to an ideal of ethical perfection. Ethics, however, means restriction of instinctual gratification. The Prophets did not tire of maintaining that God demands nothing else from His people but a just and virtuous life.[49]

Heine, Graetz, and Freud combined their admiration for Jewish aniconism and ethical restraint with an equally powerful disdain for Hellenic aesthetics and athleticism. In doing so, they were turning the tables on German intellectuals who idealized the Greeks and held the Jews, ancient and modern, in utter contempt. In 1841—the same year that Formstecher announced Judaism's hostility to the plastic arts; eleven years before Heine declared that he had renounced Hellenism in favor of Hebraism; forty years before Graetz was to claim truth, music, and morality for Judaism, leaving beauty, visual arts, and sexual perversity to the now deceased Greeks; and ninety-six years before Freud credited Jewish aniconism with initiating the intellectualism and renunciation of sensuality that eventually gave rise to science—in 1841, Ludwig Feuerbach had declared that

> using the theoretical senses, the Greeks observed nature. They heard heavenly music in the harmonious course of the stars; they saw nature arise from the foam of the all-producing ocean as Venus Anadyomene. The Israelites, on the contrary, opened to nature only the gastric sense; their taste for nature lay only in the palate; their consciousness of God in eating manna. The Greek pursued humanistic studies (Humaniora, the liberal arts, philosophy); the Israelite did not rise above the alimentary view of theology. . . . When Moses and the seventy elders ascended the mountain where "they saw God . . . , they ate and drank." Seeing the Supreme Being therefore only stimulated in them their appetite for food. The Jews have maintained their peculiarity to this day. Their principle, their God . . . [is] egoism. . . . Hence, science arises, like art, only from polytheism, for polytheism is the open, ungrudging sensibility for all that is beautiful and good. . . . The Greeks looked into the wide world that they might extend their sphere of vision; the Jews to this day pray with their faces turned towards Jerusalem. . . . Polytheistic sensibility, I repeat, is the groundwork for science and art.[50]

Three years later, in 1844, Karl Marx published an essay, "On the Jewish Problem" (*Zur Judenfrage*). Marx transported Feuerbach's list of Jewish vices—egoism, carnality, and parochialism—into Jewish selfishness (*Eigennutz*), petty commercialism (*Schacher*), and capitalistic moneygrubbing. Kant had already associated Judaism with the shady practices of commercialism, offering a strictly geographical and historical explanation.[51] Marx went beyond Kant, contending that "money is the jealous God of Israel before whom no other God may endure." He therefore predicted that "as

soon as society will succeed in abolishing the empirical nature of Judaism, commerce and its presuppositions, the existence of the Jew will be impossible, because his consciousness will have lost its object. . . . The social emancipation of the Jew is the emancipation of society from Judaism."[52]

In Freud's terms, Marx and Feuerbach had defined the Jews as people "who have remained in the bondage of the senses"; Jews were therefore incapable of matching the "Greek" achievements in art, science, and philosophy. Heine, Graetz, and Freud disagreed, just as they disagreed with Marx's call for "abolishing the empirical nature of Judaism," since for them the empirical nature of Judaism was neither materialistic nor commercial but thoroughly spiritual and chastely aniconic. Disagreeing with the potentially lethal premises of nineteenth-century cultural and political anti-Semitism, Heine, Graetz, and Freud counterattacked aggressively. It is not the monotheistic and aniconic Jews, but the Greeks and their contemporary admirers, who cultivate the merely physical. It is not the Jews, but the ancient and polytheistic Egyptians, Phoenicians, and Greeks, together with their contemporary enthusiasts, who busy themselves with fashioning commodifiable objets d'art. The counterattack was funicular. It conceded that the spirit of Judaism was not conducive to creativity in the materialistic visual arts; it stressed that, in compensation for this deficiency, the Jews have always excelled in the verbal arts—witness the biblical psalmists and prophets. The Jews also excelled in music, sexual chastity, manly restraint, and the capacity for surviving all adversity. For Heine, Graetz, and Freud—to which list must now be added the names Formstecher, Steinheim, and Cohen—Europe could ill afford to abolish Judaism, since the elimination of Judaic spirituality would annihilate the very source of high culture, abstract reasoning, natural science, and morality. Far from being a sign of deficiency, Jewish aniconism was a sign and cause of Judaic virtue.

Speaking for the anti-Semites, Richard Wagner disagreed.[53] In 1849, having absorbed the socioeconomic critique of Judaism and Feuerbach's derisive contrast between Hellenic visual culture and selfish Hebraic taste buds, Wagner published *Das Kunstwerk der Zukunft* (The Artwork of the Future). This revolutionary manifesto drew a sharp contrast between the ancient Greeks and the Jews of Wagner's own day. Wagner celebrated the Greeks, who were able to create visual beauty and enjoy sculpture for its humanistic significance; he bemoaned the nineteenth-century Jews, who produced and appreciated art only for its commercial, pragmatic value (*Utilismus*). In Wagner's opinion, Jewish aesthetics amounted to nothing more than the historic "Byzantine . . . Judaic-Oriental notion of profitability [*jüdisch-orientalische Nützlichkeitsvorstellung*]," which had ruined the free-spirited art of ancient Greece.[54]

In 1850, Wagner substituted modern German culture for the victimized ancient Greek, added biological inferiority to the list of Jewish socioeconomic defects, and

issued a racist's scathing attack against "Judaism in Music [*Das Judenthum in der Musik*]." Objecting to the "jewification of modern art [*Verjüdung der modernen Kunst*]," Wagner named Felix Mendelssohn-Bartholdy and Heinrich Heine as proof that composers and poets of Jewish origin are physiologically and constitutionally unable to contribute anything truly valuable to genuine Germanic culture. Regarding visuality and the visual arts, Wagner complained that

> the sensory capacity for sight [*die sinnliche Anschauungsgabe*] belonging to the Jew[s] was never such as to allow them to produce visual artists; their eyes are preoccupied with matters much more practical than beauty and the spiritual content of things in the phenomenal world. To the best of my knowledge, we know nothing of a single Jewish architect or sculptor [*Bildbauer*] in our own times; as for painters of Jewish origin, I must leave it to experts in the field to judge whether they have created anything real in their art. It is most probable, however, that these artists are no different in attitude toward their visual art than the modern Jewish composers are toward music.[55]

In 1869, Wagner republished the essay, helping to stoke the deadly flames of racial anti-Semitism that were beginning to engulf fin-de-siècle Europe. Two of the defensive responses to these flames were a heightened Jewish self-consciousness and Zionism, both of which in turn stimulated the avid production, collection, and public display of Jewish art.[56] Racial anti-Semitism and increasing interest in Jewish art compelled Jewish intellectuals and artists to modify their views. Earlier, against Hegel's philosophic objections to Judaism's refusal to depict God visually, German Jewish intellectuals had been able to side with Kant, who found Judaism's aniconism sublime. They had also been able to point to Judaism's compensatory genius for poetry, music, and universalist ethical monotheism. Against the Feuerbachian-Wagnerian enthusiasm for Greek visuality, German Jewish intellectuals had been able to use the same arguments developed for rebutting Hegel. Others, like Graetz, who discredited the visual arts by stressing their carnality, paganism, and moral depravity, had thereby transformed an apparent ethnic deficiency into a virtue. Against the Feuerbachian-Marxian-Wagnerian charge that Jewish selfishness and money-grubbing threatened Europe, German Jewish intellectuals from Heine to Freud had been able to stress Judaism's affinity for the temporal rather than the spatial, its moral self-restraint in renouncing libidinal instinct, and its cultivation of abstract intellectualism. Against Wagnerian claims that Jews were unable to produce anything worthwhile in the visual arts, Steinheim had acknowledged the didactic and devotional functions of illuminated Hebrew manuscripts, and Hermann Cohen had underscored the spiritual legitimacy of Jewish religious architecture. New arguments were needed, however, against fin-de-siècle racism and the accumulating evidence

of Jewish visual art. The new arguments would have to neutralize charges of Jewish racial inferiority as well as account for Jewish art without sacrificing altogether the cherished principle of spiritually driven aniconism.

One version of these new arguments, clustered with the old, was formulated by Martin Buber.[57] In 1903 Buber edited *Juedischer Kuenstler,* an illustrated volume of essays featuring six modern Jewish artists: Josef Israels, Lesser Ury, E. M. Lillien, Max Liebermann, Solomon J. Solomon, and Jehudo Epstein.[58] Buber wrote both a brief introduction for the volume and the essay devoted to Lesser Ury. He began the introduction by conceding that the sorry state of Jewish visual art justified Wagner when he "denied to the Jewish sensory capacity for sight [*sinnliche Anschauungsgabe der Juden*] the power to produce visual artists." Buber also conceded that Wagner was not wrong in explaining this deficiency in terms of "racial characteristics [*Rasseneigenschaften*]."

These concessions "obliged" Buber to defend the publication of the book and to explore the "causes" for Judaism's "lack of creativity [*Unfruchtbarkeit*]" in the visual arts. Buber invoked history. He declared that because of racial characteristics, "the ancient Jew had no visual art."[59] He explained that racial characteristics are not "final and irreversible, but rather the product of soil and its climatic conditions, the economic and social structure of the community, the form of life and historical fate." He then rehearsed the typological distinction between Hebraism and Hellenism made familiar by Heine, Formstecher, Steinheim, and Graetz: "The ancient Jew was more a person-of-the ears [*Ohrenmensch*] than a person-of-the-eyes [*Augenmensch*] and more a person-of-time [*Zeitmensch*] than a person-of-space [*Raummensch*]. Of all his senses, it was mostly his hearing that inspired him to form his image of the world."[60] The quintessential art form of the ancient Jew was therefore "acoustic, music being a barely adequate means of expression." The impassioned, "lyrical poetry of the prophets" was its capstone: "The brilliantly gifted Jew of antiquity had to become a prophet; otherwise he would perish [*untergehen*] in the fullness of his passion. To visual art, he could not come; his emotion was too fierce [*wild*] and the way too vast [*weit*]."

From antiquity, Buber passed to a consideration of Jewish culture in the Diaspora, especially to the "form of life" in the ghetto. He argued that medieval Judaism was unable to produce art because Jews were buffeted by life's circumstances, dragged under by the corrupting and exclusive involvement with moneylending, and hemmed in by the all-powerful regimen of oppressive religious law [*Religionsgesetz*]. The law "stifled" creative impulses at their first appearance. The law made the "human body contemptible. Beauty was an unknown value. To behold [*schauen*] was sinful. Art was sinful." Buber believed, however, that subterranean "mystical" forces, percolating beneath the surface of medieval Judaism, made their breakthrough in Hasidism.[61] For Buber, Hasidism "was the birth of the new Judaism" in which "the

human body" was "marvelous" rather than contemptible; "beauty an emanation from God, beholding a unification with God"; and "love," rather than "law, the goal of life."

Having deflected Wagner's racism by introducing the novel consideration of mythic forces within Judaism that surfaced in Hasidism and by reducing racial characteristics to the "evolutionary" effects of variable historical circumstances, Buber brought the introduction to a close with a brief discussion of the post-Emancipation period, when the "door to art stood open." In modernity, Buber argued, "the essence of the Jewish race was merely entering a new phase, not undergoing a dialectical nullification [*Aufhebung*]." First in music, fed by the dominant aurality of the synagogue liturgy and folk art, and then in lyric poetry, in which "subjectivity" blossomed forth, modern Jews gave "new form" to old impulses. Finally in the visual arts Jews began to experiment with giving unprecedented visual form to the "characteristics of their folk." "They are merely a beginning," Buber concluded, and it is better to observe them than to "theorize" about their work. They will show what contemporary Jewry is capable of producing in the visual arts.

Wagner and the anti-Semites had claimed that Jews were unable to produce genuine art steeped in communal awareness of divine, mythic beauty because Jews were forever yoked to insidious commercialism. Buber used evolutionary considerations, historical arguments, biblical poetry, and Hasidism to prove otherwise. He granted that Jews had produced no visual art until the nineteenth century, but he also insisted that Jewish culture possessed authentically folkish, indigenous aesthetic impulses. Other German Jewish intellectuals were less interested than Buber in the invigoration of Jewish national creativity, but they were equally eager to prove that Jews were no threat to European society. Accordingly, they adopted a different strategy in combatting racial anti-Semitism. They too leaned heavily on historical arguments. Unlike Buber, however, they used the growing body of archaeological evidence to prove that Jews have always produced visual art, though they carefully noted that there was no Jewish "look," nothing distinctively Jewish about it.[62] As formulated by Graetz and the German-educated Kaufmann Kohler in the English-language *Jewish Encyclopedia* of 1902, this historical argument presupposed "that it is . . . somewhat incorrect to speak of Jewish art. Whether in Biblical or in post-Biblical times, Jewish workmanship was influenced, if not altogether guided by non-Jewish art. Roman architecture was invoked in the building of Herod's Temple just as Phoenician architecture was in the construction of those of Solomon and of Zerubbabel." As for modern Jewish art, in which Buber hopefully saw the "characteristics of their folk" in new forms, Kohler emphatically proclaimed that it "no longer bears the specific character of the Jewish genius, but must be classified among the various nations to which the Jewish artists belong."

The *Jüdisches Lexicon*, published in Berlin in 1929, sponsored a similar argument. Written in the light of accumulating archaeological and artifactual evidence, its entry "Jewish Art" claimed that Jews have always produced visual art but, with equal emphasis, also denied that the art is particularly Jewish.[63] Written by Kurt Freyer, a specialist on Spinoza, the entry begins with a Kohler-like proviso:"To speak of Jewish art in the same sense as any other kind of art is not possible without further qualifying details [*weiteres*]." Freyer concludes that one can properly speak of "art by Jews" and "art for Jews," but not of "Jewish art." The reasons are threefold: art by and for Jews lacks a well-defined, "specifically Jewish characteristic, since [it] always employs the forms and motifs of the contemporary host societies [*Wirtsvölker*]" in whose midst the Jews have lived; it lacks continuity or "internal coherence" because of vast differences in the temporal circumstances of its production; and finally it lacks a canon of "extraordinary, brilliant achievements, either by individual artists or an entire epoch." As for the modern Jewish art over which Buber was reluctant to pass qualitative judgments, Freyer concedes that "important things have been achieved." Nevertheless, he is quick to add, these "creations belong more to the art history of the peoples in whose midst [the artists] live than to the Jewish people."

Regarding the abundance and inferior quality of premodern Jewish art, the entry is equally apologetic. Freyer offers two reasons why "Jews have not produced important art of their own." The first reason harks back to the nineteenth-century philosophic and theological arguments published by Hermann Cohen; it invokes the "special spiritual disposition of the Jewish people," its "anti-Hellenism," which ignored the surrounding world and dedicated itself to the "knowledge of God and the normativity [*Gesetzlichkeit*] of ethical behavior." Were it not for this spiritual disposition, the *Jüdisches Lexicon* argues, the aniconic Second Commandment would never have been able to exert so powerful an influence in Jewish culture. Kohler was saying much the same thing in 1902 when his contribution to the *Jewish Encyclopedia* stressed that "far more potent than the Law was the spirit of the Jewish faith in putting a check on plastic art. In the same measure as polytheism, whether Semitic or Aryan, greatly aided in developing art as it endeavored to bring the deity in ever more beautiful form . . . , Judaism was determined to lift God above the realm of the sensual and corporeal and to represent Him as Spirit only." Echoing Graetz's denunciations of lascivious European visuality, the *Lexicon*'s historicized, restricted notion of Jewish art reverberates with assurances that Judaism is neither sexually perverse nor carnally materialistic, that its spiritual essence neither poses a moral threat to its host cultures nor evinces hostility to the fine arts and the universal sciences. This was also precisely the argument developed by Freud in *Moses and Monotheism*, and it is interesting to note that Freud's private library in Vienna contained the four volumes of the *Jüdisches Lexicon*.[64]

The second argument advanced by the *Jüdisches Lexicon* folds historical anthropology into this philosophic Idealism. Echoing Buber, Freyer maintains that the

"political-social" circumstances of the Diaspora were not conducive to the creation of truly important art. Having made all these "qualifications" explicit, Freyer nonetheless disagrees with Buber and asserts that historical Jewish visual art does indeed exist. He then outlines its achievements, especially in ceremonial art, synagogue architecture, and medieval illuminated manuscripts.

Freyer's deprecation of premodern Jewish art and his insistence on the lack of national character and stylistic definition in all of Jewish art would be difficult to understand were it not for the racism against which the German Jews were contending and the Zionist options, which the vast majority was refusing. Writing in 1929, Freyer was speaking on behalf of an assimilating, acculturated, besieged group, who were still convinced that the way to defuse racism was to outsmart it with scholarly arguments and that the best way to flatter a host culture was to imitate it.[65] Freyer's affirmation of an assimilative, physically nondistinct, derivative Jewish visual art mirrors European Jewry's desperate and ultimately futile denial of the racist proposition that Jewish bodies differ from the physical bodies of the people in whose midst they live.[66]

Their racist enemies were no figment of the imagination. In 1923 a "Professor of Racial Hygiene" at the University of Munich (who collaborated on a translation for his English readers in 1931) typically asked his German readers to "think of the faces of the more refined Jews of Southern Europe" in order "to picture . . . the Oriental race [which] is distinguished by its small stature, by a long and narrow cranium, a narrow face with thick and fleshy lips, and a narrow, prominent, equably curved, and not excessively large nose." He asked them to consider the statistically significant, genetically transmitted propensity of the Jews to suffer from blindness, deafness, skin disease, flat feet, arteriosclerosis, diabetes, obesity, sterility, myomata, Parkinson's disease, lumbago, feeblemindedness, melancholia, schizophrenia, and—like women—all forms of hysteria, especially hypochondria and nosophobia. He informed his readers that "it would certainly seem to be a fact that where the male sex is concerned hysteria manifests itself more often in Jews than it does in the Teutonic races, the explanation being that Jews on the average have in respect to both . . . body and . . . mind a less markedly developed masculine character."[67]

In the *Lexicon* entry Freyer summarized nineteenth- and twentieth-century German Jewish arguments regarding Jewish visual art. Kohler and Freud fed these arguments into the mainstream of twentieth-century Anglo-American opinion. A review of these Germanophone arguments makes it apparent that the idea of Jewish aniconism was made possible by a combination of Kantian ethics, Hegelian spirituality, Romanticism's enthusiasm for poetry or music, Judaism's traditional veneration of book learning, and the nineteenth century's nationalistically tinged version of cultural anthropology.[68] What made the idea of Jewish aniconism necessary and persistent was ongoing anti-Semitism in all of its escalating variety, from Kantian

and Hegelian philosophic disparagement, through Feuerbachian-Marxist socio-economic villification, to Wagnerian racism, and on to the horrific state-sponsored, genocidal mass psychosis of Nazi Judeophobia. What complicated the idea of Jewish aniconism was late-nineteenth-century Zionism, as represented by Buber, and the growing interest in recovering and displaying the lost heritage of Jewish artifacts, which the archaeologists were unearthing in ever increasing abundance. What continues to make the modern idea of Jewish aniconism hopelessly overdetermined and ambiguous is its sponsorship by friend and foe alike.[69] When the future Professor Goodenough was assured by mentors at Oxford and Yale, two bastions of a secularizing Protestant ethos, that strictly speaking there "was no such thing as Jewish art," he was simultaneously hearing the praise of Judaism and its condemnation.[70]

Notes

1. Translated from the Yiddish and quoted by Lucy S. Dawidowicz, *The Golden Tradition: Jewish Life and Thought in Eastern Europe* (Boston: Beacon Press, 1968), 332. For further discussion and a slightly different translation, see Ziva Amishai-Maisels, "Chagall and the Jewish Revival: Center or Periphery," in *Tradition and Revolution: The Jewish Renaissance in Russian Avant-Garde Art, 1912–1928*, ed. Ruth Apter-Gabriel (Jerusalem: Israel Museum, 1987), 71–100. Arthur A. Cohen, reading Chagall's statement, concluded that he intended "a weak affirmation of [Jewish art's] possibility." See Arthur A. Cohen, "From Eastern Europe to Paris and Beyond," in *The Circle of Montparnasse: Jewish Artists in Paris, 1905–1945*, ed. Kenneth E. Silver and Romy Golan (New York: Universe Books, 1985), 62. For further discussion regarding the East European matrix of Chagall's attitudes, see Avram Kampf, *Jewish Experience in the Art of the Twentieth Century* (South Hadley, Mass.: Bergin and Garvey, 1984).

2. Erwin R. Goodenough, *Jewish Symbols in the Greco-Roman Period* (New York: Pantheon, 1954), 1:27–28.

3. Let one example suffice: In a recent monograph exploring the Byzantine iconophiles, Moshe Barasch argued that "in the Middle Ages or during the Reformation . . . whoever dealt with images had to come to terms with the Second Commandment, to interpret it, and to assess its place in a comprehensive system of beliefs. . . . For fifteen centuries it was an established truth that the ban on depicting God began with the Bible." Barasch offered two typological readings of the prohibition: the "comprehensive" and the "restrictive." The comprehensive reading "rejects every mimetic image, whatever the figure or object it represents . . . a total negation of the image depicting something." The restrictive reading "prohibits the depiction of only one subject—the representation of God." See Barasch, *Icons: Studies in the History of an Idea* (New York: New York University Press, 1992), 13, 15–17.

4. See, for example, Harold Rosenberg, "Is There a Jewish Art?" *Commentary* 42 (1966): 58–59. Referring to "silver menorahs and drinking goblets, embroidered Torah coverings, [and] word carvings," Rosenberg concluded "that this priestly work is not art in the sense in which the word is used in the 20th century." For the standard complaint against critics

who "ignore the existence of Jewish ritualistic art," see Stephen Kayser, "Defining Jewish Art," in *Mordecai M. Kaplan Jubilee Volume* (New York: Jewish Theological Seminary, 1953), 457. Kayser was the director of the Jewish Museum in New York City. For analysis of the cultural politics involved in ascribing aesthetic value to diverse artifacts, see James Clifford, *The Predicament of Culture: Twentieth-Century Ethnography, Literature, and Art* (Cambridge, Mass.: Harvard University Press, 1988), 220–30.

5. *The Jewish Encyclopedia* (New York: Funk and Wagnalls, 1901–1906), 2:142.

6. *The Catholic Encyclopedia* (New York: Appleton, 1907–1922), s.v. "Images," by Adrian Fortescu.

7. Focusing on racism and anti-Semitism, I follow the lead of Salo W. Baron, *The Jewish Community* (Philadelphia: Jewish Publication Society, 1948), 2:137, and Harold Rosenberg, "Is There a Jewish Art?" 58. Marshall G. S. Hodgson identified similar ideological motives in scholarship regarding the visual arts in Islam; see *The Venture of Islam: Conscience and History in a World Civilization* (Chicago: University of Chicago Press, 1974), 2:503 no. 3. To Hodgson's list of "silly . . . Western racialism," one may add the well-known pronouncement of Bernard Berenson that "the Jews like their Ishmaelite cousins the Arabs, and indeed perhaps like all pure Semites (if such there be), have displayed little talent for the visual, and almost none for the figure arts." Berenson did not believe, however, that the Jews, perhaps himself included, were without a compensatory art of their own: "To the Jews belonged the splendours and raptures of the word. Hebrew literature . . . has afforded inspiration and comfort to Christian and Mohammedan [and] has fashioned or reshaped their instruments of expression." See Bernard Berenson, *Aesthetics and History in the Visual Arts* (New York: Pantheon, 1948), 167. For the genesis of the book, its critical reception, and its place in Berenson's thought, see Ernest Samuels, *Bernard Berenson: The Making of a Legend* (Cambridge, Mass.: Belknap Press of Harvard University, 1987), 440–41, 464, 498, 503–7.

8. Immanuel Kant, *Critique of Judgement,* trans. Werner S. Pluhar (Indianapolis: Hackett Publishing, 1987), 135.

9. G. W. F. Hegel, *Aesthetics: Lectures on Fine Art,* trans. T. M. Knox (Oxford: Clarendon Press, 1975), 1:70. For Hegel's earlier speculations, see his "The Spirit of Christianity and Its Fate" in *Early Theological Writings,* trans. T. M. Knox (Chicago: University of Chicago Press, 1948), 182–205. For discussion of these earlier speculations, see Margaret Olin, "C[lement] Hardesh [Greenburg] and Company" in *Too Jewish? Challenging Traditional Identities,* ed. Norman L. Kleebatt (New York: Jewish Museum, 1996), 43.

10. Immanuel Kant, *Religion within the Limits of Reason Alone,* trans. and introd. Theodore M. Greene and Hoyt H. Hudson (New York: Harper Torchbooks, 1960), 116–18. For discussion, see Paul L. Rose, *Revolutionary Antisemitism in Germany from Kant to Wagner* (Princeton, N.J.: Princeton University Press, 1990), 91–97.

11. For the German philosophic landscape in which German Jewish intellectuals thoroughly ethicized Judaism, see Julius Guttmann, *Philosophies of Judaism: A History of Jewish Philosophy from Biblical Times to Franz Rosenzweig,* trans. David W. Silverman (New York: Schocken, 1973), 327–451; Nathan Rotenstreich, *Jewish Philosophy in Modern Times: From Mendelsohn to Rosenzweig* (New York: Holt, Rinehart and Winston, 1968), 1–218; and Eliezer Schweid, *A History of Jewish Thought in Modern Times: The Nineteenth Century* [Hebrew]

(Jerusalem: Kether/Hakkibutz Hameuchud, 1977), 122–51, 216–72, 281–328. For the "gist of Kant's and Hegel's analysis of Judaism" with which the German Jewish intellectuals had to contend, see Nathan Rotenstreich, *Jews and German Philosophy: The Polemics of Emancipation* (New York: Schocken, 1984), 3–7.

12. Solomon Formstecher, *Die Religion des Geistes* (Frankfurt: J. C. Hermann, 1841), 68.

13. Ibid., 71.

14. Ibid., 69.

15. Ibid., 68–69.

16. Heinrich Heine, "Geständisse," in *Heinrich Heine*, ed. Mazzino Montinari (Berlin: Akademie-Verlag, 1988), 12:70–71. The English translation is taken, with some minor modifications, from S. S. Prawer, *Heine's Jewish Comedy: A Study of His Portraits of Jews and Judaism* (Oxford: Clarendon Press, 1983), 620–21. For biographical details and additional literary studies of Heine's works, see Jeffrey L. Sammons, *Heinrich Heine: A Modern Biography* (Princeton, N.J.: Princeton University Press, 1979). For the topos of Moses in modern German Jewish thought, see Bluma Goldstein, *Reinscribing Moses: Heine, Kafka, Freud, and Schoenberg in a European Wilderness* (Cambridge, Mass.: Harvard University Press, 1992), esp. 26–36.

17. For the original text, see Hermann Cohen, *Religion der Vernunft aus den Quellen des Judentums*, 2d ed. (Cologne: Joseph Melzr Verlag, 1928). It was first published in 1919. For an English translation, see Hermann Cohen, *Religion of Reason out of the Sources of Judaism*, trans. and introd. Simon Kaplan, introductory essay by Leo Strauss (New York: Frederick Ungar Publishing, 1972), 338–70. For philosophic discussion, see the histories of Julius Guttmann, Nathan Rotenstreich, Eliezer Schweid, and the comments of Hans Liebeschütz, "Hermann Cohen and His Historical Background," *Leo Baeck Institute Year Book* (1968), 13:3–33. See also Peter Gay, "Encounter with Modernism: German Jews in Wilhelminian Culture," in *Freud, Jews, and Other Germans: Masters and Victims in Modernist Culture* (New York: Oxford University Press, 1978), esp. 114–21. For Cohen's familiarity and sympathy with Heine, see his 1867 essay "Heinrich Heine und das Judentum," in *Hermann Cohens Jüdische Schriften*, ed. Bruno Strauss (Berlin: C. A. Schwetschke & Sohn, 1924; reprint ed. 1980), 2:2–44. Other references to Heine are scattered throughout Cohen's writings, especially in connection with Spinoza and the problems of pantheism and the affinity between German and Jewish spiritual outlooks.

18. For an account of the debate, see Michael A. Meyer, *Response to Modernity: A History of the Reform Movement in Judaism* (New York: Oxford University Press, 1988), 10–224.

19. Cohen, *Religion der Vernunft*, 427–29; *Religion of Reason*, 368–69.

20. *Religion der Vernunft*, 484–86; *Religion of Reason*, 417–19.

21. *Religion der Vernunft*, 43–44; *Religion of Reason*, 37.

22. *Religion der Vernunft*, 63; *Religion of Reason*, 54.

23. *Religion der Vernunft*, 62; *Religion of Reason*, 53.

24. *Religion der Vernunft*, 64; *Religion of Reason*, 55.

25. For illustrations and analysis, see Harold Hammer-Schenk, *Synagogen in Deutschland: Geschichte einer Baugattung im 19. und 20. Jahrhundert, 1780–1933* (Hamburg: H. Christians, 1981); *Synagogen in Berlin: Zur Geschichte einer zerstörten Architektur*, ed. Rolf Bothe (Berlin: Verlag Willmuth Arenhövel, 1983); Carole Herselle Krinsky, *Synagogues of Europe: Architecture,*

History, Meaning (Cambridge, Mass.: MIT Press, 1985); and Harold Hammer-Schenk, "Die Architektur der Synagogue von 1780 bis 1933," in *Die Architektur der Synagogue*, ed. Hans-Peter Schwarz (Stuttgart: Klett-Cotta, 1988), 157–286. I am grateful to my colleague Professor Annabel J. Wharton for these references.

26. Cohen, *Religion der Vernunft*, 66; *Religion of Reason*, 57. For an art historian who placed Cohen's approval of religious architecture at the heart of a systematic study of Jewish art, see Helen Rosenau, *A Short History of Jewish Art* (London: J. Clarke, 1948).

27. *Religion der Vernunft*, 477; *Religion of Reason*, 384.

28. For Cohen's inconclusive remarks regarding visual representations of the human being, see *Religion der Vernunft*, 66–67; *Religion of Reason*, 57–58. The implication seems to be that, for Cohen, visual depictions of the human are as aversive to the spirit of Judaism's ethical monotheism as are visual images of God.

29. For Heine's profound appreciation of biblical literature, see S. S. Prawer, *Heine's Jewish Comedy*, esp. 609–23. For the persistence and cultural significance of the trope "portable homeland," see Sidra DeKoven Ezrahi, "Our Homeland, the Text . . . Our Text the Homeland: Exile and Homecoming in the Modern Jewish Imagination," *Michigan Quarterly Review* 31 (1992): 463–97.

30. Franz Rosenzweig, *The Star of Redemption*, trans. William Hallo (Boston: Beacon Press, 1972), 245–46. The argument on behalf of the superiority of poetry among the arts is intensified on pages 370–71 ("Thus it remained for the poetic arts to emerge as the arts of the whole man over and beyond the fine arts and music"). The translation is based on the second edition, published in 1930. Rosenzweig completed the book in 1919. For his conceptual relationship to Hermann Cohen, see Jacques Derrida, "Interpretation at War: Kant, the Jew, the German," *New Literary History* 22 (1990–1991): 39–95.

31. Cohen, *Religion der Vernunft*, 67; *Religion of Reason*, 58.

32. Kant, *Critique of Judgement*, 196–98.

33. Hegel, *Aesthetics: Lectures on Fine Art*, 1:88–90.

34. Cited in F. W. J. Schelling, *The Philosophy of Art*, ed., trans., and introd. Douglas W. Scott (Minneapolis: University of Minnesota Press, 1989), 291. For the Kantian dilemmas facing modern poets in their ambivalent reliance on visuality, see Geoffrey H. Hartman, *The Unmediated Vision: An Interpretation of Wordsworth, Hopkins, Rilke, and Valéry* (New Haven, Conn.: Yale University Press, 1954).

35. Salomon Ludwig Steinheim, *Die Offenbarung nach dem Lehrbegriffe der Synagoge* (Leipzig: Leopold Schnauss, 1856), 2:428–29. For discussion, see the histories of Guttmann, Rotenstreich, and Schweid. See also Aharon Shear-Yashuv, *The Theology of Salomon Ludwig Steinheim* (Leiden: E. J. Brill, 1986), 56; and *Salomon Ludwig Steinheim: Studies in His Thought*, ed. Aharon Shear-Yashuv (Jerusalem: Magnes Press, 1994).

36. Steinheim, *Die Offenbarung*, 2:433. For a discussion of this distinction and its relevance to Buber, Bergson, Proust, and Freud, see Stephen Kern, *The Culture of Time and Space, 1880–1918* (Cambridge, Mass.: Harvard University Press, 1983), 50–51. The afterlife of Steinheim's distinction can be traced in the widely read and deeply flawed, tendentious monograph by Thorlief Boman, *Das hebräische Denken im Vergleich mit dem griechischen* (Göttingen: Vandenhook & Ruprecht, 1954) [*Hebrew Thought Compared to Greek* (London: SCM Press,

1960)]. Boman's arguments loom large in Susan Handelman, *Slayers of Moses* (Albany: State University of New York Press, 1982), 33–37.

37. Steinheim, *Die Offenbarung,* 2:433.

38. Ibid., 2:434.

39. Ibid., 2:436.

40. Ibid., 2:445.

41. Ibid., 2:446.

42. See Heinrich Graetz, *The Structure of Jewish History and Other Essays,* trans., ed., and introd. Ismar Schorsch (New York: Jewish Theological Seminary of America, 1975), 68–69. This passage was cited and its point developed, uncritically, by José Faur, *Golden Doves with Silver Dots: Semiotics and Textuality in Rabbinic Tradition* (Bloomington: Indiana University Press, 1986), 29–49. Elliot R. Wolfson, too, seems to agree with Graetz. Wolfson assures his readers that "there can be no doubt that the view that became normative in the history of Judaism is one that favored auditory over visual images," and he uses ideas developed by Derrida to validate "the ancient preference reflected in the Deuteronomic author [that] it is more appropriate to speak of a voice of God rather than a visible form. . . . " It is against the background of this "normative" aniconism and funicular preference for the auditory that Wolfson's researches in the phenomenology of Jewish mysticism yield such stunning and corrective results. See Elliot R. Wolfson, *Through a Speculum That Shines* (Princeton, N.J.: Princeton University Press, 1994), 13–16.

43. Graetz, *The Structure of Jewish History and Other Essays,* 174–83.

44. Ibid, 301. The essay from which the lines are cited was originally published in English by Graetz in 1889 and 1890, in the first issues of the *Jewish Quarterly Review.*

45. Ibid, 233. For the biography, work, and critical reception of Hans Makart (1840–1884), the Austrian artist whose paintings Graetz reviled, see *Makart,* ed. Klaus Gallwitz (Baden-Baden: Staaliche Kunsthalle, 1972); and Brigitte Heinzl, *Hans Makart: Zeichnung-Entwürfe* (Salzburg: Salzburger Museum Carolino Augusteum, 1984).

46. Graetz, *The Structure of Jewish History and Other Essays,* 236.

47. See S. S. Prawer, *Heine's Jewish Comedy,* 621. For further discussion of Heine's distinction between the "Greek" and the "Hebraic," see Vassilis Lambropoulos, *The Rise of Eurocentrism: Anatomy of Interpretation* (Princeton, N.J.: Princeton University Press, 1993), 175–76. For the echoes of Heine in Matthew Arnold's famous distinction between "Hebraism and Hellenism," see Matthew Arnold, *Culture and Anarchy,* ed. Samuel Lipman (New Haven, Conn.: Yale University Press, 1994), 86–96. Arnold cited Heine explicitly on page 87. For nineteenth-century racial and ethnic typologies, see Maurice Olender, *The Languages of Paradise: Race, Religion, and Philology in the Nineteenth Century,* trans. Arthur Goldhammer (Cambridge, Mass.: Harvard University Press, 1992).

48. For discussion, see Yosef Hayim Yerushalmi, *Freud's Moses: Judaism Terminable and Interminable* (New Haven, Conn.: Yale University Press, 1991), and Goldstein, *Reinscribing Moses,* 66–136.

49. Sigmund Freud, *Moses and Monotheism,* trans. Katherine Jones (New York: Vintage Books, 1939), 144–52. In the *Standard Edition of the Complete Psychological Works of Sigmund Freud,* ed. and trans. James Strachey, vol. 23 (London: Hogarth Press and the Institute of

Psychoanalysis, 1964), the relevant passages are found on pages 112–19. For the original German text, I have consulted Sigmund Freud, *Der Mann Moses und die monotheistische Religion: Drei Abhandlungen* (Amsterdam:Verlag Allert De Lange, 1939), 200–10.

50. Ludwig Feuerbach, *Das Wesen des Christenthums,* ed.Wilhelm Bolin and Friedrich Jodl (Stuttgart-Bad Cannstatt: Fromann Verlag, 1960), 136–37. For an English version of the whole work, see Ludwig Feuerbach, *The Essence of Christianity,* trans. George Eliot (New York: Harper, 1957). For a critical discussion of Feuerbach's proclamations, see Emil L. Fackenheim, *Encounters between Judaism and Modern Philosophy* (New York: Basic Books, 1973), 79–169, esp. 134–52. See also Rose, *Revolutionary Antisemitism in Germany from Kant to Wagner,* 253–55, and Enzo Traverso, *The Marxists and the Jewish Question: The History of a Debate, 1843–1943,* trans. Bernard Gibbons (Atlantic Highlands, N.J.: Humanities Press, 1944), 18–19.

51. See Immanuel Kant, *Anthropology from a Pragmatic Point of View,* trans.Victor L. Dowell, rev. and ed. Hans H. Rudnick (Carbondale: Southern Illinois University Press, 1978), 101–2. For the German original, see Immanuel Kant, *Gesammelte Schriften,* Koniglich Preussischen Akademie der Wissenschaften (Berlin: Georg Reimer, 1917), 7:205–6, corresponding to book 1, section 46, of *Anthropologie in pragmatischer Hinsicht.*

52. Quoted in *The Jew in the Modern World,* ed. Paul Mendes-Flohr and Jehuda Reinharz (Oxford: Oxford University Press, 1995), 324–27, from the translation prepared by Helen Lederer. For the German original, see *Karl Marx/Friedrich Engels Gesamtausgabe,* ed. Rolf Dlubek (Berlin: Dietz Verlag, 1982), 2:141–69. The passages cited are found on pages 164 (30–33); 166 (35–36); and 169 (9–16). For discussion, see Paul Lawrence Rose, *Revolutionary Antisemitism from Kant to Wagner,* 296–305.

53. For Wagner's niche in the history of modern anti-Semitism, see Jacob Katz, *From Prejudice to Destruction: Anti-Semitism, 1700–1933* (Cambridge, Mass.: Harvard University Press, 1980), 184–94.

54. Richard Wagner, *Gesammelte Schriften und Dichtungen* (Hildesheim: Georg Olms Verlag, 1976), 3:144, 145. For the standard English translation, see *Richard Wagner's Prose Works,* trans.William A. Ellis (London: Kegan Paul,Trench,Trübner & Co., 1895), 1:177, 179.

55. Richard Wagner, "Das Judenthum in der Musik," in *Gesammelte Schriften und Dichtungen,* 5:72–73 (facsimile reproduction of the original Leipzig edition of 1888). For discussion and bibliographic references to the immense literature surrounding this essay and Wagner's anti-Semitism, see Jacob Katz, *The Darker Side of Genius: Richard Wagner's Anti-Semitism* (Hanover, N.H.: University Press of New England, 1986); and Paul Lawrence Rose, *Wagner: Race and Revolution* (New Haven, Conn.: Yale University Press, 1992), esp. 78–88. For an alternative, apologetic view, which did not profit from Jacob Katz's discussion and overlooked the racist language and revolutionary politics stressed by Rose, see L. J. Rather, *Reading Wagner: A Study in the History of Ideas* (Baton Rouge: Louisiana State University Press, 1990), 114–78.

56. See Richard I. Cohen, "An Introductory Essay—Viewing the Past," and Michael Berkowitz, "Art in Zionist Popular Culture and Jewish National Self-Consciousness, 1897–1914," in *Art and Its Uses: The Visual Image in Modern Jewish Society,* ed. Richard I. Cohen, Studies in Contemporary Jewry: An Annual, 6 ed. Ezra Mendelsohn (New York: Oxford University Press, 1990), 3–42; Richard I. Cohen, "Self-Image through Objects:

Towards a Social History of Jewish Art Collecting and Jewish Museums," in *The Uses of Tradition: Jewish Continuity in the Modern Era,* ed. Jack Wertheimer (New York: Jewish Theological Seminary of America, 1992), 203–42; and Joseph Gutmann, "Is There a Jewish Art?," in *The Visual Dimension: Aspects of Jewish Art,* ed. Clare Moore (Boulder, Colo.: Westview Press, 1993), 1–19. For the other defensive reactions of Germanophone Jews, see the discussions in *Living with Antisemitism: Modern Jewish Responses,* ed. Jehuda Reinharz (Hanover, N.H.: University Press of New England, 1987), 3–208. See also Michael A. Meyer, *The Origins of the Modern Jew: Jewish Identity and European Culture in Germany, 1749–1824* (Detroit: Wayne State University Press, 1979); and David J. Sorkin, *The Transformation of German Jewry, 1780–1840* (New York: Oxford University Press, 1987).

57. For an overview of Buber's struggle against anti-Semitism, see Paul Mendes-Flohr, "Buber and the Metaphysicians of Contempt," in *Living with Antisemitism,* ed. Jehuda Reinharz, 133–64.

58. See *Juedischer Kuenstler,* ed. Martin Buber (Berlin: Juedischer Verlag, 1903), 1–6.

59. In a monograph written in 1946, Buber modified his opinion regarding the total absence of visual art in biblical Israel. See his *Moses: The Revelation and the Covenant,* introd. Michael Fishbane (Atlantic Highlands, N.J.: Humanities Press International, 1989), 115–18, 125–27. ("The fight against [images of God] is not a fight against art, which would certainly contrast with the report of Moses' initiative in carving the images of the cherubim; it is a fight to subdue the revolt of fantasy against faith," 127.) For Buber's earlier denials of Jewish art, at the Fifth Zionist Congress in Basel in 1901 and in an article published in 1902, see Avram Kampf, *Jewish Experience in the Art of the Twentieth Century,* 15, 203.

60. For discussion of Buber's dialogic religious existentialism, see Harold Stahmer, *"Speak That I May See Thee!": The Religious Significance of Language* (New York: Macmillan, 1968), 183–215. For a compelling critique of Buber's typological distinction between Hebraic ears and Hellenic eyes, see Vasilis Lambropoulos, *The Rise of Eurocentrism,* 304–11.

61. For the persistence of these anti-rabbinic themes in Buber's thought, see the so-called "early addresses (1909–1918)" collected in *On Judaism by Martin Buber,* ed. Nahum N. Glatzer (New York: Schocken, 1972), 3–107. For Buber's fascination with Hasidism, see Paul-Mendes Flohr, "*Fin-de Siècle* Orientalism, the *Ostjuden* and the Aesthetics of Jewish Self-Affirmation," in *Studies in Contemporary Jewry,* ed. Jonathan Frankel, Institute of Contemporary Jewry/ Hebrew University (Bloomington: Indiana University Press, 1984), 1:96–139. For a critique of Buber's rendition of Hasidism, see Gershom Scholem, "Martin Buber's Interpretation of Hasidism," trans. Michael A. Meyer, in *The Messianic Idea in Judaism* (New York: Schocken, 1971), 228–50.

62. For a scathing parody of racist stereotypes regarding Jewish bodies and Jewish art, see Harold Rosenberg, "Is There a Jewish Art?" 57–58: "And if there is such as thing as looking like a Jew, does it not follow that the art Jews produce must also have a look of its own—that this art must look like Jewish art? In that case, there is a Jewish style—for in art the look is the thing." Rosenberg, of course, denied that there was a distinctive style or "look" to the art produced by Jews.

63. *Jüdisches Lexicon* (Berlin: Jüdischer Verlag, 1929), 3:934–38.

64. See the comments of Susan L. Braunstein in "Sigmund Freud's Jewish Heritage" (Binghamton: State University of New York; London: Freud Museum, 1991), 13, published

as a special supplement to *Sigmund Freud and Art: His Personal Collection of Antiquities,* ed. Lyn Gamwell and Richard Wells, introd. Peter Gay (Binghamton: State University of New York; London: Freud Museum, 1989).

65. For the modern controversy regarding the relation of Jewish culture to its host societies, see Ahad Ha-'Am [Asher Ginzberg], "Imitation and Assimilation," *Selected Essays of Ahad Ha-'Am,* trans. Leon Simon (New York: Atheneum, 1970), 107–38. For the original Hebrew, see idem, *'Al Parashat Derakhim,* ed. J. Frankel (Tel Aviv: Dvir, 1963), 1:162–73. See also Gerson D. Cohen, "The Blessing of Assimilation in Jewish History" (Boston: Hebrew Teachers College, 1966).

66. For discussion and references to the literature, see Sander Gilman, "The Jewish Body: A Footnote," and Jay Geller, "(G)nose(e)ology: The Cultural Construction of the Other," in *People of the Body: Jews and Judaism from an Embodied Perspective,* ed. Howard Eilberg-Schwartz (Albany: State University of New York Press, 1992), 223–82.

67. Edwin Baur, Eugen Fischer, and Fritz Lenz, *Human Heredity,* trans. Edend Paul and Cedar Paul (New York: Macmillan, 1931), 246, 264, 272, 294, 336, 351, 354, 358, 402, 404, 418, 423–24, 437, 439, 446, 454 (hysteria), and 644 ff., for the behavioral implications, including Jewish aptitude for music, shrewd commercial instincts, and poor visual skills, including incapacity for the arts. Lenz is the author of all the cited passages.

68. For the politics of cultural anthropology, see, for example, Talal Asad, *Genealogies of Religion: Discipline and Reasons of Power in Christianity and Islam* (Baltimore: Johns Hopkins University Press, 1993); and Jack Goody, *The Domestication of the Savage Mind* (Cambridge: Cambridge University Press, 1977), esp. 146–62.

69. For an exploration of anti-Semitism and its ambiguities from the perspective of art history, see Linda Nochlin, "Starting with the Self: Jewish Identity and Its Representation," in *The Jew in the Text: Modernity and the Construction of Identity,* ed. Linda Nochlin and Tamar Garb (London: Thames and Hudson, 1995), 7–19.

70. In a frequently cited study of premodern, positive Jewish attitudes toward the visual arts, J.-B. Frey reviewed the evidence for allegations that Jewish interventions prompted the destruction of Christian images by both iconoclast emperors and Muslims. Frey concluded that the Jews had indeed lapsed into iconoclasm and were blameworthy for their anti-Christian motives. Explicitly invoking Tertullian's condemnations of the Jews, Frey emphatically agreed that "the Jewish synagogues are the source of persecutions [*Synagogue Iudaeorum fontes persecutionnum*]." See J.-B Frey, "La Question des images chez les Juifs à la lumière des récentes découvertes," *Biblia* 15 (1934): 265–300. For the historical implausibility of effective Jewish influence on the iconoclastic emperors, see Gerhard B. Ladner, "Origin and Significance of the Byzantine Iconoclastic Controversy," in *Images and Ideas in the Middle Ages: Selected Studies in History and Art* (Rome: Edizioni di Storia e Letteratura, 1983), 1:37–47.

To Figure, or Not to Figure

The Iconoclastic Proscription and Its Theoretical Legacy

LISA SALTZMAN

> Nach Auschwitz ein Gedicht zu schreiben ist barbarisch.
> —Theodor Adorno

"After Auschwitz, to write a poem is barbaric."[1] So wrote Theodor Adorno in 1949, in the penultimate sentence of "Cultural Criticism and Society," an essay otherwise unconcerned with aesthetics. Out of context even in its original context, later qualified and regretted, Adorno's statement has nevertheless come to function as a moral and aesthetic dictate for the postwar era.[2] Further, although the historically motivated pronouncement speaks of the present, a time "after Auschwitz," its aesthetic ethics remain deeply embedded in the past. In other words, "after Auschwitz," Adorno may question the very propriety and possibility of aesthetic representation. "After Auschwitz," he may formulate a response to metaphysics, the micrology of negative dialectics. "After Auschwitz," the cosmopolitan, assimilated Adorno, born Wiesengrund, may explicitly confront the implications of his paternal Jewish heritage in the research project on anti-Semitism. But even more, in the very articulation of his proscription "after Auschwitz," he reveals a time "before Auschwitz," an ethical time, one shaped by the law of the Hebraic father, which with his proscription he both evokes and instantiates. For behind Adorno's postwar proscription lies another, biblical, prohibition, the Second Commandment, "Thou shalt not make graven images." That is to say, this Hebraic ethics fully emerges only "after Auschwitz," first in Adorno's own proscription and then in his ensuing writings.

Adorno's Jewish identity has typically been invoked to explain the messianism of his ultimately emancipatory utopian formulations,[3] a messianism first secularized in Marxism and later displaced into the realm of aesthetics. Less central to such analyses is the ethical force of his prohibition on graven images.[4] In recent German

writing on Adorno the biblical prohibition has come, interestingly and most emphatically, to the interpretive fore.

Hans-Jürgen Syberberg, best known for such controversial films as *Hitler: A Film from Germany* (1978), wrote a book suffused with xenophobic and anti-Semitic sentiment. Entitled *Vom Unglück und Glück in der Kunst in Deutschland nach dem letzten Krieg* (1990), Syberberg's book is a nostalgia-laden plea for the aesthetic, for beauty, whose loss he attributes to what he perceives as a dominance of "Jewish" aesthetics in the aftermath of the war. He claims that returning Jewish members of the Frankfurt School, with Adorno in a position of centrality, imposed their aesthetics on postwar Germany, an aesthetics that to Syberberg's eyes was an anti-aesthetics because it called for and existed in the absence of, or in place of, true art, that is to say, of beauty.[5]

In contrast to Syberberg's ode to the loss of beauty and authentic German cultural identity, Gertrud Koch, the founder of the feminist film journal *Frauen und Film* and the German-Jewish cultural journal *Babylon,* affirms and in some sense celebrates what she takes to be the fundamental Jewishness of critical theory. In her book *Die Einstellung ist die Einstellung: Visuelle Konstruktionen des Judentums* (1992), Koch sets out to demonstrate the very fundamental importance to critical theory of the biblical prohibition on image making. Koch contends that Adorno's Jewish identity, and the Jewish identity of many Frankfurt School members, could be seen all along in their profound ambivalence toward mimesis and their favoring of abstraction, as evidenced most explicitly in their reception of Schönberg's opera *Moses and Aaron.*[6] While I would not make such a sweeping claim about the fundamental Jewishness of critical theory, I am prepared to contend that "after Auschwitz" the biblical prohibition on images—what could be termed a position of iconoclasm—experienced a theoretical renaissance.

Such examples as Dura-Europos notwithstanding,[7] the Second Commandment proposes a world without images, a world in which not only God, but no other thing, be it from the earth, the sea, or the sky, may be represented.[8] Further, the Second Commandment does not simply prescribe that God *should* not be portrayed but also implies that God *cannot* be portrayed. God is beyond the knowable or perceptible. God is thus unrepresentable. Unlike Adorno, whose postwar dictum is a result of history, of Auschwitz, the Second Commandment determines a representational impossibility a priori. Taken together, the intertwined dicta leave us with an aesthetic ethics of visual absence and poetic silence.

That silence has been articulated most clearly, has been given its inaudible voice, in the poetry of Paul Celan, whose work is somewhat paradoxically considered both the catalyst for and the aesthetic fulfillment of Adorno's proscription. While Celan's lyrical evocation of the death camps, "Fugue of Death" (1944), may have occasioned Adorno's dictum, Celan's "Tübingen, January" (1963) echoed its ethics of impossibility and unrepresentability. Celan wrote:

Came, if there
came a man,
came a man to the world, today, with
the patriarchs'
light-beard: he could,
if he spoke of this
time, he
could
only babble and babble,
ever- ever-
moremore.[9]

Turning from the question of poetry to that of visual representation, we find Adorno writing in *Aesthetic Theory* that "the Old Testament prohibition of graven images can be said to have an aesthetic aspect besides the overt theological one. The interdiction against forming an image—of something—in effect implies the proposition that such an image is impossible to form."[10] At the same time, Adorno paradoxically posits a visual fulfillment of the aesthetic prohibition. Just as "Celan's poems articulate unspeakable horror by being silent,"[11] because their themes are the very silence and impossibility their existence would seem to disrupt, so Adorno claims that visual abstraction satisfies "the old prohibition of graven images," by offering a mode of aesthetic representation that avoids what Auschwitz and the Hebrew Bible expressly forbid, because it is both nonreferential and nonfigurative.[12]

Adorno's "taboo on sensuality,"[13] which proscribes all that is material, all that is from nature, finds expression in modernism, most particularly in the asceticism and dissonance of Schönberg. Turning again to the example of abstraction, Adorno writes, "The images of the post-industrial world are images of dead anorganic matter."[14] Abstraction, as aesthetic practice, defies, perhaps even precludes, fetishistic, animalistic behavior. Or does the taboo on sensuality regard not so much the object as our relation to that object?

Whereas abstraction might allow for the dialectical possibility of representation without figuration, the fundamental import of the biblical prohibition for the Judeo-Marxist tradition is not its ethical stance toward the making of images. Rather, the biblical prohibition speaks against the *worshiping* of images. In smashing Aaron's golden calf, Moses prevents the Jews from looking, from displacing their adoration from God to icon. Moses prevents the Jews from entering into a fetishistic relationship with the image. Adorno, writing against the spectator's experience of pleasure and desire in response to the art object, again invokes a language of prohibition and taboo. He writes, "Perhaps the most important taboo in art is the one that prohibits an animal-like attitude toward the object, say, a desire to devour it or otherwise to subjugate it to one's body."[15]

Thus, what Adorno gives us is ultimately less a Hebraic ethics of art, or art making, than what might be termed a Hebraic ethics of spectatorship. Adorno is less concerned with the qualities of the art object, for example whether it is abstract or representational, than he is with the attitude of the spectator, with encouraging an attitude of disinterestedness. He is deeply wary of fetishism. Although Adorno's spectatorship would initially seem dependent upon an anti-aesthetic, "anorganic," even abstract art that circumvents the possibility of a libidinous engagement with the object, ultimately he shifts that responsibility from the object to the viewer.

Adorno's use of the Second Commandment as a taboo on any sort of sensual or libidinous relationship with the image recalls an aspect of the prohibition that has been explored more explicitly by such post-1968 French thinkers as Jean-François Lyotard and Jean-Joseph Goux, first in Lyotard's "Jewish Oedipus"[16] and more pointedly in Goux's "Moses, Freud, and the Iconoclastic Proscription."[17] According to these writers, to sculpt an image of God is to create a material image, a "maternal" image, and to encourage its sensual worship. Correspondingly, to tear oneself away from the enticements of the senses and direct one's thoughts toward the unrepresentable God is to turn away from desire for the maternal and to rise toward the sublime father. It is to respect his law. For Goux, this is where the Mosaic proscription acquires its fundamental import. In Freudian terms, Mosaic law articulates the threat of castration brandished in opposition to a fundamentally incestuous desire.[18]

If we trace the legacy of the Second Commandment even further, the full force of the libidinous nature of the spectatorial relationship is revealed in one of the foundational texts of feminist aesthetics. Laura Mulvey's essay "Visual Pleasure and Narrative Cinema" is a text whose fundamental iconoclasm reiterates the Mosaic proscription and positions Mulvey as a significant ethical voice in the postwar era.[19] Although largely concerned with film—narrative film—and its manipulations of time and space, Mulvey's call for an end to visual pleasure, for an end to the pleasures that arise in the conventional cinematic situation, especially in its representation of women (what Mulvey calls scopophilia, its attendant narcissism, voyeurism, and fetishism) comes to sound much like Adorno's call for viewing without pleasure, viewing without fetishism. In the conclusion of her essay Mulvey writes, "The first blow against the monolithic accumulation of traditional film conventions is to free . . . the look of the audience into dialectics and passionate detachment. There is no doubt that this destroys the satisfaction, pleasure and privilege of the 'invisible guest' "—that is to say, the spectator.[20]

Although Mulvey's visual economy shaped feminist studies of images, moving and still, for years to follow, Mulvey herself came to qualify, though not to regret, her iconoclastic formulation, her call for a cinema of displeasure, a "negative aesthetics of counter-cinema"[21] that would circumvent the fetishistic impulses of the presumptive male spectator. In "Afterthoughts on 'Visual Pleasure and Narrative Cinema' " Mul-

vey renounced her prior iconoclastic prescription and posited the possibility of a positive cinema, one with active female protagonists undaunted by the gaze of the camera.[22] In her later essay "Pandora: Topographies of the Mask and Curiosity" Mulvey fully articulates a spectatorial position opposed to voyeurism and fetishism, a position of intellectual curiosity.[23] She contrasts the fetishist, who becomes fixated on an object in order to avoid knowledge, to indulge a scopophilic impulse and avoid confrontation with lack, with absence, with the curious spectator, who seeks knowledge.

Likewise, Adorno does not simply oppose images, or advocate looking only with what Martin Jay might term "downcast eyes,"[24] echoing and perhaps misprising Jacques Lacan's pronouncement that "he who looks is always led by the painting to lay down his gaze."[25] Rather, as I have said, Adorno would allow us to look, but to look as ethical spectators, who have internalized the law of the Hebraic father. He does not allow us merely to look at objects so ascetic, so stripped of the organic, of the sensuous, of pleasure, that they would never tempt us to a libidinous relationship to them. Rather, he would have us, as spectators, always aware of the Mosaic proscription so that we will already have forgone the prospect of fusion with the material image; we will have forgone the pleasure of the spectatorial process, the pleasure of suspending traumatic knowledge. He would have us view the object as ethical spectators. He would have us accede to knowledge.

In that call for knowledge, heard in the writings of both Mulvey and Adorno, there is a recognition of the fundamental importance of images, of aesthetic representation, for their ability to convey knowledge—to bear witness. For if to make images or to worship images is to transgress the Second Commandment—to play Aaron rather than Moses—to remain silent transgresses the law of bearing witness, the law of Leviticus 5:1.[26] It is to perpetuate the silence in which Auschwitz was encircled and enshrouded, first in a Nazi policy of Night and Fog, and then in a postwar silence of those "unable" or, more accurately, unwilling to mourn.[27] As Adorno writes in *Negative Dialectics,* "Perennial suffering has as much right to expression as a tortured man has to scream; hence it may have been wrong to say that after Auschwitz you could no longer write poems."[28]

In the discussion that follows, I concentrate not on poems but on paintings. Through the consideration of particular images, I return to the implications of Adorno's original dictum and its later qualifications, to the paradoxical logic engendered by a historical event, the Holocaust, whose very horror, exceptionality, and incomprehensibility at once defy expression and, at the same time, demand remembrance. As a means of further exploring the postwar legacy of the Second Commandment, I turn to the work of the postwar German artist Anselm Kiefer.

From his paintings involving Aaron, to those of the Iconoclastic Controversy of Byzantium, to those of Sulamith and Lilith, Kiefer immerses us in the theoretical and aesthetic terrain of the biblical prohibition on image making. He does so not

FIGURE 4
Anselm Kiefer, *Aaron,* 1984–85, collage, resin, gouache.
Courtesy of Marian Goodman Gallery, New York.

only through the textual referents of his titles, but through visual enactment, the contesting strategies of photography, painting, writing, and burning, aesthetically embodying the dialectic of figurality and discourse, image and word, representation and iconoclasm.

The printings of Kiefer's *Aaron* series (Fig. 4) suggest as a point of interpretive departure their framing narrative, the biblical account of Aaron and his oppositional relation to Moses and the tenets of the Second Commandment. Interestingly, the paintings are not portraits of Aaron, but precipitously pitched landscapes. Aaron, their titular subject, emerges pictorially only through Kiefer's

use of metonymic processes—the synecdochic inclusion of Aaron's staff. Rendered either in a photographic cutout or a thinly wrought leaden strip, each vaguely anthropomorphic in form, the staff, whose meaning in these pictures depends on the semantic field determined by the title, comes to function as the marker of the biblical iconophile, who is represented but not mimetically figured. Although Moses' staff contains greater powers—making serpents appear, parting the Red Sea, and striking a rock to obtain water—this staff, we know from Kiefer's titles, is Aaron's and represents Aaron. Signifying Aaron without portraying him, Kiefer simultaneously engages in the practice of pictorial representation and avoids its most idolatrous characteristics. With this picture that is not a portrait, with this landscape that verges on a painterly field of abstraction, Kiefer would seem to play both Aaron and Moses, creating a proverbial golden calf and then undermining its power as idol by resisting a traditional figural pictorial language.

The representational paradox incarnated in Kiefer's *Aaron* series is anticipated in two series of works that directly precede it. In his *Iconoclastic Controversy (Bilderstreit)* series (1977–80) (Fig. 5), German toy tanks, painted palettes, and the inscribed names of key Byzantine iconoclasts and iconophiles do battle. As in the *Aaron* paintings, Kiefer finds themes in the Second Commandment, but in this series he particularizes its historical and aesthetic resonances. By situating his imagery in the epic time of the Hebrew Bible, the historical time of Byzantium, and the not-so-distant time of Nazi Germany and the Second World War, Kiefer historicizes the Second Commandment and the prohibition on image making and calls attention to the political uses and abuses of both representation and iconoclasm.[29]

In the early 1980s Kiefer created the *Margarethe* and *Sulamith* paintings. In certain respects, these paintings, even more than the *Iconoclastic Controversy* series, locate themselves firmly in the historical terrain of the twentieth century. Yet despite this anchoring—for example, in the architectural spaces of Nazism (in the case discussed here, in a building designed by Wilhelm Kreis)—the images hover, like so many in Kiefer's paintings, in a mythopoetic sphere.

The *Margarethe* and *Sulamith* paintings (Fig. 6) appear in several different versions. Typically, the *Margarethe* paintings are composed of areas of configured straw, embedded in and loosely covering painted canvases, whose surfaces comprise and magnify into intense detail the thick encrustations of Kiefer's signature landscapes. In contrast to the organic imagery of the *Margarethe* paintings, the *Sulamith* canvases evoke deeply recessional architectural spaces or built environments. The *Margarethe* and *Sulamith* canvases, in their titles and their iconography, refer expressly to Paul Celan's evocation of the Holocaust and the death camps in his "Fugue of Death."[30]

FIGURE 5

Anselm Kiefer, *Bilderstreit,* 1980, photographic image on paper.
Courtesy of Marian Goodman Gallery, New York.

I quote the last two stanzas of Celan's poem to demonstrate how heavily Kiefer drew on its evocative imagery, and to suggest the many ways in which Kiefer's reductive, monumental translation of Celan is incompatible with Celan's language:

> Black milk of daybreak we drink you at night
> we drink you at midday and morning we drink you at evening
> we drink and we drink
> a man lives in the house your goldenes Haar Margareta
> your ashenes Haar Shulamith he plays with his vipers
>
> He shouts play death more sweetly this Death is a master from Deutschland
> he shouts scrape your strings darker you'll rise then as smoke to the sky
> you'll have a grave then in the clouds there you won't lie too cramped

FIGURE 6
Anselm Kiefer, *Sulamith,* 1983, mixed media on canvas.
Courtesy of Marian Goodman Gallery, New York.

Black milk of daybreak we drink you at night
we drink you at midday Death is a master aus Deutschland
we drink you at evening and morning we drink and we drink
this death is ein Meister aus Deutschland his eye it is blue
he shoots you with shot made of lead shoots you level and true
a man lives in the house your goldenes Haar Margarete
he looses his hounds on us grants us a grave in the air
he plays with his vipers and daydreams der Tod ist ein Meister aus Deutschland

dein goldenes Haar Margarete
dein ashenes Haar Sulamith[31]

As in many of Kiefer's other works, the text in *Margarethe* and *Sulamith* overlays and literalizes the often nonliteral, nonfigurative painting, in some way fixing the metaphoric field. Kiefer's Margarethe, who is at once Celan's and Goethe's, is a blond-haired ("strohblond," literally straw-blond) figure of German womanhood, embodied and metaphorized in straw. The straw is at once the German landscape, in its pure materiality, and, at the same time, strands of blond hair, the conflation pictorially enacting the ideological conceit of Nazism—namely, that German identity was autochthonous, that it was rooted in and emerged from German soil.

The brilliant colors, planarity, and highly textural materiality of *Margarethe* (1981), its insistent presence, contrast dramatically with the empty, dark, cavernous space depicted in *Sulamith* (1983). In *Sulamith* Kiefer represents a vaulted brick chamber, an architecturally exact rendering of Wilhelm Kreis's Mausoleum for German War Heroes. The painting's deeply perspectival recession into the crypt-like chamber is typical of Kiefer's evocation of Nazi architecture. The recession leads to a tangle of flames, whose shape and delineation evoke a menorah, which has been seen as transforming the commemorative potential of the space. Whereas the flames-as-menorah transform the space from a mausoleum to Nazi war heroes into a memorial to Jewish victims, all other fires in the chamber—torches hung in the bays of each transversal arch—are extinguished with a blackened cutout.[32]

A more diffuse covering, a black, sooty, ashen residue, overlays the upper half of the painting, out of which emerges, in the upper left corner, the name *Sulamith* in small white print. Here, in name only, is Margarethe's other, the dark-haired woman of the Song of Songs, transformed by Celan's verses into an ashen symbol of the destruction of European Jewry, irrevocably absent. Unlike the majority of Kiefer's linguistic inscriptions, which are scrawled expansively across the center of his images, Sulamith's name in tiny characters in the uppermost corner of the canvas is not integrally related to the pictorial space. She does not even occupy the cavernous chamber. She is consigned to the margins, the framing brickwork of the outermost arch, a sign of her own absence.[33]

If Sulamith's figure remains absent, her textual lineage does not. In their evocation of Margarethe and Sulamith, Kiefer's canvases bring us back, not just to Celan, their most immediate referent, but, more important, to Adorno. For whether or not it is apocryphal that Adorno's dictum was occasioned by his reading of Celan's "Fugue of Death," his dictum has become intimately linked with that poem. The relationship has been so firmly established that, as Sidra DeKoven Ezrahi writes, "the two are as intertwined as a talmudic commentary and its biblical source."[34] Thus Kiefer's series is not only a palimpsest through which we read Celan but a palimpsest through which we read Adorno. From "Fugue of Death," through Kiefer, we return to Adorno.

Sulamith might lead us, then, to ask in what way Adorno comes to function as a moral dictate for Kiefer. In Kiefer's paintings concerned with the Second Commandment, metonymy is the standard representational device. With *Sulamith,* in contrast, metonymic substitution seems to give way to pure absence. Sulamith herself, whose name appears in the very margins of the image, outside the aching void of a Nazi architectural structure turned Jewish memorial, is nowhere portrayed, though one might claim that the ashen surface of the canvas is indeed her metonymic representation.

How do we come to understand this figural absence? Does Kiefer avoid representing the human figure in *Sulamith* because to represent, to create aesthetically, is, taking Adorno to the letter, not so much impossible as barbaric? Or does Kiefer, a non-Jewish German, invoke these voices of moral authority—the Second Commandment, Celan, Adorno—to avoid representing, to avoid working through the most painful aspects of his country's traumatic history? Moreover, does Kiefer use Adorno's moral call for silence, a deeply ethical silence, to perpetuate a silence that was Germany's?

Such questions have no easy answers. It has been argued that Kiefer takes us into the very spaces of Nazism and engages us, with his use of monumental scale, deep perspective, and densely textured, material surfaces, in the spectatorial and ideological lure of fascism, the aestheticization of politics.[35] For if such images seduce us, lure us in, but then remind us in their historical referent of the danger there, then Kiefer's paintings would seem to instantiate, not just the prohibition on image making and viewing, but its qualification. That is to say, even as Kiefer's *Sulamith* indulges a certain fascination with fascism, the spectatorial lure of the image, the worshiping of idols, it simultaneously blocks that spectatorial relationship, ruptures that unity, insofar as it gives us that Zizekian unassimilable "traumatic kernel" that is, in this case, history.[36] Moreover, even as *Sulamith* instantiates the impossibility of representation—the incommensurability emphatically metaphorized in the Second Commandment by the sublime unrepresentable object that is divinity—Kiefer's image nevertheless exists as visual object, as image.

As such, we might read Kiefer's images, and *Sulamith* particularly, within and against Adorno's call for witness. In *Sulamith,* if only in *Sulamith,* the biblical injunction against imagery and Adorno's historical call for silence *are* contextualized, embodied in the painting, not just textually by the various levels of reference— biblical, poetic, and theoretical—but visually, architecturally, by the hollow crypt of Kreis's Nazi mausoleum. The space is rooted, not just in Germany, but in Germany of the Nazi period. Through the absence that *Sulamith* implies, if not features, the rendered space may function as Kiefer's most commemorative piece, its monumentality and pointed reference to the absent Jew and the historical trauma of the

Holocaust configuring a pictorial space of memory akin to a memorial, what Pierre Nora has termed a "lieu de mémoire."[37]

Viewing *Sulamith* as a space of memory allows us to link Kiefer's work with the commemorative monuments in Germany of the 1980s that James Young has termed "Gegen-Denkmäler" (countermonuments).[38] Young views such contemporary German countermonuments as sculptural pieces that challenge the very premise of the monument, resisting not just figuration but other conventions of commemorative sculpture or site-specific installations. In this context, Young discusses Jochen and Esther Gerz's *Monument against Fascism* for the city of Harburg, Alfred Hrdlicka's monuments in Hamburg and Vienna, Sol LeWitt's *Black Form Dedicated to the Missing Jews,* designed for the city of Münster, and Norbert Rademacher's memorial in the Neukölln district of Berlin. These countermonuments, according to Young, besides eschewing figuration, are characterized more by themes of absence than presence, more by impermanence than permanence. Young considers these "counter" or in some cases "vanishing" monuments emblematic of questions about history, memory, and representation that shaped public and political discourse and practice in Germany during the 1980s. He writes, "Ethically certain of their duty to remember, but aesthetically skeptical of the assumptions underpinning traditional memorial forms, a new generation of contemporary artists and monument makers in Germany is probing the limits of both their artistic media and the very notion of memorial."[39]

I would add to Young's list Christian Boltanski's *Missing House,* a 1989 project in Berlin's formerly Jewish Scheunenviertel.[40] Boltanski's piece participates in a process analogous to that of Young's countermonuments, marking and configuring absence. It consists solely of commemorative name plaques, reminiscent of German obituary notices, mounted along the fire walls of the two buildings adjacent to the now "missing" house.[41] Similar projects include the haunting photographic projections of Shimon Attie, such as *The Writing on the Wall* (1992), in which the prewar Jewish residents of Berlin's Scheunenviertel return as an ephemeral play of light and shadow on the crumbling facades of their former neighborhood. Another is Christo's Reichstag project. During the two weeks in June 1995 that it was "wrapped," the Reichstag was at once absent and monumentally present. Micha Ullman's 1996 installation beneath Berlin's Bebelplatz consisted of a room of empty bookshelves, visible only through a translucent glass window, the ghostly and barren *doppelgänger* of Kiefer's massive leaden-book-filled shelves in the newly renovated Hamburger Bahnhof. Closer to home, Maya Lin's Vietnam Veterans Memorial commemorates the Vietnam War and its American victims with decidedly nonfigurative means, its inscribed yet abstract minimalist form representing absence and loss.[42]

In contrast to such countermonuments, Kiefer's *Sulamith* seems to remain monumentally present. Yet its powerful form ultimately acts only as a frame, a pictorial space that configures nothing but an emptied, cavernous void. Its sheer size and its doubly inscribed recessional movement, in which both the tiles of the floor and the arches of the chamber accentuate and accelerate the visual regression to its depths, create a dramatic illusion of space. The viewer is forced to confront its emptiness, an emptiness made meaningful through the absence of Sulamith, the Jew.[43] Like Young's countermonuments, Kiefer's work has become an emblem, in the deep ambivalence of its reception, for Germany's conflicted struggle with remembering and representing the past.

No matter how fundamentally the epistemological and moral claims of representation have been undermined, by history, by secularized notions of sublimity, by ethical constraints on the image, Kiefer nevertheless continues to make pictures, and pictures which are, moreover, self-conscious about their radically compromised ethical and aesthetic status. Their continued presence, coupled with their thematics of impossibility and failure, allies them with Adorno and, moreover, with Adorno's negative dialectics, even as their very being-as-art departs radically from what Adorno may have envisioned as the necessarily autonomous, utopian possibilities of art. The fact that Kiefer, however asymptotically and problematically, deals with questions of representation, deals with history, deals with Germany's other, the Jew, and deals with the legacy of the past and its weight in the present, lends aesthetic, ethical, and historical gravity to his work.

Kiefer's work gives voice to what was silenced, to those who were silenced. In his essay "Commitment" Adorno reiterates the position he articulated in *Negative Dialectics*. It is a stance that constitutes the dialectical intertwining, though not a reconciliation, of a Hebraic ethics of unrepresentability and a Hebraic ethics of bearing witness, a stance that I see fundamentally enacted in the work of Kiefer. Adorno writes, "The abundance of real suffering tolerates no forgetting. . . . [It] demands the continued existence of art [even as] it prohibits it. It is now virtually in art alone that suffering can still find its own voice, consolation, without immediately being betrayed by it."[44]

Because images stand as visualized taboos against past, present, and even future wrongs, as witnesses to those wrongs, we cannot maintain a position of unqualified iconoclasm until we have a world without suffering, until we have a world without injustice, until we have a world in which ethical law is thoroughly internalized. Both Adorno and Mulvey, two foundational voices of iconoclasm in the postwar era, came to recognize this. Each asserts the fundamental importance of the image, even as both decry the danger represented by its continued existence. And Kiefer, for all his iconoclasm, literally and figuratively, continues to make pictures.

Notes

1. Theodor Adorno, "Kulturkritik und Gesellschaft," written in 1949, published singly in 1951, collected in Adorno, *Prismen* (1955), and translated into English as "Cultural Criticism and Society," in *Prisms,* trans. Samuel Weber and Sherry Weber (London: Neville Spearman, 1967), 34.

2. Adorno states, not that it is "impossible" to write poetry after Auschwitz, but rather that it is "barbaric." What has endured, however, is not so much this literal interpretation as one that moves from the barbarism of poetry to the impossibility of any form of aesthetic representation. See, for example, such post-Holocaust collections as *Languages of the Unsayable: The Play of Negativity in Literature and Literary Theory,* ed. Sanford Budick and Wolfgang Iser (New York: Columbia University Press, 1989); *Probing the Limits of Representation: Nazism and the "Final Solution,"* ed. Saul Friedlander (Cambridge, Mass.: Harvard University Press, 1992); Dominick LaCapra, *Representing the Holocaust: History, Theory, Trauma* (Ithaca, N.Y., and London: Cornell University Press, 1994); and André Neher, *The Exile of the Word: From the Silence of the Bible to the Silence of Auschwitz* (1970), trans. David Maisel (Philadelphia: Jewish Publication Society of America, 1981). It is in this broader sense that I take up Adorno's dictum in this chapter.

3. On Adorno's messianic utopianism, see, for example, Martin Jay, *Adorno* (Cambridge, Mass.: Harvard University Press, 1984); Richard Wolin, "Utopia, Mimesis, and Reconciliation: A Redemptive Critique of Adorno's *Aesthetic Theory,*" *Representations* 32 (Fall 1990): 33–49; Terry Eagleton, "Art after Auschwitz: Theodor Adorno," in *The Ideology of the Aesthetic* (London: Basil Blackwell, 1990), 341–65; Lambert Zuidervaart, *Adorno's Aesthetic Theory: The Redemption of Illusion* (Cambridge, Mass.: MIT Press, 1991); and most recently, Thierry de Duve, "Silences in the Doctrine," in *Clement Greenberg between the Lines,* trans. Brian Holmes (Paris: DisVoir, 1996), 39–86. More broadly, the work of Sander L. Gilman, particularly sections of *Jewish Self-Hatred: Anti-Semitism and the Hidden Language of the Jews* (Baltimore and London: Johns Hopkins University Press, 1986), addresses the "Jewishness" of Adorno.

4. In fact, in "Utopia, Mimesis, and Reconciliation," Wolin argues that in discussing the utopian function of art in *Aesthetic Theory* "Adorno comes close to violating the Judeo-Marxian *Bilderverbot* (the taboo against graven images) insofar as utopia is well-nigh concretely depicted" (41). That is to say, for Adorno, according to Wolin, art is a form of remembrance, a wedding of past and present, a concrete utopian projection. One might look as well to "Something Missing: A Discussion between Ernst Bloch and Theodor W. Adorno on the Contradictions of Utopian Longing," in Bloch, *The Utopian Function of Art and Literature: Selected Essays,* trans. Jack Zipes and Frank Mecklenburg (Cambridge, Mass.: MIT Press, 1988), 1–17, in which Adorno quite explicitly links the Second Commandment with the category of the "false utopia." As Adorno says, "And this is why I believe—all this is now very tentative—the commandment not to 'depict' utopia or the commandment not to conceive certain utopias in detail as Hegel and Marx have. . . . Hegel did this insofar as he depreciated the world-reformer in principle and set the idea of the objective tendency in opposition—this is what Marx adopted directly from him—and the realization of the ab-

solute. In other words, that which one could call utopia in Hegel's works, or which one *must* call utopia in his youth, originated right at this moment. What is meant there is the prohibition of casting a picture of utopia actually for the sake of utopia, and that has a deep connection to the commandment, 'Thou shalt not make a graven image!' This was also the defense that was actually intended against the cheap utopia, the false utopia, *the* utopia that can be bought" (10–11).

5. Hans-Jürgen Syberberg, *Vom Unglück und Glück in der Kunst in Deutschland nach dem letzten Krieg* (Munich: Matthes & Seite Verlag, 1990).

6. Gertrud Koch, *Die Einstellung ist die Einstellung: Visuelle Konstruktionen des Judentums* (Frankfurt: Suhrkamp Verlag, 1992). It is the first section of her book, "In Sachen Moses gegen Aron: Die Kritische Theorie und das Kino," particularly the chapters "Mimesis und Bilderverbot in Adornos Asthetik," 16–29, and *"Moses und Aron:* Musik, Text, Film und andere Fallen der Rezeption," 30–53, to which I am most indebted. See as well Gertrud Koch, "Mimesis and *Bilderverbot,*" *Screen* 34, no. 3 (Autumn 1993): 211–22. I share this indebtedness with other scholars in the field of post-Holocaust film studies. See, for example, Miriam Bratu Hansen, *"Schindler's List Is Not Shoah:* The Second Commandment, Popular Modernism, and Public Memory," *Critical Inquiry* 22 (Winter 1996): 292–312.

7. For a deconstructive approach to the historiography of Dura-Europos, one which challenges traditional Western conceptions of Jews as aniconic, see A. J. Wharton's "Good and Bad Images from the Synagogue of Dura Europos: Contexts, Subject, Intertexts," *Art History* 17 (March 1994): 1–25.

8. This initial reading I offer of the Second Commandment is purposely emphatic in its literalness. I will go on to broaden that interpretation shortly. Russell A. Berman takes another view. His "Avantgarde und Bilderverbot," in *Kunst und Politik der Avantgarde* (Mousonturm: Künstlerhaus, 1989), 49–64, theorizes about the meaning and temporality of the avantgarde within the postmodern, suggesting that in fact, and quite paradoxically, the *Bilderverbot,* the Second Commandment, sanctions art, in the form of images, at the same time that it would seem to forbid it. He writes, for example: "The Ark of the Covenant is to be understood here as the model of art work, a model that results from the paradoxes of revelation, namely from sensual idolatry and ascetic iconoclasm in a delicate unity" ["Die Bundeslade ist daher zu verstehen als das Vorbild des Kunstwerks, die Inszenierung des Paradoxen der Offenbarung, nämlich des sinnlichen Bilderdienstes und des asketischen Bildersturms in einer labilen Einheit"], 60.

9. Paul Celan, "Tübingen, January," from the collection *Die Niemandsrose* (Frankfurt: S. Fischer, 1963), reprinted and translated in John Felstiner, *Paul Celan: Poet, Survivor, Jew* (New Haven, Conn., and London: Yale University Press, 1995), 172.

10. Theodor Adorno, *Aesthetic Theory,* trans. C. Lehnhardt (London and Boston: Routledge and Kegan Paul, 1984), 100.

11. Ibid., 444.

12. Ibid., 32. If we look beyond Adorno, we find the historically induced Hebraic theme of mimetic impossibility emphatically and somewhat paradoxically expressed in the resolutely ahistorical terrain of postwar, poststructuralist theory, most succinctly in the formulation that all forms of representation are always already inadequate to the task with which

they are charged. Of course, one could speak much more broadly of the interdiction against figuration, arguing that it is not so much specific to a post-Holocaust condition as to the constitution of modernism at large. One could argue that the problem of historical representation and representability is at the very heart of modernism's project. However, insofar as I am not attempting to situate the works I will discuss within either historical modernism or the historical avant-garde and, more important, insofar as Adorno's dictum and other writings in question emerged precisely in a post-Holocaust context, I will keep my discussion within those parameters.

13. Adorno, *Aesthetic Theory,* 22.

14. Ibid., 312.

15. Ibid., 16.

16. Jean-François Lyotard, "Jewish Oedipus" (1970), translated in *Genre* 10 (Fall 1977): 395–411.

17. Jean-Joseph Goux, "Moses, Freud, and the Iconoclastic Proscription," in *Symbolic Economies: After Marx and Freud,* trans. Jennifer Curtiss Gage (Ithaca, N.Y.: Cornell University Press, 1990), 134–50. When originally published in France, the essay was a section in *Les Iconoclastes* (Paris: Seuil, 1978), which explored the theoretical implications of iconoclasm for a range of subjects, such as the Marxist theory of the commodity fetish, the fall of the gold standard, the Nazi persecution of the Jews, and modern art. The subject of a "modern" or contemporary iconoclasm was addressed further in France at a colloquium in 1984, organized by Adelie and Jean-Jacques Rassial, the proceedings of which were published in *L'interdit de la représentation: Colloque de Montpellier* (Paris: Seuil, 1984).

18. Yosef Hayim Yerushalmi, *Freud's Moses: Judaism Terminable and Interminable* (New Haven, Conn., and London: Yale University Press, 1991), offers a suggestive and provocative re-reading of Freud's *Moses and Monotheism* as, at its essence, a treatise on the personal, religious, ethical, and political implications of the Moses narrative, an account of the presumptive repressed patricide upon which Judaism and monotheism are founded, and, finally, of Freud's own attitude toward Judaism and his own Jewish identity.

19. Laura Mulvey, "Visual Pleasure and Narrative Cinema" (1973), in *Visual and Other Pleasures* (Bloomington and Indianapolis: Indiana University Press, 1989), 14–26.

20. Ibid., 26.

21. Ibid., ix.

22. Mulvey, "Afterthoughts on 'Visual Pleasure and Narrative Cinema,' Inspired by King Vidor's *Duel in the Sun* (1946)" (1981), in *Visual Pleasures,* 29–38.

23. Laura Mulvey, "Pandora: Topographies of the Mask and Curiosity," in *Sexuality and Space,* ed. Beatriz Colomina (New York: Princeton Architectural Press, 1992), 53–71.

24. Martin Jay, *Downcast Eyes: The Denigration of Vision in Twentieth-Century French Thought* (Berkeley and Los Angeles: University of California Press, 1993).

25. Jacques Lacan, *The Four Fundamental Concepts of Psycho-Analysis,* trans. Alan Sheridan (New York: Norton, 1981), 101.

26. Lev. 5:1, "And if any one sin, and hear the voice of one swearing, and is a witness either because he himself hath seen, or is privy to it, if he do not utter it, he shall bear his iniquity."

27. Alexander Mitscherlich and Margarete Mitscherlich, *The Inability to Mourn: Principles of Collective Behavior* (1967), trans. Beverly R. Placzek (New York: Grove Press, 1975).

28. Theodor Adorno, *Negative Dialectics* (1966), trans. E. B. Ashton (New York: Continuum, 1973), 362.

29. The Iconoclastic Controversy of Byzantium is relevant in the broader context of Kiefer's project not only for its historical instantiation of the debates about figuration and representation catalyzed by the Second Commandment, but also for the ways in which scriptural Judaism and the Jews were taken up in those debates, insofar as the Iconoclasts were equated with, or likened to, the Jews. See, for example, Kathleen Anne Corrigan, *Visual Polemic in the Ninth-Century Byzantine Psalters* (Cambridge: Cambridge University Press, 1992). See as well John Gager, *The Origins of Anti-Semitism: Attitudes toward Jews in Pagan and Christian Antiquity* (Oxford and New York: Oxford University Press, 1983); and Rosemary Radford Reuther, *Faith and Fratricide: The Theological Roots of Anti-Semitism* (New York: Seabury Press, 1979).

30. Composed not in a concentration camp, as has often been suggested, but in Czernowitz in late 1944, not long after Soviet troops reoccupied Bukovina, Celan's poem was nevertheless the work of a Jewish survivor of the Holocaust, written with the plural pronoun "wir" (we) and in an insistent present tense, allowing the poem to read as if from a Nazi camp where the speaker is present, giving it an air of witness. See John Felstiner, "Translating Paul Celan's 'Todesfugue': Rhythm and Repetition as Metaphor," in Friedlander, *Probing the Limits of Representation*, 241.

31. Felstiner, *Paul Celan: Poet, Survivor, Jew*, 31–32.

32. As Christiane Hertel has suggested, this black paper covering may be an ironic motif, suggesting the literal "Verdunklung," (blacking out) of windows during the war and the metaphorical "Verdunklung" that resulted in obedience and ethical blindness.

33. Kiefer painted a version of *Sulamith* in which a nude female figure appears before the backdrop of a densely packed, urban skyline. Her treatment is formally expressionistic. Her long dark hair dominates the composition, cloaking the body and obscuring much of the underlying cityscape. In the dominance of the hair, it would seem that, although she is portrayed, the representation of Sulamith remains fundamentally metonymic, her hair serving as a marker of her identity (much as in the accompanying *Margarethe* and the later projects involving Lilith and kabbalistic mysticism).

34. Sidra DeKoven Ezrahi, " 'The Grave in the Air': Unbound Metaphors in Post-Holocaust Poetry," in Friedlander, *Probing the Limits of Representation*, 260.

35. Such an argument is made by Andreas Huyssen in "Anselm Kiefer: The Terror History, the Temptation of Myth," *October* 48 (Spring 1991): 85–101.

36. Here I am allying my reading of Kiefer's work with Kaja Silverman's work on postwar cinema, *Male Subjectivity at the Margins* (New York and London: Routledge, 1992), in which she both builds on and departs from the work of Jacques Lacan and Slavoj Zizek, describing history as Kiefer's "traumatic kernel." For a further discussion of Kiefer's relationship to traumatic history and memory, see my "To the Unknown Painter: Anselm Kiefer and the Inscription of Identity" in *Text and Nation: Cross-Disciplinary Reflections on National and Cultural Identities,* ed. Peter C. Pfeiffer and Laura Garcia-Moreno (Columbia, S.C.: Camden House, 1996), 105–20.

37. Pierre Nora, "Between Memory and History: *Les Lieux de Mémoire*," *Representations* 26 (Spring 1989): 7–25.

38. James Young, *The Texture of Memory: Holocaust Memorials and Meaning* (New Haven, Conn., and London: Yale University Press, 1993). Young curated a related show at the Jewish Museum in New York, *The Art of Memory: Holocaust Memorials in History*, which ran from April until July of 1994.

39. Young, *The Texture of Memory*, 27.

40. The Scheunenviertel is a neighborhood in Berlin near the Alexanderplatz, which in the 1920s and 1930s became almost exclusively a neighborhood for working-class, unassimilated Jewish immigrants from Russia and Poland, their eastern origins earning them the appellation *Ostjuden*. The neighborhood's name derives from the *Scheune* (barns) that were built in many backyards in the eighteenth and nineteenth centuries to house farm animals.

41. For a discussion of Boltanski's piece, see John Czaplicka, "History, Aesthetics, and Contemporary Commemorative Practice in Berlin," *New German Critique* 65 (Spring/Summer 1995): 155–87. Setting Boltanski's site-specific project against two more standard public commemorative sites in Berlin (the execution chambers used by the Nazis at the Plötzensee Prison, where resisters were murdered by the Nazis, and the Topography of Terror, a historical exhibition installed in the excavated basement cells of the former Gestapo headquarters), Czaplicka probes the means and effectiveness of linking an aesthetic representation with a presentation of historical facts for a contemplative and enlightening engagement with history.

42. For a treatment of Lin's monument, see Daniel Abramson, "Maya Lin and the 1960s: Monuments, Time-Lines, and Minimalism," *Critical Inquiry*, 22, no. 4 (Summer 1996): 679–709.

43. Kiefer's work again recalls the writings of Slavoj Zizek, who articulates what might be called a postmodern ethics. He writes, "The point is *not* to remember the past trauma as exactly as possible: such 'documentation' is a priori false, it transforms the trauma into a neutral, objective fact, whereas the essence of the trauma is precisely that it is too horrible to be remembered, to be integrated into our symbolic universe. All we have to do is to mark repeatedly the trauma as such, in its very 'impossibility,' in its nonintegrated horror, by means of some 'empty' symbolic gesture." *For They Know Not What They Do: Enjoyment as a Political Factor* (London: Verso, 1991), 273.

44. Theodor Adorno, "Commitment," in *Aesthetics and Politics: Ernst Bloch, Georg Lukacs, Bertolt Brecht, Walter Benjamin, Theodor Adorno,* trans. Ronald Taylor (London: Verso, 1977), 188. In *Aesthetic Theory*, Adorno claims that art, specifically modern art at its best, offers a utopian moment, the possibility of social change, a state of non-identity. He opposes this to the legacy of German idealism, which Adorno sees as a philosophy of identity in which the subject always takes a relation of domination over the object, stressing the difference between the subject and the object. Adorno advocates an ethical mandate for a relation without domination. For a more extensive account of Adorno's philosophy of non-identity in relation to modern art, see J. M. Bernstein, *The Fate of Art: Aesthetic Alienation from Kant to Derrida and Adorno* (University Park: Pennsylvania State University Press, 1992).

PART II

Artists and Collectors

Jewish Identity in Art and History
Maurycy Gottlieb as Early Jewish Artist

LARRY SILVER

 Identity-based studies of the history of art and of artists during the past two decades have taught us to see more vividly the issues of individual artistic formation as a process within cultural norms and discourse. In particular, feminist art historians have reminded us of the difficulties faced by those outside the normative terms, including the term "artist" itself, with "woman artist" as a marked term, since the unspoken definition of the term "artist" usually signifies males in the history of art.[1] Likewise, "Jewish artist" is a marked term, since the dominant culture of European art is Christian, at least in its religious themes. The very possibility of this concept of Jewish art makers and their works was unthinkable prior to the general cultural movement of the Jewish Emancipation, or Haskalah, beginning in the 1770s.

This essay examines the difficult process of self-fashioning an identity as an artist in the latter nineteenth century by a young Polish Jew, Maurycy Gottlieb (1856–1879). To establish the category "Jewish artist," Gottlieb had to inflect a series of available and inherited tropes derived from existing cultural patterns, including visual models, since there was no established model for being a Jewish artist of European ambition available in his time and place.[2] Gottlieb aspired to the artistic practice of history painting, the representation of significant actions by notable persons, chiefly heroic figures from ancient history, religious history, or myth. Moral instruction through visual representations of virtue, exempla, was the aim of history painting. This high ambition not only directed artistic striving toward serious moral instruction, but also served as a demonstration of artistic learning, both visual and verbal, from accumulated tradition, rooted in classical texts and Renaissance images.[3] Gottlieb saw his role as creating a new hybrid, "Jewish history painting," in which both sacred scriptures and Jewish identity could be simultaneously represented to a broad—not exclusively Jewish—viewing public. In his hybrid solution

Gottlieb evaded marginalization as a Jewish specialist but also renounced assimilation and the erasure of his Jewish identity, instead forging a new, Jewish, emphasis in the field of history painting.

Such a process of adaptation is not unique to Gottlieb, though he is one of the most assertive and self-aware of the pioneer artists of Jewish ancestry in the later nineteenth century. For the German Jewish artist Moritz Oppenheim (1800–1882), called "the first Jewish artist," the search for models was equally diverse.[4] Oppenheim was raised and worked near Frankfurt, where he attended art school, later studying in Munich, Paris, and, especially, Rome (1821–25), where he was considerably influenced by the "Nazarenes," or the Lukasbund, a German art community dedicated to "pre-Raphaelite" modes of painting with an emphasis on Christian spirituality.[5] Oppenheim allied himself with this movement, particularly with its leader, Friedrich Overbeck, in his choice of biblical and mythological subjects.[6] In this ambitious vein, Oppenheim painted works based on rich family subjects from the Hebrew Bible, including *Abraham Expelling Hagar* (1824; Dusseldorf, Kunstmuseum) and *The Return of Young Tobias* (1823; Copenhagen, Thorvaldsen Museum). For a competition in the Roman Accademia San Lucca, however, he submitted a drawing with a New Testament subject, *Christ and the Samaritan Woman* (John 4:1–42), a theme traditionally dedicated to the reconciling of rival ethnicities and faiths in a universal divine grace.[7] After returning to Germany, Oppenheim largely abandoned history painting and depended for much of his support on portraits and his later figural paintings featured Jewish customs; among these was his series *Jewish Family Life,* portraying rituals and festivals in the Jewish calendar and life cycle. Twenty of these images were replicated in prints (1866–81) by the Frankfurt publisher Heinrich Keller.[8]

When Maurycy Gottlieb was born in Galicia, in the Polish segment of the Austro-Hungarian Empire, there was no nation of Poland.[9] A nascent Polish nationalist movement existed, directed against the distant imperial capital in Vienna. But Gottlieb went to public, German-speaking schools, where he was one of the few Jewish students. Following his initial artistic training at Lemberg/Lvov, he naturally went to the capital, attending the Vienna Art Academy for two years, 1871–73. The last year of Gottlieb's sojourn in Vienna coincided with the World Exhibition (Wiener Weltausstellung), one of the world's fairs or universal expositions of the latter half of the nineteenth century, that made the city a crossroads of artistic currents from all over Europe (France was represented by 1,573 pieces, Germany by 1,026).[10] Here Gottlieb could quickly absorb the leading models of art making of his day.

The most prominent German painting on display in Vienna was *Thusnelda in the Triumphal Procession of Germanicus* by the Munich Academy painting professor Karl von Piloty (1826–1886), a commission of the Bavarian King Ludwig II that was housed in the Neue Pinakothek collection.[11] Like most history painting of the

nineteenth century, this work derives its theme from ancient texts, in this case from Tacitus's *Germania* with its tales of the triumphs of the Roman Germanicus over the Germans; Thusnelda was the main trophy of war, but she is celebrated for her fortitude and moral courage. Here the agenda was expressly political: the German nation challenged a decadent Latin nation, France. The subtext was Germany's victory in 1871 in the Franco-Prussian war and its implicit challenge to French cultural domination, especially in painting. Piloty's monumental canvas exemplified all the conventions of history paintings—large scale, operatic lavishness of settings and costumes, crowds of figures—while shifting some of the authority of myth and biblical scenes to venerable national chronicles (even though written by Tacitus, a foreigner, who was at least a foreigner with a classical pedigree, whose praise for German valor against his own Roman nation served as a founding myth of national pride and identity for German speakers).[12]

In Vienna, as often happened to those who went from Galicia to the capital, Gottlieb truly discovered Poland; art served as the medium. At the Universal Exposition he first saw the works of the Kraków history painter and Polish patriot Jan Matejko (1838–1893).[13] This painter, too, was a cultural leader, head of the academy in Kraków; his agenda was to use great events from Polish history to exhort modern patriotism and to challenge emulation; for example, to the 1874 Paris Salon, Matejko would send *Stephen Báthory after the Battle of Pskov* (1872), depicting a triumph in 1582 of the Polish king over Ivan the Terrible of Russia.[14] In portraying this event (resembling Sergey Eisenstein's cinematic invocation during World War II of both Ivan the Terrible and Alexander Nevsky, Russians victorious over German invaders), Matejko clearly alluded to the current political situation in Poland, partitioned by Russia, Austria, and Prussia. Matejko's celebration of the golden ages of Polish history also included acknowledgment of the powerful cultural contribution of the Jews of Kraków under the enlightened patronage of King Casimir the Great: he produced one canvas on this theme, *The Welcome of the Jews in 1096 by King Casimir* (1889; Warsaw, National Museum), in a cycle on Polish national history. This powerful model inspired Gottlieb to return to Kraków in 1874 in order to study with Matejko. The young Jewish painter also attempted to master the Polish language, local literature, and history, with which he was largely unfamiliar. He even produced a self-portrait in the historical garb of the Polish gentry.[15] This first salvo of self-fashioning by the young Gottlieb reveals already how he would use both the costume and attitudes of his self-portraits as an index of his own aspirations and ideologies, both political and religious, throughout his career.

The provincialism and anti-Semitism of his student peers drove Gottlieb from his studies in Kraków, back to Vienna in 1875 and to Munich and Piloty in 1876. Polish scholars of the past half century have emphasized the pervasive influence of Matejko's history paintings and assertive Polish nationalism on the young Gottlieb;

his orientation toward history painting was, however, abetted equally by the academic environment of Munich, a leading German center at the time of the Vienna exhibition. Moreover, the Kraków experience seems to have influenced Gottlieb in powerfully negative ways: stung by his sense of Jewish difference from his Polish fellow students in Kraków, Gottlieb began in Munich to investigate with equal zeal both his Jewish heritage and the old-master heritage of the great collection of the Alte Pinakothek. It was here that the fundamental definition and direction of his Jewish artistry was charted, and we can observe the creative young expatriate assembling his new vocation out of a variety of constituent elements.

Gottlieb's work was shaped by three essential sources and models, one of them verbal and two of them visual. The verbal source was the newly published eleven-volume *History of the Jews* (1856–66) by Heinrich Graetz, a work that argued for an ongoing Jewish national identity, in some ways akin to the claims for Polish nationhood that had already attracted Gottlieb. One of the two visual models remained the tradition of history painting as exemplified by Piloty. To that tradition Gottlieb added another pictorial and artistic model, a venerated old master: Rembrandt, whose biblical images of the teaching Christ complemented his portraits of Jewish sitters (or purported Jewish sitters, especially old men who were taken to be Jews by nineteenth-century scholars).[16] Gottlieb's lasting and uniquely personal vision was to combine these disparate models, synthesizing the separate strands—one presenting the dominant views of what it meant to be Jewish and the others offering models of what it meant to be an artist—in the last quarter of the nineteenth century.

Previous scholars have not pursued the importance of Rembrandt in Gottlieb's artistic identity, but, except for Oppenheim, whose identity at this time rested largely on his Jewish-life series, there was no earlier Jewish painter whose work combined that influence so directly with an abiding interest in Jewish faces and costumes and in Old Testament stories as part of a national history. We do not know just what works by Rembrandt, especially prints or reproductions, were accessible to Gottlieb during his sojourns in either Munich or Vienna. But the evidence of Gottlieb's own pictures suggests that the work of the seventeenth-century painter and printmaker held deep meaning for him.

The first telling index of Gottlieb's engagement with Rembrandt during his year in Munich is a *Self-Portrait as Ahasuerus* (1876; Kraków, National Museum) (Fig. 7). Rembrandt's engagement with his own features, within a shifting variety of headgear and other costume accessories, lasted throughout his career and remained essential to his own self-fashioning, something that became fundamental for Gottlieb as well.[17] Ahasuerus is the name usually given in German literature to the Wandering Jew, or "eternal Jew," a legendary figure who taunted Christ on the way to Calvary and was subsequently cursed and condemned to wander the world until the Second Coming at the end of time (or at such time as he would acknowledge Christ

FIGURE 7
Maurycy Gottlieb, *Self-Portrait
as Ahasuerus,* 1876, Kraków,
National Museum.

as the Messiah, making him the Jewish witness to Christian salvation). Ahasuerus
became a stock figure of suffering, sometimes also of Jewish evil, in nineteenth-
century literature, including a planned epic poem by Goethe; *Le Juif errant*
(The Wandering Jew), a huge French novel by Eugène Sue (1844–45); a play called
Ahasverus by Hans Christian Andersen; and an essay by the German nationalist au-
thor Karl Ferdinand Gutzkow (we recall that Gottlieb's education was in German)
entitled "Julius Moses Ahasver" (1842).[18] Gottlieb conflates this tragic figure with
the non-Jewish king of the Persians from the Book of Esther, and accordingly he
bestows a crown on the bearded, youthful self-portrait. Gottlieb would later include
a self-portrait with a turban among the witnesses surrounding Christ in *Christ
Preaching at Capernaum* (1878–79; Warsaw, National Museum). In *Ahasuerus* the
isolation of the swarthy head and its mood of self-absorption against a glowing
red background (with a dramatically parted green curtain barely visible) suggest a
heightened, thoughtful sensibility, verging on melancholy. If the mood of self-
consciousness seems appropriate to the Wandering Jew, the crown and earring evoke
the biblical exoticism and power of the Persian monarch, who adopted the Jews

through his marriage and worked for their preservation. Interestingly, the importance of the saving of the Jews in the Book of Esther formed the basis of one of Rembrandt's most powerful late religious works, usually titled *The Condemnation of Haman* (ca. 1665; St. Petersburg, Hermitage), though Gottlieb could never have seen this particular work, unless in some form of reproduction.[19]

What Gottlieb could have seen by Rembrandt in Munich was an early *Self-Portrait* (no. 11427; monogrammed and dated 1629), from which the Pole could appropriate bold, broad brushstrokes, moody shadows, curly hair, and the dreamy yet anxious facial expression.[20] The Rembrandt image shows the dark eyes of the youth gazing out of shadows directly at the viewer, whereas Gottlieb's gaze is oblique and turns down out of the field of the picture, further underscoring the pensive, melancholic temperament of the self-representation. As Guralnik points out, in the same year, Gottlieb adopted Oppenheim's practice of depicting in grisaille subjects from Jewish life, specifically in *Jewish Wedding* (1876; Jerusalem, Israel Museum), like Oppenheim's design, painted for reproduction. Gottlieb's choice of Ahasuerus as the title of his self-portrait reveals his deliberate adoption in Munich of a new role, explicitly steeped in Jewishness, here emphasizing suffering.

Also painted in Munich in 1876, a double half-length entitled *Shylock and Jessica* (Fig. 8; Kraków, Jewish Museum), reveals Gottlieb's commitment to the literary programming of ambitious painting after the model of Piloty. Here the text is not biblical and not by a Jew; but the protagonist of Shakespeare's *The Merchant of Venice* is Jewish, and his overprotective love for his lone daughter is complemented by his famous speech about the universal brotherhood of humanity, asserting the equality of Jews in suffering:[21]

> I am a Jew. Hath not a Jew eyes? hath not a Jew hands, organs, dimensions, senses, affections, passions; fed with the same food, hurt with the same weapons, subject to the same diseases, healed by the same means, warmed and cooled by the same winter and summer, as a Christian is? If you prick us, do we not bleed? If you tickle us, do we not laugh? If you poison us, do we not die? And if you wrong us, shall we not revenge? (act 3, scene 1, lines 58–66)

In this painting, the doting father's betrayal by his scheming daughter, seduced by a Christian lover to abandon her father and family honor, is made explicit by their interaction—his attentive embrace, which she returns only with an averted and preoccupied glance as she accepts into her keeping his trusting bestowal of the keys to the house (act 2, scene 5). The old man has the caricatured features—beaked nose, white beard—and the dark costume of a Jewish moneylender, but his parental emotions evoke the same ambivalence toward this potentially alien Jew as the Christian author's play itself. It is possible that a Rembrandt prototype, *The "Jewish Bride"*

Maurycy Gottlieb, *Shylock and Jessica,* 1876,
oil on canvas. Kraków, Jewish Museum.

(Amsterdam, Rijksmuseum), lies behind this picture as well, although the original
remains in Amsterdam and would have been accessible only through reproduc-
tions.[22] While the Rembrandt portrait shows two figures, both youthful and equally
loving, they do seem, characteristically for Rembrandt, lost in their own thoughts;
by contrast Gottlieb's figures mix the generations in what almost appears a tradi-
tional "Ill-Matched Pair"—lustful old man with greedy young wench—while re-
taining the same close-up three-quarter-length presentation.[23] Gottlieb won a gold
medal for *Shylock and Jessica* in 1876, so his success as a history painter after literary
models was acknowledged early in his career, albeit with ambivalent vestiges of Jew-
ish stereotypes in the face of the old man.

Encouraged by this success with a literary program for his history painting, and
emboldened to choose other sources with sympathetic Jewish protagonists, in 1877
Gottlieb accepted a commission from the Munich publisher Bruckmann Verlag for
a series of reproducible paintings illustrating scenes from Gotthold Ephraim Less-
ing's play *Nathan the Wise* (1779) on the eve of its centennial anniversary. Never
published, this project stands in sharp contrast to the contemporary reproducible

images by Oppenheim, which focused on the uniqueness of Jewish life. The venerable Lessing drama, which had canonical status in German literature of the Enlightenment, offered a plea for mutual tolerance among the three main warring religions.[24] In contrast to an earlier cabinet picture by Oppenheim (Fig. 9), which featured the eighteenth-century playwright Lessing himself together with Lavater and Moses Mendelssohn, Gottlieb's subject is, characteristically, the more exotic Crusader-era setting of Lessing's play, enriched by Moorish architecture and orientalizing costumes.[25] At the heart of the drama (act 3, scene 7) is Nathan's recounting to Sultan Saladin (Fig. 10; Guralnik cat. no. 27), a Muslim Saracen leader, his parable of the "three rings," in which the genuine prototype of a magic ring with the inscription "loved of God and men" cannot be discerned from two identical copies by the three sons who receive it as a legacy from their father. The implication of the drama is that all three religions have a claim to sanctity but not to spiritual superiority (and that Judaism, being the oldest, is the prototype for the others). For Gottlieb, such a subject would have had the appeal of squaring the moral accounts of his own suffering at the anti-Semitic hands of his fellow artists in the academy while also making a plea for universal spiritual values.

Not all of Gottlieb's scenes from *Nathan the Wise* have survived. The publisher directed him to use grisaille (like Oppenheim) for easier reproduction and to produce a series of twelve studies, to be followed by larger paintings.[26] The staging of the scene depicting the ring parable has the air of authenticity of the Islamic Middle East, from the costumes of the two protagonists to such decorative details as a hexagonal, ornamented side table and a window with interlaced arches of tracery (other paintings in the series have horseshoe arches, palms, and camels). Clearly for Gottlieb, who would also paint non-narrative orientalizing works in 1877, including *Slave Market in Cairo* (Guralnik, cat. no. 33) and the topless but richly clad *Odalisque* (no. 34), there was a piquancy to capturing in his images not only fantasized versions of sites in the "Holy Land" but also the current fashions of eroticized harem painting.[27] Even here Rembrandt could offer a distant affinity, for he had frequently portrayed figures in turbans and other costumes suggesting the exoticism of biblical history.[28] The *Nathan the Wise* series may exhibit a further Rembrandt influence, in the dialogue of speaker and listener in a biblical scene, recalling such mature drawings by the Dutch artist as *Nathan Rebuking David* (ca. 1655; New York, Metropolitan Museum, Benesch 948).[29]

In 1877, the same year in which Gottlieb undertook his *Nathan the Wise* series, he was approached by its Munich publisher to produce illustrations for a play. In 1847 Karl Ferdinand Gutzkow (the author of the essay on the evil Ahasuerus mentioned above; see note 18) published a play, *Uriel Acosta,* set among the Sephardic Jews in Rembrandt's Amsterdam. The title character, Uriel da Costa (d. 1640), a forerunner and contemporary of the philosopher Spinoza and a Portuguese Jew from a noble

FIGURE 9

Moritz Oppenheim, *Lavater and Lessing Visit Mendelssohn,* 1856, oil on canvas.
Berkeley, Judah L. Magnes Museum.

family, had been raised Catholic by a *converso* father until he reconverted (or re-verted) to Judaism and moved to Amsterdam. There, however, he remained un-conventionally apart from the synagogue congregation and was excommunicated, like Spinoza a few years afterward, only to recant his rationalist beliefs before a synod of the synagogue. Eventually he committed suicide after writing an autobiography critical of both religious traditions. Thus his life can be interpreted as a call for tol-erance from all parties, like the parable of the three rings in *Nathan the Wise.* For Gottlieb the syncretic universalism of this earlier religious impulse would have held the same attraction as the Lessing drama, with the poignancy of the convergence of faiths made all the more powerful by the tragic biography of an actual historical—and Jewish—figure.

Gottlieb's work on this series too was never published. Only a single study sur-vives, representing the climactic moment: *Uriel d'Acosta in the Synagogue Abjuring*

FIGURE 11

Maurycy Gottlieb, *Uriel
d'Acosta in the Synagogue
Abjuring His Beliefs,* 1877,
oil on canvas. Jerusalem,
Israel Museum.

His Beliefs (Fig. 11, Jerusalem, Israel Museum).[30] With this assignment, Gottlieb was
plunged into the world of Dutch Sephardic Jews from the neighborhood where
Rembrandt lived. He made a particular effort to capture the distinctive architec-
ture of Sephardic sanctuaries, with a central bema where the philosopher stands in
profile to read his declaration while facing the ark (which features inscriptions in
Hebrew). Below him the listening figures wear the characteristic prayer shawls
(talliths), but a pair in the lower left corner have distinctive Dutch ruff collars, and
one of them wears the period-style broad-brimmed black hat. Gottlieb could have

modeled this costume on any Dutch portrait of the era, but he might well have relied on one of Rembrandt's signal works of contact with the Jewish community, his 1648 etching of the scholar-physician *Ephraim Bueno* (*Bonus*).[31] In fact, close inspection reveals that the hatted figure at the left edge probably derives from Rembrandt's *Bueno*, in not only his hat (though not his fancier collar) but also his bearded features and the turn of his head. How much Gottlieb knew about Bueno's biography is unclear, but he surely treasured this tangible connection between the renowned Dutch artist and leading Jewish contemporaries, such as this physician and Hebraic scholar who actively supported the publications of Rabbi Menasseh ben Israel.[32]

A sense of community with the Jewish people as well as an "enlightened" religious universalism (after the models of Lessing's parable or Gutzkow's da Costa), which could reconcile Jews to Gentiles, remained ongoing themes of Gottlieb's later history paintings. The artist oscillated between ambitions to be comfortably assimilated into the dominant culture of Polish Catholics, where his artwork would find its largest potential audience as well as a peer community of other artists, and counterpressures to be acknowledged—and accepted—as a Jew. On an artistic level, Gottlieb sought to fuse the idiom of history painting, after the model of Piloty and Matejko, to biblical history, with Jewish ethnography, as exemplified in Oppenheim's widely circulated prints. For Gottlieb, the reconciling agent who could bridge these disparate goals remained the venerated old master painter and printmaker, Rembrandt.

No other picture more fully displays Gottlieb's discomfort or ambivalence with the problem of being both Jewish and an artist than his own large and ambitious contribution to ethnography, *Jews Praying in the Synagogue on Yom Kippur* (Fig. 12).[33] This work is Gottlieb's fullest affirmation of his Judaism as well as his most careful observation of the customs, costumes, and settings of Jewish religious life in the sanctuary (rather than in the home, which Oppenheim had stressed). However, the scene also portrays Gottlieb himself as a pensive outsider (though like the other men he is dressed in tallith and festive hat), standing below the bema and dreamily turning his attention away from the prayers that absorb the rest of the congregation, his reflective pose and averted gaze once more reminiscent of Rembrandt's listeners. In this image the head of Gottlieb's *Ahasuerus* reappears, again portraying the painter as troubled in the midst of his heritage, once more through the emphatic self-fashioning of a costumed self-portrait.[34] Surely significant too is the painter's decision to document the most solemn Jewish holiday, the Day of Atonement, at its most solemn moment, when the sacred scroll, the Torah, has been removed from the Ark for reading to the congregation. This holiday is the occasion when each individual Jew is most alone with thoughts of his own behavior and relations both to his fellow Jews and to God.

FIGURE 12

Maurycy Gottlieb,
*Jews Praying in the Syn-
agogue on Yom Kippur,*
1878, oil on canvas.
Tel Aviv, Tel Aviv Mu-
seum of Art.

Yom Kippur is also the occasion in the Jewish year when the dead are solemnly commemorated (in the service called *Yizkor*), and Gottlieb has injected into this picture several prominent self-memorials. Scholars have commented on his morbid sense of his mortality, premonitory of his death at age twenty-three, only a year after completing this picture. The choice of the holiday of Yom Kippur in conjunction with the self-portrait confirms self-memorialization as the very premise of the image. In Hebrew on the decorative cover of the Torah scroll, as though he were its donor, Gottlieb has painted the inscription: "Donated in memory of our late honored teacher and rabbi Moshe Gottlieb of blessed memory 1878." Moreover, the

artist has based the features of the two young boys in the painting on his own, as if recapitulating a deep religious training that he never felt comfortable with. Indeed, the vignette in the lower right corner of a young boy sharing a prayerbook with an older, bearded man (presumably a likeness of Gottlieb's father) explicitly continues the generational links underscored in the same corner of the *D'Acosta*. Besides his father, the *Yom Kippur* ensemble features additional portraits of Gottlieb's loved ones, including his mother and possibly his fiancée.

Yet this picture examining Gottlieb's personal relationship to Judaism could not serve to reconcile his Jewish identity with his role as an artist in the larger Polish culture. To that end he returned to the dominant idiom of history painting that he had first learned with Matejko and Piloty. He began to work on a pair of large, ambitious canvases that would deliberately confront the tensions between Christians and Jews, taking as their central theme the Jewish identity of Christ himself. By stressing Christianity's roots in Judaism, and ignoring the traditionally dominant anti-Semitic bias of the Church toward the Jews as persecutors of Jesus, this project attempted to rewrite religious history through art.

Gottlieb's first such canvas took on that bias as its source in the judgment of Christ. *Christ before His Judges* (Fig. 13) was begun in the wake of Gottlieb's orientalism at the time of the *Nathan the Wise* series.[35] As an academic art student in both Kraków and Munich, Gottlieb surely had to learn the basics of Christian biblical iconography, and the scenes of Christ before officials, both the high priest Caiaphas and the magistrate Pilate, had been standard elements of Passion cycles in both paintings and prints since the Renaissance. What is significant in Gottlieb's version of the scene with the judges is that Christ is portrayed as Jewish, dressed in a distinctive skullcap, with sidecurls and a robelike garment with a tallith visible beneath a *kittel*, a loose white surplice worn on solemn occasions and as a burial garment. The judges are dressed in the traditional robes and jeweled breastplate of Aaron and the high priests of the temple, while their scriptural authority stands behind them in the unfurled scroll, open to the Ten Commandments, in particular the key stricture at issue, "Thou shalt have no other gods before me." Gottlieb presents the entire scene as one in which the controversies over Christ's teachings lay in a debate with the dominant temple priests (whose Sanhedrin location is complemented at the right by a seated secular figure, presumably a Roman magistrate, like Pontius Pilate, under a canopy of honor bearing the inscription of Roman authority, SPQR).

This scene offers nothing less than a monumental translation of the conflicts over orthodoxy and heresy or blasphemy that were reenacted sixteen centuries later by Uriel da Costa in his synagogue in Amsterdam and visualized earlier in 1877 by Gottlieb. Once more the protagonist is presented in dramatic profile amid a potentially hostile congregation of community authority, elders elaborately and authentically

FIGURE 13
Maurycy Gottlieb, *Christ before His Judges,* 1877–79, oil on canvas. Jerusalem, Israel Museum.

costumed in the tradition of history painting. Here the subsequent Roman (hence secular) persecution of Jesus is signaled by the crown of thorns held above the head of the defendant by a pair of Roman soldiers.

The source for this richly staged scenario and for this view of Christ as a good Jew, who revered Jewish customs but came into conflict with religious and political authorities, was Heinrich Graetz, whose 1875 German history of the Jewish people as a nation Gottlieb had encountered in Munich in 1876.[36] Basing his account on the Gospel text of Matthew (26:55–66, 27:11–26), Graetz places the responsibility for the punishment of Jesus squarely on the shoulders of the secular Roman authorities, transferring the traditional guilt for Christ's death from the priests of the Sanhedrin to Pilate and thus absolving the Jews as a people (a full century before the recent absolution by papal decree) of the traditional blood libel that named them Christ killers. Indeed, the building depicted by Gottlieb resembles a Roman basilica, the assembly space for the dispensing of justice, more closely than any currently accepted reconstruction of the ancient Temple of Jerusalem.

If Graetz could offer Gottlieb historical exoneration from the key slander of anti-Semitism, then Rembrandt could offer him artistic justification for the Jewish

Jesus. Rembrandt's prints of Christ-as-teacher offered precisely the precedent for dramatic stagings of a Jewish figure preaching to a multitude of diverse, sometimes hostile, listeners. Indeed, Rembrandt had also painted images of the head of Christ, based on a single figure type, possibly taken from a Jewish model in Rembrandt's own neighborhood, one of which, dated 1661, the *Risen Christ* (Bredius 630), Gottlieb could have seen in Munich's Alte Pinakothek and used as a model for the Jesus in *Christ before His Judges*.[37]

For staging the multiple figures around a central preaching Christ, Rembrandt offered Gottlieb two clear and frequently reproduced models that were easily adaptable to the conventions and archaeological interests of nineteenth-century history painting. Both of these etched masterworks bear nicknames today: *Christ with the Sick around Him, Receiving Little Children* is called "The Hundred Guilder Print," and *Christ Preaching* is called "La Petite Tombe" (Fig. 14).[38] In the first, a rich complex of figures surrounds the figure of the preaching and healing Christ, including a variety of sick and aged people on the viewer's right and on the left a group of parents with children, pharisaical types in exotic costumes, and even a pensive young man of wealth. In the second, smaller, etching, Christ is a humbler, more human figure but elevated on a stone slab and given additional prominence by a halo and vertical masonry that bisects the composition behind him. Here Rembrandt displays some of his favorite costume varieties, including bearded, turbaned figures, as well as figures of all ages, all in rapt attention (except for the foreground child, who is fully absorbed by his own finger drawing in the dirt). These Rembrandt etchings are reflected in the staring faces, especially those of the older men in profile, in Gottlieb's *Christ before His Judges*.

An understated, easily overlooked self-portrait appears in Gottlieb's picture, just behind Christ, shadowed by the crown of thorns, staring intently at the protagonist. Thus the artist shows himself, like the historical Jewish Christ, caught between two worlds: that of traditional Jewish authority, with which he still felt uncomfortable despite his own best efforts, and that of the Roman state, or—for Gottlieb—the modern Austro-Hungarian political authority, the contemporary incarnation of the Holy Roman Empire, dominated by the religious authority of the Roman Catholic Church. Gottlieb as Ahasuerus still finds himself suffering for his developing yet independent and unconventional beliefs. Only now he seems to wish to identify with Christ—not mock him—and thus to provide the healing synthesis of his heritage as a Polish-Catholic and a Jew.

Once again, the precedent of Rembrandt may have provided Gottlieb a sanction for including himself as a witness to the events of Christ's Passion. In Munich Gottlieb would have seen the principal works of a major painted cycle by Rembrandt on the events of Christ's Passion, produced for the royal house of Holland during the 1630s.[39] In both Munich scenes with Christ on the cross, *The Raising of the Cross*

FIGURE 14

Rembrandt, *Christ Preaching,* ca. 1652, etching.

and *The Descent from the Cross,* Rembrandt included among the observers a figure with his own features (in the former case spotlit and wearing a Dutch blue costume; in the latter case with his face shrouded in shadow). Rembrandt's clear identification with the sufferings of the scenes into which he inserted himself must have encouraged the later artist to consider his own relation to Christ's Passion and to show his ambivalence or tension toward Christ amid his accusers. Gottlieb leaves his own status ambiguous, unclear whether his image is that of a shadowy supporter of the defendant or a mere observer of the judicial process, tacitly condoning the punishment.

One other large biblical canvas with Christ as its subject was Gottlieb's final attempt at reconciling his roles as Jew and history painter vis-à-vis the dominant Catholic culture of his native Poland (Fig. 15). Left uncompleted, *Christ Preaching at*

Capernaum resulted from an earlier preparatory sketch, now lost.[40] Once more the artist includes in the work a self-portrait, clearly based on the earlier *Ahasuerus.* He is among the Jewish listeners to the new doctrine in the traditional space of the synagogue. Again the resemblance to the situation of Uriel da Costa is unmistakable, although here the Jewish dissenter is Jesus himself. For this work Gottlieb has called on all of his experience as a history painter to render authentic oriental-biblical costumes and settings.

The message of the painting is the commonality of the two religious traditions, again based upon Graetz's interpretation, deriving from Mark 1:21–22, in which the teaching of Christ at Capernaum amazed the people "because he taught them as one who had authority, not as the teachers of the law." As if he were composing the visual equivalent to Graetz's conflation of traditions, Gottlieb has once more drawn on Rembrandt's *Christ Preaching* (Fig. 14) for his

composition, as well as for the gesture and elevated position of Jesus, including the light-infused halo above his head. Another possible source for the exaggerated extension of Christ's arms and his height above his gesturing followers is Rembrandt's *Ascension* (1636; Bredius 557), another work Gottlieb could have seen in Munich. While Rembrandt's Christ is seen from below, however, Gottlieb's preaching figure is seen at eye level by the viewer.

In *Christ Preaching at Capernaum* Gottlieb clearly emphasizes the Judaic qualities of his setting, from Christ's tallith and skullcap to the Torah scroll from which he has been reading. As if to underscore the religious synthesis accomplished here, Gottlieb also includes contrasting outsiders in the congregation, among them a beardless Roman in a toga who sits prominently, and visually apart, bored or skeptical, above the fervent bearded and turbaned Jews below Christ. Once more in the lower right corner, beside a bearded elder, a youth prays, this time in the person of a girl with hands clasped reverently. Gottlieb himself sits on the other side of that elder, this time listening to the sermon as well as to a companion. A figure in front of him buries his head in his hands, while a second stretches upraised hands toward the preaching Christ in prayerful, affirmative response. The purpose of such a painting is made explicit in Gottlieb's letter to a friend from his trip to Rome in 1878: "How deeply I wish to eradicate all the prejudices against my people! How avidly I desire to uproot the hatred enveloping the oppressed and tormented nation and to bring peace between the Poles and the Jews, for the history of both people is a chronicle of grief and anguish."[41] These poignant words point to the artist's personal struggle to reconcile and synthesize his shared cultures of Judaism and nascent Polish nationalism. The artist was able to adopt as a struggle equivalent to that of the Jews the cause of a national identity for the Polish language and culture against the oppressive dominance of the Austro-Hungarian Empire. As a result, at the end of his life he was searching for admirable figures—exempla from both literature and history—who were both Polish *and* Jewish.

If we evaluate the tragically brief career of Maurycy Gottlieb against the issues of "ethnicity and discourse" posed by the essays in this volume, we see the profound ways in which he struggled with his ethnic identity and strove to merge it within a larger, more universalized religious spirituality. In contrast to his German predecessor Moritz Oppenheim, Gottlieb tended not to trade upon the ethnographic recording of Jewish life for a mass market; on the rare occasions when he did grapple with contemporary Jewish life and his role in it, notably in the *Yom Kippur* painting (Fig. 12), his self-presentation is ambivalent and self-conscious. He did not repress his Jewish consciousness but tried, instead, to build on the foundations of both the Enlightenment and the Haskalah to forge a new, more universal spirituality, in which the common principles and

Jewish roots of later faiths (Islam as well as Christianity) could be exemplified. His exemplary figures from Jewish history and literature consisted primarily of suffering Jews, who were persecuted by their own communities (Uriel da Costa) as well as by the dominant religious culture of Christianity (Shylock, Nathan the Wise). With the authority and legitimation of Heinrich Graetz's great history of the Jews, reinforced by the visual precedent and model of Rembrandt's New Testament imagery of Christ preaching, Gottlieb was able to break through to a new understanding of the Jewish Jesus, who became for him a major figure of reconciliation and common suffering—akin to his own.

Having chosen the career of an artist, a vocation newly available to a young Jew as a result of the Haskalah and the general Jewish entry into the larger society, and having rejected the marginalized (even stereotyped) status of mere visual Jewish ethnographer, Gottlieb was obliged to enter the dominant artistic arena of history painting. He succeeded in his short career in inflecting the dominant religious and literary sources of history painting with an assertive Jewish marking, the product of his own self-conscious identity in active dialogue with the visual discourse he had learned from Matejko and Piloty. Indeed, Gottlieb made Jewish figures, not excepting a more Judaic Christ, part of the vocabulary of acceptable history painting (in contrast to Moritz Oppenheim, whose competition piece in Rome was about reconciling a woman Gentile to the new faith of Christ). In the process, Gottlieb constructed a new hybrid, the Jewish history painter, a role for an artist with the highest social and cultural ambitions, a role in which to advocate reconciliation between Jews and Gentiles (especially Poles) and a new toleration of Jewish identity in the majority culture. Gottlieb did not content himself with delineating Jewish customs and difference.[42]

In the rapidly shifting climate of both art (where history painting fell out of favor for either more descriptive or more subjective versions of modernity) and politics (where any movement toward alliance between Jews and Poles was shattered in the subsequent national independence movements), Gottlieb's fragile universalism, derived from the twin sources of Enlightenment and Haskalah, could not have survived. Pogroms in Russia in the wake of the 1881 assassination of Czar Alexander II imposed new restrictions on Jews in that country, and anti-Semitic parties increasingly controlled political life in Vienna and throughout Germany, as the nationalist identity of Jews themselves began to crystallize around Zionism. A hybrid Jewish-Polish existence was no longer tenable, and Jewish artists, like their intellectual and scholarly brethren in the field of art history, increasingly assimilated their Jewish identity into a purely modernist project, one that often concerned the very issues of representation and national identity that had loomed so large for Maurycy Gottlieb.

Notes

1. Out of a vast literature, the best introductions are the pioneering article by Linda Nochlin, "Why Have There Been No Great Women Artists?" reprinted in Nochlin, *Women, Art, and Power and Other Essays* (New York: Harper and Row, 1988), 145–78; Roszika Parker and Griselda Pollock, *Old Mistresses: Women, Art, and Ideology* (New York: Pantheon, 1981); Pollock, "Feminist Interventions in the History of Art: An Introduction," in *Vision and Difference: Femininity, Feminism and the Histories of Art* (London: Routledge, 1988), 1–17; the review article on the history of feminist art history up to that time by Thalia Gouma-Peterson and Patricia Mathews, "The Feminist Critique of Art History," *Art Bulletin* 69 (1987): 326–57; Whitney Davis, "Gender," in *Critical Terms for Art History*, ed. Robert Nelson and Richard Shiff (Chicago: University of Chicago Press, 1996), 220–33; Whitney Chadwick, *Women, Art, and Society*, rev. ed. (London: Thames and Hudson, 1996). On the larger issues, see Judith Butler, *Gender Trouble: Feminism and the Subversion of Identity* (London: Routledge, 1990); Seyla Benhabib, *Situating the Self: Gender, Community and Postmodernism in Contemporary Ethics* (New York: Routledge, 1992).

2. I borrow the term "self-fashioning" from the influential study by Stephen Greenblatt, *Renaissance Self-Fashioning* (Chicago: University of Chicago Press, 1980), in which the shaping influences of "family, state, and religious institutions" are readily acknowledged. This Renaissance situation is particularly relevant, I would argue, to a figure like Gottlieb, who emerges with new opportunities for shaping his identity as a Jewish artist in the Haskalah era, much as artists and writers of the Renaissance in Christian Europe had experienced their formative years centuries earlier. As Greenblatt argues, "In the sixteenth century there appears to be an increased self-consciousness about the fashioning of human identity as a manipulable, artful process" (2). Greenblatt also underscores the importance of social mobility for the authors at the heart of his Renaissance study. For the relationship between Renaissance biography and artistic formation, see Catherine Soussloff, *The Absolute Artist: The Historiography of a Concept* (Minneapolis: University of Minnesota Press, 1997), esp. 19–72. I have also made considerable use of Rembrandt's continuous refashioning in his self-portraits; see H. Perry Chapman, *Rembrandt's Self-Portraits: A Study in Seventeenth-Century Identity* (Princeton, N.J.: Princeton University Press, 1990).

3. An excellent introduction to the history painting of one of its most learned practitioners, Rubens, during the early seventeenth century, treating the heritage of the Renaissance and its classicism, is Elizabeth McGrath, *Rubens' Subjects from History*, Corpus Rubenianum Ludwig Burchard 13.1 (London: Harvey Miller, 1997). Basic sources for secular ancient history included Plutarch, Livy, Appian, and Valerius Maximus. The Bible was the source for important events from sacred history.

4. See the major study and catalogue by Elisheva Cohen, *Moritz Oppenheim: The First Jewish Painter* (Jerusalem: Israel Museum, 1983). See also Norman Kleeblatt, *The Paintings of Moritz Oppenheim* (New York: Jewish Museum, 1981). A useful reference for the larger cultural and artistic setting of Jewish Emancipation in Germany is provided by *Monumenta Judaica*, ed. Konrad Schilling (Cologne: Stadtmuseum, 1963), esp. *Handbuch*, in which Oppenheim is discussed in the essay by Christine von Kohl, "Jüdische Kunstler und Schriftseller—ihr

Beitrag zum rheinischen Kulturleben. Von der Emanzipation bis zur Ausschliessung," 471, 476. Now see Richard Cohen, *Jewish Icons* (Berkeley and Los Angeles: University of California Press, 1998), esp. 163–71.

5. For an introduction to this group, see Keith Andrews, *The Nazarenes: A Brotherhood of German Painters in Rome* (Oxford: Clarendon, 1964); William Vaughan, *German Romantic Painting* (New Haven, Conn.: Yale University Press, 1980), 163–91.

6. See McGrath, *Rubens' Subjects from History*. For a broader overview of the Renaissance foundations of history painting in relation to verbal, moral, and other serious themes, see Rensselaer Lee, *Ut Pictura Poesis: The Humanistic Theory of Painting* (New York: Norton, 1967); also see Svetlana Alpers, "Ekphrasis and Aesthetic Attitudes in Vasari's *Lives*," *Journal of the Warburg and Courtauld Institutes* 23 (1960): 190–215; Clark Hulse, *The Rule of Art* (Chicago: University of Chicago Press, 1990). For the Carracci Academy in Italy, see Carl Goldstein, *Visual Fact over Verbal Fiction: A Study of the Carracci and the Criticism, Theory, and Practice of Art in Renaissance and Baroque Italy* (Cambridge: Cambridge University Press, 1988). For the general issue of the academy, particularly in the nineteenth century, see Albert Boime, *The Academy and French Painting in the Nineteenth Century* (Oxford: Clarendon Press, 1971); Carl Goldstein, *Teaching Art: Academies and Schools from Vasari to Albers* (Cambridge: Cambridge University Press, 1996).

7. Cohen, *Oppenheim,* 81–83, nos. II.1–14, catalogues the history paintings by the artist and draws upon Oppenheim's *Reminiscences* to tell the story of how Bertel Thorvaldsen, the renowned Danish neoclassical sculptor in Rome (who had acquired the *Tobias* painting, II.7), defended the young artist against detractors in the Accademia who attacked him in the contest for being both German and a Jew (II.6). Virtually all of Oppenheim's history paintings were produced in or shortly after the artist's stay in Italy in the early 1820s. For a survey of the theme of the Samaritan Woman in art up to the time of Rembrandt, see the fine recent dissertation by Donald McColl, "Christ and the Woman of Samaria: Studies in Art and Piety in the Age of the Reformation," University of Virginia, 1996.

8. Cohen, *Oppenheim,* 27–28, 84–86, nos. III.10–35; also Ismar Schorsch, "Art as Social History: Oppenheim and the German Jewish Vision of Emancipation," in *Oppenheim,* ed. Cohen, 31–61. See also Richard Cohen, *Jewish Icons,* 167–69.

9. The indispensable text for Gottlieb is Nehama Guralnik, *In the Flower of Youth: Maurycy Gottlieb 1856–1879* (Tel Aviv: Tel Aviv Museum, 1991).

10. A dissertation (in progress) at Northwestern University by Isabel Balzer investigates the cultural policy of the newly unified German Empire under Bismarck and its contribution to this 1873 Vienna Universal Exposition. I have benefited from reading early chapters of Balzer's work, presented first in public at the College Art Association meetings in New York, in February 1997, in a talk entitled "The Empire and the Market: Germany's International Exhibition Policy, 1871–1885." As Balzer indicates, Bavaria, whose capital Munich would be a future site of study for Gottlieb, maintained both political and cultural independence from the Prussian core of the empire and insisted on having its own commission for fine arts displays in Vienna in 1873. Munich even published a separate catalogue of its art on display, so this city would have been seen as a leading center for art by the ambitious young Polish Jew. On the larger context of such international exhibitions, see *The Art of All Na-*

tions: 1850–1873, ed. Elizabeth Gilmore Holt (Garden City, N.Y.: Anchor, 1981), esp. 545–76 for Vienna in 1873 (on Piloty, 558; on Matejko, 559).

11. Horst Ludwig, *Malerei der Gründerzeit* (Munich: Neue Pinakothek, 1977), 261–70, offers the definitive catalogue of Piloty's massive "machines" within the collections of Munich. The *Thusnelda* (1869–73), cat. no. WAF 771, discussed in particular at 265–67, is an enormous work, measuring 490 × 710 cm. (191 × 277 in.).

12. Kenneth Schellhase, *Tacitus in Renaissance Political Thought* (Chicago: University of Chicago Press, 1976), esp. chapter 7, "The Legacy of the Renaissance Political Use of Tacitus," 150–72.

13. On Matejko in the context of nineteenth-century Polish painting, see *Pölnische Malerei von 1830 bis 1914* (Kiel: Kunsthalle, 1978), esp. 231–36. Matejko had already won a medal in the Paris 1867 International Exposition and had been elected to the Legion of Honor in 1870.

14. Robert Rosenblum and H. W. Janson, *Nineteenth-Century Art* (New York: Abrams, 1984), 355, fig. 281.

15. Illustrated in Guralnik, *Gottlieb,* 29, fig. 10. According to the author, this same kind of nostalgic dress had been favored in photographs of leaders of the abortive Polish uprising of 1863.

16. Heinrich Graetz, *History of the Jews* (Leipzig: O. Leiner, 1856–66). On Rembrandt's paintings, including a revisionist account of his later portraits of "Jews," see Gary Schwartz, *Rembrandt: His Life, His Paintings* (New York: Viking, 1985), esp. 284–85 for "Christ from Life," and figs. 266 and 299 for portraits of actual Jews; on Rembrandt and Menasseh ben Israel, "Rembrandt and a Jew," 175–76; on Rembrandt's relation to Old Testament dramas, 272; on his twin paintings of *Jacob and the Angel* and *Moses with the Tablets of the Law,* 324–25. For the relationship between Menasseh ben Israel and his neighbor Rembrandt, see also Reiner Haussherr, *Rembrandts Jacobssegen* (Opladen: Westdeutscher Verlag, 1976); Hans van de Waal, "Rembrandt's Etchings for Menasseh Ben Israel's *Piedra Gloriosa,*" and "Rembrandt and the Feast of Purim," reprinted in van de Waal, *Steps towards Rembrandt* (Amsterdam: North-Holland, 1974), 113–32, 201–32, with bibliography on earlier interpretations of Rembrandt's relationship to Jewish history from the Old Testament. An earlier study by a non–art historian that has useful background is Fr. Landsberger, *Rembrandt, the Jews, and the Bible* (Philadelphia: Jewish Publication Society of America, 1946). For the general history of Jews in Holland, see Mosez Heiman Gans, *Memorboek: History of Dutch Jewry from the Renaissance to 1940* (Baarn: Bosch and Keuning, 1977); Jonathan Israel, *History of the Jews in the Age of Mercantilism* (Oxford: Clarendon Press, 1985); and Susan Morganstein and Ruth Levine, eds., *The Jews in the Age of Rembrandt* (New York: Jewish Museum, 1981).

17. H. Perry Chapman, *Rembrandt's Self-Portraits: A Study in Seventeenth-Century Identity* (Princeton, N.J.: Princeton University Press, 1989) remains the fundamental analysis.

18. Guralnik, *Gottlieb,* 36–37, with further bibliography at n. 14.

19. Van de Waal, "Rembrandt and the Feast of Purim," with references to earlier scholarship.

20. Chapman, *Rembrandt's Self-Portraits,* 24–25, fig. 23, draws attention to the implications of melancholy in the use of shadows: "in art a shaded face had long been a clear indication of a troubled or melancholic mind. Both children of Saturn and melancholics were traditionally swarthy" (31).

21. For the issue of Shakespeare's complex reaction to issues of Jews as humans against the background of Elizabethan culture, see James Shapiro, *Shakespeare and the Jews* (New York: Columbia University Press, 1995).

22. Schwartz, 328, interprets the theme as "Cyrus and Aspasia." For the history of the painting, see *Rembrandt, 1669/1969* (Amsterdam: Rijksmuseum, 1969), 104–07, no. 22. The theme of the picture has been interpreted as various Old Testament pairs, including Abraham and Sarah, Tobias and Sarah, Boas and Ruth, Jacob and Rachel, and—most likely—Isaac and Rebecca, because of a preliminary drawing that suggests the couple viewed by Abimelech. See Christian Tümpel, *Rembrandt: Mythos und Methode* (Antwerp: Mercatorfonds, 1993), 355–57, 394, cat. no. 32; also 141–46 for a broader discussion of Rembrandt and the Jews.

23. For the "Ill-Matched Pair" tradition, see Lawrence Silver, "The *Ill-Matched Pair* by Quentin Massys," *Studies in the History of Art* (Washington, D.C.: National Gallery of Art, 1974), 6:4–23; Alison Stewart, *Unequal Lovers* (New York: Abaris, 1977).

24. Oppenheim painted one work that clearly exhibits his own crystalizing self-image as a Jew: *Lavater and Lessing Visit Moses Mendelssohn* (1856; Berkeley, Judah L. Magnes Museum; fig. 9). Here the famous "court Jew," Mendelssohn, spiritual father of the Haskalah, or Jewish Enlightenment, is met by Lavater, famous to art historians as a major contributor to the theory and practice of physiognomy, but a man who was also a clergyman and who challenged the redoubtable Mendelssohn to a debate on the truth of the Christian faith. Lessing's *Nathan the Wise* (1779) expressly takes up the theme of religious superiority, equating the merits of both Judaism and Islam with those of Christianity through the mediating figure of the "court Jew." See Richard Cohen, *Jewish Icons*, 163–66, figs. 92–93.

25. On orientalism as an exotic, distant antipode to Western values and modernity, see Linda Nochlin, *The Politics of Vision: Essays on Nineteenth-Century Art and Society* (New York: Harper and Row, 1989), 33–59; the touchstone for analysis of this attitude is Edward Said, *Orientalism* (New York: Pantheon, 1979).

26. For the extant works, see Guralnik, *Gottlieb,* 54–57, 204, cat. nos. 23–31. Intriguingly, Lessing's plot recalls that of *The Merchant of Venice.* Nathan's adopted daughter, Reha, also falls in love with a Christian, in this case a Templar who rescues her from a fire; Nathan also makes a loan to the Sultan. Gottlieb's *Reha Welcoming Her Father,* which survives in two versions (one in Rehovot, Weizmann Institute of Science), closely resembles, although the characters are portrayed at full length and with full orientalizing treatment, Gottlieb's *Shylock and Jessica* of the previous year.

27. In contrast to our contemporary sense of the Jews and Arabs as implacable enemies, we should remember that during Gottlieb's lifetime Palestine was ruled by Moslem successors of Saladin, the Ottoman Turks, who, as a host culture, had welcomed even the Sephardic Jews who fled Spain after the expulsion of 1492. Around 1877 Gottlieb produced his own painted version of the *Expulsion of the Moors [sic] from Granada* (Lodz, Art Museum; Guralnik, fig. 35), complete with banded architecture, minarets, and orientalizing costumes. These exotic figures, who could be either "Moors" or Sephardic Jews from Southern Spain, recall in their ambiguity the relativity and toleration also advanced in *Nathan the Wise.*

28. The subject of Rembrandt's "orientalism," including his use of historical costumes, deserves much fuller study. For the moment see Schwartz, 199, fig. 217, commenting on "sultans" and other figures with turbans in relation to the *Man in Oriental Costume,* often called *"The Noble Slav"* (New York, Metropolitan Museum of Art). See also Leonard Slatkes, *Rembrandt and Persia* (New York: Abaris, 1983).

29. On this phenomenon of speakers and listeners in Rembrandt, see Julius Held, "The Spoken Word in Rembrandt," *Rembrandt Studies* (Princeton, N.J.: Princeton University Press, 1991), 164–83. As always, it is difficult to determine which images by Rembrandt were available to Gottlieb, either as originals or, more likely, as reproductions.

30. Guralnik, *Gottlieb,* 57–59, cat. no. 32.

31. In addition to the etching, Rembrandt painted a portrait sketch of the same sitter (1647; Amsterdam, Rijksmuseum); see Schwartz, 259, fig. 299. Bueno was a financial backer of Menasseh ben Israel's press. See also *Face to Face/Oog in Oog* (Amsterdam: Museum Rembrandthuis, 1986–87), 49–52, cat. nos. 34–37, including the portrait etching of Bueno by Rembrandt's associate Jan Lievens.

32. It is also possible that Gottlieb modeled the bearded features and floppy hat of the prominent figure by the steps in this painting upon Rembrandt's portrait etching of *Menasseh ben Israel* (1636; *Face to Face,* 28–34, cat. no. 9), although the prominent tallith, appropriate to the synagogue location of the D'Acosta scene, does not appear in Rembrandt's work.

33. Guralnik, 38–42. Gottlieb's principal ethnographic work of contemporary Jewish life other than this large picture is his small grisaille sketch, the *Jewish Wedding* (Guralnik, 37–38, fig. 11; 1876, Jerusalem, Israel Museum), in both the same medium and scale as Oppenheim's models for prints. The groom in that work wears the same festive hat, or *streimel,* and the same tallith as the figures in the Yom Kippur setting.

34. It is noteworthy that in 1877, at the height of Gottlieb's orientalizing Middle Eastern settings of Jewish life, the same period as his *Nathan the Wise* series, he also produced a *Self-Portrait in Arab Attire,* now lost but copied in 1887 by his brother Marcin Gottlieb (Guralnik, 70, fig. 40; Warsaw, Jewish Historical Institute).

35. Guralnik, 44–49, cat. no. 39. For additional comments on the Polish context of such a picture, see Jerzy Malinowski, "Maurycy Gottlieb: A Polish Perspective," in Guralnik, 93–109, esp. 103–4. Malinowski makes clear that Polish contemporary critics noted the Jewish flavor of Gottlieb's Christ. He quotes one comment by Josef Wojciechowski from 1880: "Gottlieb's Christ is an entirely fresh figure, conceived not out of faith but love; this is neither God, nor a common man; this is a biblical prophet, a Hebrew addressing the Hebrews and communicating with them."

36. Guralnik, 36, cites a letter from Gottlieb to the artist Krycinski of Munich written in 1876, as edited and discussed by Bezalel Narkiss, *Maurycy Gottlieb, Letters and Diary* (Jerusalem, 1956), 24–26. Narkiss's book has been unavailable to me. The English version of the passage for this painting is Heinrich Graetz, *History of the Jews* (Philadelphia, 1893), 2: 155–56, 229–30. See also, more generally for this phenomenon in Jewish art, Ziva Amishai-Maisels, "The Jewish Jesus," *Journal of Jewish Art* 9 (1982): 92–97.

37. On "Christ from life" in Rembrandt's painted work, see Schwartz, 284–85, cat. nos. 316–22 (the Munich example is fig. 321), and Tümpel, 145. As Schwartz's commentary

makes clear, citing a contemporary poem by Jan Vos, the model for Rembrandt's numerous heads of Christ was assumed in the artist's day to have been Jewish.

38. "The Hundred Guilder Print" (H. 236, B. 74) is undated and unsigned but is usually considered to have been completed around 1649. "La Petite Tombe" (H. 256, B. 67) is also undated and unsigned but is generally regarded as having been completed around 1652. For the fullest analysis, see Tümpel, 255–59, and Christopher White, *Rembrandt as an Etcher* (University Park: Pennsylvania State University Press, 1969), 55–70. White stresses Rembrandt's adoption in these two works of the grandeur and compositional models of the Italian Renaissance, which might have added to their attraction for Gottlieb in light of his training as an academic artist and history painter.

39. See Schwartz, 106–18, esp. figs. 98 and 99, *The Raising of the Cross* (Bredius 548) and *The Descent from the Cross* (Bredius 550). In both of these paintings Rembrandt includes self-portraits. Although she does not comment on what seems to be Rembrandt's compassion for Christ's suffering in the latter picture, Chapman, in "Rembrandt's Biblical Roles," *Rembrandt's Self-Portraits,* 105–13, notes the significance of his identification with sinful humanity in the former work.

40. Guralnik, 49–51, cat. no. 52.

41. Quoted by Guralnik, 51, after Narkiss, 55–56. In 1879, at the end of his life, on the suggestion of Matejko, who had arranged a studio for him in Kraków, Gottlieb was working on a major work from Polish history that stemmed from the golden age of reconciliation: *Casimir the Great Granting Rights to the Jews.* He was also working on an image of Casimir and Esterka (Esther), showing the love of the great Polish monarch (1310–79) for a Jewish woman, a clear Polish parallel (however mythical) to the Book of Esther and the saving role of King Ahasuerus. See Guralknik, 64–65, for the importance of this latter theme in Polish literature of the nineteenth century. For the general phenomenon of Jews in Polish culture, see the classic study by Aleksander Hertz, *The Jews in Polish Culture,* trans. Richard Lourie (Evanston: Northwestern University Press, 1988; orig. ed. 1961), including the image of Jankiel in Adam Mickiewicz's *Pan Tadeusz* (1834), 209, a work that Gottlieb was working to illustrate in 1879, the last year of his life (Guralnik, 63–64). Hertz, 237, briefly describes Gottlieb as "having a Polish point of view," and he concludes: "In order to make any sort of contribution the Jew had to escape the caste, to cease to be a Jew. . . . In Poland the people who sought places for themselves in both cultures became comic figures. In reality, they were profoundly tragic."

42. To date there is no analytical assessment of either Polish-Jewish artists or of images of Jews in Polish art in general (comparable to Hertz's overview of Jews in Polish literature and culture; see note 41 above). One survey exhibition, *Zydzi—Polscy* [The Jews—of Poland] (Kraków, 1989, with English summary), made an initial effort. At the end of the nineteenth century there were other Jewish artists, chiefly genre painters with an ethnic orientation toward picturesque Jewish figures: Samuel Hirszenberg, Isidor Kaufman, Artur Markowicz. Moreover, there were images of Jewish life produced by non-Jewish painters in nineteenth-century Poland. Later figures, led by Jankiel Adler or Bruno Schulz, brought Polish-Jewish artistry to a high level on the eve of World War II. A full survey of the subject might be modeled on the fine example provided by Susan Tumarkin Goodman, ed., *Russian Jewish*

Artists in a Century of Change, 1890–1990 (New York: Jewish Museum, 1995–96). On the general issue of Jewish identity and modernity, see Linda Nochlin and Tamar Garb, eds., *The Jew in the Text: Modernity and the Construction of Identity* (London: Thames and Hudson, 1995), especially the lead essays by the editors. More generally, see the essay by Daniel and Jonathan Boyarin, "Diaspora: Generation and the Ground of Jewish Identity," *Critical Inquiry* 19 (1993): 693–735, with references to stimulate further reflection on the basic topic. See Richard Cohen, *Jewish Icons,* 221–55.

Collecting and Collective Memory
German Expressionist Art and Modern Jewish Identity

ROBIN REISENFELD

In the early 1950s, the German Jewish émigré and art historian Dr. Rosa Schapire offered her collection of German expressionist art to the Tate Gallery, London, in gratitude to England for admitting her as a Holocaust refugee. A. E. Popham, then Keeper of the Tate, refused Schapire's offer, and most of her collection returned to Germany, divided among various museums.[1] Similarly, many leading American museums have historically eschewed German expressionist art because of its Nazi signification, while American Jewish audiences have embraced it.[2] Indeed, the Jewish German émigrés who moved to New York and California in the late twenties and thirties—the art dealers J. B. Neumann, Galka Scheyer, and Curt Valentin and the collectors Dr. Franz H. Hirschland and Benjamin Weiss—initially introduced German expressionist art to American audiences and made possible the first museum exhibition of German expressionist prints at the Brooklyn Museum in 1948–49.[3]

This essay examines the role of German Jewish patrons expelled from Germany in collecting and preserving German expressionist art at a time when modern German art was an undervalued element in early modernism. I argue that by collecting and selling German expressionist art, particularly prints, the émigré German Jews could retain an identification with a stream of German culture that was itself antithetical to the values of the Nationalist Socialist ideology that deemed it degenerate. I emphasize a nexus of interrelated issues of Jewish and cultural identity and art history. First, my concern is not the activity of collecting for its utilitarian worth but what Walter Benjamin, in his essay "Unpacking My Library," has identified as collecting's contemplative and reflective value.[4] The selection process that is part of acquiring artworks and the memories evoked in reviewing the choices enable the collector to sustain and re-create a sense of personal history. Second, I argue for a reexamination of the historical conditions in which our present under-

standing of modern art was formulated and the role of the collector, art dealer, museum, and artist who took part in determining this history. The historical narrative points to reasons other than aesthetic for the undervaluing of German expressionism in the interpretation of early modernism and suggests that identity politics, cultural biases, and nationalism were significant in shaping the reception of modern German art in the United States.[5] German expressionist art provides a lens for viewing both Jewishness and Germany—not only the conflicts in Weimar society, but also a link to the vital part that Jewish artists, dealers, and collectors played in German culture. German expressionism provides a potent emotive record to counteract recent revisionist accounts of the Holocaust and Germany's role in World War II proposed as the last few witnesses of these events pass away.

In identifying the specific conditions that drove this activity, I have drawn on Gayatri Spivak's discourse of the postcolonial exile because of its methodological pertinence. The German Jewish émigré's situation closely follows Spivak's example of the postcolonial intellectual in the metropolis, whose geographical displacement from the homeland sustains a sense of a privileged Other while reinscribing ethnic identity.[6] In this context, it is useful to recall that spatial segregation was a familiar condition for a large percentage of the European Jewish population, who lived out generations within the confines of the ghetto.[7] I argue that spatial displacement becomes an underlying motivating force for German Jewish collectors too, whose "cultural difference" and dislocation allowed them to recognize German expressionism's aesthetic and ideological contribution. By applying Spivak's framework, I develop a temporal model that seeks to define specific attributes of Jewish transnational culture. My essay will consider three successive periods in Germany and America: (1) the years from 1900 through 1920; (2) the inter-war years and those immediately following World War II; and (3) the present day. I will demonstrate that the activity of collecting contributed to both the formation of modern American Jewish identity and to an authentication of self and culture on the part of individual collectors when traditional means, such as attachment to religious and political institutions, were not feasible.[8]

Explanations for first-generation German Jewish collectors' particular affinity for German expressionist art are not difficult to find.[9] Peter Paret, among others, has observed that the incentive for many art patrons, whether Jewish or not, is the desire to gain recognition and to improve their social standing. It is evident why such an incentive would apply even more emphatically to Jewish patrons, whose ability to own property in Germany had been restricted. Thus collecting and patronage became part of the Jewish assimilation process, an avenue not only for gaining cultural recognition but also for publicly expressing loyalty to the German state.[10] As George Mosse has pointed out in his examination of the concept of *Bildung* (self-cultivation through education and learning) and Jewish identity in nineteenth-century Germany, the attempt by Jews to overcome their separate past and cultivate

common ground that transcended history was one reason that "Jews as a group tended to support cultural and artistic innovation to a greater extent than did Gentiles."[11] While Paret warns against overemphasizing the Jewish role in supporting modern art, pointing to the number of non-Jewish supporters, benefactors, and critics (as well as to the fact that not all Jewish collectors devoted themselves to modern art), he nevertheless concedes that a high proportion of Jews from the reign of Wilhelm II and continuing through the Weimar period entered the art professions because of their practical exclusion from university, military, and law careers, the foreign ministry, and bureaucratic offices.[12] It seems reasonable to conclude that the large number of Jews in the art professions enhanced German Jewish collectors' awareness of contemporary art, thereby perpetuating a kind of special interest group. Jewish interest in German expressionist art was sparked by the affinity Jews felt between their own position in society and that of the artists; they sensed a parallel between the German exclusion of Jews from significant segments of society and the German rejection of the aesthetic innovations of modern art. Thus collecting as a means of Jewish assimilation cut both ways. As a respectable bourgeois activity, collecting provided a means to merge with more traditional components of German society; but the inordinate emphasis placed on collecting, and indeed on the arts in general, as a means to achieve this goal stood as a continual reminder to the collectors of the prejudices toward them and their own outsider status.

Thus, during the Wilhelmine era, one way for German Jewish collectors to resolve the paradox of not quite belonging to the society with which they most identified was by collecting innovative art. While breaking with past traditions, modern art did not threaten the respectability of its owners, as the collecting activities of Ludwig and Rosy Fischer of Frankfurt and of Alfred and Thekla Hess of Erfurt attest. Unlike the "court Jews," so called because of their close links to the monarchy—for example, the coal magnate Eduard Arnhold, who collected French and German impressionism and Renaissance art, or the Jewish "Cotton King" James Simon, who focused primarily on ancient and Early Christian art[13]—the Fischers, who had recently achieved their wealth, collected only contemporary German artists, with many of whom they had personal contact. Beginning in 1905, they initially collected eclectically, only to sell off their early purchases when introduced to German expressionist art in 1916 through the Frankfurt art dealer Ludwig Schames. In the process of creating a cohesive collection of early modern German art and through the gallery that Rosy Fischer ran briefly after her husband's death in 1922, they generated a social circle of prominent intellectuals, including German Jews with similar interests such as Alfred Flechtheim, Schames, Carl Sternheim, and Paul Westheim.[14] The collecting activity of the Fischers and the Hesses provided them with a niche in the ranks of middle-class society. Both couples valued their acquaintance with the artists and through their purchases financially supported German expressionist artists

during World War I, when few others were purchasing art.[15] Hans Hess recalls how his parents, Alfred and Thekla Hess, who acquired their collection in the late teens, would go around the rooms of their home in Erfurt and, because of space limitations, replace what was on the walls with works by whatever artist was about to visit them. Furthermore, each room had two names; the dining room, for example, was also the "Marc Room," painted with yellow walls and a blue ceiling. In addition to the artists Paul Klee, Ernst Ludwig Kirchner, Franz Marc, Otto Mueller, Emil Nolde, and Karl Schmidt-Rottluff, the couple's visitors included the museum directors Edwin Redslob and Walter Kasebach, the poets Else Lasker-Schüler and Walter Hasenclever, the musician Kurt Weill, and the art historians Hans Tietze and Wilhelm Worringer.[16]

While collecting created a sense of belonging for German Jews, it did not significantly alter how German society regarded them. The numerous depictions of these collectors by German artists provide insight into the prominence of Jews in German society. Gerhard Wietek relates that between 1907 and 1933 at least fourteen artists rendered Schapire;[17] the Fischers were portrayed by Walter Gothein and Conrad Felixmüller, Alfred Hess by Erich Heckel, Paul Westheim by Ludwig Meidner, Schames by Kirchner, Alfred Flechtheim by Otto Dix, J. B. Neumann by Max Beckmann and Herwarth Walden, and Dr. Hans Tietze and his wife by Meidner and Oskar Kokoschka. Although sympathetic, nevertheless these depictions collectively reveal the ambiguous attitudes toward their sitters and inadvertently project deeply held attitudes in the popular imagination regarding the Jewish character. In 1904 the Munich-based weekly illustrated magazine *Simplicissimus* recognized the Jew as a significant cultural force by devoting a cartoon strip "Metamorphosis" to lampooning the aspirations of Jewish art patrons (Fig. 16).[18] The first caption reads "Moische Pisch sold used clothing in Tarnopol," under an illustration of Moische depicted as a peddler. This is followed by "When he moved to Posen he became Moritz Wasserstrahl and sold Parisian fashions," showing him as a shrewd salesman wearing a flashy suit. The strip concludes with "Now he lives in Berlin as Maurice Lafontaine where he has found a new artistic trend and again sells cast-off Parisian fashions," portraying the Jewish figure as having traded in his garish suit for a discreet black one and holding an impressionist landscape painting. The Jewish figure's portrayal as an assimilated social climber attests to his success in business, the arts, and other professions. But the crude racial stereotype—short, hook-nosed, thicklipped, with hooded eyes—insists on his "difference." As Moische transforms himself into Lafontaine, he retains his stereotyped physical characteristics, implying the essentialist view that his offensive "Jewishness" can never be eradicated by culture. The caricature reflects the almost universal belief in "racial theories" (held by Jews themselves, many of whom were on the staff of *Simplicissimus,* such as the illustrator of this strip, Thomas Theodor Heine), which drew a parallel between psychological and physical traits.

FIGURE 16

"Metamorphosis," from *Simplicissimus: Illustrierte Wochenschrift,* 1904.

Another image meant to venerate, Ernst Ludwig Kirchner's woodcut of his dealer Ludwig Schames (Fig. 17), whom the artist trusted and held in high regard, seems at first to have little in common with the caricature. Kirchner pays homage to his subject by cutting the block with fine, angular lines to render a careworn yet dignified face whose sad eyes are meant to reflect a sensitive inner soul. Kirchner portrays Schames, who seems to be deep in thought, against a wooden sculpture inspired by so-called tribal art, probably made by the artist himself. But if we divorce the image from its context and what we know about Kirchner's feelings toward Schames, its positive interpretation becomes less clear.[19] Kirchner's depiction betrays the same heavy eyes, attenuated nose, elongated face, big ears, and beard that belong to the common caricature of the old Jewish demonic magician, exemplified by a cover from another *Simplicissimus* (Fig. 18). Under the title "The Polandization of West Prussia," the cartoon depicts a field of rabbits in whose midst stand three hunched, bearded old East European Jews conversing with one another. Their stooped posture and wizened features reflect the stereotype of the old and weak Jew who lacks physical prowess and manly vigor.[20] The cartoon conveys the view that the Jewish immigrant is creating a bastardized German language and culture by having one of the Jews comment, "Pretty soon we will be the only ones who can speak German," using the Yiddish word "daitsch" for "deutsch." Similarly, Otto Dix's *Der Kunsthändler Alfred*

FIGURE 17

Ernst Ludwig Kirchner, *Head of Ludwig Schames,* 1917, woodcut. New York, Museum of Modern Art.

FIGURE 18

"The Polandization of West Prussia,"
from *Simplicissimus: Illustrierte
Wochenschrift,* 1903.

Flechtheim (Fig. 19), in which the artist depicts Flechtheim as yellow-skinned and
stooped, with the characteristic hooked nose, like Karl Schmidt-Rottluff's *Bildnis
Rosa Schapire* (Fig. 20), perpetuates what Sander Gilman has detailed as the stereo-
type of the diseased and deformed Jew whose outward anatomy corresponds to a
morally corrupt soul.[21] I am not suggesting that the artists consciously felt antago-
nistic toward their patrons or meant to portray them in harsh and unflattering terms,
but rather indicating that they reflect the ambivalence of their society.

From a second generation of collectors, who witnessed the growing anti-Semi-
tism and rising power of the National Socialists during the Weimar period, one might
expect a different attitude toward German expressionism. Ironically, even after emi-
gration and expulsion from Germany in the twenties and thirties, the German Jew-
ish patron continued to identify closely with German expressionism. Lacking a
strong visual art heritage of their own, the Jewish émigrés identified in their exile

FIGURE 19

Otto Dix, *The Art Dealer Alfred Flechtheim,* 1926, oil on wood. Berlin, Staatliche Museum.

with progressive German art, designated degenerate by the Nazis. The 1937 Entartete Kunst exhibition crystallized and reinforced the common outsider status of modern German art and Jewish character. The designers of the exhibition wrote didactic explanations such as "German Farmers—a Yiddish View" beneath paintings by Kirchner, Pechstein, and Schmidt-Rottluff and "The Jewish longing for the wilderness reveals itself—in Germany the Negro becomes the racial ideal of a degenerate art" below a painting by Otto Müller showing gypsies around a tent, revealing

FIGURE 20

Karl Schmidt-Rottluff, *Portrait of Rosa Schapire,* 1915, oil on canvas.
Schleswig, Schleswig-Holsteinisches Landesmuseum.

German fears that creators of modern art, Jews, and other non-Aryans were conspiring against and undermining the traditional morals of society.[22]

For the art dealers such as Neumann and Scheyer, who came to America, and the collector Schapire, who resettled in London, what was at stake was not just the continuation of their careers but the very core of their identity: as German Jews who promoted and preserved modern German art, they saw themselves as guardians of a humanitarian cultural tradition stemming from the Enlightenment. The liberal idealism of the Enlightenment had emancipated the Jews from their ghetto existence and allowed them to enter German middle-class society. Their acceptance into this society depended, however, on their adherence to another by-product of liberal Enlightenment thought, Wilhelm von Humboldt's advocacy of *Bildung* coupled with *Sittlichkeit* or the concept of respectability. For the newly emancipated Jew, the path to German citizenship required the fostering of one's intellectual potential, aesthetic taste, and reason and the development of refined manners and proper moral comportment. So thoroughly successful was the Jewish community in meeting these bourgeois standards that those who possessed *Bildung* became models of both Jewishness and Germanness.[23] Liberal thought, assuming the meaning that Jewish law and religious rituals had once had, became anchored in secular Judaism because it had led to Jewish emancipation and was closely intertwined with the Jew's newly achieved bourgeois status. By the end of the nineteenth century, as the center of Judaism shifted increasingly from the theological and metaphysical to the social and cultural, the Jewish community placed greater importance on the humanistic ideal of *Bildung,* regarding it as part of their own heritage and integral to their survival.[24] This conflation of a religious tradition with a high regard for culture can be glimpsed, for example, in Schapire's writings on the power of Schmidt-Rottluff's religious woodcuts. In 1919, long before her forced emigration, Schapire understood these works as a quasi-mystical expression of inner spirituality and linked them to the Jewish theologian Martin Buber's concept of transcendentalism. Addressing the beauty of Schmidt-Rottluff's *Christ and the Adulteress* (Fig. 21) and the power in the artist's ability to convey the shared experience of human suffering, she wrote:

> Buber conveys beautifully how quality guarantees an artwork only entrance into the outer ring; in the inner alone "stand artworks that have produced a sense of the world." Schmidt-Rottluff's religious prints are suited for membership in the inner ring. The deepest secret of the soul reveals itself in black and white, in lines and planes with the fiery power of the creeds of mystics who, when filled with their God, give witness of him.[25]

German expressionist art thus served its possessors as a material relic, emblematic of Jewish social integration, and the preservation of that culture became a refuge for

FIGURE 21

Karl Schmidt-Rottluff, *Christ and the Adulteress,* 1918, woodcut.
New York, Museum of Modern Art.

the Jews in exile, reassuring them of their German Jewish identity. In the face of
their own dispersion, the Jewish community drew comfort from German expres-
sionist artists' advocacy of individuality as an expression of a larger human spirit.

The émigrés' desire to make German expressionist art known to an international
audience and legitimize it as a significant component of modern art demonstrates
their allegiance to this idea. Immediately upon her first visit to London in 1938 and
continuing until her death in 1954, Schapire corresponded with various museum
officials, including those at the Tate and the Victoria and Albert Museum, in hopes
of finding a home for her collection of Schmidt-Rottluff's paintings, prints, and
sculptures.[26] As her correspondence reveals, she was only partially successful, and in
exasperation bluntly confided to her friend Agnes Holthausen in a letter of Sep-

tember 1950 that John Rothenstein, the keeper of the Tate, was a "conceited fool, who does not understand art much more that a cow understands dancing."[27]

That German expressionist art found a more receptive audience in America than in England was largely due to the exhibitions, lectures, publications, and other promotional efforts in New York of the art dealers and collectors J. B. Neumann, Karl Nierendorf, and Curt ("percentage non-Aryan")[28] Valentin, who collectively were able to validate the German works as a significant component of modern art.[29] Although these men were not the first to introduce modern German art to the United States,[30] their persistent and joint efforts, characterized by innovation and an entrepreneurial spirit, were largely responsible for the audience that modern German art gained in this country. The incentive for their large promotional efforts was not monetary reward, as the small sums for their sales testify, but their sincere belief in the significance of the work.[31] They were among the "new type of art dealer" who emerged in the first two decades of the twentieth century and combined the qualities of "art dealer, art lover, donor, sponsor and speculator."[32]

Before coming to the United States, Neumann had been one of the foremost publishers of the prints of Beckmann as well as of Lovis Corinth, Erich Heckel, Kirchner, and Müller. The first of the triumvirate to come to the United States, Neumann naively believed that he would find an enthusiastic American audience for modern German art when he arrived in 1923.[33] Thus he was unprepared for the indifferent reception that, with few exceptions, greeted his early attempts to promote artists such as Beckmann and Edvard Munch. The customary reason given for the American public's disregard for modern German art is their preference for a French-oriented version of the modern canon. In this connection, it is useful to recall that before World War I expressionists saw themselves as part of a pan-European community with which they exchanged both stylistic and aesthetic principles. The war brought a rupture, however, isolating the German artist and fueling a nationalistic and ethnocentric climate. Marit Werenskiold has indicated in her historiographic study of the origins of the term "German expressionism" that from 1910 to 1920 the umbrella appellation for the works of the Brücke and the Blaue Reiter shifted from "expressionism" to *German* expressionism.[34] Because of the hostile feelings engendered by World War I, audiences on both sides of the Atlantic increasingly regarded modern German art as the product of a nationalistically determined character. Thus while the Nazis, on the one hand, labeled German expressionist art degenerate and subversive, its chronological coincidence with the period of the war, on the other, made that art unappealing to an isolationist American audience. The distaste grew so strong that with the outbreak of World War II, the American public projected a Nazi signification onto German expressionism. This is corroborated by Neumann himself, writing in his unpublished autobiography: "While Beckmann was under pressure in Nazi Germany because of his ties to me, I was under pressure

from anti-Nazis in America because of my connection with him. In fact, I recall that the art dealer Joseph Brummer stopped me in the street one day and reproached me for continuing to represent a 'Nazi' artist like Beckmann."[35]

Once in New York, Neumann, rather than severing his ties with Germany, retained a relationship with his former country. He established his gallery, the New Art Circle, and continued his publishing activities in the form of the *Art Lover,* a small pamphlet devoted to art from the twentieth century as well as past periods. Following the example of Kandinsky and Marc's *Blue Rider Almanac,* Neumann's publications and exhibitions presented a continuum of art that represented the "expression of the human spirit" and had been collected out of the conviction that "living art" of "great vitality and imaginative appeal" comprised both the old and the modern.[36] He implemented this notion by displaying young American artists such as Lee Gatch and Karl Knaths alongside the European modernists and past art, hoping to encourage the collectors of one to purchase the other.[37] As early as 1924 he exhibited German expressionist prints and continued to display them throughout the 1920s, including lithographs, etchings, and woodcuts by Feininger, Grosz, Heckel, Nolde, and Munch.[38]

Neumann did not confine his publicizing and promotional activities to his gallery and New York. However, a sense of the dealer's almost missionary zeal in promoting modern art, including German expressionism, is conveyed by a letter written to Neumann by W. R. Valentiner in 1956. Valentiner expressed his disappointment in not finding Neumann at his gallery and learned that he had deserted his exhibition space to "become a lecturer, and a popular one too, who could excite the audience to whom [he] spoke like a prophet with the greatness and vision of our modern masters."[39] Indeed, because of his gallery's limitations at reaching a wider audience, Neumann devoted his later career to art lectures across the country and to teaching. In 1934 he taught an art appreciation course at the New School for Social Research that reflected a nondogmatic approach to modern art. He advocated various coexisting and overlapping modernisms in twelve lectures, beginning with "The Origin of Art" and followed by "Greek and African Artistic Influences," in which he compared the Greek ideal to so-called Negro sculpture. The twentieth-century segment included "Expressionism," "The New School of Paris," "Thirty-Three Years of German Art," "North American Art," and "The Art of the Cinema." His syllabus indicates how he borrowed from the German expressionist artists' concept of the "Urkunst" (primordial origins of art), incorporating the notion into his teaching.

During the thirties and forties, in an effort to legitimate German expressionism, these dealers directed a large portion of their energy toward New York's modern art museums, establishing relations with, and selling works to, the Museum of Modern Art, the Solomon R. Guggenheim Museum, and the Brooklyn Museum.[40] In 1931 the Museum of Modern Art sponsored the first major museum exhibition devoted

solely to modern German art in an English-speaking country, accompanied by Alfred Barr's catalogue (England's first such exhibition was in 1938). Although Flechtheim and Valentin assisted Barr, it was Neumann upon whom Barr primarily relied, not only in conceiving the museum's exhibition, but also in making arrangements for many of the loaned works.[41] In November 1936, Valentin obtained an export license from the German ministry and soon thereafter left with a number of German paintings and graphics to set up the Buchholz Gallery on West Forty-sixth Street in New York.[42] In association with his partner, Karl Buchholz, who carried on a "back-room" business in "degenerate art" in Hamburg, Germany, Valentin rescued many of the works confiscated by the Nazis from German museums by exporting them to New York.[43] In the fall of 1938, he wrote to Hilla Rebay, curator of the Museum of Non-Objective Painting in New York, inquiring about her interest in these works, particularly those by Klee, Kandinsky, and Marc. Between 1937 and 1955 both the Museum of Modern Art and the Brooklyn Museum acquired a significant portion of their German expressionist print collections through purchases, gifts, and exchanges made by Neumann, Valentin, and Hirschland. As a consequence of Neumann's endeavors, Una Johnson mounted one of the first major German expressionist print exhibitions in 1948–49, comprising 125 woodcuts, lithographs, and etchings drawn from the Brooklyn Museum, the Museum of Modern Art, Valentin's Buchholz Gallery, and, most prominently, Neumann.[44]

Deploying their collections to gain social and cultural acknowledgment in a new country, these émigrés remained in contact with their own cultural roots. Thus the German Jewish émigrés, transnationals shuttling between Germany and the United States, found themselves in a situation analogous to that of Spivak's postcolonial exile.[45] Spatial displacement and ethnicity became underlying motivating forces for the German Jewish collectors, who, while acquiring artworks produced in the nation with which they most identified, reinterpreted these works to blur the boundaries between their former cultural identity and their new sense of place.[46] Through their continual involvement with German expressionism these émigrés upheld a strand of German intellectual culture to sustain a link with the remembered country after leaving it.

The year 1957 marks a watershed in the history of the reception of German expressionist art. The German Jewish émigrés' earlier efforts to legitimate their art through exhibitions and acquisitions bore fruit with a flood of recognition, exemplified by major exhibitions and publications, including *German Art of the Twentieth Century* at the Museum of Modern Art (1957–58), a solo exhibition of Kirchner's works at the North Carolina Museum under the direction of W. R. Valentiner, and Charles Kuhn's 1957 catalogue publication of Harvard's collection of German expressionism and abstract art. More important, Peter Selz's *German Expressionist Painting* (1957) and Bernard Myers's *German Expressionists: A Generation in Revolt*

(1957) provided the first substantial art-historical treatments of the movement in English.[47] In May 1962 Klipstein and Kornfeld auctioned Neumann's extensive inventory and archives and prompted a second era in German expressionist collecting by placing on the general market a large quantity of works.

Contemporary collections devoted to German expressionist prints, which indirectly owe their existence to earlier efforts, have been assembled by a third generation of Jewish patrons of modern German art.[48] Unlike Spivak's postcolonial subject, however, exemplified by Neumann, contemporary Jews no longer define themselves in relation to a former country. Thus, as Jonathan Boyarin has observed, whereas Spivak can refer to herself as "a non-resident Indian," it makes no sense for German Jewish Americans to call themselves nonresident Israelis or nonresident Germans, thereby linking themselves to a territorial state.[49] Furthermore, unlike the Indian, Polish, or other immigrant groups, the transnational status of the Jewish community has historically discouraged Jews from socializing with the dominant ethnic population of their former country. For example, the Polish or Russian Jew who emigrates to America, once here, does not customarily seek out the Polish or Russian immigrant community. Instead, the Jewish immigrant assimilates or settles in his or her own recognized "Jewish" neighborhood.[50] Therefore, Spivak's model of spatial displacement does not apply to present-day American Jewish collectors of German expressionism, whose ancestors were not necessarily German. Instead, as Boyarin has argued, Jewish identity can be read through a temporal framework of spatial dispersion.[51] For the modern Jew, the memory of the Holocaust provides a common touchstone, given the Jewish population's strong assimilationist tendencies, Jewish migration, and ideological disillusionment with Zionism. In fact, many argue that the memory of the Holocaust and its attending anti-Semitism, whether experienced firsthand or once removed, is *the* major defining aspect of modern Jewish identity.[52] Thus a temporal model for defining Jewish Otherness subsumes Spivak's spatial model, and, as a corollary, the distinction between the German Jew and other European Jews, formerly subdivided by national boundaries, breaks down. For the contemporary American Jew, what remains is a rather general sense of modern Jewish continuity understood in relation to events before and after the Holocaust, which provides an otherwise divided and fragmented Jewish community with a sense of a shared past.

As Alice Kaplan has made clear, the generation once removed from the Holocaust must reconstruct its history indirectly through a host of new signs drawn from its own generation's culture.[53] Members of later generations continually invent contemporary approaches to their common ancestral and religious heritage based on popular societal and cultural values.

This narrative on Jewish patronage of German expressionism has defined three fluid periods for the Jewish collectors, beginning with a motivation to collect for

assimilationist purposes, followed by a need to *recollect* to sustain a cultural association with a country that had rejected them, and concluding with today's third generation, which collects as an ideological basis for defining a new identity. From this perspective, the activity of collecting German expressionist art exemplifies the Jewish community's determination to survive. Through collecting, the American Jew seeks to recapture something of a personal past while preserving the art that the Nazis sought to destroy. Like the books from Benjamin's library, the content and expressive power of these images serve as a testimony to a past that is quickly receding from living memory. By embodying the events of the past, they nurture the contemporary American Jewish collectors' quixotic quest for an understanding of the self. As Janet Fishman, one of today's prominent American Jewish collectors of modern German art, has so eloquently stated in a recent interview:

> The art we have collected . . . helps us to comprehend the rise of Hitler and the terrible increase in anti-Semitism. . . . [These works] show the history and critique the institutions. We did not shy away from unappealing subject matter, as other collectors often do, because this is how it was—the sick, the crippled, the starving, the street battles, desperation and angst.[54]

Notes

1. As discussed in Frances Carey and Antony Griffiths, *The Print in Germany, 1880–1933: The Age of Expressionism* (New York: Harper and Row, 1984), 7; and Dennis Farr, "J. B. Manson and the Stoop Bequest," *Burlington Magazine* 125 (November 1983): 690.

2. Never very solid, the American museum's declining interest in German art from 1912 onward can be traced to, among other political and social factors, the outbreak of World War I, and the subsequent breakdown in American-German cultural relations. Whereas German film, science, and music regained American acceptance during the twenties, modern German art, because of its tangible reminders to German society, was not widely embraced by American museums. Alfred H. Barr, Jr., as director, had first to convince the trustees of the Museum of Modern Art of the importance of his influential 1931 exhibition *German Painting and Sculpture* and admitted later in a letter from 1931 to the director of the Folkwang Museum, Ernst Gosebruch, that "almost none of the Trustees are at all interested in German painting. . . ." (Museum of Modern Art Archives, registrar's file for German Painting and Sculpture). For an account of the early-twentieth-century American museum's uneven sponsorship of German art, see Penny Joy Bealle, "Obstacles and Advocates. Factors Influencing the Introduction of Modern Art from Germany to New York City, 1912–1933: Major Promoters and Exhibitions," Ph.D. diss., Cornell University, 1990.

3. Galka Scheyer first came to New York and worked for J. B. Neumann briefly before settling in California, where she represented the "Blue Four," Alexei von Jawlensky, Wassily Kandinsky, Paul Klee and Lyonel Feininger. See Christina Houstian, *Die Blaue Vier:*

Kandindsky, Jawlensky, Feininger, Klee, exh. cat., Kunstmuseum Bern and Kunstammlung Nord-rhein-Westfalen (Munich: Prestel Verlag, 1997). Information on Neumann's, Valentin's, and Hirschland's contributions to the Brooklyn Museum was obtained from the Gallery Files, Department of Prints & Drawings, The Brooklyn Museum Archives. See also Barry Walker and Karyn Zieve, *Prints of the German Expressionists and Their Circle: Collections of the Brook-lyn Museum* (New York: Brooklyn Museum, 1988).

4. Walter Benjamin, *Illuminations,* ed. Hannah Arendt (New York: Schocken, 1969), 60.

5. The reception of modern German art in the United States has yet to be written. Rein-hold Heller's account of Alfred Barr's and James Plaut's contrasting attitudes and promotion of German expressonism during the thirties and forties raises interesting issues and provides a good case for further investigation. See Reinhold Heller, "The Expressionist Challenge: James Plaut and the Institute of Contemporary Art," in *Dissent: The Issue of Modern Art in Boston* (Boston: Institute of Contemporary Art, 1985), 16–54.

6. I am drawing a parallel between Spivak's postcolonial intellectual, who resides outside his or her country in a position of authoritative scholarly privilege, in contrast with a "na-tive" disenfranchised group, and the German Jewish collector in America, whose status dif-fers greatly from that of his or her nonémigré Jewish counterpart. Jonathan Boyarin, "The Other Within and the Other Without," in *Storm from Paradise: The Politics of Jewish Memory* (Minneapolis: University of Minnesota Press, 1992), 80; and Gayatri Chakravorti Spivak, "Who Claims Alterity?" in *Remaking History,* ed. Barbara Kruger and Phil Mariani (Seattle: Bay Press, 1989), 269–92.

7. For an analysis of the narrative fate of another nationless "Other" within Europe, see Katie Trumpener, "The Time of the Gypsies: A 'People without History' in the Narratives of the West," *Critical Inquiry* 1, no. 4 (September 1992): 843–84.

8. On collecting as a peculiar Western strategy for deployment of a possessive self, see James Clifford, "On Collecting Art and Culture," *The Predicament of Culture: Twentieth-Century Ethnography, Literature, and Art* (Cambridge, Mass.: Harvard University Press, 1988), 218–22.

9. Peter Paret, "Bemerkungen zu dem Thema: Jüdische Kunstsammler, Stifter und Kunst-händler," in *Sammler, Stifter und Museen: Kunstförderung in Deutschland im 19. und 20. Jahrundret,* ed. Ekkehard Mai and Peter Paret (Cologne: Böhlau, 1993), 178.

10. Ibid.

11. George L. Mosse, *Confronting the Nation: Jewish and Western Nationalism* (Hanover, N.H., and London: Brandeis University Press, 1993), 143.

12. Paret, 183.

13. Werner E. Mosse, "Wilhelm II and the Kaiserjuden," in *The Jewish Response to German Culture: From the Enlightenment to the Second World War,* ed. Jehuda Reinharz and Walter Schatzberg (Hanover, N.H., and London: University Press of New England, 1985), 171–72. See also Karl Schwarz, "Kunstsammler," in *Juden im deutschen Kulturbereich,* ed. Siegmund Kaznelson (Berlin: Jüdischer Verlag, 1962), 121.

14. Georg Heuberger, ed. *Expressionismus und Exil: Die Sammlung Ludwig und Rosy Fischer Frankfurt am Main* (Frankfurt: Jüdisches Museum; and Munich: Prestel Verlag, 1990). See also Cordula Frowein, "Die Sammlung Rosy und Ludwig Fischer in Frankfort am Main," in *Avantgarde und Publikum,* ed. Henrike Junge (Cologne: Böhlau Verlag, 1992), 73; and Dr.

Ernst Fischer, "A Memoir," in *German Expressionism: Die Brücke. Paintings, Prints, and Watercolors from the Collection of Dr. & Mrs. Ernst Fischer,* exhibition organized by Angelika S. Powell and catalogue essay by Alessandra Comini (Charlottesville: University of Virginia Art Museum, 1978), 7–9.

15. Ljuba Berkankova, "Kunstsammeln als Erlebnis," in *Expressionismus und Exil,* 43–51.

16. Wolf-Dieter Dube, "Sammler des Expressionismus in Deutschland," in *Expressionismus und Exil,* 19–20. See also Mechthild Lucke, "Der Erfurter Sammler und Mäzen Alfred Hess," in *Avantgarde und Publikum,* 149–55.

17. Gerhard Wietek, "Dr. phil. Rosa Schapire," *Die Kunst* 9 (1974): 143.

18. I am in debt to Ann Taylor Allen's analysis of this image in *Satire and Society in Wilhelmine Germany: Kladderadatsch and Simplicissimus* (Lexington: University Press of Kentucky, 1984), 192–93.

19. For an analysis of pictorial representation of Jewish character, although heavily weighed toward English and French culture, see Linda Nochlin and Tamar Garb, eds., *The Jew in the Text: Modernity and the Construction of Identity* (London: Thames and Hudson, 1995), especially Nochlin's introductory essay, "Starting with the Self: Jewish Identity and Its Representation," 7–19.

20. This characterization of the Jew is in Mosse, *Confronting the Nation: Jewish and Western Nationalism,* 140–41.

21. Sander L. Gilman, *The Jew's Body* (New York and London: Routledge, 1991).

22. Stephanie Barron, ed., *"Degenerate Art": The Fate of the Avant-Garde in Nazi Germany* (New York: Harry Abrams; and Los Angeles: Los Angeles County Museum of Art, 1991), 56–57.

23. Mosse, "Jewish Emancipation: Between Bildung and Respectability," in *Confronting the Nation,* 131–45.

24. Laurence J. Silberstein, "Others Within and Others Without: Rethinking Jewish Identity and Culture," in *The Other in Jewish Thought and History: Constructions of Jewish Culture and Identity,* ed. Laurence J. Silberstein and Robert L. Cohn (New York: New York University Press, 1994), 2.

25. Rosa Schapire, "Schmidt-Rottluff religiöse Holzschnitte," *Die Rote Erde: Monatsschrift für Kunst und Kultur* 1 (September–October 1919): 186–87 (my translation), and Robin Reisenfeld, cat. entry 122, in Reinhold Heller, *Brücke: German Expressionist Prints from the Granvil and Marcia Specks Collection* (Evanston, Ill.: The Gallery, 1988), 300–301.

26. Tate Gallery Archives, Tate Gallery, and Archive Files, Victoria and Albert Museum, London.

27. "Eingebildeten Narren, der von Kunst nicht viel mehr als eine Kuh vom Tanzen." Quoted by Maike Bruhns, "Rosa Schapire und der Frauenbund zur Förderung deutscher bildenden Kunst," in *Avantgarde und Publikum,* 282, note 48 (my translation).

28. There exists confusion surrounding Nierendorf's and Valentin's Jewishness, calling attention not only to the fact that these expatriates regarded themselves foremost as German but also to the fluid character of Jewish identity, which was invoked when it served one's purposes and otherwise ignored. For example, Nierendorf is generally not regarded as Jewish; however, Schwarz, "Kunstsammler," in *Juden im deutschen Kulturbereich,* 127, lists him

among the Jewish art collectors. In contrast, although Valentin had been baptized, according to Will Grohmann, he arrived in New York in 1937 after he was forced to leave Germany as a "percentage non-Aryan." See *On the Death of Curt Valentin,* Jane Wade Papers, Archives of American Art, Washington, D.C., microfilm 2322. Alfred Barr supported this view, perhaps as a way of confirming Valentin as "not" German and therefore not an enemy of the United States, in a 1942 letter to the U.S. Attorney: "Valentin is a refuge [*sic*] from the Nazis both because of Jewish extraction and because of his affiliation with free art movements banned by Hitler." Curt Valentin Papers, Archives of American Art, Washington, D.C., microfilm 2322.

29. I suggest that Neumann's, Nierendorf's, and Valentin's promotional efforts were more successful than either Scheyer's or Schapire's solo attempts, not only because they worked collectively, but also because of gender biases. See Houstian, *Die Blaue Vier,* for a detailed account of the continual resistance Scheyer encountered throughout her career.

30. They were preceded by Martin Birnbaum's 1912 exhibition of Contemporary German Graphic Art at the New York Branch of the Berlin Photographic Company, Katherine Dreier's exhibitions at the Société Anonyme, founded in 1920, and William Valentiner's 1923 exhibition of Modern German Art at the Anderson Galleries. See Penny Bealle, "J. B. Neumann and the Introduction of German Art to New York, 1923–1933," *Archives of American Art Journal* 29, nos. 1–2 (1989): 3.

31. For example, in 1943 the Brooklyn Museum bought a selection of prints by Otto Dix, George Grosz, Erich Heckel, E. L. Kirchner, Oskar Kokoschka, Max Pechstein, Franz Marc, Käthe Kollwitz, and others that sold for between $25 and $30 each. The highest price was $65 for Kirchner's *Ludwig Schames,* the lowest $15 for Grosz's *Offsprings* (Gallery Files, Brooklyn Museum, New York). In 1948, the Guggenheim Museum purchased Nierendorf's estate of over 550 paintings, including 110 Klees, 18 Kandinskys, and 54 Kirchner watercolors and graphics, for $72,500. Kirchner's woodcuts were individually priced at $15, a Max Beckmann painting at $200, and a Feininger drawing at $10 (Karl Nierendorf File, Archives, Solomon R. Guggenheim Museum, New York).

32. Robin Reisenfeld, "The Revival, Transformation and Dissemination of the Print Portfolio in Germany and Austria, 1890–1930," in *The German Print Portfolio: Serials for a Private Sphere* (Chicago: Philip Wilson; and Smart Museum of Art, University of Chicago, 1992), 19–31. See also Peter Springer, "Alfred Flectheim: Ein Kunsthändler neuen Typs," in *Avantgarde und Publikum,* 86.

33. See Bealle, 4, and Neumann's unpublished autobiography, "Confessions of an Art Dealer," undated (post-1957) (J. B. Neumann Papers, Museum of Modern Art Library, New York).

34. Marit Werenskiold, *The Concept of Expressionism: Origin and Metamorphoses* (Oslo: Universitetsforlaget; New York: Columbia University Press, 1984).

35. Neumann, "Confessions," 40.

36. J. B. Neumann, "Living Art Old Masters," undated publication, Neumann Papers, N/69–93, Archives of American Art, Washington, D.C.

37. See A. Deirdre Robson, *Prestige, Profit, and Pleasure: The Market for Modern Art in New York in the 1940s and 1950s* (New York and London: Garland Publishing, 1995), 86–93, for an interesting but slightly different account of Neumann's, Nierendorf's, and Valentin's significance for the American art market.

38. Walker and Zieve, 15, note 4.

39. Neumann Papers, N/69–93, Archives of American Art, Washington, D.C.

40. Vivian Endicott Barnett, "Banned German Art: Reception and Institutional Support of Modern German Art in the United States, 1933–45," in *Exiles and Emigrés: The Flight of European Artists from Hitler* (Los Angeles: Los Angeles County Museum of Art, 1997), 273–84.

41. Museum of Modern Art, registrar's files.

42. In 1939 he moved to East 57th Street.

43. "Curt Valentin, Sixty-two, Art Dealer, Dies," *New York Times,* August 21, 1954.

44. Walker and Zieve, 9.

45. Boyarin, 80; and Spivak, 269–92.

46. Or alternatively, as Homi Bhabha would argue, they turned "these authorized images against themselves." Bhabha, "Between Identities," in *Migration and Identity,* ed. Rina Benmayor and Andor Skotnes (Oxford and New York: Oxford University Press, 1994), 190.

47. Charles Kuhn, *German Expressionism and Abstract Art: The Harvard Collections* (Cambridge, Mass.: Harvard University Press, 1957); Peter Selz, *German Expressionist Painting* (Berkeley and Los Angeles: University of California Press, 1957); and Bernard Myers, *German Expressionists: A Generation in Revolt* (New York: Praeger, 1957).

48. Today's major patrons include Marvin and Janet Fishman of Milwaukee, Wisconsin; Robert Gore Rifkind of Los Angeles; and Marcia and Granvil Specks of Evanston, Illinois. Their collections are reproduced, respectively, in Reinhold Heller, *Art in Germany, 1909–1936: From Expressionism to Resistance. The Marvin and Janet Fishman Collection* (Munich: Prestel, in association with the Milwaukee Art Museum, 1990); Robert Gore Rifkind Center for German Expressionist Studies, *German Expressionist Prints and Drawings* (Munich: Prestel; and Los Angeles: Los Angeles County Museum of Art, 1989); and Reinhold Heller, *Brücke: German Expressionist Prints from the Granvil and Marcia Specks Collection* (Evanston, Ill.: The Gallery, 1988).

49. Boyarin, 81; and Spivak, 279.

50. Perhaps the best-known and most densely settled communities, or "ghettos," established in the 1880s and 1890s were the Lower East Side of Manhattan and Maxwell Street in Chicago. Equivalent neighborhoods, however, existed in cities elsewhere in the nation, including Baltimore, Boston, and Philadelphia. In them Jews clustered in districts according to the parts of eastern Europe from which they had emigrated. For one of the most comprehensive studies, with demographic figures, see Jacob Rader Marcus, *United States Jewry, 1776–1985* (Detroit: Wayne State University Press, 1993), vol. 4. More anecdotal and personal are Milton Meltzer, *A History of Jewish Life from Eastern Europe to America* (Northvale, N.J., and London: Jason Aronson, 1996), 197–207; and Ronald Sanders, *Shores of Refuge: A Hundred Years of Jewish Emigration* (New York: Henry Holt and Company, 1988), 165–68.

51. Boyarin challenges the conventional dichotomy between the dimensions of time and space that several scholars apply in understanding identity. He advocates replacing the Cartesian model, which plots time and space on contrasting axes, with an organic model that relates memory's dimensionability to the body. Thus temporal and spatial dimensions become "embodied" by the self and cannot be linearly dissociated. See Jonathan Boyarin, "Space, Time, and the Politics of Memory," in *Remapping Memory: The Politics of TimeSpace,* ed. Jonathan Boyarin (Minneapolis: University of Minnesota Press, 1994), 1–37.

52. See, for example, Michael Meyer, *Jewish Identity in the Modern World* (Seattle: University of Washington Press, 1990), 57–58. The spectacular popularity of Holocaust memorials and monuments in recent years, particularly in the United States, exemplifies how the Holocaust has replaced Zionism as a potent symbol of Jewishness. For a popular account of coming to terms with the indeterminate character of modern American Jewish identity, see Craig Horowitz, "Are American Jews Assimilating Themselves out of Existence?" *New York Magazine* (July 14, 1997): 28–37.

53. Alice Kaplan, "Theweleit and Spiegelman: Of Men and Mice," in *Remaking History,* ed. Barbara Kruger and Phil Mariana, 150–72.

54. Quoted from Reinhold Heller's "Interview with Marvin and Janet Fishman," in Heller, *Art in Germany, 1909–1936,* 13–14.

Ethnic Notions and Feminist Strategies of the 1970s
Some Work by Judy Chicago and Eleanor Antin

LISA BLOOM

> A relational approach to representation would take into account both a racial dimension—the Whiteness of European-Jewish immigrants—and an ethnic/religious dimension—their Jewishness.
>
> —Ella Shohat and Robert Stam

> Eleanor Antin [was] unusual in that [she] countered the myth of a unified female experience early in the 1970s through performances that questioned the fixity of women's experience in racial terms.
>
> —Amelia Jones

In recent years the academy in the United States has staged high-profile events to define and reconceptualize feminism. The shift in consciousness that has informed such contemporary debates was prompted by recent poststructuralist philosophies and theories of representation as well as models that emerged from Jewish studies and postcolonialist and antiracist debates. Though these sets of issues have been influential in the humanities and the social sciences, particularly in women's, film, and literary studies, only recently have art schools and the traditional disciplines in academe that study visual representations—in particular art and art history—paid attention to them. The purpose of this essay is to make feminist art history more responsive to important scholarship that is already under way in other humanistic disciplines more receptive to

This essay has been published (in Japanese) in *Rim: Pacific Rim Women's Studies Association Journal* (Josai International University, Chiba-ken, Japan) 7, no. 1 (March 1998): 46–70. Portions of it, including the section on Eleanor Antin, will appear in my essay "Contests for Meaning in Body Politics and Feminist Conceptual Art: Revisioning the 1970s through the Work of Eleanor Antin," in *Performing the Body / Performing the Text,* ed. Amelia Jones and Andrew Stephenson (London: Routledge, 1998).

ethnic, racial, and national concerns. This is important since much of the ongoing feminist work in the arts does not address feminist participation in these discourses, or the issue of how Jewish identity operates as a category within them.

A case in point is a major anthology of 1970s feminist artistic practices, titled *The Power of Feminist Art: The American Movement of the 1970s, History and Impact,* edited by Norma Broude and Mary Garrard and published in 1994. It includes the work of Adrian Piper, Faith Ringgold, Ana Mendieta, and other women of color. It is also the first anthology in recent years to bring back to scholarly attention the work of Jewish artists from the period, such as Judy Chicago, Miriam Schapiro, Carolee Schneemann, Joyce Kozloff, and others previously neglected. Although this collection represents a strong and refreshing revisionist history, it is structured on the exclusionary presupposition that a feminist sisterhood cannot come to terms with racial and ethnic differences. The relative invisibility in the book of ethnicity as a category, and of Jewishness in particular, over and against the visibility of African Americans and Latina artists (identified as "women of color"), points to the limits of such a revisionist project. Despite the book's inclusions, it reinstates long-standing values (visibilities and invisibilities), dating from the period it studies.

The difficulties of current feminist art historians in dealing with racial, ethnic, and generational differences during the 1970s have led me to revisit the work of Judy Chicago and Eleanor Antin to provide a critical account of the different ethnically marked practices in it. Many well-known feminist artists, poets, and critics prominent in California during that period—Kathy Acker, Martha Rosler, Joyce Kozloff, Lynn Hershman, and Miriam Schapiro—as well as Antin and Chicago, had emerged from New York and Chicago communities heavily marked by ethnicity, race, religion, and class. In the 1960s some of them moved to California.

Because spectators are also ethnically, racially, and generationally constituted, a study like mine attests to the difference and diversity among feminists along these axes of identification. A younger feminist community shaped by feminist visual cultural studies, postcolonial discourse, queer theory, postmodernism, and the burgeoning field of Jewish cultural studies in the academy might be especially alert to certain ethnic references in Chicago's and Antin's work. Recent work by the theorists Sander Gilman, Richard Dyer, and Ann Pellegrini examines how ethnicity, gender, sexuality, and race have signified different relations between the body and society at various historical moments.[1]

Another change of the past twenty-five years has been a redefinition of the meaning of "identity." This reconceptualization has occurred at the same time as the shift in consciousness in feminist art practices by lesbian women, women of color, and white women.[2] The way in which I situate myself as a feminist has been shaped in part by such debates. I am of a younger generation than the women artists

I write about here, yet like them my Jewish family's trajectory—immigration to the United States from Eastern Europe and Russia, and then from New York to California, and finally (in my case) from California to Japan—shapes the ways in which I perceive myself in relation to American culture as a whole. By rethinking Antin's and Chicago's work, I hope to provide a different understanding of the historiography of feminist work from the 1970s—one that will allow for divergent and competing histories of Jewish immigration. The models and lifestyles that influenced the dominant Southern Californian feminism of the period will be part of this new historiography.

The concerns and feminist passion that shaped Norma Broude and Mary Garrard's history are different from my own, but their work alerted me to some of the specific directions and priorities of their generation of scholars. The introduction to their anthology presents a challenge:

> How then do we situate the Feminist Art Movement on the broader stage, conceptually and historically? Is it merely another phase of avant-garde? Or is it not, rather, to borrow a phrase that has been used to describe the cultural climate of the 1960s, "one of those deep-seated shifts of sensibilities that alter the whole terrain?" The feminist critic Lucy R. Lippard argued persuasively in 1980 that feminist art was "neither a style nor a movement," but instead "a value system, a revolutionary strategy, a way of life," like Dada and Surrealism and other nonstyles that have "continued to pervade all movements and styles ever since." What was revolutionary in feminist art, Lippard explained, was not its form but its content. Feminist artists' insistence on prioritizing experience and meaning over form and style was itself a challenge to the modernist valorization of "progress" and style development.[3]

Because women of my generation no longer face the same resistance from patriarchal institutional structures, it is easy to forget the force that feminism had at that moment when women were engaged in activist movements. They aimed to alter dramatically their personal lives as well as their art practice and teaching. The feminist commitment to revolutionary socialist ideals was an important part of the idealism of the 1970s.

If we are to better understand the generational differences within feminism now, we need to encounter, revisit, and rethink some of these older histories and antagonisms. Given the importance in the last twenty-five years of work theorizing difference, race and ethnicity seem important categories to revisit. Responding to this very concern, Moira Roth and Yolanda M. López write:

> There is a dramatic inequality of information on women of color as opposed to Euro-American women. The feminist art movement . . . suggests an identity prioritized by gender not race. For women artists of color—despite their concern

with women's issues—ethnicity more than gender has shaped their primary identities, loyalties, and often the content of their art. Also from the start the women's art movement has been dominated by Euro-American leadership.[4]

López and Roth's critique is a significant intervention in *The Power of Feminist Art,* for their essay, "Social Protest: Racism and Sexism," provides a way to describe the larger cultural issues that have conditioned the development of North American feminist art up to our time. They emphasize the need to understand the complex way that the categories of gender and ethnicity are interarticulated. I would extend their categories, however, to include not only women of color but white ethnic women perhaps uneasy with a feminism that would erase a consideration of differences beyond gender. There remains a great need to examine how different Jewish women's identities are tied to other social identities and mediated through institutional discourses of art history and modernism. It would be a mistake to believe that ethnicities could be understood in isolation, without considering how they belong to a complex matrix of differences among women. I focus on the complicated dialectics of feminism and other social identities—what Ella Shohat calls "ethnicities in relation . . . [which] can help us envision the possibility of a critical reading which complicates the 'center/periphery' dichotomy."[5]

In what follows, I discuss the suggestiveness of the work of Judy Chicago and Eleanor Antin for exploring the ethnic, religious, and racial undertones in what were once seen as dominant white feminist art practices. I also examine the different terms under which the works of these artists were accepted into the canon of art. Drawing from Michel Foucault's analysis of historical writing, of discursive formations and their practical institutionalization, I look at the contradictory textual means by which Judy Chicago scripts herself into an older and more conservative discourse of art history, where "quality" in art and the "artist-genius" remain central. Her allegiance to a traditional art history inflected her feminist politics at the time and contributed to her public erasure of her Jewish ethnicity.

From Gerowitz to Chicago

Though the work of Judy Chicago has already gained much attention—most recently from Lucy Lippard, from the contributors to the recent anthology edited by Amelia Jones, and from British feminist writers Lisa Tickner and Michèle Barrett—most writers have not examined how Chicago's discourse was never only about gender, but rather about a whole set of identifications mediated through various social identities, all involving questions of power inequality.[6] This oversight is due in part to Chicago herself, who gained visibility in the 1970s as an artist by emphasizing

her gender exclusively. Yet ethnicity played a central role in her self-construction as both a feminist and an artist, as evidenced in the following passage from Chicago's first autobiography, *Through the Flower:*

> I . . . wanted my being a woman to be visible in the work and had thus decided to change my name from Judy Gerowitz to Judy Chicago as an act of identifying myself as an independent woman.
>
> My name change was on the wall directly across from the entrance. It said:
> *Judy Gerowitz* hereby divests herself of all names imposed upon her through male social dominance and freely chooses her own name *Judy Chicago.*[7]

Her name change in 1970 from the ethnically marked Gerowitz to the more ethnically neutral Chicago is seemingly central to her scripting herself as an autonomous feminist subject and artist. Thus from the outset the categories of gender and ethnicity speak to each other, although the erasure of her ethnic name was not at the time seen as a public rejection of her ethnic group, but rather of patriarchy in general. It is hard to know to what degree her allegiance to feminism reflected a desire either to join the cultural elite of artists or to dissociate herself from the stereotype of women in traditional Jewish culture, with its familial and domestic expectations.

Whatever Chicago's motivation, it is clear that conditions might not have been propitious for someone identified as a middle-class Jewish woman in the burgeoning Los Angeles art community at the time. Miriam Schapiro describes her own case thus:

> How do you identify an artist? What does an artist look like? When I grew up an artist was defined by a Rembrandt self-portrait. There would be his smock and his beret, velvet usually, and his palette in one hand, his brushes in the other, and these were the symbols of the outward appearance of the artist. So then I say to myself, but I'm a woman, how do I fit into that? Not only that, but I'm a middle-class woman. Not only that, but I'm a Jewish woman. Not only that, I'm not particularly beautiful. In fact, you probably wouldn't pick me out of a crowd. So how would I identify myself as an artist?[8]

Despite the modernistic rhetoric of the time that appeared to favor a value-free tradition of art regardless of social identities, Schapiro felt that making art was exclusively the preserve of the dominant white male group which envisioned itself as the universal subject, somehow outside specific social or gender identities. The very words "woman," "middle-class," and "Jewish" implied minor, lesser, or subaltern

status. That women such as Miriam Schapiro saw themselves as a minority vis-à-vis a white male power structure led them to distinguish between what it meant to be a "Jewish male" artist and what it meant to be a "Jewish woman" artist. Such a dichotomy between center and periphery suggests that Schapiro and Chicago occupied a position in the art world not unlike the "non place" Johannes Fabian describes—the temporally distinct space of the "Other" in anthropological texts that differs from that of the speaking subject.[9]

In the 1990s an earlier generation's predilection for a universalist, formalist art ideology is being questioned and slowly replaced by a notion of identities that is not wedded to the assimilationist discourse of Jewish identities championed in the 1970s by artists such as Chicago.[10] Earlier romantic notions of artistic genius are also being challenged. The assumed autonomy of artist and work no longer defines the aspirations of all contemporary women artists. Since the early 1980s feminist scholars and artists have frequently analyzed and countered the older paradigms of art-historical discourse such as the concept of an artist as genius and its assertion of the priority of one identity over another.[11] As a result of such scholarship, many women critics and artists are less conflicted in negotiating these seemingly disparate and incompatible discourses than the first generation of feminist artists and critics, such as Chicago, might have been in the 1970s.[12] Michèle Barrett, noting the gap between Judy Chicago's feminism and her apparent desire to belong to an older, more conservative discourse of art history, wrote that Chicago's work process in her *Dinner Party* installation entailed

> principles of collective work . . . not so much . . . ones I might recognize as a feminist but an attempt to recreate the "school" or studio of an "Artistic Genius" like Michelangelo. Although hundreds of people gave much time and work to the project it is Judy Chicago personally who has, apparently not unwillingly, made an international reputation from it.[13]

Barrett's remarks, published in 1982, suggest a new frankness among feminists about acknowledging these discontinuities, and a greater emphasis on revealing gaps and tensions between an elitist and hierarchical discourse of art history that distinguishes the creative artist from ordinary individuals and a feminist discourse that favors nonhierarchical collaboration. Contemporary feminist theorists realize how the egalitarian ideals promoted by feminism, in particular cooperative authorship, become vulnerable to traditional concepts such as individual genius and unacknowledged (gentile) whiteness. In tracing generational differences, I am aware of the dangers of an oversimplistic division of feminist art theory into generations. I am not claiming that theorists from the 1980s and 1990s are more advanced than those of the 1970s. Rather, I am noting the shifts in feminist art-historical thought during the period and observing that some of these issues are now dealt with in a more complex way.[14]

Indeed, Judy Chicago herself now seems influenced by feminist revisionist work of the 1980s and 1990s, acknowledging the oversimplification in her having given priority to gender over other forms of difference in the 1970s. She recently wrote, "We cast the dialogue incorrectly in the seventies. We cast it around gender, and we were also simplistic about the nature of identity. Identity is multiple."[15] Her awareness of opposition between gender identification and other modes of identification does not extend, however, to an examination of the conflicts inevitable in a project that attempts to join feminist ideals of sisterhood with the traditional individualism of art history and its emphasis on the artist as romantic individual genius.[16] Though she might not repudiate the value of individualism, she brings quite different values to her recent account of her individuality as a white ethnic woman artist and the complex motives that led to her name change:

> I was a twenty-three-year-old widow with a different name—Gerowitz—taken not out of wifely duty, no way. . . . When Jerry and I were wed, young proto-feminist that I was, I had kept my original surname, altering it only after noticing —while doing the "gallery stroll" every Saturday afternoon, which is what all the "cool" art people did—that there seemed to be too many other artists named Cohen. I soon exchanged one seemingly patriarchal name for another, my then young husband's seemingly less common. But after Jerry died, people kept mistaking me for the daughter of his parents; not that I didn't like them. I did. It was just that two years of marriage hardly seemed sufficient reason to carry someone else's name for the rest of my life. . . .
>
> The upshot of this was that I felt as though I did not have a name that suited me. Still, I had to become somewhat known under the marital appellation, particularly after I started showing at the Rolf Nelson Gallery, one of the best spots in town. Rolf . . . started calling me Judy Chicago, due in part to the strong Windy City accent I had retained, but also because he thought it suited the tough and aggressive stance I had felt obliged to take in order to make my way into the macho art scene that was L.A. in the 1960s. Rolf tried to convince me to take this name professionally, but I went only so far as to use it in the phone directory. This was, in fact, an "in" thing to do at the time, as there were several artists with "underground" names.[17]

Chicago's name change seems to have been initially important as a means of associating her clearly with the dominant masculinist artistic culture of the 1960s in which "underground names" listed in the phone book were in keeping with the style of the local Los Angeles art community. Though Chicago is describing a gradual process, her comments are little in keeping with her claims of her name's importance later in her career as a feminist artist when she writes about "divesting herself of all names imposed upon her through male social dominance." These words suggest that strong and independent women like her could not permit any

male to mediate or authorize their declaration of a new feminist identity. In retrospect, however, such a statement appears too sweeping to permit a space for men such as Rolf Nelson who, she suggests, not only knew how exclusionary and masculinist the L.A. art scene was at that time but also went so far as to support promising women artists like her against the charge of being different by giving them a new name that would offer the built-in privilege of an anglicized last name. The idealized terms of Chicago's 1970s feminism did not allow her to acknowledge either her ethnicity, her collaboration with men, or the ways in which her concepts of gender and ethnicity related to ideologies of race and class. As she suggests in 1996,

> I sometimes joke that in these early days of the Women's Movement, we had not yet discovered (or invented, as the case may be) our own forms. Therefore we borrowed some, notably from the Civil Rights Movement. Perhaps inspired by the radical stance of the Black Panthers, I decided to publicly "divest" myself of the name Gerowitz in favor of Judy Chicago.[18]

In such passages Judy Chicago reveals the wide-ranging influences on her and suggests with hindsight that she might have called into question the universalism of both her feminism and art world practices of that time. In her reference to the Black Panthers and the Civil Rights Movement, she recalls that feminists of the period aligned themselves with blackness, not so much to counter whiteness as to pursue the strategies and tactics of the Civil Rights Movement. Such a formulation attributes strategies of the women's movement to black people, and presents white feminism as imitating elements of other "movements."

Chicago's exhibition announcement in *Artforum,* featuring a photograph of her in full boxing gear with a supporting female boxing "trainer," moreover, suggests other influences on the art world of the day (Fig. 22). Exhibitions at L.A. galleries during this period occasionally included publicity announcements featuring photographs of mostly male artists in various masculinist poses. According to Chicago, the publicity photograph of herself dressed as a boxer is a play on such gallery practices:

> During this period my male art buddies were all prone to very macho announcements and posters in relation to their own shows, something Jack [Glenn, the owner of a rather prominent gallery] suggested spoofing with a picture of me in a boxing ring, the very one in which Muhammad Ali trained. . . . I would also see this image posted in the studios of many women artists whom I visited during the 1970s. . . . I guess that the boxing ring ad marked the moment when women all over the country came out fighting in an effort to somehow effect a change in the intense discrimination of the art world.[19]

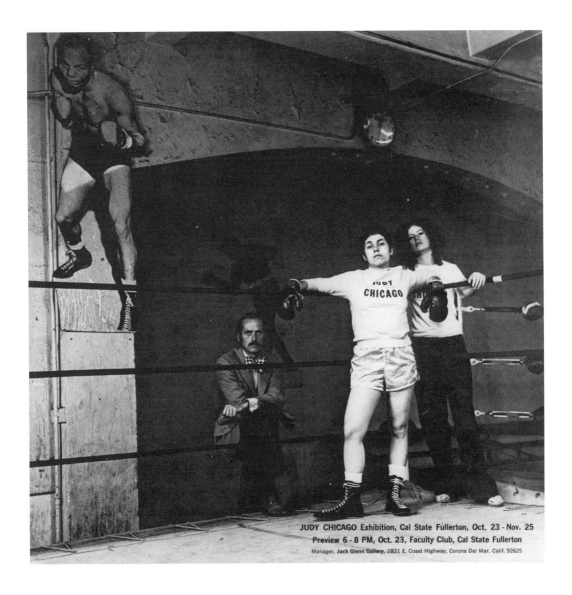

JUDY CHICAGO Exhibition, Cal State Fullerton, Oct. 23 - Nov. 25
Preview 6 - 8 PM, Oct. 23, Faculty Club, Cal State Fullerton
Manager, Jack Glenn Gallery, 2831 E. Coast Highway, Corona Del Mar, Calif. 92625

FIGURE 22
Judy Chicago, Exhibition advertisement, *Artforum,* December 1970.
Courtesy of Through the Flower Archives.

In the poster Chicago aligns herself with pop culture figures in the boxing world like Muhammad Ali. She recalls an ambivalent identification which earlier bohemian subcultures in the United States had with "blackness," for example, Norman Mailer's

"White Negro," who stalked the jazz clubs in search of sex and speed. It is not surprising that Chicago's feminism, as exemplified in this poster, was inflected by her artistic milieu, which regarded cultural signs of blackness as the mark of "cool." Yet it is striking how this poster resonated for both a male and female audience of the day in primarily gendered terms.

In Chicago's reading of her self-portrait, the ambivalent mixture of distancing from and identification with blackness is meant to lure the modernist art establishment into an affiliation with feminism and even lesbianism, which this poster seems to hint at in the confrontational stance of the two women. This affiliation between blackness and feminism evokes a tradition of avant-garde "racial romanticism" that can be traced back to the erotic extremes of Eugène Delacroix's nineteenth-century orientalist paintings. There are other particularly American Jewish influences that collude in the avant-garde's romance with race, such as the ambiguous boundaries between Jewish and black identities in Norman Mailer's 1957 figure of the "White Negro."[20] To understand Chicago's evocation of feminism in this poster and its relationship to Mailer requires taking into account not only the racial dimension, her whiteness, but also the ethnic one, her "Jewishness." Her partial identification with Muhammad Ali implies an affinity, whether past or potential, between African Americans and Jews, two groups outside the dominant culture of Europe and of WASP-dominated American art.

Chicago was also aware of certain traditional and New Age religious influences on her work. Perhaps this realization is best exemplified in her well-known celebratory feminist image-making project *The Dinner Party* (1979), a collection of thirty-nine place settings at a triangular dinner table. The arrangement references Christ and his disciples at the Last Supper and, perhaps more unexpectedly, the witches' coven and the millennium, a moment that Chicago claims will end the double standard "which defines men's rituals as not only significant but sacred, while rendering women's invisible."[21] The plates themselves are of vulvar forms emblematic of feminist heroines throughout history (Fig. 23). Celebrated as the icon of 1970s feminist art when first exhibited, the piece was shown again in 1996 as part of an exhibition in Los Angeles organized by Amelia Jones at the Armand Hammer Museum of Art, University of California at Los Angeles. The catalogue *Sexual Politics* and the exhibition were part of a wider project by Jones to rethink the reception of *The Dinner Party* in both feminist art practice and theory over the past twenty years. Jones refers in her introductory catalogue essay to Kate Millet's *Sexual Politics,* which, she says, "marks both my commitment to rethinking the terms of 1970s feminist art theory and practice and my interest in examining the politics of sexuality . . . manifest in the debates that have surrounded Judy Chicago's *Dinner Party.*"[22] Though the writers of *Sexual Politics* are mindful of the racial and ethnic tensions in Chicago's work, the overall emphasis of the catalogue is to reorient con-

FIGURE 23

Judy Chicago, "Sojourner Truth Plate," from *The Dinner Party,* 1979,
china paint on porcelain. Courtesy of Through the Flower Archives.

temporary feminist art practice in Los Angeles, now turned toward feminist debates,
around the representation of the female body and pleasure. Consequently, the *Din-
ner Party* exhibit was accompanied by important feminist work from the 1960s to
the 1990s in dealing with issues of sexuality that contrasted with those in Chicago's
Dinner Party.

As Jones is well aware, the debates around sexual politics have changed radically
from the 1970s when Millet argues that male oppression alone was the reason for

women's subordination. Two decades of extensive feminist writing on racism and, more recently, Jewishness have worked to displace two widely held beliefs among feminists: that whiteness is natural and normative and that the categories of race and ethnicity concern only nonwhites. Though these beliefs are not the main focus of the *Sexual Politics* anthology, contesting the assumption in Chicago's *Dinner Party* that the history of feminism is a phenomenon and product of white Western women alone is arguably one of the most important contributions of the book. This critique also differentiates *Sexual Politics* from the uncritical celebration of a white feminism in Norma Broude and Mary Garrard's *Power of Feminist Art.* Not only does Amelia Jones disagree with Chicago's assumption that women should be characterized as a singular group on the basis of their shared sexual oppression, but she also finds Chicago's lack of consistency in her use of the vulvar forms suggestive of an uneasiness with representing certain kinds of racial and ethnic subjectivity.[23] Amelia Jones quotes Alice Walker to describe how Chicago's design for the Sojourner Truth plate exemplifies this discomfort about black women specifically:

> All of the other plates are creatively imagined vaginas. . . . The Sojourner Truth plate is the only one in the collection that shows—instead of a vagina—a face, in fact *three* faces. . . . It occurred to me that perhaps white women feminists, no less than white women generally cannot imagine black women have vaginas. Or if they can, where imagination leads them is too far to go.[24]

Rather than take issue either with the vaginal imagery or with Chicago's disregard for difference in using the vagina as a universal symbol of femaleness, Walker and Jones criticize *The Dinner Party* for treating black women as essentially different from white women, in what was otherwise meant to be a celebration of all female sexuality.[25] This is an important critique, pointing out that by using two symbols rather than one, Chicago sets up a center-periphery dichotomy, contrasting the "norm" and the "other," putting white women at the center and black women on the margins. Thus Chicago's vaginal iconography celebrates the sexuality, not of all women, but only of white females, disavowing internal ethnic and class differences and contrasting the external "otherness" of black sexuality. Her chosen symbol unifies Euro-American female identity as feminist while expressing its difference from black "others." Walker and Jones imply that a revision of the understanding of black women's sexuality is beyond the recuperative powers of Chicago's art.

Ironically, the ethnic subtext of both *The Dinner Party* and the boxing picture, rather than transcend the opposition of center and periphery, itself becomes peripheral. This assimilation of the margins entails Chicago's speaking for all women through the ethnically and racially unmarked discourse of both feminism and Christianity. To do this she adapts the metaphor of the Last Supper for her *Dinner Party*

and through her vaginal imagery also naturalizes the Christianity of the women presented in the project.[26] Her appropriation of Christianity into her own feminist discourse may not be meant to exalt Christian women at the expense of "other" women such as herself, since her project also references New Age religions. Given the dominance of Christianity in the United States, however, it is not surprising that Nancy Ring, one of the Jewish contributors to *Sexual Politics,* forcefully expresses her skepticism about Chicago's choice of the iconography of the Last Supper as a means to celebrate feminism. She even goes so far as to imply that Chicago used the Christ figure in the project to enhance her status as a white feminist. Ring writes,

> Where exactly was she [Chicago] coming from when she chose to power her art-making activities by mixing the primary metaphors of the Last Supper and the dinner party? . . .
>
> The consistency with which Chicago chose Anglo-American and European women to sit at her table and her selection of the figure of a soon-to-be-transubstantiated Christ to signify feminist transformation can reveal as much about the grounds from which her project sprang as they do about the lofty place to which she aspires.[27]

If *The Dinner Party* evokes female solidarity, that evocation is problematic, for in staging harmony, it also represses awareness of Jewish ethnicity. Chicago's "imagined community," to use Benedict Anderson's term, dominated by famous Anglo-American and European women who are mostly Christian, avoids even a "managed" harmony among ethnic groups. Jewishness is repressed historically too, since even a Jewish woman like Gertrude Stein becomes associated exclusively with her sexuality and nationality, and her Jewishness is not mentioned.

The Dinner Party was seen in the late 1970s, not in the ethnic and racial terms outlined above, but as part of the liberal critique of stereotypes of the 1960s and 1970s and as an instance of the positive feminist sexual imagery popular in the period, along with such slogans as "Sisterhood is Powerful" and "Black is Beautiful." It was a common misconception then to regard images as merely a reflection, good or bad, and to compare "bad" or "false" images of women (such as fashion advertisements) to "good" or "true" images of women. Christian whiteness and middle-classness was seen as the unspoken norm. The best example of such misconceptions is the collaborative project *Womanhouse* (1972), organized by Judy Chicago and Miriam Schapiro. They took over and renovated an empty downtown house in Los Angeles and remade each of its rooms as a "true" dramatic representation of women's experiences beginning in childhood: home, housework, menstruation, marriage, and so on. The work represented a middle-class, Euro-American perspective, although it suggested the underlying presence of an unacknowledged nonwhite ethnic or racial class. *Womanhouse* did not represent the experiences of the black or Chicana

maid or the white working-class cleaning woman, since the only "true" experiences of domesticity and marriage represented were those of white, American, middle-class women. The project did not address the differences among women themselves, specifically those arising from an inequality in power relations on the project itself. Not did it engage the question why middle-class women who spend their days scrubbing, cleaning, and scraping go to incongruous lengths to disguise their work and erase its evidence from their hands. It does not consider how the emblems of female upper-class prestige depend on the labor of black or Chicana domestics. Nor does it address the heterogeneity of identities among women from different ethnic groups, and how they might represent themselves differently from the way they are represented in the popular media, as in the case of Jewish women, who are frequently presented in popular culture as unwilling to participate in any form of domestic labor, refusing to clean or cook.[28]

Eleanor Antin: Jewish Contentions

There is no point at which she suddenly stops being Eleanor Antin. What she becomes is already part of her, and she never ceases to be what she is to begin with. There are no borders, no precise contours, no center.

—Jonathan Crary

Whereas Judy Chicago celebrated white feminist identities in a way that left racial and cultural hierarchies intact, Eleanor Antin, in her own work, complicated any evocation of female harmony as well as the white normative space and set of identities it marked out. Antin does not separate "culture" from other dimensions of daily life. She focuses on what women in their everyday lives cannot always see or name—that is, how their interests are often at odds with one another, as evidenced by her projects *Domestic Peace* and the *Encounter and Withdrawal* series. Antin's work of the 1970s that emphasized the complexities and self-contradictions of a feminist position was often less popular than her pieces that conformed to a recognizable celebratory feminism or met more traditional standards of high art. For example, a great deal of critical attention was given to her photopiece *Carving: A Traditional Sculpture,* (Fig. 24), which was seen at the time and continues to be interpreted as an ironic comment on how the ideal of the nude is gendered in the history of art. Emphasizing its feminist importance, the art critic Cindy Nemser wrote in 1975 that *Carving* is about "how women are always concerned with the need to improve their bodies."[29] She refers to the female desire for future perfection, the lure of achieving ideals—in this case literally embodying the Greek ideal of the nude or that of a thin female body through dieting. According to Nemser, Antin shows that the popular

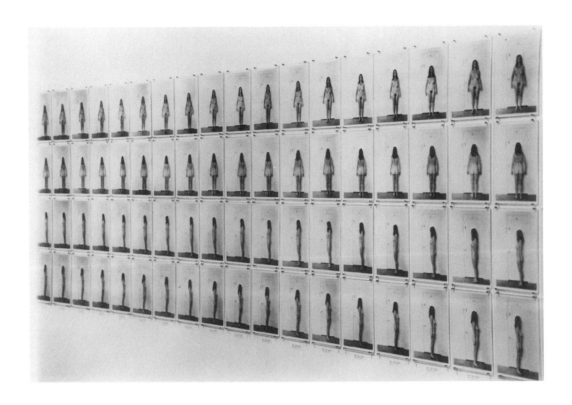

FIGURE 24

Eleanor Antin, *Carving: A Traditional Sculpture,* 1972.

ideals on offer do not actually exist for women, not even as the end product of photographic techniques. Similarly, Joanna Frueh writes of *Carving* that "just as the Classical Greek nude occludes women's bodies in this kind of aesthetically rigid form, so the socially correct beautiful body disciplines and punishes women, through frustration, guilt, anxiety, and competitiveness with other women."[30]

Despite the considerable critical attention giving to *Carving,* much of what makes it a complicated work is the ethnic subtext, which has been largely ignored. While Chicago's assimilation was eased by the facility with which she associated herself with the socially normative group (famous white Christian women), Antin uses her own body as the subject of *Carving* and in so doing forces us to consider what it means to be both an embodied female and a member of an ethnic minority. In this regard, Antin's attempt to exert formal control over her own body and achieve the aesthetic ideal required also has a great deal to do with societal constructions built

upon body differences, a legacy not only of art history but also of the physiognomically based racial theories of the nineteenth century. It is significant in this respect that *Carving* references police or medical photographic and cinematic practices of the early twentieth century in which discourses of physiognomy, photographic science, and aesthetics coincided and overlapped.

Antin establishes this connection between her work and earlier medical and scientific photographic and cinematic discourse by using a sequence of photographs that looks almost like film stills: the stills present her isolated body, which changes slightly from frame to frame, standing against a stark white background in a seemingly exhaustive catalogue of gestures and poses. In this sense we can view Antin as playing off earlier traditions to mark herself as Jewish. The cultural critic Sander Gilman writes on medical theories about the difference of the Jewish body and explains how these included a theory of adaptability: "One form of that difference was their [Jews] uncanny ability to look like everyone else (that is, to look like the idealization of those who wanted to see themselves as different from the Jew)."[31] With such theories in mind, Antin's project can be seen as her inability to adapt to the ideal and thus to assimilate as an unmarked subject. Unlike Chicago, Antin does not offer an easy solution to the dilemma of being both Jewish and female. Instead she points to the limits of fitting in, by presenting a series of anti-aesthetic photographic self-portraits that refuse to offer a neutral and undisturbing aesthetic experience.

Domestic Peace: An Exhibition of Drawings (1971), though less well known than *Carving*, operates in a similar way, in the sense that it offers no easy solution to the dilemma. Moreover, unlike other renowned works from the period, such as Judy Chicago's *Dinner Party, Domestic Peace* allowed Antin to explore the equally taboo subject of conflict in mother-daughter relations in the context of her own Jewish family. Given its unusual focus and the fact that art history tends to privilege references to high culture over the popular and the everyday, it is not surprising that this project has received less attention from both the art world and the feminist community than the other works discussed so far. According to Cindy Nemser, "The art world did not like it because it disrupted the whole romantic myth of the artist as someone who doesn't have the same everyday family connections as everyone else."[32] If artists felt uneasy with it because it dealt with the taboo topic of bourgeois Jewish family relations, feminists kept their distance because it was at odds with accepted white feminist notions of the mother-daughter bond as an arena for noncontentious women's connections and social activism (Fig. 25). Antin's previously unpublished explanation of this conceptual work reveals generational differences between Jewish women, suggesting that the kind of independence feminism offers women artists can become a divisive force between certain mothers and daughters:

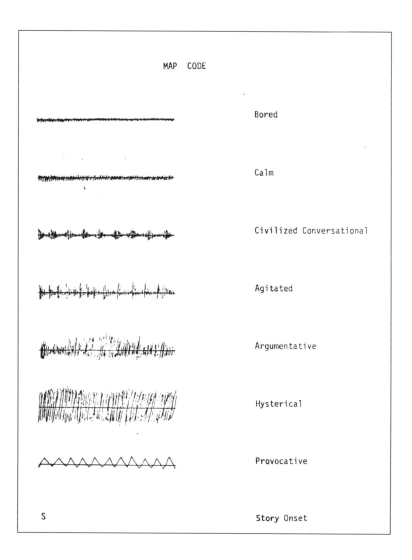

MAP CODE

Bored

Calm

Civilized Conversational

Agitated

Argumentative

Hysterical

Provocative

S

Story Onset

FIGURE 25
Eleanor Antin, *Domestic Peace,* "Map Code," 1971.

I live in California and from Nov. 29–Dec. 15, 1971—a period of 17 days—I planned to visit NYC with my husband and small child. It would serve our economic and domestic convenience but was also an opportunity for me to discharge familial obligations. However, though my mother insists upon her claim to the familial she is not at all interested in my actual life but rather in what she considers an appropriate life. No matter what kind of life a person leads he can always, by careful selection, produce an image corresponding to anyone else's view of appropriateness. By madly ransacking my life for all the details that suited my mother's theory of appropriateness and by carefully suppressing almost all the others, I was able to offer her an image of myself that produced in her "a feeling

of closeness." It should be kept in mind that this "closeness" was a "closeness" to her theory rather than to her life but appeal to her didacticism was the only way to give her sufficient satisfaction to ensure the domestic peace necessary to free me for my own affairs. I planned a daily set of conversational openers consisting of carefully chosen stories. Several of these stories contained slightly abrasive elements which might be expected to mitigate peace. I considered these to be alternates for use only on "good" days. For those hectic times when I would be forced to remain in the apartment for fairly long periods, I kept a set of reserves I could throw in to hold the line. Hopefully, these stories would act as gambits leading to natural and friendly conversation.[33]

Antin could never have the "domestic peace" she desired on her own terms, nor could it ever conform to nostalgic feminist notions of harmony between mothers and daughters. Neither does it follow the more conservative, mythic script of the gifted (usually male) artist who is separate from economic, social, familial, and sexual relations and therefore does not need "domestic peace." The project highlights mother-daughter relationships as the sites of private warfare, in which female conflict is the norm. To achieve "peace" during the periods when she must remain in her mother's house for a long time, Antin would stage a set of conversations to coincide with "what her mother considered revealing of an appropriate middle-class life," such as a sixty-minute discussion of the artist's purchase of a green velvet love seat (Fig. 26).

These conversations, specifying a white Jewish ethnicity situated in middle-class affluence, were short and peaceful by comparison with others that posited the possibility of enjoying a different form of consumption deviating from her mother's notion of middle-class success. The latter type of conversation is exemplified by a seven-hour agitated interaction between mother and daughter that most likely took place while they did other things around the house (Fig. 27). The story included in the piece is a half hour of calm during that conversation when Antin discourages her mother from shopping at GoodWill stores in California because the "stuff is low class." Trying to gain her mother's acceptance, she says, "Even if they had bargains you wouldn't want them." Those conversations that explored ideological conflicts between middle-class Eastern Europe Jews and African Americans (Antin's mother was working as a clerk in a state office at the time), delving into class and even racial tensions in the Jewish community, created the strongest disagreements and conflicts between mother and daughter, as evidenced by the way that Antin satirizes her mother's hypocritical racial politics in one of the charts in the piece (Fig. 28).

Domestic Peace reveals how harmony and calm between mother and daughter come only at the price of the artist's own silence. Yet the parodic form of the proj-

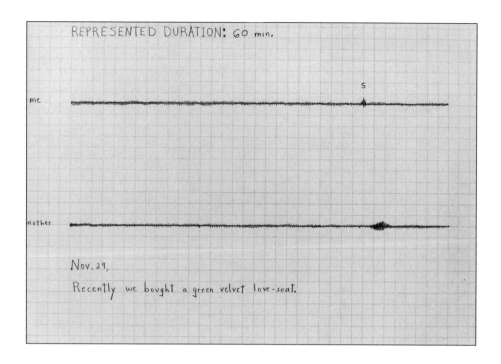

REPRESENTED DURATION: 60 min.

me

S

mother

Nov. 29,

Recently we bought a green velvet love-seat.

FIGURES 26-28

Eleanor Antin, *Domestic Peace*: (*above*) "Nov. 29, 1971," (*following page, above*) "Dec. 15, 1971," and (*following page, below*) "Dec. 5, 1971."

ect—the exaggerated way it meticulously records in a pseudo-scientific manner the reactions to various conversations—frequently enables Antin to transcend the oppressiveness of these relations, since its satirical mode of discourse renders explicit the points of tension. In this respect, *Domestic Peace* has a lot in common with Antin's two *Encounter and Withdrawal* pieces, which also deal with the problematic bond between women, but in a setting that ordinarily would not encourage the examination of their differences—a feminist consciousness-raising group of women artists in San Diego in 1972 and 1975. The performance piece consisted of four declarations that were officially signed and stamped by a notary in advance of the group's meeting (Figs. 29 and 30). *Encounter,* "#1" provides an example:

> At the February 20th meeting, I shall take on the job of ombudsman. This will necessitate my pointing out to each member of the group, and in any manner I choose, a particular failing she displays in relation to the others. These may be of an ephemeral sort such as personal bugginess taken out on someone else or of a

REPRESENTED DURATION: 7 hrs.

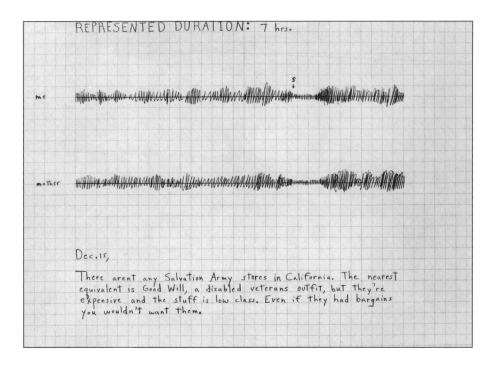

me

S
↓

mother

Dec. 15,

There arent any Salvation Army stores in California. The nearest
equivalent is Good Will, a disabled veterans outfit, but they're
expensive and the stuff is low class. Even if they had bargains
you wouldn't want them.

REPRESENTED DURATION: 110 min.

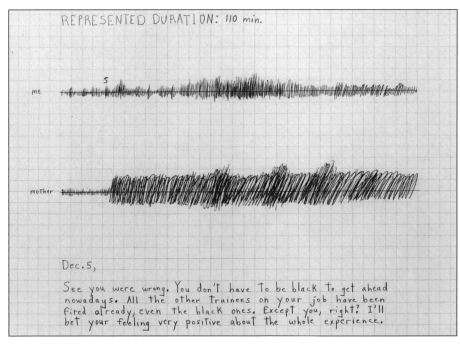

me

S
↓

mother

Dec. 5,

See you were wrong. You don't have to be black to get ahead
nowadays. All the other Trainees on your job have been
fired already, even the black ones. Except you, right? I'll
bet your feeling very positive about the whole experience.

more serious nature like, say, a rip-off of the entire group. I must always keep in mind that my statements are intended to bring about more satisfactory behaviour from the others and are never to be used for egotistic purposes of my own. I must complete these 8 tasks before the group normally disperses otherwise I must keep the session going by whatever means I can until I do complete them.[34]

This piece is unusual for the way Antin perversely performs the problem that she claims to identify and to remedy. At first, the use of the official rhetoric of the notary document itself, with its seal and signature, seems to suggest female authoritarian behavior since it references a legal discourse that opens the women in the group to unexpected scrutiny and observation. On closer inspection, however, Antin's use of such a device is performative in that it dislodges the women from the pretense of a safe utopian environment and puts them back within a context that re-creates the more complex pressures the art world and academia present for feminists such as Antin (who was a university professor at the time): hierarchy, competition, and distrust on the one hand and coalition, mentorship, and respect on the other. Moving beyond simple utopian feminist art projects of the period, Antin's piece stages the complex relations of betrayal, knowledge, and power among women and reminds the viewer of the more unsightly side of feminism. It is important that the pieces were produced in secret and have never been publicly exhibited, for this suggests that, even in a progressive social movement such as feminism, many issues at the time were left unexamined. Despite the rhetoric of openness that seemingly prevailed, problems and imbalances in the group were not addressed, and thus the artist was not willing to risk being misunderstood or perceived as disloyal.

Besides the content of Antin's conceptual pieces discussed so far, the spareness and coolness of her work distance it from the traditional melodramatic gestures of an immigrant Eastern European Jewish culture and the presumed highly emotional content of Jewish ethnic relationships. Conflict, anger, and disagreement between and among women are mapped by codes, graphs, or a notarized document. Official documents stand in for the pressure to assimilate and adopt the relatively more controlled body language of Anglo-American northern European culture, which has stigmatized expressive gestures as signs of backward and uncultivated societies. In both *Domestic Peace* and *Encounter and Withdrawal,* Antin satirizes bourgeois codes of etiquette, privacy, politeness, and good manners in a way that reduces these codes to their hypocritical core. Even the women's movement does not escape Antin's critical scrutiny.

In certain ways Antin's work reveals her interest in addressing the discourse of modernism, if only to critique and occasionally reference it, as she does in the 1970s

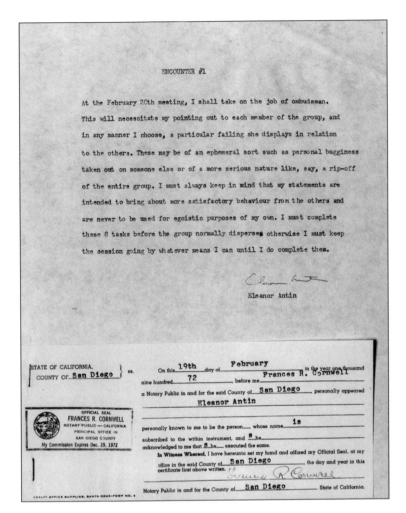

FIGURE 29

Eleanor Antin, *Encounter,* "#1," 1972.

construction of an invented autobiography of the black ballerina Eleanora Antinova from Diaghilev's Ballets Russes. Moreover, there is a tendency in Antin's work to mime and parody whiteness. In this respect her work reveals complexities in the relations between feminism and modernism, both movements in which she participates. The intersections of race, ethnicity, and culture do not appear in the projects of Antin's discussed so far, since even in *Encounter,* "#1" (see Fig. 29) Antin speaks about differences between women in a feminist space occupied exclusively by middle-class Euro-American women. It is only in her invented autobiographies, each of which experientially re-creates a character and a history, that she deals directly with other kinds of difference—though she references other models of difference in Europe and Russia more often than the United States. In many of her per-

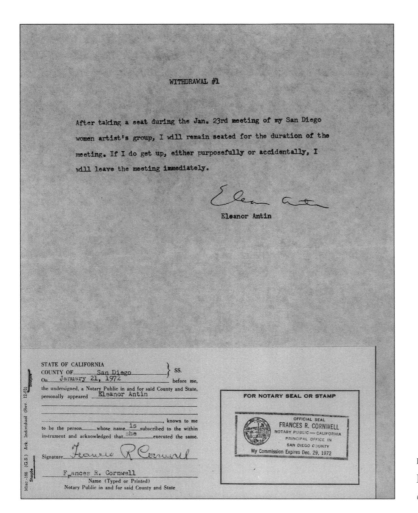

WITHDRAWAL #1

After taking a seat during the Jan. 23rd meeting of my San Diego women artist's group, I will remain seated for the duration of the meeting. If I do get up, either purposefully or accidentally, I will leave the meeting immediately.

Eleanor Antin

STATE OF CALIFORNIA
COUNTY OF_____San Diego_____ } SS.
On____January 21, 1972____ before me, the undersigned, a Notary Public in and for said County and State, personally appeared ____Eleanor Antin____

_____, known to me to be the person____whose name__is__subscribed to the within instrument and acknowledged that__she____executed the same.

Signature__Frances R Cornwell__

F.ances R. Cornwell
Name (Typed or Printed)
Notary Public in and for said County and State

FOR NOTARY SEAL OR STAMP

OFFICIAL SEAL
FRANCES R. CORNWELL
NOTARY PUBLIC — CALIFORNIA
PRINCIPAL OFFICE IN
SAN DIEGO COUNTY
My Commission Expires Dec. 29, 1972

FIGURE 30
Eleanor Antin, *With-drawal, "#1,"* 1972.

formances Antin deliberately situates herself in the margins and plays British or European roles—the Seventeenth Century French King, Florence Nightingale, or the black Russian prima ballerina Eleanora Antinova, a work that takes the form of photographs, personal memoirs, and a performance piece. In this project Antin performs in blackface to posit Russian ballet as a "white machine" but constructs herself as "black" to resist conforming to an image of what an unmarked white woman performer should be:

> I have a curved spine, my breasts are too large, my legs too short, my feet are weak, they bleed after *pointe* work, my skin is too dark to be a ballerina. Ballet is, after all, a white machine. There's very little room for life in it. I was a black face in a snow bank.[35]

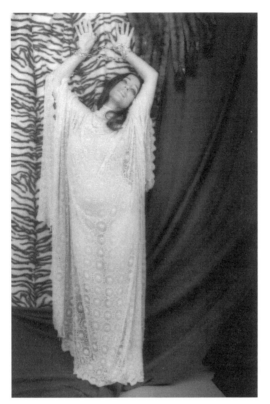

FIGURE 31

Eleanor Antin, "Eleanora Antinova in 'L'Esclave,' " from *Recollections of My Life with Diaghilev,* 1983.

FIGURE 32

Eleanor Antin, "Eleanora Antinova in 'Pocahontas,' " from *Recollections of My Life with Diaghilev,* 1983.

By presenting herself as "black"—rather than simply as white and Jewish—Antin seems to suggest how unimaginable it is that Jews like herself, who have assimilated to the point that they now appear indistinguishable from dominant white Americans, could have had parents or grandparents who were arbitrarily distinguished by race. Thus Antin dresses up in "blackface" to treat stereotypes of, and discrimination against, Jews as ideologically akin to such treatment of blacks.

Though Antin's black ballerina, Antinova, ostensibly belongs to Diaghilev's Ballets Russes, she descends not so much from the world of Martha Graham and Balanchine as from a whole tradition of vaudeville and theater in which Jewish as well as black women were regarded as exotic and erotic spectacles. Antinova's mem-

FIGURE 33
Eleanor Antin, "Eleanora Antinova in 'The
Hebrews,' " from *Recollections of My Life with
Diaghilev,* 1983.

FIGURE 34
Eleanor Antin, "Eleanora Antinova in 'Before the
Revolution,' " from *Recollections of My Life with
Diaghilev,* 1983.

oirs, written by Antin, present a complex commentary on the marginalization of both Jewish and black women in exoticized modernist dance like that Diaghilev produced. Each dance Antin creates for Antinova parodies dances an American black or Jewish ballerina might have been forced to perform in a European dance company: Antinova as a slave girl in a ballet where she does not move her feet (Fig. 31); or as Pocahontas (Fig. 32); or as the dancer of "The Hebrews" (Fig. 33). These dances thus comment on the confining roles of "otherness" and the exotic that American Jews and blacks occupy in European modernist ballet. Antin's critique challenges an exclusive class and racial system that defines a set of normative high-cultural practices against which all are measured and into which all are expected to fit. In

her parodic performance as Marie-Antoinette the shepherdess (the queen dressed as working-class Other), Antin ironizes an older form of appropriating otherness and thus undercuts any notion that a transcendent racial and class position can be easily occupied (Fig. 34).

Whereas some of the power of the works by Antin and Chicago discussed here is contingent on their ethnic subtext, these artists have more recently produced work that explicitly reflects that they are both white and Jewish. I am referring to Judy Chicago's book *Holocaust Project: From Darkness into Light* (1993) and to Eleanor Antin's film *The Man without a World* (1991), a simulation of a silent-era Yiddish film.[36] Both of these newer projects display some consistency with their earlier works. Chicago is still producing iconic images that deal on a literal level with unquestionable oppression, though this time it is the Nazis rather than American men who are the perpetrators. Antin turns to shtetl life in Poland, in a satirical way not unlike that of her earlier projects on women, to present the heterogeneity of identities among Jews, revealing that the shift toward Jewish assimilation that took place decades later in the United State was anything but uniform.

By historicizing Chicago's and Antin's work in terms of gender, race, and ethnicity, I have attempted here to affirm the struggles and to indicate the blind spots of older Jewish feminist artists. The work of these women generates the feminist work of the present. Women working and writing on the arts today should continue to rethink their relationship to earlier generations of feminists and to challenge entrenched perceptions of feminist generational differences. An intergenerational dialogue is crucial for historical critique and a feminist future.

Notes

1. See Sander L. Gilman, *The Jew's Body* (New York: Routledge, 1991); Ann Pelligrini, *Performance Anxieties* (New York and London: Routledge, 1997); and Richard Dyer, *White* (London: Routledge, 1997).

2. For further discussion of this generational shift in feminist art history, see Griselda Pollock, ed., *Generations and Geographies in the Visual Arts: Feminist Readings* (London: Routledge, 1996); Griselda Pollock, "The Politics of Theory: Generations and Geographies: Feminist Theory and the Histories of Art Histories," *Genders,* no. 17 (Fall 1993); Janet Wolff, "The Artist, the Critic and the Academic: Feminism's Problematic Relationship with 'Theory,' " in *New Feminist Art Criticism,* ed. Katy Deepwell (New York: Manchester University Press, 1995), 14–19; Thalia Gouma-Peterson and Patricia Mathews, "The Feminist Critique of Art History," *Art Bulletin* 69 (September 1987): 326–57; Amelia Jones, "Postfeminism, Feminist Pleasures, and Embodied Theories of Art," in *New Feminist Criticism: Art, Identity, Action,* ed. Joanna Frueh, Cassandra L. Langer, and Arlene Raven (New York: HarperCollins, 1994), 25–29.

3. Norma Broude and Mary D. Garrard, "Introduction: Feminism and Art in the Twentieth Century," in *The Power of Feminist Art: The American Movement of the 1970s, History and Impact,* ed. Broude and Garrard (New York: Abrams, 1994), 10.

4. Yolanda López and Moira Roth, "Social Protest: Racism and Sexism," in *The Power of Feminist Art,* 140.

5. Ella Shohat, "Ethnicities in Relation: Toward a Multicultural Reading of American Cinema," in *Unspeakable Images: Ethnicity and the American Cinema,* ed. Lester D. Friedman (Urbana and Chicago: University of Illinois Press, 1991), 217.

6. Lucy Lippard, "Uninvited Guests: How Washington Lost 'The Dinner Party,'" *Art in America* 79, no. 12 (December 1991): 39–49; Amelia Jones, "Sexual Politics: Feminist Strategies, Feminist Conflicts, Feminist Histories," in *Sexual Politics: Judy Chicago's* Dinner Party *in Feminist Art History,* ed. Amelia Jones (Berkeley and Los Angeles: University of California Press, 1996), 84–118; Michèle Barrett, "Feminism and the Definition of Cultural Politics," in *Feminism, Culture and Politics,* ed. Rosalind Brunt and Caroline Rowan (London: Lawrence and Wishart, 1982). The exception is Nancy Ring's article in the *Sexual Politics* anthology, entitled "Identifying with Judy Chicago." Though I found Ring's article useful for this essay because it provides a detailed analysis of the impact of ethnicity on Chicago's life as well as on her own, its biographical and autobiographical approach to Chicago offers a perspective different than my own. Drawing from a multiculturalist, theoretical perspective that considers Jewish identities in relation to other political issues, including feminism and colonial discourse, I am less concerned with evaluating or identifying with Chicago the person than I am with examining how Chicago's treatment of ethnicity relates to the other seemingly contradictory combination of discursive frameworks and ideologies she was working from.

7. Judy Chicago, *Through the Flower: My Struggle as a Woman Artist* (New York: Doubleday, 1975), 63.

8. Miriam Schapiro, "Interview with Amelia Jones, 21 July 1994," in *Sexual Politics,* 75.

9. Johannes Fabian, *Time and the Other: How Anthropology Makes Its Subject* (New York: Columbia University Press, 1983).

10. Inspired by the debates on multiculturalism and Eurocentrism, new conversations among Jews are taking place in the arts. See Lisa Bloom, "Ghosts of Ethnicity: Rethinking Art Discourses of the 1940s and 1980s," *Socialist Review* 42, nos. 1 and 2 (1994): 129–64; Norman Kleeblatt, ed., *Too Jewish: Challenging Traditional Identities* (New Brunswick, N.J.: Rutgers University Press; New York: Jewish Museum, 1996).

11. The concepts of canonization and artistic genius have long been debated by feminist art historians. See Griselda Pollock, "Artists, Mythologies and Media Genius, Madness and Art History," *Screen* 21, no. 3 (1980); Janet Wolff, *The Social Production of Art* (New York: Macmillan, 1981); Linda Nochlin, *Women, Art, and Power and Other Essays* (New York: Harper and Row, 1988); Eunice Lipton, "Here Today, Gone Tomorrow? Some Plots for a Dismantling," in *The Decade Show: Frameworks of Identity in the 1980s* (New York: New Museum of Contemporary Art and the Harlem Museum, 1990). See now Catherine M. Soussloff, *The Absolute Artist: The Historiography of a Concept* (Minneapolis: University of Minnesota Press, 1997).

12. As Amelia Jones points out in "The 'Sexual Politics' of *The Dinner Party: A Critical Context*," 107–9, Chicago's investment in masculinist notions of greatness was very much in keeping with early art-historical feminist writing from the period, in particular Linda Nochlin's famous essay "Why Have There Been No Great Women Artists?" (first published in 1971 in *Art News*), in *Art and Sexual Politics,* ed. Thomas B. Hess and Elizabeth C. Baker (New York: Macmillan, 1973), 1–43.

13. Michèle Barrett, "Feminism and the Definition of Cultural Politics," in *Feminism, Culture and Politics,* ed. Brunt and Rowan, 44.

14. For further discussion of this generational shift, see the works cited in note 2.

15. Quoted in Amelia Jones, "The 'Sexual Politics' of *The Dinner Party*," 103.

16. In her 1979 *Dinner Party* book, Chicago explicitly associates herself with Michelangelo, writing "I can imagine how Michelangelo must have felt—twelve years at that ceiling." *The Dinner Party: A Symbol of Our Heritage* (Garden City, N.Y.: Doubleday, 1979), 29. Also quoted in Amelia Jones, "The 'Sexual Politics' of *The Dinner Party*," 105.

17. Judy Chicago, *Beyond the Flower: The Autobiography of a Feminist Artist* (New York: Viking, 1996), 15–16.

18. Ibid., 20.

19. Ibid., 20–21.

20. Norman Mailer, "The White Negro: Superficial Reflections on the Hipster" (1957), in *Advertisements for Myself* (New York: Andre Deutsch, 1964).

21. Judy Chicago, *Embroidering Our Heritage: The Dinner Party Needlework* (Garden City, N.Y.: Anchor Books), 265.

22. Amelia Jones, "Sexual Politics: Feminist Strategies, Feminist Conflicts, Feminist Histories," 22.

23. Amelia Jones refers to another critique of Chicago written in 1978 by Estelle Chacom, a woman who represented a group of Chicanas from the National Women's Political Caucus. See "The 'Sexual Politics' of *The Dinner Party*," 100–01.

24. Ibid., 101; Alice Walker, "*One* Child of One's Own: A Meaningful Digression within the Work(s)" (1979), in *In Search of Our Mothers' Gardens: Womanist Prose* (San Diego: Harcourt Brace Jovanovich, 1983), 383.

25. Also see Lorraine O'Grady's more recent critique "The Cave," *Artforum* 30 (January 1992): 22.

26. For a more thorough discussion of this issue, see Nancy Ring, "Identifying with Judy Chicago," in *Sexual Politics,* ed. Amelia Jones, esp. 133–35.

27. Ibid., 133.

28. See Riv-Ellen Prell, "Why Jewish Princesses Don't Sweat: Desire and Consumption in Postwar American Jewish Culture," in *Too Jewish,* ed. Kleeblatt, 74–92.

29, Cindy Nemser, "Eleanor Antin," in *Art Talk* (New York: Scribners, 1975), 281.

30. Joanna Frueh, "The Body Through Women's Eyes," in *The Power of Feminist Art,* ed. Broude and Garrard, 195.

31. Sander L. Gilman, "The Jew's Body: Thoughts on Jewish Physical Difference," in *Too Jewish,* ed. Kleeblatt, 70.

32. Cindy Nemser, "Eleanor Antin," 282.

33. Collection of the artist.

34. This series by Eleanor Antin has never been exhibited or published. Collection of the artist.

35. Quoted in Henry Sayre, introduction to Eleanor Antin, *Eleanora Antinova Plays* (Los Angeles: Sun and Moon Press, 1994), 13.

36. For an excellent close reading of Eleanor Antin's 1991 feature film *The Man without a World,* see Jeffrey Skoller, "The Shadows of Catastrophe: Towards an Ethics of Representation in Films by Antin, Eisenberg, and Spielberg," *Discourse: A Journal for Theoretical Studies in Media and Culture* 19, no. 1 (Fall 1996): 131–59. The article examines the ways that Antin and other postmodern Jewish media artists deploy different representational strategies to reimagine the history of European Jewry and its culture beyond the popularly fetishized spectacle of its destruction. For information about Judy Chicago's *Holocaust Project: From Darkness into Light,* contact Through the Flower, 101 North Second Street, Belen, N.M. 87002. See also *The Holocaust Project: From Darkness into Light,* with photographs by Donald Woodman (New York: Viking Penguin, 1993).

Art Historians and Critics

Art History, German Jewish Identity, and the Emigration of Iconology

KAREN MICHELS

Art history, a relatively young discipline in German universities in 1900, has since then attracted a high proportion of Jewish intellectuals.[1] Approximately one-quarter of the art historians active in Germany and Austria around 1930 were of Jewish origin;[2] almost all of them were expelled by the Nazis after 1933. This percentage was unusually high vis-à-vis that of both other disciplines and the population as a whole. Several explanations suggest themselves. There may have existed a special German Jewish affinity for the arts in general and for visual art in particular. This predilection might be explained by the process of emancipation and assimilation in which the majority of German-speaking Jews had participated since the early eighteenth century. The fathers of the art historians forced to emigrate from 1933 onward had belonged primarily to the few professions that Jews were allowed to practice; among them were numerous lawyers, doctors, businessmen, bankers, factory owners, and art dealers.[3] Music and art as leisure occupations had played an important role among these families. The profession of art history, however, seems to have appealed particularly to the generation born around the turn of the century. They wished to make their parents' cultural pursuits their own professions by studying the arts at a university. In this decision they hoped not only to follow their personal inclinations, but also to take another step toward assimilation into bourgeois German society. Many of them studied art history, so that from the early 1930s Jews were overrepresented in this field.[4] It was not unusual, however, for these young Jews, at the instigation of their parents, to undertake and sometimes even to complete a course of study that promised greater financial security—such as law or economics—before embarking on their studies in art history.

The wish to assimilate determined not only the choice of profession but also the social conduct of these families. The students took pride in attending the *humanistisches*

Gymnasium,[5] and their parents, in the high standards of their children's education there. In the Gymnasium the foundations were laid for an attitude toward the humanism felt to be the precondition of assimilation. This attitude, encompassing the ideals of culture and reason, individualism and rationality, accorded not only with the general views of assimilated Jews but also with the convictions and traditions of most German Christian scholars. In the educational milieu humanistic educational principles had now replaced religion. If they could translate into societal reality the ideas of the Enlightenment and German idealism—of Goethe, Kant, and Lessing—German Jews would, they hoped, solve several problems at once: individuals could fully develop their personality, and a reformed society would gradually render religious and ethnic differences insignificant.

Because Jewish art historians did not form a homogeneous group, it is necessary to generalize to determine the differences between them and their non-Jewish colleagues. The most striking difference with respect to German mainstream art history was the tendency of Jewish art historians to deal predominantly with the source of humanistic ideals, that is, with Renaissance topics. The best-known example is the group of scholars around the Kulturwissenschaftliche Bibliothek Warburg in Hamburg. Among them were not only art historians, but also philosophers, philologists, archaeologists, and historians, all trying to overcome the traditional boundaries between academic disciplines. These scholars defined themselves as *Kulturwissenschaftler.*[6] A favorite subject of theirs was the development of Kantian philosophy, as revitalized by the neo-Kantians, most prominent among them Hermann Cohen (1842–1918) and Ernst Cassirer (1874–1945). Erwin Panofsky (1892–1962), above all, transferred neo-Kantianism to the field of art history. The majority of Jewish art historians did not concern themselves with Jewish topics. The Berlin art historian Adolph Goldschmidt (1863–1944), for example, was an internationally renowned specialist in medieval ivories. Methodologically he favored an objective approach to research, characterized by distance from one's subject rather than identification with it.

For this first generation of Jewish university professors, objectivity and distance were seen as the means to avoid anti-Semitic prejudice. Remaining outside the realm of religion seemed to permit a position of neutrality. If they worked on Jewish topics at all, Jewish scholars tried to suppress any hint of personal interest.[7] A case in point is Richard Krautheimer's (1897–1994) thesis on medieval synagogues,[8] written in the dry positivistic style of his teacher Paul Frankl (1878–1962).[9] According to James Ackerman, one of Krautheimer's students, had Krautheimer been unable to assume this stance, he would surely have avoided the topic.[10] In all his later works, which never again dealt with Jewish art, Krautheimer took a decidedly neutral stance. Panofsky too dealt with Jewish questions only once, in a 1921 lecture to the Hochschule für die Wissenschaft des Judentums zu Berlin that was published

only posthumously.[11] This lecture on "Rembrandt and Judaism" indicates an anthropological rather than a personal interest, yet it bears witness to Panofsky's intensive study of Baruch Spinoza, who, as a heretic, had become a figure with whom twentieth-century Jewish intellectuals identified.[12] Only a small group of art historians, among them Alfred Werner (1911–1978) and Rachel Wischnitzer-Bernstein (1885–1989), had shown Zionist sympathies in their ready involvement in the study of Jewish art before their expulsion from Germany. Both Werner and Wischnitzer-Bernstein were, however, active on the periphery, not in the mainstream of the discipline. Werner had studied law and philosophy rather than art history, and later he earned his living in adult education. Wischnitzer-Bernstein had graduated as an architect and later worked, without institutional affiliation, on topics of Jewish cultural history. In contrast, Franz Landsberger (1883–1964), Guido Schönberger (1891–1974), and Hermann Gundersheimer (b. 1903) first became interested in Jewish history after their dismissal from their academic posts in 1933 and during their subsequent work at the Museum Jüdisches Alterhaüser in Frankfurt and the Jüdisches Museum in Berlin. All three pursued the topic further in their American exile: Landsberger at the Hebrew Union College (Cincinnati); Schönberger at the Jewish Museum (New York) and, less intensively, in his teaching position at the Institute of Fine Arts of New York University; and Gundersheimer at Temple University (Philadelphia).

The resistance of the families of German Jews to their children's serious study of art history in the early years of the century was matched by the resistance Jewish graduates confronted upon the completion of their studies. When it came time for their second qualification for a professorial position (*Habilitation*) or for obtaining a full professorship, they were again poignantly reminded of their origins. Richard Krautheimer in his memoirs recalls his *Habilitation* process, discreetly leaving the offending professor anonymous: "The professor whom I first approached was not averse to taking me on. Then came the surprise: 'Are you a Jew, Doktor Krautheimer?' 'Yes, I am, Sir.' 'That can, of course, be changed?' 'I am afraid not, Sir.' That was the end of that interview. And I was not then, and am not now, a practicing Jew; or a nationalist Jew, a Zionist. I reacted completely spontaneously to an immoral and an indecent demand, and very definitely with the feeling of having obligations towards my own origins."[13] Krautheimer's second attempt was more successful: Richard Haman (1879–1961) in Marburg accepted his thesis on the construction of synagogues in the Middle Ages unconditionally.[14]

Employment policy was problematical for Jewish art historians. If the museums, up to the level of curator at any rate, were relatively open to them, the universities accorded those Jews who had gained access to the academic system through the *Habilitation* posts the title *Ausserordentliche Professoren* only (they were not full members of the university staff).[15] Until 1933 only three Jewish art historians had attained a

full professorship: Adolph Goldschmidt, Paul Frankl, and Erwin Panofsky.[16] Panofsky secured his position because the liberal director of the Hamburg Kunsthalle, Gustav Pauli (1866–1938), energetically advocated his cause at the start of his career in 1920. Hamburg was a liberal university, founded in 1919 with great support from the Jewish citizens and businessmen of Hamburg. Yet even as a new institution unburdened by an anti-Semitic tradition, the University of Hamburg could offer Panofsky only an unsecured post with the prospect of later tenure—a situation that would not have been attractive to more established scholars.

Before the National Socialists assumed power (in 1933), the majority of the German Jewish educated elite enjoyed a social environment in which they experienced progressive emancipation and developing tolerance from the state and their fellow Germans. Incidents of anti-Semitism were trivialized as individual aberrations and, from the elevated position of the Jewish intellectuals, all but ignored.[17] Consciously unaggressive and reticent behavior was characteristic of these assimilated Jews. The looming danger of Hitler's increasing following did not cause them to deemphasize their Germanic identity, so dearly won and often difficult to maintain. They viewed themselves as citizens of a constitutional state and as members of a civilized nation. They simultaneously despised as "barbarous" and grossly underestimated National Socialist policy.[18] The idealist paradigm blinded German Jewish intellectuals to the reality that was soon to materialize with extraordinary brutality. Legislative changes in 1933 altered their situation dramatically. Individual identity was no longer defined by the individual but by the state. The concept of equal rights for all citizens was rejected. The state now decided who was German, or "Aryan," and who was a Jew. For all of their enlightened heritage, the victims of this legislation were powerless against it. Though their identity as German Jews was severely tested by the "barbaric" legislation, they did not accept the racist definition of that identity.

Persecution and expulsion did not, as could have been expected, lead to any recognizable process of radicalization, politicization, or solidarity in the group of art historians who immigrated to America.[19] The art historians did not respond to the German policy of genocide with a new group identity based on their common interests or common origins. Instead, these émigrés concentrated on joining the American professional associations and on trying to adjust to the American way of life. Their relationship to Judaism remained ambivalent and was frequently marked by a certain distance. It is difficult to evaluate this response. Perhaps it reflects the readiness to assimilate that had been developed over generations in those German Jews who, to ensure their own survival, had assumed an ambivalent attitude to all matters Jewish and particularly to orthodox and to Eastern European Jews.[20] Erwin Panofsky remarks in a letter to Walter Friedlaender in 1933 that he has no difficulty seeing why the "New York millionaires" are "totally fed up with the the expelled

Jews."[21] But there was also a new tendency to manifest Jewishness openly. Panofsky, for example, together with Albert Einstein, worked for a Jewish aid organization, the United Jewish Appeal.[22] He also gave a funeral oration for one of the founders of the Jewish community in Princeton;[23] his wife Dora, moreover, to some extent regretted her sons' mixed marriages.[24] Generally, however, the patterns of behavior brought to America from Germany did not change much. The refugee scholars again tried to adapt as fully as possible to a national identity. In America, however, the compensation for disappointments with reality was the Erasmian concept of an international republic of scholars.

Only in their opposition to the National Socialist Party of Germany were the émigré Jewish art historians united, a unity, shared with all the expelled Germans, that expressed itself in broad support in 1932 for the Democratic presidential candidate, Franklin Delano Roosevelt. Such politically diverse personalities as Thomas Mann, Heinrich Mann, Bertolt Brecht, and Panofsky felt compelled to vote for the Democrats.[25] Roosevelt carried all their hopes in the battle against Germany. Although external political criteria seemed far more important than internal politics for the majority of émigrés, Roosevelt's New Deal reforms were also to the taste of those who had been liberals in the Weimar Republic. Roosevelt's wife, Eleanor, who even after her husband's death in 1945 proved a passionate advocate for all European émigrés, played an important role in supporting their integration into American society.[26]

Even for those whose adaptation to the new life was successful, the psychic wounds inflicted on the refugees by the National Socialist persecution went deep, although it rarely showed openly. The typical reaction to anti-Semitism was to assume a superior, stoic stance, born of a continued belief in human dignity and humanistic values.[27] This attitude was expressed most markedly in a heightened sensitivity to manifestations of anti-Semitism and to the McCarthyism of the late 1940s and 1950s, as numerous letters and statements show. The anti-Jewish prejudice in America in various areas of life, such as the universities, had quickly become evident to the émigrés. Conservative East Coast society above all clung to a clear distinction between Jew and non-Jew.[28] As early as 1936 a disillusioned Panofsky wrote to Fritz Saxl in London that he was reckoning on "a reunion of our whole circle of friends in Honduras or Liberia, probably in 1940. By then things will have gone so far here too that Jews and Liberals will no longer be welcome."[29] In 1944 he reported to his friend and colleague Walter Friedlaender from Kennebunkport, where he was vacationing, that it was proving somewhat difficult to organize accommodations for Friedlaender's visit since "the situation is that all the hotels here don't want a Jew . . . with the exception of the real greats."[30]

Real concern was aroused, however, as may be detected in an alarmed letter from Panofsky to his friend Booth Tarkington, the American author, by the anti-Semitic

campaign propaganda of the Republican Party in the elections of 1944.[31] As a conservative Republican, Tarkington tried to allay all of Panofsky's fears and to explain American anti-Semitism as a "normal," xenophobic reaction that was sometimes directed toward one minority group and sometimes toward another: It was nothing but electioneering, not a political program. Panofsky agreed but, as a result of his experiences in Europe, remained skeptical when he perceived any potential for organized anti-Semitic hostility. Still, his philosophical attitude enabled him to view discrimination against Jews dispassionately: "It seems to be the historical mission of the Jews to contribute, like Socrates' gadfly, to the process of civilization by being a perennial nuisance, and responsibility for the results lies neither with the gadfly nor with the horse."

The swing to the right in the United States, which followed hard upon the death of Roosevelt, was impossible for the émigré scholars to ignore, particularly as the persecution of "un-American activities" under the auspices of Senator Joseph McCarthy began to extend even into the universities. This persecution was directed principally against Communists. With its nationalistic and anti-Semitic tendencies, the campaign soon included attacks on nonconformist intellectuals. It led to the severe repression of many intellectuals and artists and shattered the faith that the majority of the émigrés had placed in a free and democratic America.[32] A particular example was made of those who taught at the University of California in Berkeley, who in order to ensure the anti-Communist "cleansing" of the faculty were asked to take the loyalty oath introduced by President Truman in 1947. Anyone who refused was summarily dismissed.[33] It was not the relatively harmless text of the oath but rather the political arbitrariness and the rape of conscience underlying it that aroused in many émigrés the evil memory of National Socialism. The historian Ernst Kantorowicz (1895–1963), who had taught at Berkeley since 1939, publicly resisted. He was dismissed in 1950 and immediately thereafter appointed to a professorship at the Institute for Advanced Study in Princeton, whose private status placed it outside the sphere of state interference.[34] In a long and carefully argued essay, published privately, the otherwise conservative Kantorowicz threw the full weight of his authority and perspicacity as a historian and his experience in dealing with National Socialism into the balance to demonstrate the absurdity, and the danger, of the loyalty oath.[35]

His impressive plea for the freedom of conscience of the academic professions, a summa of European humanism, reflects upon the fundamental differences, as he saw them, in European and American concepts of the university and of scholarship. The administration of the University of California treated its professors as private employees whose status, in principle, was no different from that of any other employee. All were equally expected to follow the directions of their employer. Against this situation Kantorowicz pitted the privilege of the European university professor who,

independent like a priest or a judge, was answerable only to his own conscience.[36] To underscore his argument, he unfolded a vast panorama of learning and historical precedence. The art historian Walter Horn (1908–1997), who was also teaching at Berkeley and who, as a non-Jew, had left National Socialist Germany as an act of conscience, felt himself unable for financial reasons to refuse to take the oath and to risk dismissal. His letter to the university administration, written in a tone of resigned disappointment, was appended by Kantorowicz to his publication as an example of the ethical conflict in which numerous other colleagues also found themselves.[37]

Those émigrés who did not themselves immediately confront such a predicament also reacted to this "political inquisition."[38] In 1953 Panofsky pleaded in a speech to the alumni of Princeton University for intellectuals to assume a stance of social distance as a prerequisite for "social responsibility." The basic tenor of his plea accorded with Kantorowicz's exposition. Panofsky, as was his wont, couched his political purpose in more metaphorical terms and raised it to the more abstract level of learned discourse.[39] Kantorowicz had taken the offensive; Panofsky made a virtue of his intellectual distance from the politics of the day. According to his address, those like the faculty members of a university who find themselves above the hurly-burly of everyday life have a far better overview of events and are thus able to perceive more clearly when liberty is endangered. It is their duty as intellectuals to raise their voices against such dangers. Similarly, as a professor at Smith College, Edgar Wind (1900–1971), another émigré art historian, organized a symposium in 1953, "The Relation of Art and Morals." It dealt with the questions whether and how the artist should defend the values of civil society when they are in danger.[40] Among the participants were the architect Philip Johnson, the English-American poet W. H. Auden, and the philosopher George Boas.

The expulsion from Germany affected the way émigré art historians treated their material. It is possible to discern in their work after emigration a specifically Jewish concept of the self where Jewish topics are concerned. Most of Jewish art history had hitherto been a terra incognita. It was now defined and systemized by the German and Austrian émigrés. Most prominent in the study of Jewish religious objects were Rachel Wischnitzer-Bernstein, Alfred Werner, and, above all, Franz Landsberger, mentioned earlier, along with Stephen Kayser (1900–1988) and Guido Schönberger at the Jewish Museum in New York. They examined and classified these objects, using criteria of stylistic interpretation such as Henrich Wölfflin's basic principles. Landsberger wrote his successful *History of Jewish Art*,[41] Schönberger and Kayser published a catalogue of Jewish ceremonial objects,[42] and Wischnitzer-Bernstein compiled a comprehensive bibliography that contained, in addition to numerous other subjects, studies of the history of Jewish iconography and of the synagogue at Dura-Europos.

German Jewish scholars of the humanities salvaged their identity after their emigration by adhering to those principles of art-historical scholarship that had been formed in Germany. The émigrés conceived of themselves as true advocates of the German academic tradition, despite their readiness to adjust to the social and political conditions of America. The independence of the university as the "conscience of the nation," the academic community of professors and students, the indivisibility of teaching and research, and the *Gymnasium* as the mediating institution of a broad-based humanistic education were all integral to the tradition and the values that had contributed to the process of Jewish emancipation in Germany.[43] This process had been oriented not only to the improvement of personal living conditions but also to the utopian ideal of a human community based on tolerance, Kantian ethics, and reason. Faced with the National Socialist dictatorship in Germany and the perception of a renewed threat of discrimination in the United States, the émigrés held on to their deeply engrained set of Enlightenment values.

The preference for the Renaissance and its humanist and Neoplatonic patterns of interpretation shaped the mind-set of a large group of German Jewish intellectuals in art history and in the humanities in general. Where American research used the Renaissance to legitimize the American political system,[44] the émigrés used the same historical epoch as a cultural paradigm for the transmission of the values that had been responsible for Jewish emancipation in Germany. These included the liberty of the individual, the independence of reason in contrast to the dogma of religion, and the concept of universal human dignity. Ernst Cassirer examined the Renaissance as the "first Enlightenment," but in doing so never lost sight of the contradictions between the theoretical ideals espoused by the humanists and the social reality of intolerance and despotism.[45] This renewed emphasis on the Renaissance, but also on the protohumanism of the Middle Ages, produced a number of studies that focused on historical figures seen as paradigmatic individuals: Erwin Panofsky wrote on Dürer, Erasmus, and Galileo;[46] Ernst Kantorowicz on Petrus de Vinea;[47] Paul Oskar Kristeller on Marsilio Ficino;[48] Felix Gilbert on Bernardo Rucellai;[49] and Hans Liebeschütz on John of Salisbury,[50] to name but a few. These studies originated in the same outlook that governed the émigré art historians' belief in the humanizing potential of art. That the Renaissance as a whole offered Panofsky figures and ideas with which to identify is illustrated in his letter to the editor of the *Art Bulletin*, published in 1939. In it he refers to the "Neo-Platonic theory of life on earth as life in 'exile,' "[51] equating a life such as the one he lived with extreme idealism.

The concern of art history with humanistic and Neoplatonic topics was linked to a specific methodological approach, which came to be known as iconology. Originally developed in the circle around the Kulturwisensschaftliche Bibliothek

Warburg in Hamburg, a thriving yet still peripheral institution from 1915 to 1933, it was accepted with remarkable speed by American art historians. Iconology became an international approach in art history. As a method it came to dominate the field of art history and even influenced related disciplines, such as the sociology of culture. The "career" observable here of an initially marginal but, after its "emigration," unusually fruitful methodology has parallels in subdisciplines of such sciences as molecular genetics and nuclear physics.[52] Historians and sociologists of science have shown that Jewish researchers, because of their difficulties obtaining secure positions, exercised greater creativity than their established colleagues.[53] The academic environment of American universities, with its openness to new ideas, offered these Jewish scholars and scientists the chance to develop their innovative research strategies. The success of iconology and the perception of Renaissance art that emerged through the iconological perspective are thus closely linked to the emigration of Jewish art historians to America and to America's acceptance of the innovative methodology they brought with them. The difficulties of Jewish emancipation in Germany had engendered an intellectual and emotional investment on the part of these Jewish scholars in the ideals and values that had driven the emancipation process. Its catastrophic demise in Nazi Germany did little to change their fundamental attitudes.

Today, most art historians would not accept the validity of universal claims, such as those underlying Panofsky's iconology. We find it difficult to envision the humanization of society by purely intellectual means. The iconological method today is controversial, while other approaches seem to come closer to answering contemporary questions.[54] During the first half of the century, however, iconology was considered, at least in part, the methodological answer to contemporary concerns. The tragic irony is that the objectivity that served art historians so well as scholars proved so inadequate as a response in the political struggle preceding the advent of the National Socialists. The problems of the day, from their perspective, seemed of little import: "Success," wrote Gertrud Bing (1892–1964), a member of the Warburg circle, in 1926, "does not prove one to be right in questions of principle!"[55] They regarded ethical categories as timeless and unchangeable. For Ernst Cassirer, teaching at Yale University in 1944, this belief remained the basis of his worldview. Yet the events of the preceding years brought him closer to Judaism:

> No Jew whatsoever can and will ever overcome the terrible ordeal of these last years. The victims of this ordeal cannot be forgotten; the wounds inflicted upon us are incurable. Yet amidst all these horrors there is, at least, one relief. We may be firmly convinced that all these sacrifices have not been made in vain. What the modern Jew had to defend in this combat was not only his physical existence or the preservation of the Jewish race. We had to represent all those ethical ideas that

had been brought into being by Judaism and found their way into general human culture, into the life of civilized nations. And here we stand on firm ground. These ideals are not destroyed and cannot be destroyed. They have stood their ground in these critical days. If Judaism has contributed to break the power of the modern political myths, it has done its duty, having once more fulfilled its historical and religious mission.[56]

Notes

1. I would like to thank Charlotte Schoell-Glass and Catherine Soussloff for their generous help with the English version of my essay.

Of the estimated 1,100 academically trained art historians who were active in Austria and Germany before 1933, about 250 had to emigrate. See Karen Michels, *Transplantierte Kunstwissenschaft: Der Wandel einer Disziplin als Folge der Emigration deutschsprachiger Kunsthistoriker in die USA* (Berlin: Akademie-Verlag, 1998); and Ulrike Wendland, *Verfolgung und Vertreibung deutschsprachiger Kunsthistoriker im Nationalsozialismus: Ein biographisches Handbuch* (Munich: K. G. Saur-Verlag, 1998). Still fundamental are the first studies on this topic: Colin Eisler, "Kunstgeschichte American Style: A Study in Migration," in *The Intellectual Migration: Europe and America, 1930–1960,* ed. Donald Fleming and Bernard Bailyn (Cambridge, Mass.: Harvard University Press, 1969), 544–629; and Erwin Panofsky's famous text on the emigration of art history, "Three Decades of Art History in the United States: Impressions of a Transplanted European," in *Meaning in the Visual Arts: Papers in and on Art History*, ed. Erwin Panofsky (Garden City, N.Y.: Doubleday, 1955), 321–46.

2. Wendland, 99ff.

3. Ibid.

4. Ibid., 128. The Jewish art historians, in the main from prosperous families, were also in a position to finance a profession that offered no financial security over quite a long initial period.

5. An institution of higher education for pupils between the ages of eleven and eighteen, leading to an examination that was the precondition of access to a university education. Compulsory Greek and Latin specifically prepared students for the study of the humanities.

6. For this reason I am concentrating not only on art historians but also on persons such as the historian Ernst Kantorowicz and the philosopher Ernst Cassirer, who were trained in different fields but whose intellectual interests touched the field of art history.

7. The demand for unconditional objectivity and neutrality is one of the most important themes in the diaries of the Kulturwissenschaftliche Bibliothek Warburg, which was also known as a "laboratory." See diary 1, 31 January 1925, and diary 3, 8 December 1927, Warburg Institute Archive, London.

8. Richard Krautheimer, *Mittelalterliche Synagogen* (Berlin: Frankfurter-Verlags-Anstalt, 1927).

9. See Kevin Parker, "Art History and Exile: Erwin Panofsky and Richard Krautheimer," in *Exiles and Emigrés: The Flight of European Artists from Hitler*, ed. Stephanie Barron, with Sabine Eckmann (Los Angeles: Los Angeles County Museum of Art, 1997), 317–25.

10. James S. Ackerman, "Richard Krautheimer: An Homage," in *Rome: Tradition, Innovation, and Renewal: A Canadian International Art History Conference, 8–13 June 1987, Rome, in Honour of Richard Krautheimer on the Occasion of His Ninetieth Birthday and Leonard Boyle, O.P., Prefect of the Biblioteca Apostolica Vaticana* (Victoria, B.C.: University of Victoria, 1991), 93–126.

11. Erwin Panofsky, "Rembrandt und das Judentum," in *Jahrbuch der Hamburger Kunstsammlungen* 18 (1973): 75–108.

12. Michael A. Meyer, *Jewish Identity in the Modern World* (Seattle: University of Washington Press, 1990), 15.

13. Richard Krautheimer, *Ausgewählte Aufsätze zu europäischen Kunstgeschichte* (Cologne: DuMont, 1988), 11 (my translation).

14. Krautheimer later distanced himself from this work. In an extensive interview carried out within the framework of an oral history project of the Getty Center for the History of Art and the Humanitites, the work is not mentioned (Getty Center, Santa Monica, Calif., Ms.).

15. In 1930 there were ten Jewish Professors Extraordinary and seven private lecturers in Germany and Austria (Wendland, 125).

16. A total of ten percent of the art history professorships were thus occupied by Jews.

17. A prominent example was Cassirer's markedly reticent and mild behavior toward Martin Heidegger, with whom he disputed during the debate on the interpretation of Kant's "Critique of Pure Reason" in Davos in 1929; Cassirer obviously did not consider these debates a forum in which to dispute political positions. On the Cassirer-Heidegger debate, see John Michael Krois, "Aufklärung und Metaphysik: Zur Philosophie Cassirers und der Davoser Debatte mit Heidegger," *Internationale Zeitschrift für Philosophie* 2 (1992): 273–98; and Enno Rudolph, "Politische Phänomene nach Ernst Cassirer," in *Kulturkritik nach Ernst Cassirer*, ed. Enno Rudolph and Bernd-Olaf Küppers (Hamburg, Meiner-Verlag, 1995), 143–58. Warburg's widely known and paradoxical dictum "Nicht mal ignorieren" (Don't even bother to ignore) was reported by his nephew, Eric M. Warburg.

18. Panofsky wrote to Walter Friedlaender on 2 June 1932: "Now, as the general barbarism has emerged victorious. . . . In our little university there are also great political upheavals; I find myself in a rather exposed position through my actions and will most probably be one of the first to go when the idiots finally assume power" (my translation); Walter Friedlaender's Papers, Leo Baeck Archive, New York.

19. The twelve art historians who immigrated to Palestine were the exception at the time.

20. Meyer, *Jewish Identity in the Modern World*.

21. Panofsky to Friedlaender, 20 December 1933, Walter Friedlaender's Papers, Leo Baeck Archive, New York.

22. Panofsky, newspaper article, *Princeton Herald*, 2 May 1947, Princeton University Archives.

23. Panofsky, newspaper article, *Princeton Packet*, 2 January 1961, Princeton University Archives.

24. Gertrude M. Dubrovsky, "Jews in Princeton," *Princeton History: The Journal of the Historical Society of Princeton* 6 (1987): 30–38.

25. See Richard M. Ludwig, ed., *Dr. Panofsky and Mr. Tarkington: An Exchange of Letters, 1938–1946* (Princeton, N.J.: Princeton University Press, 1974), 42.

26. See Anthony Heilbut, *Exiled in Paradise: German Refugee Artists and Intellectuals in America, from the 1930s to the Present* (New York: Viking Press, 1983).

27. See Michels, *Transplantierte Kunstwissenschaft.*

28. Dubrovsky, "Jews in Princeton," 36ff., esp. note 24. For the topic in general, see Leonard Dinnerstein, *Antisemitism in America* (New York: Oxford University Press, 1994).

29. Panofsky to Saxl, 7 December 1936, Warburg Institute Archive, London.

30. Panofsky to Friedlaender, 15 July 1944, Walter Friedlaender's Papers, Leo Baeck Archive, New York.

31. Ludwig, ed., *Dr. Panofsky and Mr. Tarkington*, 44–52, esp. note 25.

32. Heilbut, *Exiled in Paradise*, 291ff., esp. note 26.

33. Ernst Kantorowicz, *The Fundamental Issue: Documents and Marginal Notes on the University of California Loyalty Oath* (San Francisco: Parker Printing Company, 1950). "The original text of the so-called Loyalty Oath, as suggested in June 1949, read: '. . . I do not believe in and am not a member of, nor do I support any party or organization that believes in, advocates for or teaches the Overthrow of the United States Government by any illegal, unconstitutional means' " (4).

34. Thirty-one others who had been teaching at the University of California as lecturers since 1948 were dismissed with him. They were rehabilitated when California's Supreme Court declared the oath unconstitutional in 1952. See Hans H. Christmann, "Deutsche Romanisten als Verfolgte des Nationalsozialismus: Vermächnis und Verpflichtung," in *Deutsche und österreichische Romanisten als Verfolgte des Nationalsozialismus*, ed. Hans H. Christmann (Tübingen: Stauffenburg-Verlag, 1989), 311.

35. Kantorowicz, *The Fundamental Issue*, see note 33.

36. Ibid., esp. 48.

37. Ibid., 41: "I wish to make it clear that I am acting against the better voice of my conscience—and for no other reason than to protect my family from financial hardship."

38. Ibid.

39. Erwin Panofsky, "In Defense of the Ivory Tower," in *Association of Princeton Graduate Alumni, Report of the Third Conference* (Princeton, N.J.: Princeton University, 1953), 77–84.

40. I am grateful to Christa Buschendorf for drawing this to my attention at a symposium on Edgar Wind in February 1996 at the Einstein Forum in Potsdam.

41. Franz Landsberger, *A History of Jewish Art* (Cincinnati, Ohio: Union of American Hebrew Congregations, 1946).

42. Stephen Kayser and Guido Schönberger, *Art of the Hebrew Tradition: Jewish Ceremonial Objects for Synagogue and Home* (Philadelphia: Jewish Publication Society of America, 1955).

43. George L. Mosse, *Jüdische Intellektuelle in Deutschland: Zwischen Religion und Nationalismus* (Frankfurt: Campus-Verlag, 1992), 34.

44. See Edward Muir, "The Italian Renaissance in America," *American Historical Review* 199 (1995): 1095–118.

45. Enno Rudolph recently commented on Cassirer's ambivalent picture of Macchiavelli, formulated in "Hegel's Theory of the State (1942)," in *Symbol, Myth, and Culture: Essays and Lectures of Ernst Cassirer, 1935–1945,* ed. Donald Phillip Verene (New Haven, Conn.: Yale University Press, 1979), 133–14, at a symposium in the Hamburg Warburg-Haus, 1–2 May 1996.

As Cassirer's work on the history and function of myth in National Socialist propaganda shows, the émigrés commented on the contemporary situation not only via the past but also directly.

46. Erwin Panofsky, *Albrecht Dürer* (Princeton, N.J.: Princeton University Press, 1943); idem, *Galileo as a Critic of the Arts* (The Hague: M. Nijhoff, 1954); idem, "Erasmus and the Visual Arts," *Journal of the Warburg and Courtauld Institutes* 32 (1969): 200–227.

47. Ernst Kantorowicz, "Petrus de Vinea in England," *Mitteilungen des Österreichischen Instituts für Geschichtsforschung* 51 (1937): 43–88.

48. Paul Oskar Kristeller, *The Philosophy of Marsilio Ficino*, trans. Virginia Conant (1943; Gloucester, Mass.: P. Smith, 1964).

49. Felix Gilbert, "Bernardo Rucellai and the Orti Oricellari: A Study on the Origin of Modern Political Thought," *Journal of the Warburg and Courtauld Institutes* 12 (1949): 101–31.

50. Hans Liebeschütz, *Mediaeval Humanism in the Life and Writings of John of Salisbury* (London: Warburg Institute, University of London, 1950).

51. Erwin Panofsky, "Note on the Importance of Iconological Exactitude" (letter to the editor), *Art Bulletin* 13 (1939): 402.

52. Klaus Fischer, "Die Emigration deutschsprachiger Kernphysiker nach 1933: Ein kollektivbiographische Analyse ihrer Wirkung auf der Basis szientometrischer Daten," *Exilforschung: Ein internationales Jahrbuch* 6 (1988): 44–72.

53. See Shulamit Volkov, "Soziale Ursachen des Erfolgs in der Wissenschaft: Juden im Kaiserreich," *Historische Zeitschrift* 245 (1987): 315–42. See also Klaus Fischer, "Wissenschaftsemigration und Molekulargenetik: Soziale und kognitive Interferenzen im Entstehungsprozeß einer neuen Disziplin," in *Die Emigration der Wissenschaften nach 1933: Disziplingeschichtliche Studien*, ed. Herbert A. Strauss (Munich: K. G. Saur-Verlag, 1991), 105–36.

54. For a current overview, see Muir, "The Italian Renaissance in America," 111, esp. note 45.

55. Diary of K. B. W., vol. 4, 20.2.1928, Warburg Institute Archive, London.

56. Ernst Cassirer, "Judaism and Modern Political Myths (1944)," in *Symbol, Myth, and Culture,* ed. Donald Phillip Verene, 241.

Reframing the Self-Criticism

Clement Greenberg's "Modernist Painting" in Light of Jewish Identity

LOUIS KAPLAN

> This writer has no more of a conscious position towards his Jewish heritage than the average American Jew—which is to say, hardly any. Perhaps he has even less than that. Nevertheless, the reflection in my writing of the Jewish heritage—is *heritage* the right word?—though it may be passive and unconscious, is certainly not haphazard. I believe that a quality of Jewishness is present in every word I write.
>
> —Clement Greenberg, "Under Forty: A Symposium on American Literature and the Younger Generation of American Jews" (1944)

Joke's on Clem: Greenberg Given the Slip

In an "Autobiographical Statement" from 1955, Clement Greenberg boasts of being bilingual, able to converse in two tongues from the moment that he was marked as a speaking subject. This confession of a Jewish-American child of Eastern European immigrants reads as follows: "My father and mother had come, in their separate ways, from the Lithuanian Jewish cultural enclave in northeastern Poland, and I spoke Yiddish as soon as I did English."[1] Such a "Yinglistic" background led Greenberg to mastery of the German language as well and to the profession of translator. Greenberg's first publishing effort was as neither a writer nor an editor, but rather as a translator from a decidedly Jewish perspective. Three years before the publication of his first art-critical essay, "Towards a Newer Laocoön" (1939), Greenberg translated a book, *The Brown Network: The Activities of the Nazis in Foreign Countries*, that warned the American public of the Nazi peril.[2]

Given this polylingual résumé, it is surprising to find an error in translation in the epigraph to a book review entitled "The Jewish Joke" that Greenberg wrote in 1947 on the classic Eastern European joke compilation *Röyte Pomerantsen*, published in transliterated Yiddish.[3] Greenberg begins by reciting an old Jewish saying:

"Iz antkegen a vits muz men ophitn de töyre mer vi fun jeder anderer zach." He proceeds to translate: "(The Torah must be protected from a jokester more than from anything else)" (2:182). But for all his fluency and mastery of Yiddish, Greenberg has mistaken the tale for the teller—the joke for the jokester or, in Yiddish, the *vitz* for the *vitzling*. This Freudian slip substitutes the speaking subject ("the jokester") for what is enunciated ("the joke") as the cause of the threat.

In the history of modern art criticism, Clement Greenberg is best known for his formalist insistence on the autonomy and purity of the medium above all else. This might be understood as a repression of subjectivity in understanding the meaning and significance of artistic or critical production. It involves privileging the subject that is enunciated (i.e., the formal aspects of the artwork) over the speaking subject (i.e., the artist or critic). But here it appears that subjectivity—in the form of a trouble-making jokester—has played a trick on Clement Greenberg in spite of himself and has managed to slip back into the analytical mix. In other words, Greenberg's substitution of the jokester for the joke functions as a sign for the return of the repressed subjectivity of the critic.

The goal of this essay is to take this jokester's slip into subjectivity seriously and to extend it into a more general account of Clement Greenberg. This means the recovery of that element of Greenberg's Jewish subjectivity involving his relationship to the question of self-criticism. This essay focuses on a series of substitutions whereby the question of "self-criticism" was displaced and diverted from the matrix of Greenberg's Jewish identity to other intellectual historical markers and proper names (e.g., Kantianism, formalism, modernism). The analysis follows the basic definition of displacement as sketched by Laplanche and Pontalis in *The Language of Psycho-Analysis*: "The fact that an idea's emphasis, interest or intensity is liable to be detached from it and to pass on to others, which were originally of little intensity but which are related to the first idea by a chain of associations."[4] In the case at hand, Greenberg's use of self-criticism in the context of Jewish subjectivity in the forties and fifties passes on to other frames of reference in chains of association that serve to promote the formalist project of modernist art and to foreground the self-critical tendency at the basis of modernism. This process reaches its climax in Greenberg's extended discussion of self-criticism in the essay "Modernist Painting" (1960), which serves as a pivot for the analysis that follows because it reframes the problematic of self-criticism so as to remove the issue of Jewish subjectivity completely. But what has receded into the unconscious of the Clement Greenberg who wrote "Modernist Painting" is the mark of Jewish self-criticism.

Many of Greenberg's early texts on the theme of self-criticism and other topics of Jewish interest are found in *Commentary*, the monthly magazine sponsored by the American Jewish Committee; Greenberg served as an associate editor from its

inception in 1945 to 1957.[5] Clement Greenberg's association with *Commentary* placed him at the center of a group of young and talented intellectuals who wanted to forge a *positive* Jewish identity in postwar America in the wake of the Holocaust. Greenberg's texts on Jewish themes range from the book review of Maurice Samuel's biography of the Yiddish humorist Sholom Aleichem, "The Jewish Dickens" (1943), to the review of *Röyte Pomerantsen*. They include three essays on Franz Kafka—"The Jewishness of Franz Kafka" (1955) and its revised version, "Kafka's Jewishness" (1956); "Introduction to the Great Wall of China" (1946); and "At the Building of the Great Wall of China" (1958)—as well as the controversial essay "Self-Hatred and Jewish Chauvinism: Some Reflections on 'Positive Jewishness'" (1950). These texts are crucial not only for what they tell us about Jewish identity, but also for the ways in which they articulate the importance of the concept of self-criticism in modernism as defined by Greenberg. They must be read as central to a theory of modernism in the arts that locates its essence in "the task of self-criticism" (4:86).

Self-Criticism in the Modern and Postmodern Frames: Entrenchment versus Indeterminacy

> The task of self-criticism became to eliminate from the effects of each art any and every effect that might conceivably be borrowed from or by the medium of any other art. Thereby each art would be rendered "pure," and in its "purity" find the guarantee of its standards of quality as well as of its independence. "Purity" meant self-definition, and the enterprise of self-criticism in the arts became one of self-definition with a vengeance.
>
> —Clement Greenberg, "Modernist Painting" (4:86)

"Modernist Painting" presents a strategy of containment in its handling of the concept of self-criticism. Greenberg places the self-criticism of modernist painting in the service of the purity and self-definition of the medium in respect to its striving for two-dimensionality and flatness. "Modernist painting oriented itself to flatness as it did to nothing else" (4:87). This remark leads Greenberg to trace a quasi-teleological history of avant-garde art from Courbet and Manet to abstract expressionism. "Self-criticism" in the service of the purity and autonomy of the medium becomes the major criterion by which to judge what is advanced and advancing in the arts and to separate progressive from regressive elements.

It is interesting to point out the different valences that the concept of "self-criticism" assumes in "Modernist Painting"—self-definition, purification, self-certainty. Self-criticism is understood as a process of paring down to the essentials, to

what is "unique and irreducible." As Leo Steinberg has noted, it registers a "contractionist impulse."[6] It is a matter of making things more secure and more stable. All in all, "Modernist Painting" marks the entrenchment of self-criticism. But, as Donald Kuspit has argued, Greenberg's identification of self-criticism with self-certainty in "Modernist Painting" obscures uncertainty. "Greenberg's quest for the grail of self-certainty fails not simply because it is false from the start, but because it is facile in its method. It handicaps the uncovering of uncertainty as a necessary if not sufficient condition for creation by giving art a historically readymade goal."[7]

Greenberg's conservative approach to the meaning of self-criticism was not something new. Indeed, one might say that it expressed something rather entrenched in his thinking as a modernist. One of his first major programmatic art-critical tracts, "Towards a Newer Laocoön," already identifies the tendency toward purification, contraction, and entrenchment that will come back to haunt the rhetoric of self-criticism in "Modernist Painting."[8] "The arts, then, have been hunted back to their mediums, and there they have been isolated, concentrated and defined. It is by virtue of its medium that each art is unique and strictly itself" (1:32). This passage has raised some eyebrows among Greenberg's critics. It even acquired a spooky misprint in Robert Storr's study of Greenberg's uneasy relationship to popular culture. Storr's essay added an "a" to the word "hunted": we are informed that "the arts have been haunted back to their mediums, and there they have been isolated, concentrated and defined."[9] Meanwhile, in his study of the early writings, T. J. Clark stumbles over this passage as well. He cannot resist splitting it up even while he ponders it. "The arts, then, have been hunted back [the wording is odd and pondered] to their mediums."[10] Clark, however, provides no explanation for the idiosyncrasy of "the wording."

Only Susan Noyes Platt's biographical analysis of the early Greenberg offers a reading that begins to elucidate how this passage can be understood in the light of Jewish subjectivity. Platt comments: "The peculiar territorial note to this remark may well have been a subconscious parallel to the European losses of territorial integrity in the spring of 1939."[11] Much more can be said about the ramifications of this passage in relation to the parallel losses of Jewish integrity, territorial and otherwise, however, for the Jewish question haunts the unconscious of this uncanny passage published in the summer of 1940. In a reading of Greenberg's writings that excavates the repressions and displacements of his Jewish identity, the deployment of words such as "hunted," "isolated," and "concentrated" becomes extremely loaded and fraught with ghastly overtones when one considers the precarious situation of European Jews around 1940, struggling to survive in ghettos and about to be deported to concentration camps by the Nazis. Greenberg's war-torn language—describing the artistic avant-garde on the defensive as "hunted back," on the run, and going into hiding in "Towards a Newer Laocoön"—gets replaced in

"Modernist Painting" by the rhetoric of "self-criticism" as self-imposed and as a voluntary inquiry into artistic experimentation.

Recognizing that this culture war was being waged during an actual state of siege helps to explain why Greenberg favored entrenchment and feared the subversive side of the self-critical inquiry throughout his career. The difference between Greenberg's conservative reading of self-criticism and a more radical and destabilizing reading is clearly revealed in the opening sentence of the second paragraph of "Modernist Painting." It is replete with essentialist rhetoric: "The essence of Modernism lies, as I see it, in the use of the characteristic methods of a discipline to criticize the discipline itself—not in order to subvert it, but to entrench it more firmly in its area of competence" (4:85). Whether Greenberg locates self-criticism in the Jewish joke or in modernist painting, it has everything to do with entrenchment and nothing or very little to do with subversion. The mistaken maxim of "The Jewish Joke" resonates in Greenberg's reframing of the concept of self-criticism in "Modernist Painting." For Greenberg's modernist Torah preaches the purifying doctrine of self-criticism as a search for self-certainty and self-definition, and, more than anything else, it must be protected against the radical skepticism and the subversively self-critical antics of both the joke and the jokester.[12]

Perhaps at this critical juncture the decenterings of the postmodern might join hands with the radical subversiveness of Jewish humor to forge another reading of "self-criticism"—more playful and more paradoxical, less certain and less secure—to dislodge the entrenched Greenberg and his modernist project and to challenge self-criticism as self-definition. In this light, it is well to recall Jean-François Lyotard's "Philosophy and Painting in the Age of Their Experimentation: Contribution to an Idea of Postmodernity" or "The Sublime and the Avant-Garde." Lyotard emphasizes "the doubt which gnaws at the avant-garde," a doubt that cannot be contained by a definition of self-criticism as self-definition, and thereby challenges the "formalist definition of the pictorial object, such as that proposed in 1961 by Clement Greenberg."[13]

Lyotard exposes a subversive counterdiscourse in the self-questionings of the avant-garde of the last century, from Cézanne's radical epistemological doubt to the installations of Daniel Buren, calling into question the site of an art object's display. Unlike Greenberg's modernist entrenchment, which makes each medium "all the more secure in what . . . remained to it," Lyotard locates in the work of Barnett Newman, among others, a remainder that translates as the "occurrence of a thought as the unthought that remains to be thought."[14] Rather than accept the modernist version of Greenberg's self-criticism as a quest for self-certainty, Lyotard rethinks the avant-garde within an "aesthetics of the sublime" that seeks to present the unpresentable and bears "witness to the fact that there is indeterminacy."[15] The result of such testing and experimentation is not the security of entrenchment and contrac-

tionism but the dizzying vertigo and dispersion that open up on account of new linkages in signification and significance.

Within the avant-garde matrix offered by Lyotard's reading of self-criticism, it becomes possible to speculate upon new modes of Jewish subjectivity and diasporic practices that affirm artistic experiment, indeterminacy, and alteration. Specifically, Lyotard's postmodern reframing of the self-critical problematic opens up another perspective that enables a rethinking of Greenberg's project by foregrounding the conditions of possibility for Jewish subjectivity within the modernist frame. It invites the reexamination of Greenberg's own role as Jewish self-critical subject and challenges his positing self-criticism as a means of entrenchment. From his postmodern vantage point the affirmation of Jewish self-critical subjectivity occurs in terms of difference, subversion, and indeterminacy.

Giving Greenberg a Jewish Reception

Over the past two decades, many studies have attempted to link Clement Greenberg's art criticism to issues of Jewish identity. However, the first major monograph on Greenberg, Donald Kuspit's *Clement Greenberg: Art Critic* (1979), does not consider this relationship at all.[16] Kuspit judges the "self-critical tendency" in modern art to be the most controversial of all of Greenberg's critical positions. He writes, "It has led him to conceive of criticism as the evaluation of every art in the light of its treatment of its medium, understood not only as fundamental to the art but as the source of all its consequence."[17] But Kuspit does not investigate any intellectual sources for this conception outside of art criticism and aesthetic theory (e.g., Kant); he does not bring any Jewish writings to bear on his subject. In consequence, he produces a totally assimilationist analysis.

In sharp contrast, Susan Noyes Platt's provocative essay on the early years of Greenberg's career as a critic proposes a definite link between the writer's Jewishness and his art criticism, introducing Greenberg's biography as a resource for interpretation. Platt turns to Greenberg's writings on Kafka as the essence of his critical career, drawing particularly upon Greenberg's belief that Kafka's world of "The Great Wall of China" bears many direct parallels to the Halakah (codified system of Jewish law). As Greenberg argues, "Kafka's static, treadmill, 'Chinese' world bears many resemblances to the one present in the Halachic, legal part of post-Biblical Jewish religious tradition, that department of the writings of the sages which deals with the Law" (2:101). Platt culls a further passage to serve as her emblematic epigraph: "Kafka sees life as sealed off and governed by unknowable powers who permit us the liberty only to repeat ourselves until we succumb" (2:101). Platt argues that Greenberg likewise put himself into the hermetically sealed zone

of medium purity and aesthetic formalism to fend off the powers of the unknow-able. She concludes: "The dogmatism of his art criticism, his whole program of for-malism in visual art seems, in retrospect, Kafkaesque. It reflects Greenberg's fear of impending doom. This fear forced him to maintain an absolute—religious—belief in a utopian sphere of aesthetic activity, in order to avoid surrender to despair."[18]

For Platt, Greenberg's aesthetic system and its formulaic reiteration of the same basic dogmas—the importance of unity, purity, and formalism—over the course of half a century constitute the rigorous attempt of a modern Jewish-American intel-lectual to found a secular variant of "a new Halakah" in the aesthetic realm that would rival Franz Kafka's description of his own project as the pursuit of "a new Kabbalah." "From the perspective of the Jewish tradition of the Halacha or Law, his aesthetic stance, based on the reiteration of a few concrete aspects of an art work, assumes the character of a new Halacha, a transposition of the Jewish heritage into the fabric of his thinking and writings."[19] Although Platt's perspective, with its em-phasis on displacement, provides an understanding of Greenberg's system building through the analogy with the Halakah, she does not consider the element of self-criticism, which is the basis of "Modernist Painting," the matrix of Greenberg's aes-theticizing transposition of his Jewish heritage.[20]

Incidentally, Greenberg's reading of Kafka as Halakic in scope is at great variance with Walter Benjamin's approach to the same subject. In both of these essays on Kafka, written in the 1930s, Benjamin stresses that Kafka's genius lies in his ability to tell stories that move from Halakah into Haggadah, from doctrinal law to alle-gorical tale. "They have, rather, a similar relationship to doctrine as the Haggadah does to the Halakah. They are not parables, and yet they do not want to be taken at their face value."[21] Thus, "Kafka's real genius was that he tried something entirely new: he sacrificed the truth for the sake of clinging to its transmissibility, its hag-gadic element."[22] In contrast to Benjamin's allegorical impulse (which renders him so appealing to postmodernism),[23] there is a rigidity in Greenberg's modernist read-ing of Kafka that meshes with his securing of the borders of self-criticism.

A more recent exploration of Greenberg and the question of Jewish identity is to be found in Margaret Olin's sophisticated analysis, "C[lement] Hardesh [Greenberg] and Company: Formal Criticism and Jewish Identity."[24] Olin insists that one can think about the critical career of Clement Greenberg only within the discourse of modern art history in general, particularly in light of the anti-Semitic presupposi-tions that have a direct bearing on formalist criticism's attempts to efface Jewish identity from consideration. Her effort to read Greenberg's artistic formalism as ultra-assimilationist, an instance of self-hating Jewish subjectivity conforming to the post-Holocaust model of "Jews [who] sought to demonstrate their American iden-tity," excludes the possibility of the biographical transpositions and displacements opened up by Platt's reading.[25] For all her discussion of Greenberg's aesthetic the-ories, Olin does not address "the self-critical tendency of Modernist art," one of its

key constituents, which invites a new approach to Greenberg's displaced encounter with Jewish identity.

Like Olin in her exploration of the links between Greenberg's Jewish subjectivity and his aesthetic theories, other recent commentators have focused on the essay entitled "Self-Hatred and Jewish Chauvinism" (1950). These commentators include Sidney Tillim, Bradford Collins, and Thierry de Duve.[26] According to de Duve, this approach seeks to take up the "delicate question of Greenberg's 'Jewish self-hatred,' relating it to his family origins, his quest for identity, and his precocious ambition to define modernism."[27] Collins's reading explores specifically how Jewish self-hatred catalyzed Greenberg's search for a "purist aesthetic" to overcome the debasements to which Jewish identity was subjected in the era of the Holocaust. This is a fascinating line of inquiry that can be further elucidated when read in tandem with an inquiry into Greenberg's relationship to Jewish self-criticism. After all, Jewish self-hatred can be interpreted as an extreme case of the Jewish self-critical tendency. The so-called "Jewish inferiority complex" is a sickness consisting of equal parts "self-doubt" and "self-contempt" (3:45) induced by allowing the negative appraisals cast out by the mirror reflections of Jewish self-criticism and anti-Semitism to become pathological.

Given this overview of the art-historical literature on Greenberg's "Jewishness," with its lack of any extended commentary on self-criticism in the Greenbergian text, I turn to three instances of the problematic of self-criticism in Greenberg's writings that either provoke a direct encounter with Jewish subjectivity or illustrate the displacement of Jewish subjectivity in Greenberg's guise as high modernist art critic par excellence.

Self-Criticism and the Jewish Joke:
Greenberg Reads Röyte Pomerantsen *and Sholom Aleichem*

In his review of Maurice Samuel's biography of Sholom Aleichem (1943), Greenberg turned his attention to specific sociohistorical factors in the formation of a diasporic Jewish subjectivity marked by a strong sense of humor and a critical sense. Greenberg regards Jewish humor and the Jewish critical sense as twin modes of a collective self-questioning. Though he was suspicious of political Zionism as a form of reactionary chauvinism, Greenberg's reasoning resonates with nationalist rhetoric urging the foundation of a Jewish state as the precondition for the Jew's return to history: "There is another reason why the Jews live on such close terms with humor. In the last two thousand years they have been unable to play any striking role as a whole people, with the result that history has not presented them with fresh infusions of glory and dignity from above to act as sedatives upon their critical sense" (1:156). Greenberg's text on Sholom Aleichem is especially poignant when one

considers that it was composed at a moment in Jewish and world history partaking of the blackest of humors when there was absolutely no place for such "infusions of glory and dignity." The review was published during the Nazis' institution of the genocidal Final Solution, during the dismantling of Jewish folk life in Eastern Europe, the very milieu that had produced Sholom Aleichem as the "Jewish Dickens."

In December 1947, in the immediate wake of the Holocaust, Clement Greenberg published his review of Immanuel Olsvanger's *Röyte Pomerantsen* under the title "The Jewish Joke." Greenberg says the key to understanding the Jewish joke is "self-criticism," the term that became the centerpiece of those later pronouncements in "Modernist Painting." While other theoretical frameworks were available, Greenberg aligns his interpretation of Jewish humor with the model of self-criticism found in Sigmund Freud's classic *Jokes and Their Relationship to the Unconscious* (1905). Freud offers a famous diagnosis of the Jewish brand of self-directed and self-ironic wit: "The occurrence of self-criticism as a determinant may explain how it is that a number of the best jokes have grown up on the soil of Jewish popular life. I do not know whether there are many other instances of a people making fun of its own character to such a degree."[28] Olsvanger also took this position in the preface to his Jewish joke compilation: "They [the Jews] by no means exaggerate their own virtues. The fact is that they severely criticize their faults."[29]

Greenberg isolates three self-critical aspects of the Jewish joke that are attuned to the difficult, even desperate, sociohistorical circumstances of the East European shtetl Jew. The first and third aspects are explicated with the parenthetical punch lines of two classic Jewish jokes:

> The Jewish joke criticized the Jew's habit of explaining away or forgetting the literal facts in order to make life more endurable to himself. (So what if the only thing wrong with the prospective bride is that she is a bit pregnant?) It also criticized the way in which the Jew violated his traditional decorum, while still trying to put a face on it, in his desperate struggle for individual survival. It criticized, finally, the self-absorption of individuals so devoid of power and status as most Jews had become by the 18th century. (What God does is probably good.) (2:185)

Greenberg's first point recalls how the self-critical element of Jewish humor administers an antidote to falsification or distortion, a metaphorical bucket of water to the head—or what Greenberg calls a dose of "immediate reality." With the inclusion of the first parenthetical one-liner, Greenberg alludes to a classic matchmaker, or *Schadchen*, joke that is told by Freud with a slightly different punch line in *Jokes and Their Relationship to the Unconscious*.

> The *Schadchen* was defending the girl he had proposed against the young man's protests. "I don't care for the mother-in-law," said the latter. "She's a disagreeable,

stupid person."—"But after all you're not marrying the mother-in-law. What you want is her daughter."—"Yes, but she's not young any longer, and she's not precisely a beauty."——"No matter. If she's neither young nor beautiful she'll be all the more faithful to you."—"And she hasn't much money."—"Who's talking about money? Are you marrying money then? After all it's a wife that you want."—"But she's got a hunchback too."—"Well, what *do* you want? Isn't she to have a single fault?"[30]

Freud interprets this *Schadchen* joke as a case of "faulty reasoning" that deploys sophistry and evasiveness to argue away the defects of the prospective bride to reduce her negative attributes to the one physical flaw for which the matchmaker has no rebuttal (whether Greenberg's pregnancy or Freud's hunchback). But the critical difference between Greenberg's and Freud's interpretations goes beyond the defect in question. For Freud, this joke was engaged in a critique of logic that reveals the triumph of sophistry and the subversion of reason. Thus the joke operates with "the appearance of logic which is characteristic of a piece of sophistry and which is intended to conceal the faulty reasoning."[31] In contrast, Greenberg reads the joke as engaging in a metaphysical critique that seeks "to make life more endurable." With this interpretation of the Jewish joke, Greenberg sidesteps having to reach the conclusion that a self-critical use of logic can have subversive and non-Kantian consequences.

In his Jewish joke review, Greenberg reflects on the inverted wisdom at the root of the self-critique instigated by Jewish wit. Working and playing at the limits of knowledge, the Jewish joke manages to undercut any overinvestment that the people of the book might place in the power of the intellect. Greenberg contrasts the ways in which Jewish religion and Jewish humor test the limits of knowledge and thereby subject human intelligence to an ongoing critique. While prayer criticizes in the name of the transcendental, the joke utilizes more immediate material to make its critical point. Greenberg surmises: "Religions have criticized intelligence in the name of the transcendental, but Jewish humor is almost alone in criticizing it in the name of immediate reality" (2:185).

What is most striking about Greenberg's reading of the self-critical mechanism at work in the Jewish joke is the way in which he finds it somehow revelatory of historical truth. He pairs the Jewish joke and political Zionism as the two prophetic harbingers of the tragic fate of European Jewry because only these two discourses criticized the status quo and thereby intuited the final solution to the Jewish question. Not unlike Kafka's writing practice, the most amusing of activities turns out to be something deadly serious. "The Jewish joke may have been, paradoxical as that sounds, the one way aside from Zionism in which the Jew divined the future that awaited him at Auschwitz" (2:186). Rather than acknowledge how the Jewish joke resides in an interrogative mode whose self-criticism feeds on paradoxes that

leave the question open and that cannot be resolved, Greenberg—writing these words two years in the wake of the Holocaust—attempts to make some sense of it by making the Jewish joke proleptic of the tragic fate of European Jewry ("as paradoxical as that sounds"). Here the explosiveness of Jewish humor is contained in a manner that prefigures the strategy of entrenching self-criticism in "Modernist Painting."

Kantian Self-Criticism and Greenbergian Subjectivity

> There was a special sense of triumph when Greenberg trotted out the reference to Kant: for one thing the reference was a little arcane, and there was special cachet in citing a philosopher who did not fall anywhere within the Marxist canon. But sometimes the reference did sound rather sententious coming from Greenberg's lips, and Delmore [Schwartz] would growl, "Clem is always putting on the dog—intellectually speaking." And then he turned to rebuke me at my silence. "Listen, you know Clem doesn't know what he's talking about when he mentions Kant. Why don't you show him up?"
>
> —William Barrett, *The Truants*[32]

This amusing anecdote involving an exchange between two of the movers and shakers of the New York intellectual scene, in which their associate Clement Greenberg thrived for a number of decades, raises suspicions about the Kantian pretensions of the art critic and his claims to speak about the German philosopher with intellectual authority.[33] The anecdote reveals that Clement Greenberg—however much he actually knew about the German philosopher—invoked Kant as authority figure sometime around 1950. Nevertheless, not until his definitive statement on modernist painting in 1960 did Greenberg link Kant specifically to the concept of self-criticism in a published piece. Indeed, this canonical text in twentieth-century art criticism traces the roots of the self-critical project of modernism directly to the late-eighteenth-century German philosopher. In purely statistical terms Greenberg, in his account, invokes Immanuel Kant as a proper name ("Kant") or as an adjective ("Kantian") no fewer than five times in the first four paragraphs, and he associates the name with either the concept of criticism (e.g., "Kantian immanent criticism") or self-criticism (e.g., "Kantian self-criticism") in four of these instances (4:85–86). Writing in the first person, with its explicit reference to the authority of the "I," Greenberg concludes the opening paragraph in a foundational gesture that sets up the German idealist as intellectual progenitor. "I identify Modernism with the intensification, almost the exacerbation, of this self-critical tendency that began with the philosopher Kant. Because he was the first to criticize the means itself of criticism, I conceive of Kant as the first real Modernist" (4:85).

But as suggested in the previous section, Greenberg's own identification with Kant's critical philosophy functions as a displacement of the self-critical tendency that he himself had already located in the 1940s and 1950s as a key characteristic of modern Jewish identity. By identifying Kantian philosophy in the age of Western European Enlightenment as the source of self-criticism, Greenberg represses those specific Jewish intellectual practices intimately involved with self-criticism that date from both before and after the eighteenth-century era that became known as the Jewish Enlightenment.

This was not the first time in modern intellectual history that a secular Jewish intellectual had turned to Kant for some moral support. The neo-Kantian Jewish intellectuals of the so-called Marburg School in Germany in the late 1800s and early 1900s, led by the philosopher Hermann Cohen (1842–1918), had adopted Kant as one of their own.[34] Greenberg's turn to Kant is both similar and quite different. While the neo-Kantians acknowledged how Kant's moral philosophy satisfied their Jewish ethical agenda, Greenberg never acknowledges the Jewish affinities at the basis of this "identification" of the modernist artistic project with Kantian self-criticism.

At another point in "Modernist Painting," Greenberg makes an overt reference to Kant that resonates with the same pattern of displacement of Jewish sources. In describing the origin of the self-critical method that shapes modernist painting, Greenberg argues that it was Kant who used logic in a self-critical way to test the limits of logic and the condition of its possibility. "Kant used logic to establish the limits of logic, and while he withdrew much from its old jurisdiction, logic was left all the more secure in what there remained to it" (4:85). However, Greenberg overlooks how something like the Jewish joke does not seek to secure or entrench logic. Instead, it uses the rhetorical strategies designated as *pilpul* (peppering) to drive logic to the point of absurdity, to bite its own tail. It seems almost as if Greenberg were describing in "Modernist Painting" the mental gymnastics of Talmudic reasoning and its parodic doubling in Jewish humor, both of which use logic to establish the limits of formal logic.

It is fascinating to consider that Greenberg made a point of stressing the Jewish affinity for logic in his allegorical reading of Kafka's story "At the Building of the Great Wall of China" (1958). Greenberg does nothing less than interpret this story about China as a displacement of issues related to Kafka's Jewish identity and his concrete existence as a Jew living in the Diaspora. Greenberg makes the following analogy between Chinese architecture and Jewish law: "All China is set to studying the art of building, and especially bricklaying. Similarly, all Jewry was set to the studying of the Law and the sharpening of logic years before Torah replaced Palestine as the Jewish homeland. As China had its surplus of architects, so Jewry came to have its surplus of logicians" (4:49). In this way, the Kantian investigation into the limits of logic at the end of the eighteenth

century gets started two millennia earlier as part of the long-standing Jewish tradition of Torah study. Greenberg continues this mode of substitutive and transpositional thinking that plays between the Great Wall of China and the Wailing Wall of the diasporic Jew in the following manner: "Thus China became the name of Kafka's figure of speech for Diaspora Jewry." Generating another series of substitutions, this analogy might be reframed along the following lines when applied to the case of Clement Greenberg and "Modernist Painting": "Thus Kant became the name of Greenberg's figure of speech for Jewish self-criticism."

The Matrix of Self-Criticism and the Modernist Triumvirate

The pronouncements of "Modernist Painting" are quite general in tenor: the essay omits any direct references to contemporary artistic production, reflecting Greenberg's desire to write a classic and canonical text. Beyond the references to Kandinsky and Mondrian, the reader is provided with no specific examples of contemporary modernist paintings or painters engaged in a self-critical artistic practice. In 1962, two years after the publication of "Modernist Painting," Greenberg published "After Abstract Expressionism" in *Art International*. Assuming the role of hipster appraiser of the New York art scene, Greenberg reports on the newest avant-garde gambits. In the later part of the article he focuses on three painters—Barnett Newman, Mark Rothko, and Clyfford Still—who have moved from the "painterliness associated with Abstract Expressionism" to "a vision keyed to the primacy of color" (4:128). Greenberg then goes on to link the work of these three artists directly to the self-critical project that "provides the infra-logic of modernist art" (4:132).

Greenberg sets up the avant-garde triumvirate in a reprise review of his "Modernist Painting" essay. He reiterates how the self-critical process has revealed that the "irreducible essence of pictorial art consists in but two constitutive conventions or norms: flatness and the delimination of flatness" (4:131). But his rationale for championing the trio of postpainterly abstract artists then veers off in another direction. The self-critical tendency in modernist painting is transformed into the search for the "ultimate source of value or quality in art," and this question generates a surprising answer that privileges its "conception alone."

> As it seems to me, Newman, Rothko, and Still have swung the self-criticism of modernist painting in a new direction simply by continuing it in its old one. The question now asked through their art is no longer what constitutes art, or the art of painting, as such, but what irreducibly constitutes *good* art as such. Or rather, what is the ultimate source of value or quality in art? And the worked-out answer appears to be: not skill, training, or anything else having to do with execution or performance, but conception alone. (4:132)

This was by no means the first time that Greenberg grouped Rothko, Still, and Newman together as an avant-garde triumvirate. He had been doing this on and off for fifteen years before the publication of "After Abstract Expressionism." Greenberg had first conceived of the three of them as somehow constituting a group within the New York School in 1947 in his review of the painters Adolph Gottlieb and Hedda Sterne. At this earlier date there appears to be no place for the rhetoric of self-criticism in relation to these painters. Instead, Greenberg refers to Gottlieb as "the leading exponent of a new indigenous school of symbolism which includes among others Mark Rothko, Clyfford Still, and Barnett Benedict Newman" (2:188). Considering that three of these four painters were diasporic Jews and that Rothko was not even born in the United States, the irony of Greenberg's displacement in the use of the term "indigenous" is striking. It is only compounded when the formalist critic "questions" the "metaphysical" claims of their art (in its content) and refers to that element in a disparaging manner as "revivalist" in "a familiar American way." "I myself question the importance this school attributes to the symbolic or 'metaphysical' content of its art. . . . There is something half-baked and revivalist, in a familiar American way, about it" (2:188). The review brought a rebuttal from Barnett Newman, who defended the "metaphysical" and "sublime" aspirations of his paintings and those of his colleagues as "concerned with the reality of the transcendental experience."[35]

The second phase of Greenberg's fascination with the triumvirate comes in his overall assessment of abstract expressionism, "'American-Type' Painting," written in 1955 and revised in 1958.[36] Greenberg articulates the self-purification of the medium as the becoming-flatness of modernist painting, which results in an intense focus and concentration on color.

> A concomitant of the fact that Still, Newman, and Rothko suppress value contrasts and favor warm hues is the more emphatic flatness of their paintings. Because it is not broken by sharp differences of value or by more than a few incidents of drawing and design, color breathes from the canvas with an enveloping effect, which is intensified by the largeness of the picture. (1955, 3:232)[37]

This "flat" reading of the triumvirate in "'American-Type' Painting" prefigures the formalist argument of "Modernist Painting." In pursuit of the autonomy of the medium, Greenberg argues that flatness provides "the only condition that painting shared with no other art" (4:87). This argument emphasizes the two-dimensionality of modernist painting over its content, in contrast to the paintings of the Old Masters. This thesis inspired Leo Steinberg's critical attack on Greenberg with *Other Criteria*. Steinberg takes issue with Greenberg's facile distinction between "masters" of content and "moderns" of form. He writes: "Greenberg's theoretical schema keeps

breaking down because it insists on defining modern art without acknowledgement of its content, and historical art without recognizing its formal self-consciousness."[38]

In Greenberg's view, the emphasis on flatness and its supposed revelation of the picture as picture translates as the "success of self-criticism." This statement is loaded in the sense that Greenberg's coupling of self-criticism and success again suppresses the flip side of the self-critical operation—its links to radical self-doubt, indeterminacy, and even failure. In this way, the modernist project inscribed as Greenbergian self-criticism takes the shape of an American success story.

> One is made aware of the flatness of their pictures before, instead of after, being made aware of what the flatness contains. Whereas one tends to see what is in an Old Master before one sees the picture itself, one sees a Modernist picture as a picture first. This is, of course, the best way of seeing any kind of picture, Old Master or Modernist, but Modernism imposes it as the only and necessary way, and Modernism's success in doing so is a success of self-criticism. (4:87)

Shifting matters from ethnic identity to formal constraints, Greenberg's analysis of the triumvirate in "After Abstract Expressionism" makes no overt mention of the Jewish heritage of two of his three key exponents of the self-critical tendency in modernist painting—Barnett Baruch Newman and Mark Rothko (born Marcus Rothkowitz). There may be a veiled reference to Jewish ethnicity, however, when Greenberg distinguishes Newman and Rothko from Still on the basis of shared temperament and nativity: "Newman and Rothko, temperaments that might strike one as being natively far more painterly than Still's, administer copious antidotes [to Still] in the form of the rectilinear" (4:130).[39] Seeking in its analysis to reframe the problematic of modernist self-criticism in Greenberg's repression or displacement of Jewish subjectivity, this essay underscores the Jewish heritage of two of the painters on whom Greenberg centered his analysis of the self-critical tendency of modernist painting.

In this context it is important, furthermore, to recall the influential critical studies of Rothko's and Newman's work over the years that argue for a direct connection between their "Jewishness" and their artistic practices. Unlike Greenberg's formally phobic reaction against the symbolic implications of the content of Barnett Newman's work, Thomas Hess's reading of Newman converts him into a modern-day Cabalist.[40] Hess pushes the "metaphysical" and "sublime" aspects of Newman's work, about which Greenberg had so many suspicions, into a full-fledged reading of an abstract artist as Jewish mystic who illuminates the Cabalistic ideas of Isaac Luria (by way of Gershom Scholem).[41] In a similar vein, a number of art historians, beginning with the German critic Werner Haftmann,[42] have looked to Mark Rothko as "the last rabbi of modern art" and seen his desire to be thought of as a

deeply religious painter as a reflection of his roots as a yeshiva student.[43] Critical readings of Rothko and Newman that stress their Jewishness have played up the importance of the story of Abraham and the sacrifice of Isaac as a source of inspiration for their understanding of the function of the modern artist.[44] In contrast, Greenberg's formalism suppresses the mythic and thematic possibilities in Newman's and Rothko's work and any direct encounter with Jewish issues. This displacement is dictated to a large extent by the formalist's avoidance of those areas of analysis where the Jewish roots of their work would be more legible. In this way, Greenberg's account of Rothko and Newman frames the issue of self-criticism as part of the matrix of modernist art rather than as the constitutive mark of modern Jewish identity.

Displaced Exit

At the conclusion of "Kafka's Jewishness," Greenberg posits the relationship between the Jew and art as necessarily a process of falsification of self. Greenberg asserts a Jewish imperative in Kafka that "tests the limits of art" and that questions art's false moves by grounding it in "what is literally happening to oneself." He concludes his Kafka inquest in a rhetorically interrogative mode:

> And when did a Jew ever come to terms with art without falsifying himself somehow? Does not art always make one forget what is literally happening to oneself as a certain person in a certain world? And might not the investigation of what is literally happening to oneself remain the most human, therefore, the most serious and most amusing, of all possible activities? Kafka's Jewish self asks this question, and in asking it, tests the limits of art.[45]

While Kafka's Jewish self might have asked the third question, the present essay has addressed the first two questions to Clement Greenberg's Jewish self directly. For what was his critical career if not that of a postwar American Jew trying to come to terms with modern art—with its most "advanced" tendencies, as he referred to the avant-garde gestures of his own abstract expressionist heyday? And what was the risk of this adventure in aesthetic assimilation if not the possibility of forgetting or even falsifying what was happening to him as a Jew in this world?

This essay has explored how Greenberg's speculations regarding "Kafka's Jewishness" boomerang to his own Jewish subjectivity around the problematic of self-criticism. The self-critical pronouncements of "Modernist Painting" function as the displaced locus of what was happening to him as a certain Jew in a certain world. Whether he knew it or not, this is how the displacements of "Modernist Painting" function as an autobiographical purification ritual. Whether the topic is modernist

painting or Jewish humor, Greenberg's identification of self-criticism as self-definition helps to secure his own sense of identity and his identity as an art critic. Likewise, this identification process helps to secure him against becoming "an uncertain Jew in an uncertain world." To apply this passage from "Modernist Painting" to the case history of Clement Greenberg, "The enterprise of self-criticism in the arts became one of self-definition with a vengeance." In this way, a postmodernist reframing of Greenberg's "Modernist Painting" in light of Jewish identity allows a more subversive interpretation of self-criticism and counteracts Greenberg's articulation of his Jewish identity in light of the self-defining project of "Modernist Painting."[46]

Notes

1. Clement Greenberg, "Autobiographical Statement," in John O'Brian, ed., *Clement Greenberg: The Collected Essays and Criticism* (Chicago: University of Chicago Press, 1993), 3:194. (Subsequent references to this standard edition will be given parenthetically in the text.)

2. This book has an introduction by William Francis Hare (New York: Knight Publications, 1936).

3. Immanuel Olsvanger, *Röyte Pomerantsen: Jewish Folk Humor* (New York: Schocken, 1947).

4. J. Laplanche and J. B. Pontalis, *The Language of Psycho-Analysis*, trans. Donald Nicholson-Smith (New York: Norton, 1973), 121.

5. Greenberg reviews his career as a contributor and an editor in the world of Jewish-American journalism in his "Autobiographical Statement": "After a spell of free-lancing and translating I took a job, in August 1944, as managing editor of the *Contemporary Jewish Record*, a bimonthly put out by the American Jewish Committee; when the *Record* was replaced by *Commentary* I stayed on as an associate editor of the latter, which I still am" (3:195).

6. Leo Steinberg, "Other Criteria," in *Other Criteria: Confrontations with Twentieth-Century Art* (London: Oxford University Press, 1972), 62.

7. Donald Kuspit, "A Phenomenological Approach to Artistic Intention," in *The Critic Is Artist: The Intentionality of Art* (Ann Arbor: University of Michigan Press, 1984).

8. Robert Storr makes the same point in "No Joy in Mudville: Greenberg's Modernism Then and Now," in *Modern Art and Popular Culture: Readings in High and Low*, ed. Kirk Varnedoe and Adam Gopnik (New York: Abrams, 1990), 169–70.

9. Ibid., 169.

10. T. J. Clark, "Clement Greenberg's Theory of Art," *Critical Inquiry* 9 (September 1982): 145.

11. Susan Noyes Platt, "Clement Greenberg in the 1930's: A New Perspective on His Criticism," *Art Criticism* 5, no. 3 (1989): 52.

12. In this light, one has to take issue with John O'Brian's reading of the role of self-criticism in "Modernist Painting" in his introductory essay to *The Collected Essays and Criticism*. O'Brian juxtaposes his own commentary that "[modernist art's] job was to preserve the integrity of the modern tradition by self-critically testing its own procedures" with Greenberg's statement that "in this respect alone can modernism be considered subversive"

(3:xxxiii), creating the false impression that Greenberg regards modernism's self-critical testing of its own procedures as somehow subversive. This is not what Greenberg says: the original context is radically different and includes absolutely nothing about self-criticism. Greenberg raises the possibility of subversion only in the rather limited context of how modernism involves the testing of theory for its relevance to practice: "But what I want to repeat is that Modernist art does not offer theoretical demonstrations. It can be said, rather, that it happens to convert theoretical possibilities into empirical ones, in doing which it tests many theories about art for their relevance to the actual practice and actual experience of art. In this respect alone can Modernism be considered subversive" (4:92).

13. Jean-François Lyotard, "The Sublime and the Avant-Garde," in *The Lyotard Reader,* ed. Andrew Benjamin (Cambridge, Mass.: Basil Blackwell, 1989), 207.

14. Ibid., 208.

15. Ibid., 206.

16. Interestingly enough, while Kuspit quotes the same passage from Greenberg's "Kafka's Jewishness" that appears at the conclusion of the present essay in an even longer extract in his chapter 3 ("Unity"), he avoids any commentary on the Jewish questions raised by this provocative quotation. Instead, he uses Greenberg's Kafka quotation to address purely formal and aesthetic issues related to the search for artistic unity, emptying the passage of its Jewish contents, so that it foregrounds "the conflict at the heart of art per se" and "the triumph of unity over arbitrary intensity, fiction over diverse reality." See *Clement Greenberg: Art Critic* (Madison: University of Wisconsin Press, 1979), 38.

17. Ibid., 18.

18. Platt, "Clement Greenberg in the 1930's," 59.

19. Ibid, 49–50.

20. Ibid., 59.

21. Walter Benjamin, "Franz Kafka: On the Tenth Anniversary of His Death" (1933), in *Illuminations,* trans. Harry Zohn (New York: Schocken, 1969), 122.

22. Walter Benjamin, "Some Reflections on Kafka" (1938), in *Illuminations,* 143.

23. Craig Owens, "The Allegorical Impulse: Towards a Theory of Postmodernism," *October* 13 (Summer 1980): 59–80.

24. Olin has given way to the assimilatory interests of the standardized American in transcribing Greenberg's pseudonym as "C. Hardesh." Following in the footsteps of the German-speaking Jew from Prague named Franz Kafka, Greenberg took on the first initial K. as the proper spelling for his pseudonymous calling. This essay is found in *Too Jewish? Challenging Traditional Identities,* ed. Norman L. Kleeblatt (New York: Jewish Museum and Rutgers University Press, 1996), 39–59.

25. Ibid., 51.

26. See Sidney Tillim, "Criticism and Culture, or Greenberg's Doubt," *Art in America* (May 1987): 122–28, 201; Bradford R. Collins, "Le pessimisme politique et 'la haine de soi' juive: Les origines de l'esthétique puriste de Greenberg," *Les Cahiers du Musée National d'Art Moderne* 45–46 (Fall–Winter 1993); Thierry de Duve, *Clement Greenberg between the Lines* (Paris: Dis Voir, 1996), 39–46.

27. De Duve, *Clement Greenberg between the Lines,* 40.

28. Sigmund Freud, *Jokes and Their Relationship to the Unconscious*, trans. and ed. James Strachey (New York: Norton, 1960), 111. This title can be found as vol. 8 of *The Standard Edition of the Complete Psychological Works of Sigmund Freud,* trans. James Strachey, with Anna Freud (London: Hogarth Press, 1960).

29. Olsvanger, preface to *Röyte Pomerantsen,* xvii.

30. Freud, 62.

31. Ibid.

32. William Barrett, *The Truants: Adventures among the Intellectuals* (Garden City, N.Y.: Anchor Press/Doubleday, 1982), 138.

33. Schwartz's use of conversational slang and colloquial expressions like "putting on the dog" and "doesn't know what he's talking about" move the reader out of the pristine world of aesthetic formalism to a social scene where intellectual reputation rests on rhetorical flair and the literary one-upsmanship that relies on "showing people up."

34. See Hermann Cohen, *Die Religion der Vernunft aus den Quellen des Judentums* (1919), wherein the neo-Kantian religion of reason is derived out of the sources of Judaism.

35. Barnett Newman, "Response to Clement Greenberg," in *Barnett Newman: Selected Writings and Interviews,* ed. John P. O'Neill (Berkeley and Los Angeles: University of California Press, 1990), 161–64. See Thomas B. Hess, in *Barnett Newman* (New York: Museum of Modern Art, 1971), 17, for the transformations of Newman's given name.

36. For Newman's objections to many of the details of Greenberg's reading of his work, see "Letter to Clement Greenberg," in *Barnett Newman,* 202–4.

37. The 1958 revision of the assessment reads as follows: "A new kind of flatness, one that breathes and pulsates, is the product of the darkened, value-muffling warmth of color in the paintings of Newman, Rothko and Still. Broken by relatively few incidents of drawing or design, their surfaces exhale color with an enveloping effect that is enchanced by size itself." Clement Greenberg, "'American-Type' Painting," in *Art and Culture: Critical Essays* (Boston: Beacon Press, 1961), 226.

38. Leo Steinberg, "Other Criteria," in *Other Criteria: Confrontations with Twentieth-Century Art* (London: Oxford University Press, 1972), 71. Steinberg goes on to make the claim that the self-criticism of pictorial art is much older than Kant. "It is poor practice, when modern art is under discussion, to present the Old Masters as naively concerned with eye-fooling trickery, while reserving for modern art both the superior honesty of dealing with the flat plane of painting and the maturer intellectual discipline of self-analysis. All important art, at least since the Trecento, is preoccupied with self-criticism" (76).

39. My thanks to Andrea Pappas for calling my attention to the use of the word "natively" in this comparative context and its connotations regarding Newman's and Rothko's birth and origins. Her 1997 doctoral dissertation at the University of Southern California reviews the dynamics of Jewish displacement in Rothko's work during the pivotal and tragic years of World War II against the backdrop of the Holocaust. It is entitled "The Enactment of Jewish Identity and the 'Mythmakers'—Adolph Gottlieb, Barnett Newman, Mark Rothko, 1939–1945."

40. See Hess, *Barnett Newman.* For a more recent catalogue that groups Greenberg's modernist triumvirate together along the lines of the postmodern sublime, see *Newman, Rothko, Still: Search for the Sublime* (New York: C and M Arts, 1994).

41. Jean-François Lyotard lends credibility to Hess's mystical commentaries in his intriguing essay "Newman: The Instant," in *The Lyotard Reader*, 244. He writes: "And to a certain extent the titles do lend credence to Hess's Kabbalistic commentaries, as does Newman's known interest in reading the Torah and the Talmud."

42. Haftmann's views are found in an untitled essay in *Mark Rothko*, ed. Mark McKinney (Zürich: Kunsthaus Zürich, 1971). They are discussed in Dore Ashton's *About Rothko* (New York: Oxford University Press, 1983), 177–78. Ashton summarizes with a bit of skepticism: "Haftmann seized upon the 'tent' allusion and wove a fantasy in which the 'swaying quality' he detected in certain of Rothko's largest pictures took on the character of curtains which in turn evoked old Jewish metaphors of the temple curtains in front of the Holy of Holies. This led Haftmann to assume that the course of all of Rothko's work lay in his 'Eastern Jewish humanity' and that Jewry, which remained amorphous for more than two thousand years, had found its own pictorial expression" (178).

43. This quotes and paraphrases James E. B. Breslin, *Mark Rothko: A Biography* (Chicago: University of Chicago Press, 1993), 392.

44. In the case of Rothko, see the filtering of the myth through the work of Kierkegaard in Breslin's biography (392–94). In the case of Newman, see Hess's Cabalistic discussion of the 1949 painting of the same patrimonial name (59–61).

45. Clement Greenberg, "Kafka's Jewishness" (1956), in *Art and Culture: Critical Essays*, 273.

46. I wish to express my gratitude to Catherine Soussloff for all her critical guidance and editorial direction, which have been so helpful in focusing and "reframing" this account.

Meyer Schapiro's Jewish Unconscious

DONALD KUSPIT

Margaret Olin, reviewing the fourth volume of Meyer Schapiro's *Selected Papers,* observes that Schapiro "only seldom addresses [his] Jewish heritage."[1] Surely, she suggests, it must have influenced his practice of art history and criticism. But she is at a loss to say how. Olin notes that Schapiro's neglect of the issue is all the more conspicuous because the Jewish American art critics Clement Greenberg and Harold Rosenberg, who were his contemporaries, openly viewed modern art from a Jewish point of view. While it was one among several heuristic gambits, they often privileged it as the most revelatory: the perspective that could disclose what is most at stake or immanent in modern art.

Rosenberg argued that anxiety about identity is "the most serious theme"—indeed, the ultimate "metaphysical theme"—in both Jewish life and modern art.[2] Such anxiety was at its height after World War II, which is why many Jews became artists then. Art allowed them to work through their ambivalence about being Jews. They experienced Jewish identity as increasingly problematic in the modern world, yet inescapable—even in the modern world. But it is modern to be alienated from one's received identity, which made the modern Jewish artist exemplary.

Greenberg declared that "Kafka's Jewish self . . . tests the limits of art":

> When did a Jew ever come to terms with art without falsifying himself somehow? Does not art always make one forget what is literally happening to oneself as a certain person in a certain world? And might not the investigation of what is literally happening to oneself remain the most human, therefore, the most serious . . . of all possible activities?[3]

Could Kafka reconcile the Jew and artist in himself? Did he use his art to understand his situation as a Jew in a Christian world? If a Jew turns to art to strengthen

his sense of self—to survive emotionally in a world in which he is always suspect—isn't he turning away from God? Doesn't art help one remember—indeed, embody—what emotionally happens to one in the world, and isn't that more essential than what literally happens to one?

Modern art in particular raises such questions for Greenberg, for it tends to be alienated from the world it represents. And the modern Jewish artist—most notably Kafka—has a certain ironical advantage or head start, for he can graft the alienation inescapable in modern life onto the alienation built into Jewish existence, the alienation that is the Jew's birthright. Contrary to all expectations, the Jew is in a position, by reason of his emotional if not religious heritage, to become the exemplary modern artist, which is what Kafka was for Greenberg. While "the Jewish truth, or the truth of [Kafka's] Jewishness . . . accounts for some of the frustration of his art,"[4] it also reminds us that "one of the functions of art [is] to keep contradictions in suspension, unresolved."[5] The artist is entitled to "inconsistency," however much "the triumph of art lies—as always—in [the] reconciliation" of "contradictory impulses."[6] Kafka's stories are a major test of art, for in them the impulse to make art is in conflict with Jewish awareness of menace, even as they ingeniously use art to bring the reader to full, excruciating consciousness of it, and to transpose it to the modern world: Kafka's triumph is to make its menace unmistakable—traumatic and overwhelming.

The question whether Jewish identity and artistic identity can be reconciled—whether the apparent contradiction between them can be overcome—seems very far from Schapiro's thinking about modern art, and art in general. Yet as I hope to show, it is as important for him as it is for Greenberg and Rosenberg, but much more subliminally. Like them, Schapiro was an early, forceful advocate of abstract expressionism. And like them he thought that selfhood or identity was the central issue of modern art, as his studies of Cézanne and Van Gogh indicate. But Schapiro's view of the centrality of identity rarely encompassed Jewish identity, at least overtly, as it tended to in the thinking of Greenberg and Rosenberg.

Only in his essay on Chagall's *Illustrations for the Bible* does Schapiro deal explicitly with an artist's Jewishness. And there its effect on his art is remarkably positive. It was because of his Jewishness that Chagall "surmounted . . . the limits of his own and perhaps all modern art," Schapiro writes.[7] Jewishness kept him in touch with "the full range of his emotions and thoughts," unlike other modern painters, whose "enthusiasm for new and revolutionary possibilities of form and . . . desire for an autonomous personal realm" led them "to exclude large regions of experience from their work." Jewishness gave Chagall's art a broad humanity not always in evidence in modern art. This essay is the only place I know of where Schapiro criticizes modern art; he usually praises the modern artist's preference for "the spontaneous, the immediately felt,"[8] which indicates "remarkable inner freedom."[9] Thus, while

Chagall "owes much to the happy conjunction of his Jewish culture—to which painting was alien—and modern art—to which the Bible has been a closed book," he is a "rare," even unique, phenomenon. In more ways than one: he is the only consciously Jewish artist, modern or otherwise, Schapiro deals with, apart from the anonymous artist who created *The Bird's Head Haggada,* an illustrated Hebrew manuscript of around 1300.[10]

The absence of sustained, explicit engagement with the question of Jewish identity in Schapiro's oeuvre is all the more surprising because he never denied his Jewishness, unlike the great connoisseur Bernard Berenson, who actively repudiated his Jewishness by converting to Christianity. Berenson initially became an Episcopalian—the thing to be at Harvard and in the world of Boston Brahmins that Berenson moved in—and then converted to Catholicism, supposedly out of love for the woman who became his wife, but also because it was the thing to be in Italy, where Berenson settled. Sounding like an anti-Semite, Berenson in fact once wrote that "the puzzling character of the Jews . . . and their interests are too vitally opposed to *ours* [my emphasis] to permit the existence of that intelligent sympathy between *us* [my emphasis] and them."

I am quoting from "Mr. Berenson's Values," Schapiro's notorious 1961 essay on Berenson.[11] Schapiro's title clearly suggests his determination to separate his values from those of Berenson. Berenson's disavowal of his Jewishness—his identification of himself as a Christian—is completely alien and repugnant to Schapiro. Olin focuses on the essay, correctly regarding it as essential for understanding Schapiro. It not only reveals, as she writes, "the complexities of the experience of Jewish art historians and critics,"[12] but the Jewish thread in Schapiro's consciousness of art, the Jewish thread in Schapiro's labyrinthine writing about art. To use Henry James's phrase, the essay strongly suggests that a Jewish figure can be deciphered in the carpet of Schapiro's consciousness of art, if one cares to look carefully. Jewish identity is the irrepressible issue of Schapiro's discussion of Berenson, leading one to suspect that it must be inherent in his outlook, if usually unconscious. It is as though, dealing with Berenson, Schapiro could no longer repress himself, for Berenson's denial of his Jewish heritage—a temptation for many assimilated Jews, indeed, a confirmation of their assimilation (at least in their minds)—was inseparable from his achievement. And yet, as Schapiro subtly shows, it was a peculiarly Jewish achievement: Berenson's Jewish identity gave him the strength of character and cunning to survive and flourish in alien circumstances. Schapiro's essay is a remarkable tour de force: a vigorous, if ironical, affirmation of the benefits of a Jewish identity. Moreover, Berenson forced Schapiro to show his hand—to signal, decisively if only once, the important, even crucial, role Jewish identity played in his view of art. Indeed, I will argue that for Schapiro the most innovative artists were Jewish in spirit—that he believed authentic innovation was only possible from a "Jewish position" in society.

Schapiro deals with Berenson's Jewish identity at great length. Interestingly enough, however, the index to volume four of Schapiro's *Selected Papers*, in which the essay is reprinted, does not mention "Jewishness." In general, there are few references to the subject in any index in the volumes of Schapiro's *Selected Papers*. In the index to volume three, *Late Antique, Early Christian and Mediaeval Art,* mention is made of "Jewish art," "Jewish literature and folklore," and the (good) relations between Jews and Christians in the Carolingian Empire. But apart from that, only the first volume, on *Romanesque Art,* discusses "Jewish beliefs." Two of the five references are to footnotes. The relative paucity of reference to things Jewish is no doubt predictable in the context of an analysis of Christian art. But, as I argue, it is their occurrence with Christian art in Berenson that gives them peculiar weight.

Both Berenson and Schapiro were Lithuanian Jews, born almost forty years apart, Berenson in 1865, Schapiro in 1904. Yiddish was their first language. But Schapiro never changed the surname that identified him as a Jew, while Valvrojensky became Berenson. And Berenson's birthplace was no longer Butremanz but Vilna, which is the way it is still listed in the *Encyclopaedia Britannica*. Berenson altered his identity, while Schapiro remained true to his. Noting these facts, Schapiro observes that Berenson, "through his interest in old Italian art . . . was able to surmount" the "troubling" question of his Jewish identity and origin by "transposing the questions: Who am I? Where do I come from? to the challenging problem of the identity of artists, creative personalities known by their first names" and widely admired "but often mistaken for others in the labeling of works."[13] Berenson created a new identity as a connoisseur of Italian art out of an early identity as a specialist in Oriental languages. (At Harvard he studied, apparently with rabbinical diligence and fervor, Arabic, Assyrian, Hebrew, and Sanskrit.) It paralleled his change of religious (and social) identity from Jew to Christian. These self-transformations clearly interest Schapiro as creative solutions to the problem of identity. For Schapiro, Berenson's self-creation suggests an artistic resourcefulness.

In fact, for all his skepticism about Berenson, Schapiro expresses a certain admiration for him, especially for his ability to survive in an alien, inhospitable world. Although Berenson was a Jew from the "uncouth ghetto," Schapiro writes, he was able to force "the New England patricians [to] meet him on the higher ground of culture, in his personally created establishment in the land of the great Renaissance painters."[14] "A frail little man, an aesthete dreaming of Pater's Marius, [Berenson] had the will and energy and intelligence to achieve authority and social position,"[15] as well as to make a fortune. Indeed, Schapiro remarks, not without a certain respect and perhaps surprise, that "through all dangers [Berenson] landed on both feet, even under Fascist anti-Semitism and with Hitler's army in Italy during the Second World War." Berenson in fact was a role model for Schapiro, until a moment of disillusionment, which he describes in his essay. Certainly their paths were different, yet

Schapiro identified with Berenson as a Jew making his way in a Christian world openly prejudiced against Jews. For Schapiro, Berenson's will to survive and flourish, materially and intellectually, against all odds, testified to his Jewish pride. Thus Berenson remained a Jew on the inside, however much, on the outside, he denied that he was one.

In his Berenson essay Schapiro makes clear his deep concern with Jewish identity and, more crucial, with its relationship to artistic creativity. But this concern is not generally visible on the surface of his writing (perhaps because it is deep). Nonetheless, it is possible to infer, and demonstrate, that for Schapiro the creative, paradoxical way the Jew—a Jew like Berenson—survives and establishes an identity in a world that barely tolerates his existence is the model for the way the artist achieves his creative identity. That is, the paradox that art becomes when it is most creative exemplifies what might be called the Jewish Paradox. In the paragraph that follows, I offer a reading of Schapiro to prove my point. I even attempt to explain why the Jewish truth in Schapiro necessarily remains hidden, however profoundly his thought is informed by it.

For Schapiro, all authentically creative art—which is not every art—is subliminally Jewish, not in a doctrinaire sense but in attitude. This characterization holds for modern art, which Schapiro regards as a particular triumph of creativity, but also for the remarkable sculptures of the Romanesque abbey church of Souillac. Both show the Jewish Paradox in action. For Schapiro, the achievement of creative art, in whatever society it occurs—and he studied it primarily in medieval Christian society and modern capitalist society—is "Jewish" in some sense. Thus, while Schapiro does not use the word "Jewish," the negative social experience out of which the artist makes something aesthetically positive through his creative mastery is fundamental to Jewish activities in creating art. The Jew's social role is to represent creative survival against great odds, which is why, however persecuted, Jews are never completely exterminated: they represent society's need to believe in its survival—indeed, in immortality. The Jews have been called the "eternal people" for good reason; they carry the austere banner of eternity for society. But this is also why they are regarded ambivalently: the requirements of eternity often interfere with those of the moment. Eternity is fairly demanding; it does not accept half measures. The creative artist is also a survivor—that is, a person who can establish an identity and sense of self and individuality against great odds. The artist also represents a possible immortality; truly creative art is not made just for the moment. The Jewish Paradox is cross-cultural and verges on being an ahistorical paradigm for Schapiro, but the important point is that it signals a common problem artists have faced wherever and whenever they lived, especially if they wanted to be original. The Jewish Paradox is, then, the root paradox of art for Schapiro. He understands its history through this paradox and at least two other paradoxes that follow from and, in a sense, explicate

it. Schapiro uses these paradoxes to make the most creative and innovative art intelligible. I emphasize that while Schapiro is thoroughly familiar with the history of art, he concentrates on works of art that show exceptional originality. With careful analysis, such as Schapiro provides in great empirical detail, they make it clear that originality is a paradoxical achievement.

A paradox, according to the *Oxford Universal Dictionary*, is "a statement or tenet contrary to received opinion or belief." It can also be "a statement seemingly absurd or self-contradictory, though possibly well-founded or essentially true." The prefix "para" signifies "by the side of," often implying that something is "amiss, faulty, irregular, disordered, improper, wrong," as well as in "subsidiary relation to something else." To what? To the orthodox, which the dictionary tells us means "right in opinion," "holding correct, i.e., currently accepted, opinions, especially in theology." Paradox, then, has a certain resemblance to heterodox(y), which means "not being in accordance with established doctrines or opinions, or those generally recognized as orthodox," "originally in religion and theology," that is, in the theory and practice of spirituality. But paradox is not just discordant; in contradicting established doctrine, it establishes self-contradiction. It carries difference to the point of absurdity. More precisely, it goes against received opinion and belief, but it does not offer a different opinion and belief. Rather, it signals the absurdity of opinion and belief. It frees us from opinion and belief. That is, paradox offers spiritual liberation. It releases us from our bondage to *doxa*, to use the Greek word. Instead of doctrine, it gives us a certain sense of spirit.

Thus in a paradox opposites unite to creative, spiritual effect. What looks absurd and incoherent from the viewpoint of ordinary logic acquires a spiritual logic: the logic of transcendence of received doctrines, leaving the sense that no opinion is fixed forever, indeed, that belief is beside the point of spirit. Rather than being dismissed as a logical contradiction, the paradox can be experienced as a form of play, a sign of spontaneity and freedom. Schapiro is obsessed with paradoxes. Again and again he celebrates them as characteristic of truly original art. Indeed, they are art's ultimate gift to us.

Let me bring this down to earth. The Jew is by definition heterodox in an orthodox Christian world. That is, the Jew has different received opinions and is in the minority. In a world of Christian orthodoxy, the Jew is radically Other. Jews are by definition outsiders "within the bourgeoisie," as Max Horkheimer said.[16] Moreover, because of their "basic common experience . . . no degree of conformism [has been] enough to make [the Jew's] position as a member of society secure." Jews have a long "experience of the tenacity of social alienation."[17] How can the heterodox minority survive the domination of the orthodox majority without being submissive, and without surrendering its beliefs? What does it mean to be creative? It means to establish what Schapiro calls a "chiasmic, antithetic,"[18] or "discoordinate"[19]

relationship with orthodoxy. How does one do this? By treating beliefs in a spontaneous way, which affords a certain sense of freedom from them—and unwittingly undermines them, or forces them to change. In a system of orthodoxy and conformity, spontaneity is rebellion; only the conforming orthodox do not realize this until it is too late for them to inhibit or censor it.

The artist is heterodox in an orthodox world of conformity, be it Christian or capitalist. He has to work with its received opinions, but he can treat them in a spontaneous, creative way, which liberates him from them. If he is a good abstract expressionist painter, he produces a painting that conveys a sense that there are no received opinions—a giddy sense of spontaneity and freedom, which undoubtedly looks like anarchy to the orthodox and doctrinaire. If he is a sculptor working on Souillac, he produces a self-contradictory work of art that, by reason of its interplay of sacred and profane elements, seems to undermine the official hierarchy of being. In the case of both Jew and artist, the response to the dominant, deadening, doctrinaire orthodoxy is paradoxical, and the result is a vital spiritual paradox—the core of a sense of identity. For Schapiro, art is the individual's creative solution to the problem of oppressive orthodoxy that demands conformity. The artist's nonconformist, unorthodox resources of spontaneity and inner freedom can resist and replace the orthodox. Ironically, the work becomes proof of orthodoxy's own survival power, as well as a demonstration that, after all, it is not so oppressive. Orthodox society honors unorthodox art to show its tolerance of nonconformity and insubordination, but it does so only after the fact, that is, after it created an oppressive world that made unorthodox originality—"insurgent convictions"[20]—necessary for survival.

Thus capitalism, the dominant orthodoxy of the modern world, turns unorthodox art into a commodity. In a famous passage, Schapiro deplores the commodification of art, which exploits its essential spirituality, to use his own word.[21] And yet, paradoxically, it is only as a commodity that art survives—just as, paradoxically, it was only as a Christian that Berenson survived and was able to devote himself to eternal art. Similarly, Christianity, the dominant orthodoxy of the medieval world, assimilated Romanesque art, which is only nominally Christian. As Schapiro wrote, Romanesque art was "a new sphere of artistic creation without religious content and imbued with values of spontaneity, individual fantasy, delight in color and movement, and the expression of feeling that anticipate modern art."[22] For Schapiro such qualities suggest that Romanesque art, like "much of the best art of our day . . . [was] strongly critical of contemporary life," that is, the dominant Christian orthodoxy.

Romanesque art and modern abstract art are the poles of Schapiro's interest. They converge: in a sense, what Romanesque art began climaxes in modern abstract art, which, "more passionately than ever before, [is] the occasion of spontaneity or intense feeling. The [abstract] painting symbolizes an individual who realizes freedom and deep engagement of the self within the work."[23] Such deep engagement is a

criticism of society. Intense feeling, ostensibly religious, but issuing in a new aesthetic, is implicitly critical of orthodoxy. As Schapiro argues in his brilliant analysis of the socioeconomic basis of early modernist art, the spontaneity of "early Impressionism . . . had a moral aspect. . . . its unconventional, unregulated vision . . . [is] an implicit criticism of symbolic social and domestic formalities."[24] It was an antidote to "a sense of helpless isolation in an anonymous, indifferent mass." But within a decade "the enjoying individual becomes rare in Impressionist art," and in neo-impressionism even "the private spectacle of nature" disintegrates. What is left is "the social group," broken up "into isolated spectators, who do not communicate with each other," as in Seurat's masterpiece *La Grande-Jatte* (1884–86), and the representation of "mechanically repeated dances submitted to a preordained movement with little spontaneity," as in Seurat's *Study for Le Chahut* (1889) and Toulouse-Lautrec's *Moulin de la Galette* (1888). The art of Gauguin and Van Gogh is a "groping to reconstitute the pervasive human sociability that capitalism had destroyed"—to avoid the fate of the listless, numbed, ironically dispassionate figures we see in Seurat and Toulouse-Lautrec. "But since the artist did not know the underlying economic and social causes of their own disorder and moral insecurity, they could envisage new stabilizing forms only as quasi-religious belief or as a revival of some primitive or highly ordered traditional society with organs for a collective spiritual life."

In other words, the impressionists, neo-impressionists, and symbolists were faced with the Jewish Paradox. They were forced to use their creativity in situations in which they felt they had no control. Schapiro dissects various artistic solutions to a threatening capitalism and, implicitly, to Christianity. The solutions, which are the result of a desperate struggle for emotional survival in an objectively oppressive society, as Schapiro emphasizes, involve the same spontaneity and inner freedom. The artist has the courage of his spontaneity and projects his inner freedom into his art. His artistic solution to his psychosocial problems is personal, but it clearly has social import, which is why society eventually enshrines it, without necessarily understanding it. Indeed, society has to forget the reason for originality—rebellious criticism—to "recognize" an original art. Such a recognition invariably involves a falsifying reconceptualization of the art as a purely formal matter.

For Schapiro the dialectic or paradox of originality or genuine creativity involves a heterodox individual who criticizes and contradicts an orthodox system of opinion and belief with his own spontaneity and inner freedom in order to survive and establish his independent identity or autonomy, a word Schapiro frequently uses. The irony of originality is that the individual has to partially identify with orthodoxy to defeat it or, rather, transform it into a symbol of himself. Vestiges of orthodoxy—that is, orthodox iconography, indicative of received social opinion, and orthodox style, indicative of a received conception of creative art (as though art were

simply a mimicry and reiteration of received ideas)—survive within his unorthodox representation of it, which not only reveals its underlying truth but also symbolizes his opposition to it. Basically, what the artist wants and creates is breathing space: the work of art is an unorthodox space in which it is possible to breathe in society's emotionally stifling orthodoxy. It is interesting that the highest accolade Clement Greenberg could give a work of art was to say that it "breathed." Schapiro says something similar—spells out what it means to breathe, and in fact at one point uses the same language Greenberg does.

Both the Jew in the Christian world and the artist in the capitalist world present healthy alternatives to stuffy orthodoxy. Like the Jew, the artist constantly monitors a threatening environment—an environment that asks him to sacrifice his creativity to some orthodoxy and, if he refuses, tries to impose it on him. Like Berenson he may, on the surface, give in to survive. (It is worth noting that the conception of art as a mode of health is Nietzschean, but Nietzsche didn't realize as fully as Schapiro its ironical character and social place. It should also be noted that, unlike Greenberg, Schapiro believes, and demonstrates, that "Jewishness," as an inescapable state of mind for the sensitive individual, and art, as a creative escape from it, are not only compatible but inseparable.)

Spontaneity and inner freedom show themselves through what Schapiro calls "discoordination" and chiasmic dialectic—paradox in action, as it were. Discoordination, Schapiro writes, is "a grouping or division such that corresponding sets of elements include parts, relations, or properties which negate that correspondence."[25] Chiasmic or negative dialectic is the root of discoordination—that is, it results in a discoordinated or negative aesthetic. "Chiasm" is a term derived from anatomy; it means "intercrossing or decussation." The "optic chiasma" is "the optic commissure or decussation of the fibers of the optic nerve." More directly relevant to the idea of dialectical creativity is "chiasmatypy," a term from genetics that designates "the supposed spiral twisting of homologous chromosomes about each other during parasynapsis, with fusion and possible crossing over at the points of contact." Put this another way: the heterodox and orthodox, which are homologous except for the one gene of belief—the crucial difference—conjugate to paradoxical effect. Schapiro explicitly asserts that this dialectical process of ironic doubling is the method of individualization or individuation. In fact, he is obsessed with the structure of opposition and its dialectical resolution in paradox. He routinely discloses the paradoxical doubleness of the artistic phenomena he investigates, be they works of art or such critics as Fromentin and Diderot who are, in their different ways, role models for him, because of their awareness of doubleness.

Thus Schapiro speaks of the "calculated ambiguity" of art,[26] Champfleury's "double attitude . . . to the events of 1848 and 1849,"[27] the "double character of the mousetrap . . . as domestic object and theological symbol" in Robert Campin's

Merode Altarpiece,[28] the "double process" whereby religious authority becomes humanized and realism spiritualized in that same altarpiece[29]—a process basic to the most creative religious art—and a "double gesture . . . not merely designed to represent a more complex interaction, but . . . an element of a style which promotes contrasts and movement" and "constitutes an expressive form as well as an expressive symbol."[30] Important images always have a "double character," especially in Romanesque art, and images of force, which Schapiro shows a special interest in. He repeatedly analyzes "counterpart elements," "countermovements," "counterpart patterns," "counterpart symmetrical gestures,"[31] contrast of color[32] and direction,[33] as when legs vigorously cross in a stark X-form.[34] He loves paradoxes of meaning, as when he notes "that just as two unlike words (or syntactical forms) may have a common ancestor, so in different languages two similar words with the same meaning may be [etymologically] independent of each other."[35] Thus the paradoxical import of "saltimbanque" and "banker," which both derive from the same "bank" or bench at fairs. But whereas the former symbolizes the impoverished yet independent artist, ostensibly a person of free, spontaneous, deeply feeling spirit, and as such heterodox, the latter names an authority on finance, a priest of money, a pillar of the capitalist orthodoxy.[36] Schapiro is taken with juggling and any kind of juggling with words and visual forms, with the way new art negates old art while "the old may persist beside the new in affirming an opposed or declining culture,"[37] and with Augustine's dialectical conception of beauty—"God is an artist who employs antitheses of good and evil to form the beauty of the universe, . . . where beauty is a compound of opposites, including ugliness and disorder."[38] Schapiro loves, as he says St. Bernard did, "striking contrasts, violent and astounding oppositions, . . . the antithetic and inverted."[39] He admires Mondrian's "asymmetry of unequal lines."[40] Van Gogh's paintings achieve their agonizing quality by means of "counter-goals," "competing centers," and "competing directions."[41] Their power derives from "crossing diagonals," their "strain" or tension from "self-conflicted" forms.[42] Cézanne's art engages us, emotionally and intellectually, because of his "practice of the other pole,"[43] his attempt to overcome the "polarity" between color and line as well as self and nature, and in general his use of "counterpart shapes"[44] and "color contrasts."[45] Schapiro speaks of the "stress of contrasts" in Cézanne's painting[46] and the "contradictions" in those of Van Gogh.[47] In the *Wheatfields* Van Gogh "is caught up across the yellow fields from the chaos of the paths and the dread of approaching birds and carried to the deep blue sky, the region of the most nuanced sensibility, a pure, all-absorbing essence in which at last subject and object, part of the whole, past and present, near and far, can no longer be distinguished."[48] Romanesque art makes similar use of chiasmic form to achieve an effect of sublimely nihilistic indistinguishability and ironical totality. "Expressive dualities," "polar forms," "polar ideas" acquired their particular weight "within a prevailing system of

(social) values,"[49] just as the doubleness of the Jew's existence has its weight because of its ironical place in the prevailing system of social values. Schapiro's sense of dialectic is derived from his reading of Hegel and Marx, who offer "an explanation of active historical process," and from Riegl, who examines "possible latent internal conditions" of development by analyzing the "oppositions within a style" (or society) which render it "unstable and hence suggested fresh changes and solutions."[50]

But it is also derived from his feeling of being a Jew in the opposition, forced either into submission or independence, or dialectically, some creative compromise between the two, such as Berenson in his way—and Schapiro in his way—achieved. It has been said that psychoanalysis is a Jewish science. I would rather call it the Jewish revenge, its revenge consisting in its demonstration that there is conflict behind even the most sanctimoniously orthodox, socially unctuous facade. One might say that Schapiro devoted a good part of his career to Christian art to demonstrate that it is highly—indeed, violently—conflicted and full of awkward compromises—that is, contradictions and bizarre syntheses of opposition, which give the lie to the Christian profession of universal reconciliation. In doing this—in going right to the center of traditional art history, namely, the study of Christian iconography and classical or classicizing style—Schapiro subverts traditional art history, in the process turning it into what might be called a Jewish science, that is, a science of aesthetic and moral paradoxes. Art is a matter of unbalanced psychosocial forces brought into precarious, unpredictable balance, not of divinely foreordained harmony, a preconceived unity whose historical and formal exemplification in different styles is ultimately beside the point. In showing that the most dynamic Christian art is implicitly modern, Schapiro shows that art history cannot help but be modern, he shows that art history cannot help being modern itself—that is, the study of dynamic dialectical process—rather than the reification of existing modes of art into ideals, absolute models, which is what occurs under the guise of classification.

Schapiro needs modern art to come to his aid—which in part is why he supports it and identifies with its oppositional spontaneity and inner freedom—because he is taking on the traditional art history establishment, which is heavily invested in traditional art, and thus supports Christian orthodoxy whether it intends to or not. One has only to realize that many traditional art historians think modern art was an experiment that went awry to appreciate the courage of Schapiro's conviction. And one has only to realize that Schapiro wrote next to nothing about Renaissance Christian art, which is the stronghold of traditional art history, to realize how unorthodox an art historian he is. (His most "Renaissance" essay is his response to Freud's essay on Leonardo.[51] There, with his usual irony, he opposes psychoanalytical orthodoxy with an orthodox art-historical approach.)

Schapiro's vision of art stands in paradoxical opposition to traditional art history not only because it unites traditional Christian and modern capitalist art at their

most critical and intense, but because in doing so it contradicts two of the basic tenets of traditional art history: that the aesthetic and the moral have nothing to do with each other, and that traditional art must be understood in its own terms, without references to modern art and modern ideas. The first assumption is equivalent to saying that spontaneous form and social content have nothing to do with each other, a view Schapiro fiercely combats in his critique of Jurgis Baltrusaitis's conception of Romanesque art and in his critique of Alfred Barr's conception of the development of abstract art.[52] The second assumption amounts to asserting that there is no continuity of human issues in art history, so that the art of the past cannot live in the present, a view he attacks in his critique of Berenson's attitude to modern art, among other places. For Schapiro, both assumptions reduce the living art of the past and present to irrelevance and inhumanity. They do this by denying the enduring human, subjective purpose of formal innovation.

Formal innovation is always motivated by the desperate wish to maintain the feeling of being emotionally alive and autonomous, as he argues in his essay "On the Humanity of Abstract Art" (1960). Abstract art, he writes, reflects "the pathos of the reduction or fragility of the self within a culture that [is] increasingly organized through industry, economy and the state," a potentially fascist situation that "intensifies that desire of the artist to create forms that will manifest his liberty."[53] Orthodoxy carried to an extreme becomes fascist, squeezing out, even obliterating, the sense of selfhood, which turns to art to rescue and preserve itself. In general, Schapiro's essays on modern art are an implicit critique of the totalitarian and authoritarian tendencies of capitalist orthodoxy, just as his essays on Early Christian art, particularly Romanesque art, are a critique of the totalitarian and authoritarian tendencies of Christian orthodoxy. This is part of their creative Jewishness. Genuinely creative art, like creative Jewishness—the Jewishness of Schapiro, and to a lesser extent Berenson—is a mode of adaptation to an oppressive society, and as such a declaration of independence and liberty, which is why, as Schapiro says, it moves us deeply. It reminds us that even in the most impossible circumstances we can survive and even have autonomy, if only inwardly.

The two paradoxes through which Schapiro understands art history are variations of the Jewish Paradox. The first paradox, that one can understand the sociomoral issues implicit in an art only by understanding its aesthetic character, is capsuled in his assertion that "aesthetic feeling . . . [can] be a starting point of radical thought."[54] "The aesthetic . . . [can] sublimate the imperfections of the world" and, in doing so, criticize it. If aesthetics is not a spiritual transformation of "common experience," and if it does not address "the problems of mankind," then art "risks becoming empty and sterile."[55] For Schapiro, the contradiction between aesthetic spontaneity and moral content first appeared, in its modern form, in Diderot's thought. Diderot resolved it by imagining an art of "passionate morality."[56] While being "an ethics of

altruism" and an "implicit critique of egoistic indulgence," such an art nonetheless conveys "the general principle" that "art in modern society requires for its life the artist's spontaneity."[57] According to Schapiro, Diderot was among the first to recognize this principle and to regard spontaneity as a moral, indeed altruistic, matter. Of course, Schapiro, with his usual wary irony, cannot help noting that Diderot's vision of "the artist's independence" was subsumed, in our century, by his vision of art as "a moral and civic agent," leading to its use as "an instrument of despotism and support of mediocrity"[58] by such totalitarian and authoritarian societies as Nazi Germany and the USSR. Perhaps Schapiro's most probing formation of this paradox is his view that the doubleness or contradictoriness or precariousness of form in the best art is a sign of "searching conscience,"[59] as he calls it. Creative originality is a form of searching conscience.

Schapiro's second paradox is that one can understand the past only through the present, a notion that he regards as a cliché of understanding. Nonetheless, it is suspect among traditional art historians, because they do not see the spiritual continuity between the best traditional and the best contemporary art. Schapiro's attitude is that of Fromentin, one of his critic heroes: "Studying the works of the past, he strives to make himself contemporary with them as actions of a spiritual moment and a mood."[60] This is why, like Fromentin, Schapiro "can speak . . . of the execution or colors or arrangement" of a work of art "as noble, generous, passionate, or candid," that is, "as possessing . . . the attributes of a superior humanity."[61] In other words, art can embody a "full humanity." Indeed, it can be more human than human beings, for human beings displace the hopes and aspirations they cannot realize onto art.

Schapiro's conception of the spiritual exchange that occurs between past and present art—an exchange that allows both a more comprehensive and a deeper understanding than the traditional division of art history into disconnected and incompatible periods—is perhaps at its clearest in his argument that "modern practice disposes us to see . . . prehistoric works as a beautiful collective palimpsest."[62] Schapiro believed that Berenson "failed to grow" "as a theorist and critic" because of his contempt "for contemporary taste in art" (he denounced "the whole of contemporary art as degenerate," not unlike the Nazis) even though "Berenson's aesthetic, with its categories of 'Form, Movement, and Space,' and his stern insistence on the highest values of art, seems in the line of thought which produced modern painting."[63] (Berenson's categories are the basics of visual art. The question for Schapiro is whether they are realized spontaneously and paradoxically, thus serving and symbolizing inner freedom, or they conform to some current orthodoxy's fixed conception of selfhood and society.) This is ultimately why Schapiro thinks Berenson ridiculous as a mind and even inauthentic as a connoisseur. Schapiro in fact cites several examples of major errors of attribution made by Berenson, casting doubt on

his famous eye and on his motivation for making the attribution. Many of the misattributed Renaissance works are not by the master's spontaneous hand, even to a novice eye. But in proclaiming that they were, Berenson increased their economic value and his profit enormously.

At its most literal, Schapiro's Jewish Paradox asserts that Christian art can be understood only through Jewish spirituality and spontaneity. In fact, Christian art reifies the Jewish Bible into a dogmatic iconography. Even the idea of Christ is a reification of the Jewish idea of the Messiah, a hopeful, spontaneous wish-fulfillment. Christian art historians do not sufficiently realize the Jewish truth at the core of Christian art. It has to be emphasized that Christian art has been the dominant art of the West. It has absorbed every style and moral idea into its orthodoxy. Modern art, with its unorthodox emphasis on spontaneity and inner freedom rather than on blind faith in orthodox ideas, is a passing episode compared with orthodox Christian art. This is why Schapiro defends modern art, and unorthodox Christian art, so strongly.

Finally, consistent with himself, Schapiro is against Jewish orthodoxy—"the demands of [Jewish] ideological conformity"[64]—as much as he is against Christian and capitalist orthodoxy. This is why there is relatively little explicit mention of "Jewishness" in his writing. Jewishness is as conflicted as Christianness; that is, Jewishness is not a unified position, but a precarious balance of convictions. It is split in its vision of God: on the one hand, he is a wrathful, if judicious, patriarch; on the other hand, he is pure abstract creative spirit, able to manifest itself spontaneously in a flaming bush or a pillar of smoke. Schapiro preferred the latter conception: God's power was manifested, not in the punitive authority of patriarchy or matriarchy, but in the pure grace of spontaneous creativity.

In this Schapiro is like Spinoza. In one of the most interesting parts of his essay on Berenson, Schapiro expresses his disgust at the "grotesque comparison" Berenson makes between himself and Spinoza and St. Paul.[65] In contrast to Berenson, they were, Schapiro writes, "two deeply dedicated and uncompromising Jews who, like himself, broke with the religion of their ancestors. But theirs was an act of courageous conviction, while for him the change of religion was a short-lived conversion that helped to accommodate him to a higher social milieu." I believe that Schapiro, in his conception of art as a zone of spontaneity and inner freedom, was essentially a Spinozist. That is, like Spinoza he broke with Jewish orthodoxy out of courageous spiritual belief in a creative God, even as, in his rabbinical habits of scholarship and his belief that art at its best is a kind of spiritual creativity—dare one say creation of spirit?—he showed that he was a dedicated and uncompromising Jew.

Like Spinoza, he was a heterodox Jew who had a paradoxical conception of art— a conception that went back to Genesis, not to the orthodoxy of Mosaic law. Like Jewishness, art can be reduced to orthodoxy, ritual, rules, and materialism. But at its best it is divinely—spontaneously and freely—creative, and inward in import. For

Schapiro, art is the realm in which the one true God becomes manifest: for him, as for many critic-aesthetes, art is a religion—a spiritual enterprise. It replaces traditional religion, which has lost its spirituality as it became more and more orthodox and dogmatic.

Schapiro is the last idealistic art historian-theorist-critic—certainly the last one who can even think of art as spiritual. But he expects more from his art than it can give. Even at its best art promises more than it can deliver; it is, after all, illusion, and illusion has never solved any problems in the real world. Moreover, even the most spontaneous, creative, inwardly liberated art is full of orthodoxy and conformity, however much it keeps hope alive. That is no mean feat. It would be interesting to hear what Schapiro, so strong a defender of modern abstract art, would think of postmodern abstract art, which treats spontaneity ironically, satirizing and stylizing it, and regards inner freedom as a farce. Not only is modern art over, ironically having become orthodox and institutional, but the routine parody and ironic manipulation of it suggest that it is despised.[66] In general, contemporary art tends toward orthodoxy and conformity rather than spontaneity and spirituality. It is full of oppressive ideological demands that, whether they come from the left or right, inevitably suppress genuine creativity. The mind-controlling orthodoxies of the left and right cannot help producing aesthetically incompetent, not to say critically inadequate, art. For any orthodoxy—Christian, Jewish, Marxist, Freudian, feminist, multiculturalist, conservative, liberal, and so forth—aesthetics is ultimately beside the point. Such art is of use only to the extent it reinforces ideological conformity, serves orthodoxy. It never serves individualization and individuation—autonomy. But aesthetically adequate art—art with the interiority and dialectical qualities Schapiro cherishes—has always been rare.

Notes

1. Margaret Olin, "Violating the Second Commandment's Taboo: Why Art Historian Meyer Schapiro Took on Bernard Berenson," *Forward* 98 (November 4, 1994): 23.

2. Harold Rosenberg, "Is There a Jewish Art?" in *Discovering the Present: Three Decades in Art, Culture, and Politics* (Chicago: University of Chicago Press, 1973), 230.

3. Clement Greenberg, "Kafka's Jewishness," in *Art and Culture* (Boston: Beacon, 1965), 273.

4. Ibid., 270.

5. Clement Greenberg, "The Impressionists and Proust," *Nation* 163 (August 31, 1946): 247 (review of *Proust and Painting* by Maurice Chernowitz).

6. Clement Greenberg, "David Smith's New Sculpture," *Art International* 8 (May 1964): 37.

7. Meyer Schapiro, "Chagall's *Illustrations for the Bible*" (1956), in *Modern Art: Nineteenth and Twentieth Centuries*, vol. 2 of *Selected Papers* (New York: George Braziller, 1978), 133.

8. Ibid., 121.

9. Schapiro, "Cézanne" (1959), in *Modern Art: Nineteenth and Twentieth Centuries*, 40.

10. See Meyer Schapiro, "The Bird's Head Haggada, an Illustrated Hebrew Manuscript of ca. 1300" (1967), in *Late Antique, Early Christian, and Mediaeval Art: Selected Papers* (New York: George Braziller, 1979), 381–86.

11. Meyer Schapiro, "Mr. Berenson's Values" (1961), in *Theory and Philosophy of Art: Style, Artist, and Society*, vol. 4 of *Selected Papers* (New York: George Braziller, 1994), 225.

12. Olin, "Violating," 23.

13. Schapiro, "Mr. Berenson's Values," 225.

14. Ibid., 217.

15. Ibid., 222.

16. Quoted in Rolf Wiggershaus, *The Frankfurt School: Its History, Theories, and Political Significance* (Cambridge, Mass.: MIT Press, 1994), 6.

17. Ibid., 4–5.

18. Schapiro, "On the Aesthetic Attitude in Romanesque Art" (1947), in *Romanesque Art*, vol. 1 of *Selected Papers* (New York: George Braziller, 1977), 8.

19. Schapiro, "The Sculpture of Souillac" (1939), in *Romanesque Art*, 104.

20. Schapiro, "Nature of Abstract Art" (1937), in *Modern Art: Nineteenth and Twentieth Centuries*, 186.

21. Schapiro, "Recent Abstract Painting" (1957), in *Modern Art: Nineteenth and Twentieth Centuries*, 224.

22. Schapiro, "On the Aesthetic Attitude in Romanesque Art," 1.

23. Schapiro, "Recent Abstract Painting," 215. Schapiro qualifies this more concretely: "The pathos of the reduction or fragility of the self within a culture that becomes increasingly organized through industry, economy and the state intensified the desire of the artist to create forms that will manifest his liberty in this striking [abstract] way" (222). It is worth noting that Schapiro follows Alois Riegl's method in finding "a necessary creative link" between Romanesque and modern abstract art ("Style" [1962], in *Theory and Philosophy of Art: Style, Artist, and Society*, 78).

24. Schapiro, "Nature of Abstract Art," 193.

25. Schapiro, "The Sculpture of Souillac," 104.

26. Schapiro, "On the Aesthetic Attitude in Romanesque Art," 22.

27. Schapiro, "Courbet and Popular Imagery: An Essay on Realism and Naiveté" (1941), in *Modern Art: Nineteenth and Twentieth Centuries*, 73.

28. Schapiro, "'Muscipula Diaboli,' The Symbolism of the Merode Altarpiece," *Art Bulletin* 27 (1945): 185.

29. Ibid., 186.

30. Schapiro, "The Romanesque Sculpture of Moissac I" (1931), in *Romanesque Art*, 187–88.

31. Schapiro, "The Sculpture of Souillac," 107, 113–14.

32. Schapiro pays a good deal of attention to the intense color contrasts that prevail in Cézanne's and Van Gogh's paintings (*Paul Cézanne* [New York: Abrams, 1965], 11–12, and *Vincent Van Gogh* [New York: Abrams, 1950], 19–20). This is not unlike the "intense . . . burning, heraldically bright . . . bands of contrasted color . . . spontaneous primitive" visionary color in "The Beatus Apocalypse of Gerona," a medieval manuscript (*Art News* 61 [1963]: 50).

In "From Mozarabic to Romanesque in Silos" (1939), in *Romanesque Art*, 35, he describes "Mozarabic painting as an art of color," using "constantly varied, maximum oppositions in the color through the contrasts of hue (and, to a lesser extent, of value)," and observes that in the "Beatus manuscripts color is felt as a universal force, active in every point and transcending objects."

It is worth noting that in his recurrent emphasis on "polar meanings," "polarity expressed through . . . contrasted positions," "polar structure," and "development between two poles"—to cite various references to polar thinking in his book *Words and Pictures: On the Literal and Symbolic in the Illustration of a Text* (The Hague: Mouton, 1973) and in his essay on style—Schapiro strongly resembles Alfred North Whitehead. In *Process and Reality* (New York: Humanities Press, 1955), Whitehead argues that the "doctrine of multiple contrasts . . . when there are or may be more than two elements jointly contrasted" is "a commonplace of art" (349). He also writes: "the organism's" creative achievement of "depth of experience" involves "suppressing the mere multiplicities of things, and designing its own contrasts. The canons of art are merely the expression, in specialized forms, of the requisites of depth of experience" (483). Finally, Whitehead philosophizes that "the universe is to be conceived as attaining the active self-expression of its own variety of opposites—of its own freedom and its own necessity, of its own multiplicity and its own imperfection and its own perfection. All the 'opposites' are elements in the nature of things, and are incorrigibly there." They justify "the aesthetic value of discords in art" (531), which is in effect a "minor exemplification" of major, universal opposites.

33. Schapiro, "The Younger American Painters of Today," *The Listener* 55 (January 26, 1956): 147.

34. Schapiro, "An Illuminated English Psalter," *Journal of the Warburg and Courtauld Institutes* 22 (1960): 183, observes that "the motif of the crossed legs is a general attribute of the ruler, whether good or evil; it isolates him from ordinary mankind, which sits or stands supported by both feet alike." It is perhaps the most exemplary instance of what Schapiro calls "chiasmic symmetry."

35. Schapiro, "The Miniatures of the Florence Diatessaron (Laurentian Ms. Or. 81): Their Place in Late Medieval Art and Supposed Connection with Early Christian and Insular Art," *Art Bulletin* 55 (1973): 518.

36. Schapiro, "From Mozarabic to Romanesque in Silos," 83, n. 87.

37. Ibid., 30.

38. Schapiro, "On the Aesthetic Attitude in Romanesque Art," 26, n. 10.

39. Ibid., 9.

40. Schapiro, "Mondrian: Order and Randomness in Abstract Painting" (1978), in *Modern Art: Nineteenth and Twentieth Centuries*, 235.

41. Schapiro, *Vincent Van Gogh*, 29–30.

42. Ibid., 27, 22–23.

43. Schapiro, *Paul Cézanne*, 27.

44. Ibid., 12.

45. Ibid., 18.

46. Ibid., 26.

47. Schapiro, *Vincent Van Gogh*, 8.

48. Ibid., 34.

49. Schapiro, *Words and Pictures*, 48.

50. Schapiro, "On Geometrical Schematism in Romanesque Art" (1932), in *Romanesque Art*, 268.

51. Schapiro, "Freud and Leonardo: An Art Historical Study" (1956), in *Theory and Philosophy of Art: Style, Artist, and Society*. See also, in the same book, "Further Notes on Freud and Leonardo" (1994). Schapiro's critique of Freud's psychoanalysis of Leonardo is eloquently epitomized in note 9 to "On the Relation of Patron and Artist: Comments on a Proposed Model for the Scientist" (1964) in the same book. Schapiro notes (237) that "Leonardo's slowness of work," which Freud interprets as "a neurotic sign," was a "more common characteristic [of artists] than Freud suspected. If one believes that Leonardo's failures to deliver were greater than those of other artists, it is also true that he has left us more writings, scientific observations, and technical inventions than any artist of the Renaissance, and perhaps of all time." Such slowness has to do with difficulties of creative work, not neurotic inhibition, although that may no doubt play a role.

52. Schapiro's "On Geometrical Schematism in Romanesque Art" takes as its point of departure Jurgis Baltrusaitis's *La Stylistique ornementale dans la sculpture romance* (1931); Schapiro's "Nature of Abstract Art" takes as its point of departure Alfred H. Barr, Jr.'s *Cubism and Abstract Art* (1936).

53. Schapiro, "Nature of Abstract Art," 222.

54. Schapiro, "Mr. Berenson's Values," 222.

55. Ibid., 227.

56. Meyer Schapiro, "Diderot on the Artist and Society," in *Theory and Philosophy of Art: Style, Artist, and Society*, 206.

57. Ibid., 204.

58. Ibid., 205.

59. Ibid.

60. Schapiro, "Mr. Berenson's Values," 224.

61. Meyer Schapiro, "Eugene Fromentin as Critic," in *Theory and Philosophy of Art: Style, Artist, and Society*, 105.

62. Meyer Schapiro, "On Some Problems in the Semiotics of Visual Art: Field and Vehicle in Image-Sign," in *Theory and Philosophy of Art: Style, Artist, and Society*, 6.

63. Schapiro, Mr. Berenson's Values," 212, 218, 229, 218.

64. Schapiro, "On the Relation of Patron and Artist: Comments on a Proposed Model for the Scientist," 237.

65. Schapiro, "Mr. Berenson's Values," 211.

66. As early as 1967 Clement Greenberg described it in "Where Is the Avant-Garde?" as "hypertrophied" and "institutional," later noting that "when everybody is a revolutionary the revolution is over." *Modernism with a Vengeance, 1957–1969*, vol. 4 of *The Collected Essays and Criticism* (Chicago: University of Chicago Press, 1993), 261–62, 299. Harold Rosenberg notes a similar "fashionabilizing" of the avant-garde in "The Avant-Garde" (1969), in *Discovering the Present* (Chicago: University of Chicago Press, 1973), 86.

Aby Warburg
Forced Identity and "Cultural Science"

CHARLOTTE SCHOELL-GLASS

 Calling one's field of inquiry cultural studies has become, during the past decade or so, an academic war cry of the unruly. Cultural studies—and from my point of view we must say "once again"— provides the vessel for a serious and widespread dissatisfaction with the academic structure of the disciplines we have inherited, which no longer seem to suit many of our contemporary questions, concerns, problems, or anxieties. A shared sense of the shortcomings of these divisions and the need for something better suited to the complexities had already become apparent in the academic disciplines themselves: a modified vision of our fields of research brought about by new and widely differing methodologies. These were generated by new outlooks, but also by the demands of our wider society, and consequently of politics. Perhaps the most telling example of this academic struggle is women's studies, a new discipline striving for the apparatus of periodicals, chairs, and institutes, prerequisites for funding and power. Now this struggle, not yet ended, is in various states of victory and defeat in the academic world. Nor can the debate be considered over when the intellectual implications of institutionalizing these new fields are addressed. These new disciplines only *seem* to differ from traditional ones in their close ties to the vested interests of those propagating them. The institution of inter-, cross-, and trans-studies has some bearing on the complex problems of interdisciplinarity and the forces that generate it.

Not much of this complex debate, the historian feels compelled to say, is new, if "culture" is the focal term. About a century ago many of the ingredients of today's debates were already in place, although the scenario was different. At that time art history in German-speaking countries—much earlier than anywhere else—had recently gained full recognition as an independent discipline with its own academic institutions. Alois Riegl in Vienna and Heinrich Wölfflin in Berlin (and later in Munich) were occupied with harvesting the fruits of specialization and profession-

alization.[1] Questions of *Stil* and *Form*, purportedly concerning art and art alone, were asked and answers given by the early art historians. Binary *Grundbegriffe* (fundamental principles) were developed and influential terms such as the Hegelian *Kunstwollen* (will to art) coined.[2] In the overall structure of the humanities, or *Geisteswissenschaften,* art history as a discipline was still concerned to prove its autonomous status and to emphasize its separateness from, rather than its ties with, other disciplines.

Aby Warburg (1866–1929) entered this setting with his conceptualization of art history as part of a science of culture (*Kulturwissenschaft*) that would again fuse what had only recently been separated. I argue in this essay that his need to do this and the scholarly strategies and institutional tactics he used to bring it about were concentrically related to "the problem that commands us."[3] The liberation from the demands of a particular field and the recognition of the potential of problem-oriented research in themselves seem stunningly original and can still serve as a model today. But what *was* the problem?

To answer this question, we must recall a few facts about Aby Warburg's life and work and the fate of his Kulturwissenschaftliche Bibliothek Warburg, which he founded in the 1920s in Hamburg.[4] Warburg was born the eldest son of a wealthy Jewish banking family that had come to Hamburg from Warburg, in Hesse, in the eighteenth century. By the time of Aby's birth the Warburg bank had moved into the small circle of leading private banks in Germany that helped to generate the increased productivity and wealth of the new *Reich,* founded in 1871. Family legend has it that the thirteen-year-old Aby gave up his privilege, as firstborn and heir, to his brother Max on the condition that his brother pay for every book Aby ever wished to buy. Max, as is well known, was mercilessly held to his promise.

Against the violent opposition of both his own family and his maternal relatives, the Frankfurt Oppenheims, Warburg insisted on studying art history, first in Bonn, with Henry Thode, Carl Justi, and Karl Lamprecht, and then in Strasbourg and Munich. He went to Florence, like so many others at the time, to study its art and to work in the archives. His 1892 dissertation on Botticelli's *Primavera* and *The Birth of Venus* was one of the first of many close readings of these paintings by art historians and the first to base its interpretation on a careful analysis of both visual and textual (i.e., literary and archival) documents.[5] By the time he wrote the dissertation Warburg was already interested in questions of psychology or, more precisely, the psychology of style. While he was working on the subject matter of Botticelli's images and its tradition in humanist thought and literature, he became aware that the graceful movement of drapery in these pictures had a *meaning* that transcends the purely ornamental or indeed aesthetic. His reading of "das bewegte Beiwerk," that is, movement expressed in seemingly insignificant places, as the embodiment of a spiritual and intellectual liberation resembles the reading of symptoms in medicine or clues in

criminology.[6] During the 1890s and most of the first decade of this century, Warburg systematically studied questions of "historical psychology," bringing together and relating to art and to each other a wide range of textual and visual documents on Renaissance costume and pageantry, including inventories and legal documents.

By investigating the causes of specific cultural expressions, Warburg took up that central historical discourse of his time, which was tied to the Renaissance and which one could describe as the tale of the birth of modern man and its various retellings. While contributing to the founding legend of modernity, he also undermined it, focusing as he did on tensions between the forces of progress and their antagonists, as visualized in the styles *all'antica* and *alla francese* in Florentine art; or on the meaning of the simultaneous inclusion of Flemish realist portraiture, pious Franciscan legend, and pagan imagery in the decorative program of the Sassetti Chapel in Sta. Trinità in Florence. For Warburg, the piecing together of more and more evidence from the culture of fifteenth-century Florence revealed an overall picture of a struggle between bondage in faith and superstition and the impulses of liberation embodied in the *rinascimento dell'antichità,* and man's enormous effort to balance these contradictory forces. His findings modified considerably the image of Renaissance man as the exemplary and untroubled go-getter that had emerged—for example—from Jacob Burckhardt's writings. For Warburg, the process of emancipation revealed itself as painful and dangerous, as well as potentially reversible. Warburg continued to probe even more arcane material and to reveal still more complex patterns, turning to the study of atavism, which he saw as an unavoidable, if perilous, part of the classical heritage. He studied the unshakable belief in the stars as the true rulers of men's lives; the early sciences that had emerged from this belief, such as astrology; and the "wanderings" of astrological images and texts from the Orient to the West via the Mediterranean.

Warburg's research in this field, coinciding roughly with the First World War, was influenced by the traumatic collapse of the old order that resulted.[7] In 1918 a mental breakdown necessitated his institutionization for almost six years. From 1924 until his death in 1929 his concept of *Kulturwissenschaft* took on two widely differing yet silently connected forms: the project of a *Bilderatlas Mnemosyne,* which was to contain the "Urworte der Gebärdensprache" ("basic words of the language of gesture")[8] and his Kulturwissenschaftliche Bibliothek Warburg. With the decisive help of Fritz Saxl and Gertrud Bing his collection of books was transformed into an Institute of Advanced Study. In 1933, only four years after Warburg's death, the institution, now the Warburg Institute in London, would be saved by a quick move out of Nazi Germany.

The few facts summarized here (and many more) can be found in rich detail in Ernst Gombrich's *Intellectual Biography,* published in 1970.[9] There can be no doubt about the book's formidable achievement as a lucid analysis of Warburg's scholarly life, particularly if one takes into consideration the numerous difficulties arising from the fragmentary character of Warburg's work, his use of the German language

as if it had to be reinvented for him to express what he had to say, and his complicated and sometimes obsessively repeated connections of minute detail with questions of universal scope.

Early criticism of Gombrich's book, however, rightly focused on two of its omissions: Hans Liebeschütz questioned the soundness of Gombrich's decision to give an abbreviated version of Warburg's life,[10] leaving out almost completely such non-intellectual factors as his Orthodox Jewish family background and particularly his struggle to detach himself from Judaism without denouncing it publicly. Liebeschütz refers to this whole complex as the "dialectics of assimilation."[11] Gombrich's abhorrence of what he considered irrational could itself be seen as irrational, I should like to add, in its selective perception of a full and complex historical reality.

Similarly, Felix Gilbert in his 1972 review of Gombrich's biography states that "if the reader remained not fully convinced of [Warburg's] seminal importance," it was "not Warburg's fault but that of the treatment [his work had] received."[12] Gombrich had not adequately placed Warburg's work into the context of the field of intellectual history in Germany (Gilbert refers to Wilhelm Dilthey and Max Weber as figures of similar stature and outlook) or situated it properly in the social and political landscape of the *Kaiserreich* and the Weimar Republic.

It was and continues to be Warburg's fate to be regarded and written about as a law unto himself. The considerable work that has been done since Gombrich's biography was published in a German translation in 1980 has not changed this. Both intellectual history, insofar as Warburg tried to reshape art history into a history and "science" of man, and social history—Warburg's biography as a part of that history—should be included in the current reassessment of his contribution to art history as a discipline.

In the archive and library of the Warburg Institute in London the phenomenon of *Nachleben* (after-life), which fascinated Warburg and later his collaborators so much, takes on other forms and another meaning. The archive preserves, as it were, the dark mirror image of the after-life of passions in our collective memory, one that could be seen to parallel the after-life of antiquity in its *longue durée* of almost two thousand years. A great number of documents and books on anti-Semitism, racism, and pan-Germanism and related political ideologies, collected since about 1900, are included in the famous system of arranging books according to subject in the library. I believe that understanding why they are there can help to explain the problems with the reception of Warburg's ideas. The material Warburg collected on anti-Semitism also sheds light on the very formation of those ideas. This material constitutes, it would seem, an area both in Warburg's work itself and in its tradition in England after 1933 that corresponds to the lacunae in Gombrich's biography: a central space of things unsaid, motives unspoken and never publicly acknowledged yet faithfully documented. At the root of Warburg's new way of looking at history

and artifacts lies his response to political developments in Germany and indeed in Europe since around 1880. Warburg conceptualized cultural science as a network of preliminary and correctly addressed questions in search of the answer to a bigger question that he never voiced explicitly: What is the reason for and meaning of the hatred of Jews? The answer to this question would have been necessary for any possibility of dissolving the threat of anti-Semitism.

I cannot present here a detailed analysis of all the letters, newspaper clippings, and file cards in the archive, or of the considerable number of books and photographs in the Warburg Institute that document Warburg's persistent interest in collecting, as it were, source materials fresh from the street. These include anti-Semitic pamphlets and propaganda published since the 1890s, complemented by one of the most complete sets outside specialized collections of texts on and by the founding theorist of racialism, the Conte de Gobineau, as well as other related bodies of texts.[13] The structure of these collections coincides with what we already know about the Warburgian style of scholarship in its close attention to minute detail counterbalanced by abstractions of universal scope and vice versa.

The existence of these collections, however, does not in itself constitute their historical and theoretical significance. Material clearly related to contemporary politics in a library and archive devoted to the history of the classical tradition, the *Nachleben der Antike,* in texts and images, may simply be evidence of its founder's private interests. Materials on other topics seem equally incongruous, for example the collections of books on zeppelins and stamps. Most such holdings can be ascribed to the emerging figure of a politically engaged scholar in touch with his own times, who was rather discreet about his own hopes for the contribution of cultural science to solving the problems of his troubled times. He was most explicit about the collection on anti-Semitism, however, in his library journal and private letters.[14] The true significance of much of the material on anti-Semitism in Warburg's archive and library, I would argue, lies in the way it is connected with and embedded into the primary material, the things one would logically expect to be there.

In the structure and order of the Warburg library and Warburg's files, crucial categories appear to be marked by the insertion of material on anti-Semitism. The subcategories in the file box on *Ur-Tänze* (primeval dance), for example, include not only "sword-dance," *Einverleibung* (erotic eating), "human sacrifice," and "Eucharist" but also "ritual murder" and "blood-libel." These headings label collections of press cuttings on contemporary incidents relating to accusations of ritual murder by Jews, an age-old theme put to horrible use in anti-Semitic propaganda, leading to pogroms around the turn of century, particularly in Eastern Europe but also in Germany. In the hundred or so file boxes, many more such disturbing contents come to light. Did Warburg's interest in sacrifice result from the theme's contemporary use by propagandists of racialism and anti-Semitism? Did Warburg's stress on art as a medium

to transport passions (always holding the possibility of destruction) and his view of *Pathosformeln* (which he understood as symbols of liberation as well as symbols of the reign of "brutish," irrational violence) owe something to his intense perception of the murderous threat to the lives of Jews in the midst of civilized societies? The conflicts arising from Warburg's rejection of traditional Judaism in an environment that ultimately denied him the liberty even to make such a choice because of his background must have sharpened his awareness of such themes.

Connections between Renaissance art and contemporary politics left a material trace in Warburg's work in a lecture he gave in 1905—published as a very short summary in 1906—entitled "Dürer and Italian Classical Art" ("Dürer und die italienische Antike")[15]—with separate plates illustrating the death of Orpheus.[16] The lecture deals with the iconography of the death of Orpheus in Italian Renaissance art, as exemplified in a Ferrarese print (Fig. 35) and a drawing by Dürer (Fig. 36), both in the Hamburg Kunsthalle. The Dürer is itself a copy of an Italian drawing related to the Italian print. The two maenads on either side of the fallen Orpheus who club him to death convey a sense of primeval choreography. Warburg argued in his lecture that Dürer studied these Italian versions of classical models for the depiction of the death of Orpheus. In doing so Dürer had different choices regarding *how* one could depict scenes of violence and bloodlust; in later years he came to choose—according to his "more balanced Northern temperament"—less explicitly violent subject matter and a more subdued style for it. Warburg's point here and in other articles at the time is that style could be a matter of conscious choice on the part of the artist and, what is more, a matter of *ethical* choice. He also emphasizes the all-important role of cultural exchange between different European cultures in the history of art. His emphasis on the productivity of the exchange of traditions, ideas, and *concetti* was clearly directed against the growing group of art historians who had begun to succumb to the nationalistic ideology of the day and who, in their turn, were trying to define the essence of the "Nordic" in German and Dutch art.[17]

Even if one accepts all of Warburg's assumptions, it is difficult to see how he had arrived at his conclusions solely from the material he presents, particularly as in his published text there is no reference to the actual subject matter, that is, Orpheus's horrible death at the hands of the maenads, a death ascribed in different sources either to Orpheus's ignoring all women because of his grief for Euridice, or to his pederasty, referred to in the inscription "Orpheus the first pederast" ("Orfeus der Erst puseran") in the Dürer drawing.[18] Only when we turn to the clean copy of the lecture in the archive does the source driving his forcefully worded argument about style become accessible. Inserted into the manuscript is a newspaper clipping of December 1905 from the liberal *Frankfurter Zeitung* giving a graphic description of a Cossack atrocity committed near Stavropol in Caucasia: a young woman teacher in a small town was attacked as an "intellectual" by the Czarist militia and died a

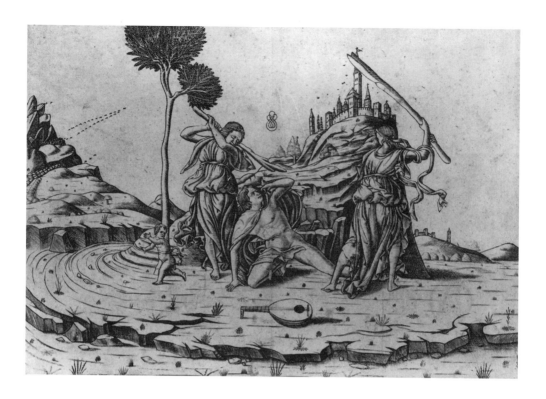

FIGURE 35

Ferrarese Master, *Death of Orpheus*, ca. 1460, engraving. Hamburg, Hamburger Kunsthalle.

martyr, torn to pieces by the Cossacks and an enraged mob. The highly stylized text plays on stereotypes of the East and culminates in the anguished cry: "This is what is going to happen to all students and Jews!" Warburg's handwritten commentary follows the newspaper clipping: "Die ewig gleiche Bestie, gen. homo sapiens (The eternal beast: homo sapiens)."[19]

Warburg was not the first to make such a statement. A detailed analysis of the collage, however, implies the collectively shared obsessions and fears of his time regarding the nature of the primitive, the masses, and the beasts within and without. Warburg's interest also shows structural parallels with Freud's undertaking, suggesting that cultural science and psychoanalysis shared origins in the stigma of belonging to the Jewish minority. Both Freud and Warburg, however, reacted to a reality, not an obsession. Warburg's effort to open up art history by confronting images with new questions that aim at understanding the nature of human resistance to enlightenment was dictated by necessity, "commanded" by the images themselves as understood in their cultural context.

FIGURE 36

Albrecht Dürer, *Death of Orpheus*, 1494, drawing. Hamburg, Hamburger Kunsthalle.

In a letter to his mother written when he was still a student, Warburg concludes from his experience of everyday anti-Semitic harassment in Strasbourg that he may devote his life to "the solution of the Jewish question."[20] Ultimately he shifted his efforts, attempting an *answer* as a historian rather than providing a *solution* as a politician. His true answer was the institution he created, with its intellectual purpose reflected in the open structure of his library. When Ernst Cassirer first saw this library, he described it as an embodiment of his yet embryonic "philosophy of symbolic forms." Warburg hoped it would be used as an instrument of enlightenment *and* as an institutional, material shelter ("Büchertrutzkasten")[21] for all those who seek to do interdisciplinary cultural studies.

From the perspective of Warburg's silent struggle, even such politically inconspicuous endeavors as the study of the *Nachleben der Antike* take on a second meaning. They belong to a struggle for identity on the symbolic battlefield of culture, where issues of supremacy, nationalism, and imperialist politics were contested well before actual fighting began in World War I.[22] The different facets of such an identity have been discussed by George Mosse in his study *German Jews beyond Judaism,* where he stresses the overwhelming importance of the German Enlightenment concept of formation (*Bildung*), which is inseparably bound up with both the rise of the German bourgeoisie and the emancipation of the Jews in that newly forming society.[23] As Robert Wistrich has argued, the Jewish *Bildungsbürger* wholeheartedly embraced the values of enlightenment, universalism, and individualism; rejected Jewish ritual; and participated in German patriotism and chauvinism yet at the very same time experienced rejection in an ever more hostile environment.[24] Those who, like Warburg, had wished to make their individual choice of where to belong were thus forced into irreconcilable inner conflicts. In Warburg's case, evidently, the price paid was a mental breakdown and years spent in psychiatric institutions.

If the urgency and the tension that are almost palpably present in Warburg's writings about Renaissance art can no longer be attributed only to mental instability, they must be seen in the context of these conflicts.[25] Warburg phrased his repeated warnings against such forced choices metaphorically as "die Räuberpistole des Entweder-oder," which virtually defies translation, although Ernst Gombrich made a valiant attempt with "answer the question at pistol point."[26] With this in mind Warburg referred to the reception of the Italian Renaissance style in Nuremberg in his Dürer lecture, warning against what he calls "a military concept of history" that allows only for "victors and defeated."[27] Later, in 1926, he expressed the same thought about Rembrandt's use of Italian and classical models.[28] Clearly, Warburg's plea in a number of his studies of Renaissance art and culture is for inclusiveness. It seems as if he were looking for proof in historical documents that such inclusiveness had been possible earlier and, consequently, would again be possible. Without

referring to the underlying motive, Gombrich describes this quest in the chapter "Harmonizing Opposites" of his biography of Warburg.[29]

In the political and cultural context of both the *Kaiserreich* and the Weimar Republic, "identity" could assume a threatening quality; it meant being one thing and not being another: Jew or German, patriot or traitor. Assimilation, for Warburg and many others, was not what today's critics see in it—or was not only that: a denial of one's own roots and heritage. Rather, the sources that document the foundation and early years of the Kulturwissenschaftliche Bibliothek Warburg make it clear that Warburg's rejection of the Jewish religion was intrinsic to his commitment to a humanistic perspective that countered the forces being unleashed in other quarters of a problem-ridden society before and after the First World War, forces that sought to forge a German identity based on racial principles and the *idée fixe* of a purely Germanic (*völkisch*) culture. Jewish Germans held on to values of humanistic universalism, not from a lack of courage to stand up for themselves, but in the face of a growing and threatening majority who questioned and distorted those values, which for Warburg, Erwin Panofsky, and many others were personified by the German authors of the eighteenth and early nineteenth centuries—Goethe and Lessing, to name but the most important.[30] Furthermore, at least for Warburg, it was quite clear that his position was precarious and somewhat anomalous, and he wanted it that way: in a letter of 1912 he refers to himself as a "futurist," uncomfortably situated between "Zionists" and "assimilationists."[31]

In their struggle to uphold these values in the political environment of the late *Kaiserreich,* the war, and the Weimar Republic, Jewish Germans did not use the term "identity," certainly not in the way we use it today. The Warburg archive, however, does document a struggle over identity or, to put it more fundamentally, over the right to one's own voice and the freedom to choose who one wanted to be. But it was also, tragically, this resistance to allying oneself to a particular ethnicity that later rendered so many Jewish Germans helpless in the face of rampant racism in the late twenties, and then after the National Socialists were given control in 1933.

It was not until the 1950s, and in the United States,[32] that the term "identity" was transplanted into the psycho-social debate by Eric H. Erikson, himself a German refugee.[33] Before that it had had its place in logic (a = a) and in the highly specialized, ongoing philosophical debate regarding the continuity of the self.[34] There is ample evidence that Erikson's concept of identity can be interpreted in part as a reflection of the struggle over cultural and ethnic identity that took place in the context of the murderous conflicts over European nationalisms, Nazism, and genocide. The concept of psycho-social "identity," as we use it to define an individual within the coordinates of group loyalties, was created as a *result* of that struggle, a weapon, and perhaps a kind of protective charm.

The concept of identity has been dismantled by psychologists and sociologists alike, as is apparent from such terms as "patchwork-identity," coined by Kenneth Gergen.[35] Only in the sphere of the *politics* of culture, where the need for an "identity" was generated more than a century ago, is it still considered useful. Perhaps it is. But it is certainly useful and necessary to keep in mind the circumstances in which the concept emerged a few generations ago in a Europe torn to pieces in the name of ethnic identities.

About his personal identity Aby Warburg once remarked that he was "a Jew by birth, a Hamburger at heart, a Florentine of the soul" ("Ebreo di sangue, Amburghese di cuore, d'anima Fiorentino" [*sic*]).[36] To help actualize an environment that would allow for such a patched-together identity, Aby Warburg had hoped to devise a *science* of culture. It is to be hoped that a new reading of Warburg's work and achievement will teach us how to combine the fulfillment of our own needs as responsible contemporaries with the ideals of scholarship that Warburg stood for and struggled for: to understand the historical Other rather than to mirror ourselves in history.[37]

Notes

1. William Heckscher, "The Genesis of Iconology," in Egon Verheyen, ed., *Art and Literature: Studies in Relationship,* Saecula Spiritalia 17, 2d ed., (Baden-Baden: Koerner, 1994), 239–62.

2. For an analysis of Wölfflin's quest for a "science of pure seeing" and his silent political motives for keeping strictly to art history see Martin Warnke, "On Heinrich Wölfflin," *Representations* 27 (1989): 172–87; a shorter version is "Sehgeschichte als Zeitgeschichte: Wölfflins 'Kunstgeschichtliche Grundbegriffe,' " *Merkur* 46 (1992): 442–49. The common historical background and its very different influence on both scholars is discussed in Martin Warnke, "Warburg und Wölfflin," in *Aby Warburg: Akten des internationalen Symposions Hamburg 1990* (Weinheim: VCH, 1991), 79–86.

3. Aby Warburg, "Heidnisch-antike Weissagung in Wort und Bild zu Luthers Zeiten," in *Die Erneuerung der heidnischen Antike. Kulturwissenschaftliche Beiträge zur Geschichte der europäischen Renaissance,* vols. 1 and 2 of *Gesammelte Schriften,* ed. Gertrud Bing for the Bibliothek Warburg (Leipzig and Berlin: Teubner, 1932; reprinted in one volume, Nendeln: Kraus, 1969), 489–558, 647–56.

4. Scholarship on Aby Warburg has grown immensely over the last decades and cannot be listed here with any degree of completeness. Among the most important studies are: Ernst H. Gombrich, *Aby Warburg: An Intellectual Biography. With a Memoir on the History of the Library by F. Saxl* (London: Warburg Institute, University of London, 1970); numerous articles in *Aby M. Warburg: Ausgewählte Schriften und Würdigungen,* ed. Dieter Wuttke with Carl Georg Heise, Saecula Spiritalia 1, 2d ed. (Baden-Baden: Koerner, 1980); Anne Marie Meyer, "Aby Warburg in His Early Correspondence," *American Scholar* 57 (1988): 445–52; Ulrich

Raulff's short afterward in Aby M. Warburg, *Schlangenritual: Ein Reisebericht* (Berlin: K. Wagenbach, 1988), 63–94; Michael Diers, *Warburg aus Briefen: Kommentare zu den Kopierbüchern der Jahre 1905–1918,* Schriften des Warburg-Archivs im Kunstgeschichtlichen Seminar der Universität Hamburg 2 (Weinheim: VCH, 1991).

5. Horst Bredekamp, *Botticellis "Primavera": Florenz als Garten der Venus* (Frankfurt: Fischer, 1988), 16–21.

6. Carlo Ginzburg, "Kunst und soziales Gedächtnis," in *Spurensicherung: Die Wissenschaft auf der Suche nach sich selbst,* 2d ed. (Berlin: Wagenbach, 1993), 63–127.

7. Martin Warnke, "Vier Stichworte: Ikonologie, Pathosformel, Polarität und Ausgleich, Schlagbilder und Bilderfahrzeuge," in *Die Menschenrechte des Auges: Über Aby Warburg,* ed. Werner Hofmann, Georg Syamken, and Martin Warnke (Frankfurt: Europäische Verlagsanstalt, 1980), 75–83.

8. For the *Bilderatlas* see Peter van Huissede, "Der Mnemosyne-Atlas: Ein Laboratorium der Bildgeschichte," in *Aby M. Warburg: "Ekstatische Nymphe . . . trauernder Flußgott": Porträt eines Gelehrten,* ed. R. Galitz and B. Reimers (Hamburg: Dölling und Galitz, 1995), 130–71.

9. See note 4.

10. Hans Liebeschütz, "Aby Warburg (1866–1929) as Interpreter of Civilisation," *Year Book of the Leo Baeck Institute* 10 (1971): 225–36.

11. Ibid., 230.

12. Felix Gilbert, "From Art History to the History of Civilization: Gombrich's Biography of Aby Warburg," *Journal of Modern History* 94 (1972): 381–91, here: 381.

13. See *Catalog of the Warburg Institute Library, University of London,* 12 vols. (Boston: G. K. Hall, 1967), 1:545–69, 3:941–53.

14. The new edition of Warburg's *Gesammelte Schriften* currently being prepared for Akademie Verlag, Berlin, will—particularly in the journals of the Kulturwissenschaftliche Bibliothek (1926–1929)—bring these concerns to light.

15. *Gesammelte Schriften,* 127–58, 353–65.

16. "Der Tod des Orpheus: Bilder zu dem Vortrag über Dürer und die Italienische Antike," in *Ausgewählte Schriften und Würdigungen,* 131–35.

17. This only becomes evident from the unpublished material related to the Dürer lecture, held by the Warburg Institute, London (Archive, III.61.3). I have discussed the central role of Dürer's and Rembrandt's art for this definition of a "Germanic" spirit in my 1996 *Habilitationsschrift* on Aby Warburg und der Antisemitismus: Kulturwissenschaft als Geistespolitik (Frankfurt: S. Fischer, 1998).

18. For recent studies, see Erika Simon, "Dürer und Mantegna 1494," *Anzeiger des Germanischen Nationalmuseums* 32 (1971/72): 21–40; Peter-Klaus Schuster, "Zu Dürers Zeichnung 'Der Tod des Orpheus' und verwandten Darstellungen," *Jahrbuch der Hamburger Kunstsammlungen* 23 (1978): 7–24. Both articles have an account of the earlier scholarship on the print and on Dürer's drawing. For another interpretation, see Edgar Wind, "Two Mock-Heroic Designs by Dürer," *Journal of the Warburg Institute* 2 (1938/39): 206–18.

19. Warburg Institute, London (Archive, III.61.3).

20. See Schoell-Glass, *Aby Warburg und der Antisemitismus.* Warburg's letters are in the Warburg Institute in London (Archive, Family Correspondence 1887, 1889).

21. Warburg expressed this hope in a letter to his brothers Paul and Felix, 11 May 1926. See Tilmann von Stockhausen, *Die Kulturwissenschaftliche Bibliothek Warburg: Architektur, Einrichtung und Organisation* (Hamburg: Dölling und Galitz, 1992), 174.

22. For the role of "culture" in the formative period of European nationalism, see Ernest Gellner, *Culture, Identity, and Politics* (Cambridge: Cambridge University Press, 1987).

23. George Mosse, *German Jews beyond Judaism* (Bloomington, Indiana, and Cincinnati, Ohio: Indiana University Press and Hebrew Union College Press, 1985).

24. Robert Wistrich, *Between Redemption and Perdition: Modern Anti-Semitism and Jewish Identity* (London and New York: Routledge, 1990); see also Dennis B. Klein, *Jewish Origins of the Psychoanalytic Movement* (Chicago and London: University of Chicago Press, 1985), esp. "Assimilation and Dissimilation," 1–39.

25. For an early account of Warburg's emotional state, see Carl Georg Heise, *Persönliche Erinnerungen an Aby Warburg* (Hamburg: Gesellschaft der Bücherfreunde, 1959, 2d ed.); for a more recent account, see Karl Königseder, "Aby Warburg im 'Bellevue,'" in *Aby M. Warburg, "Ekstatische Nymphe . . . trauernder Flußgott,": Porträt eines Gelehrten,* 74–98.

26. Gombrich, *Intellectual Biography,* 238, translating from Warburg's lecture, "Italian Antiquity in the Age of Warburg," delivered in May 1926 at the Warburg Library, Hamburg.

27. *Gesammelte Schriften,* 158.

28. Gombrich, *Intellectual Biography,* 238.

29. Ibid., 168–77.

30. See Michael A. Meyer, *Jewish Identity in the Modern World* (Seattle and London: University of Washington Press, 1990), 10–47.

31. Michael Diers, *Warburg aus Briefen,* 56.

32. Philip Gleason, "Identifying Identity: A Semantic History," *Journal of American History* 69 (1983): 910–31.

33. Erik H. Erikson, "Ego Development and Historical Change," *Psychoanalytical Study of the Child* 2 (1946): 359–96; idem, *Childhood and Society* (New York: Norton, 1950; 2d ed., 1963). For a summary of Erikson's work, see Edmund Hermsen, "Werk und Wirkung: Erik H. Eriksons als Wegbereiter psychohistorischer Forschung," in Ludwig Janus, ed., *Psychohistorie—Ansätze und Perspektiven* (Heidelberg: Textstudio Gross, 1995), 1–18.

34. John Perry, ed., *Personal Identity* (Berkeley and Los Angeles: University of California Press, 1975).

35. Kenneth J. Gergen and Keith E. Davis, eds., *The Social Construction of the Person* (New York: Springer, 1985); Kenneth J. Gergen, *The Saturated Self: Dilemmas of Identity in Contemporary Life* (New York: Basic Books, HarperCollins, 1991).

36. Quoted by Gertrud Bing in a lecture in the Hamburg Kunsthalle in 1958, in *Ausgewählte Schriften und Würdigungen,* 464; on this lecture and the occasion of the restoration of the bust of Warburg to that museum, see Joist Grolle, "Die Büste Aby Warburgs: Ein Hamburger 'Denkmalfall,' *Im Blickfeld: Jahrbuch der Hamburger Kunsthalle* 1 (1994): 149–70.

37. Warburg's motto for his 1926 Rembrandt lecture states this explictly with a quotation from Goethe's *Faust*: "Was Ihr den Geist der Zeiten heisst, das ist im Grund der Herren eigner Geist, in dem die Zeiten sich bespiegeln": *Faust* 1:578–79 ("That which you call the spirit of the age is really nothing but those masters' minds in which the ages are reflected").

Illustrations

34. Eleanor Antin, "Eleanora Antinova in 'Before the Revolution,'" from *Recollections of My Life with Diaghilev,* 1983. Photograph courtesy of Ronald Feldman Fine Arts, New York / *159*

35. Ferrarese Master, *Death of Orpheus,* ca. 1460, engraving. Hamburger Kunsthalle, Hamburg. Photograph: Elke Walford / *224*

36. Albrecht Dürer, *Death of Orpheus,* 1494, drawing. Hamburger Kunsthalle, Hamburg. Photograph: Elke Walford / *225*

Contributors

KALMAN P. BLAND teaches in the Department of Religion at Duke University. His area of interest is Jewish intellectual history, especially medieval philosophy and mysticism. His forthcoming book, *The Artless Jew,* will investigate premodern Jewish aesthetics and modern aniconism. He has published recently in the *Journal of Medieval and Early Modern Studies* and in the *Journal of the History of Ideas.*

LISA BLOOM teaches visual culture in Japan. Her book *Gender on Ice: American Ideologies of Polar Expeditions* was published in 1993 by the University of Minnesota Press. She has published on issues of multiculturalism and feminism, in such journals as *Configurations, Afterimage,* and the *Socialist Review.*

LOUIS KAPLAN teaches modern art history and Judaic studies at Tufts University. His current research is on photography and modern Jewish identity. He has published on the cultural politics of Walter Rathenau, Charlie Chaplin, and Albert Einstein, as well as on Jewish humor. He is the author of *László Moholy-Nagy: Biographical Writings,* published by Duke University Press in 1995.

DONALD KUSPIT is Professor of Art History at the State University of New York at Stony Brook. He has published widely for many years, in both German and English, on Continental philosophy, contemporary art, and art history. He is a regular contributor to *Artforum* and to major exhibition catalogues on George Baselitz, Bill Viola, and others. He is the author of *Idiosyncratic Identities: Artists at the End of the Avant-Garde,* 1995.

KAREN MICHELS, of Hamburg and Jena Universities, has recently completed a book on German Jewish art historians in exile (forthcoming, 1999) as well as a new edition of Panofsky's writings (with Martin Warnke).

MARGARET OLIN is Associate Professor of Art History, Theory, and Criticism at the School of the Art Institute of Chicago. She is the author of *Forms of Representation in Alois Riegl's Theory of Art* (1992) and has published widely on Jewish identity in the visual arts. She is currently preparing a book on the concept of Jewish art in art-historical scholarship.

ROBIN REISENFELD is an independent scholar. She has published recently in *Art History* and writes on issues of nationalism and cultural identity in German art.

LISA SALTZMAN is Assistant Professor of History of Art at Bryn Mawr College. She has published several articles on Jewish identity in art history. Her book on Anselm Kiefer will be published in 1999 by Cambridge University Press.

CHARLOTTE SCHOELL-GLASS teaches at Hamburg University, where she is also affiliated with the Warburg Haus. She has published on grisaille in the Middle Ages and is the author of *Aby Warburg und der Antisemitismus: Kulturwissenschaft als Geistespolitik* (Frankfurt: Fischer, 1998).

LARRY SILVER is Farquhar Professor of Art History at the University of Pennsylvania. He has published widely in art history, particularly on early modern North European paintings and graphics. He is the author of *Art in History* (1993) and has also published on Rembrandt and Dutch prints.

CATHERINE M. SOUSSLOFF is Professor of Art History and Visual Culture at the University of California at Santa Cruz. Her book *The Absolute Artist: The Historiography of a Concept* was published in 1997. She has published articles on Italian art history as well as on film, aesthetics, and performance. Her book on aesthetics and Jewish identity is in progress.

Index

DESIGNER
Nola Burger

INDEXER
Andrew L. Christenson

COMPOSITOR
Bookmasters, Inc.

TEXT
10.75/13.5 Bembo

DISPLAY
Weiss

PRINTER
Data Reproductions Corporation

BINDER
Southeastern Printing Company

DATE

GAYLORD

PRINTED IN U.S.A.